WOMEN AND CLASS
IN AFRICA

African Places Referred to in Women and Class

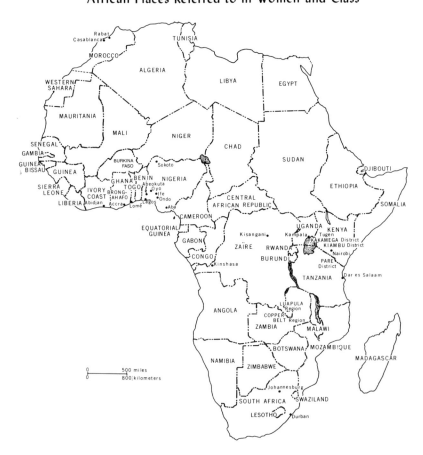

WOMEN AND CLASS
IN AFRICA

**edited by Claire Robertson
and Iris Berger**

Africana Publishing Company
a division of Holmes & Meier
New York • London

First published in the United States of America 1986 by
Africana Publishing Company, a division of
Holmes & Meier Publishers, Inc.
30 Irving Place
New York, N.Y. 10003

Great Britain:
Holmes & Meier Ltd.
Pindar Road
Hoddesdon, Hertfordshire
EN11 OHF

Book design by Ellen Foos

Library of Congress Cataloging-in-Publication Data
Main entry under title:

Women and class in Africa.

Bibliography: p.
1. Women—Africa—Social conditions—Addresses,
essays, lectures. 2. Women—Africa—Economic condi-
tions—Addresses, essays, lectures. 3. Social
classes—Africa—Addresses, essays, lectures.
4. Feminism—Africa—Addresses, essays, lectures.
I. Robertson, Claire C., 1944– . II. Berger,
Iris, 1941–
HQ1788.W57 1986 305.4'2'096 85-17568
ISBN 0-8419-0979-2

Manufactured in the United States of America

To Dee Dee Vellenga and other women of courage

Contents

Tables

WOMEN AND CLASS
IN AFRICA

Chapter 1

INTRODUCTION
Analyzing Class and Gender—
African Perspectives

CLAIRE ROBERTSON
IRIS BERGER

WOMEN HAVE LONG remained invisible in studies of class and strat-
ification; until recently Marxist and other social science theory both sub-
sumed their position as individuals into the class status of men. While
feminist research over the past decade has grappled with the issue of how
to understand women's class position, particularly under capitalism, and
of how to reconceptualize class so as to include women, many questions
require further thought and clarification. Joan Acker's review of the liter-
ature on women and stratification outlines the three predominant ap-
proaches to the study of the relationship between gender[1] and class. The
first sees gender and class stratification as distinct phenomena that should
be analyzed separately; the second attempts to integrate women into
existing theories without substantially changing those theories; while the
third assumes that reformulated ideas of class are necessary to a full
understanding of gender inequality (Acker 1980:25). We see this volume as
a part of an ongoing effort at reconceptualization and as a contribution
that will expand the discussion of women and class into a cultural area
that has been on the periphery of current theoretical dialogue in North
America. We also hope that by using gender and class as a unifying theme,
these essays will illuminate new facets of African social, economic, and
political structures.

An important aspect of this volume is its diversity. Informed in vary-
ing ways by Marxist and feminist perspectives, the essays cover West,
Central, East, and Southern Africa. Moreover, the approaches of our con-
tributors differ considerably, coming from history, anthropology, so-
ciology, and political science, although these affiliations are often invisible
in the interdisciplinary perspectives required to deal with gender inequal-
ity and class. Nonetheless, this diversity makes the regularities we un-
cover all the more significant, revealing patterns that contribute signifi-

3

cantly to our knowledge of women and culture and that challenge both widely held Western generalizations about women and androcentric analyses of class. Only through this dual process of intellectual decolonization can we begin to talk of universal theories concerning the relationship between class and gender.

BACKGROUND TO AFRICAN SOCIETIES

A number of aspects of African history and social organization are central to an understanding of women and class. First of all, changing relationships with the Western world have dramatically shaped the past and continue to influence the present. While the initial centuries of commercial contact between Africa and Europe built heavily on preestablished patterns of long-distance trade among African societies, the massive expansion of the Euro–American slave trade in the eighteenth century substantially altered the nature of this internal trade. Throughout the mercantilist era, however, Africans were able to set the terms of trade and to control European access to valuable commodities. As industrial capitalism developed in the late eighteenth and nineteenth centuries, Europeans felt a greater need for formally controlled markets and sources of raw materials. Through a combination of improved military technology and treaties that restricted African access to state-of-the-art firearms, they were able to conquer much of the continent between 1880 and 1900 and to establish effective control during the first decades of the twentieth century. Only after World War I did most Africans begin to feel the strong impact of colonial rule. Colonial boundaries drawn up in the intra-European treaties of the late nineteenth century became the geographic delimitations of the new states that have gained their independence since the late 1950s, sometimes through negotiations with the leaders of mass-based nationalist movements and sometimes through protracted guerrilla warfare. The exceptions to this rule are Ethiopia,[2] controlled briefly by the Italians during World War II, and South Africa and Namibia (South-West Africa), still under white minority rule. The other countries with significant white settler populations (Kenya, Mozambique, Angola, and Zimbabwe) are now independent under African governments.

Enriching the mother countries (France, Great Britain, Portugal, Italy, Belgium, and Germany, until after World War I) remained the primary goal of colonial rule. Unlike the American experience, where colonialism affected only a small part of the country and ended before industrialization, African colonialism involved the incorporation of most of the continent into an already well-developed European industrial economy as suppliers of raw materials and cheap labor. Government protection of large companies dominated by nationals of the colonial power discouraged the development of African-owned business, as did the domination of small-scale trade in many areas by other foreigners, often from non-Western areas (India, Lebanon). Only after World War II did some

metropolitan governments become concerned about providing Western education or other social services on a significant scale. Thus, much of the economic development that occurred prior to independence involved the construction of transportation and communication systems aimed at exporting raw materials to Europe, rather than at encouraging internal trade or self-sustaining economic development.

Colonial rule imposed European economic and political systems on a continent combining enormous geographical and cultural diversity with significant underlying similarities in many aspects of society, including the position of women. Most African economies were based on agriculture and iron technology, although pastoralism dominated in certain areas of the continent and small pockets of hunting and gathering peoples remained in other areas. Rotating slash-and-burn cultivation on communally owned land was the norm. Women and junior males usually contributed a portion of the fruits of their labor to senior male lineage heads or political authorities, who allocated use rights to particular plots of land, which might be reallocated rather than inherited at a person's death. Women performed much of the agricultural labor, as they still do. Their great labor value made them most valued as slaves; in precolonial Africa a majority of the slaves were women, who usually fetched higher prices than men (Robertson and Klein 1984). In some cases the privileges of age overcame the disabilities of gender and women held high political office more often than at present, frequently within the context of authority structures parallel to men's. And women were vital to commerce, particularly in coastal West Africa and riverine areas, where they dominated the retail food trade. They also played a significant part in many aspects of religion. That couples generally did not practice community of property in marriage gave women a great deal of autonomy in handling their finances. In many areas of North, West, and East Africa, however, Islam limited women's commercial participation as well as their role in orthodox religious observance.

Varying family structures also greatly affected women's position. Most African peoples were unilineal, tracing descent either through the maternal or the paternal line. Although matrilinearity was more common in Africa than elsewhere, most property was nonetheless inherited through men (father to son, mother's brother to sister's son). As in many nonindustrial societies, marriage generally involved family, political, and economic interests as well as personal considerations. The household, the most important unit of production, usually was composed of several generations; although residential patterns varied greatly, nuclear families were relatively rare. Polygyny was more common for wealthy than for poor men, helping to generate wealth and a high fertility rate for men (but not for women). A man's wives produced much of the agricultural surplus that could be sold or used to support clients and to achieve political influence, while children provided essential labor. Women grew and processed most of the food for the household and performed all other domestic work. The need for bridewealth payments reflected this relationship

between control of labor and wealth. In order to marry, a man and/or his lineage (family tracing descent from a common ancestor) usually had to make a gift or payment to his prospective wife or, more commonly, to her lineage. Without this bridewealth the marriage was not valid. The amount of bridewealth varied according to socioeconomic status and sometimes was not paid in full until long after the birth of many children. Divorce, which was fairly common in sub-Saharan Africa, was female-initiated more often than in Western traditions. Some strongly Muslim areas again form an exception to this rule, although not all: for example, Hausa women in Northern Nigeria and Southern Niger frequently seek and obtain divorce (Saunders 1979; Smith 1965).

Colonialism, with its introduction of new mechanisms for systematically extracting African wealth and its importation of many aspects of Western culture (Christianity, formal education, Western technology and living standards for the new upper class, and new forms of patriarchal ideology and practice) had a drastic effect on the continent. Urbanization intensified, as did class and gender differences. Cash cropping was introduced mainly to men, who also found more numerous opportunities for wage labor. Pressured by the need to pay taxes, virtually everyone was brought directly or indirectly into the nexus of a commercial economy. As European sexism was added to patriarchal elements in indigenous cultures, sex roles changed to the detriment of women, and they lost political power. While women retained responsibility for feeding their families, the prevalence of male labor migration in many areas left them to do even more of the agricultural work. Divisions were heightened after World War II and even more after independence, as people sought more remunerative employment and better services in towns. Colonialism not only exacerbated inequality, but ultimately turned over governmental mechanisms for extracting wealth to new African ruling classes.

Independence has not alleviated many of the continent's problems. Rather, most African economies remain subordinated to Europe and the United States through multinational corporations that profit a tiny upper class. Women, as well as most men, are experiencing impoverishment. While most independent African nations have passed laws favoring equal rights for women, few have been enforced. In the 1970s and 1980s severe economic difficulties have beset many countries in the face of high oil prices, falling food production, severe drought, government corruption, and neocolonial economic relationships that have limited the degree of structural change in the economy and have kept most countries dependent on a limited number of exports for foreign exchange. Women's dominant role in food production continues to be ignored in "development" planning (Boserup 1970; Rogers 1980). Africa now is the poorest continent, with poverty an everyday reality for most people and starvation for many, but particularly for African women and the children they support. The vital economic functions of most women are more important than ever, but events have conspired to impoverish them further. In this setting, then, it is especially important to consider the relationship of gender and class, for it has dramatic contemporary implications.[3]

AFRICAN STUDIES AND THE CONCEPT OF CLASS

Serious study of both women and social class in Africa has formed part of the reconceptualization of Africanist scholarship that occurred in the 1970s. But, whereas women's previous marginality went unnoticed because of Western academic canons that ignored women as a valid subject for investigation, class analysis was overtly and consciously dismissed in the 1960s as part of the postwar tendency to reject the relevance of Marxism to contemporary social science. African nationalist efforts to create undifferentiated unity within their state boundaries reinforced the academic effort to deny the applicability of class analysis to Africa. Perhaps the most representative work of this period was P. C. Lloyd's *The New Elites of Tropical Africa* (1966), which both reflected and set a tone for accepted discourse on the issue. The subject of its study was perceived as "men [mainly in bureaucratic employment] who are predominantly young, highly educated and comparatively wealthy" (Lloyd 1966:1, 7). While the introduction notes that scholars a decade earlier had commonly referred to this group as a new middle class, most contributors to the volume preferred the concept of elites to classes, believing that on the basis of property ownership and consciousness, a class structure was as yet nonexistent in Africa. Disregarding Marx, most writers of the period took their analytical framework from the American social science tradition of Warner, Bendix, and Lipset (see Shivji 1976:24–26 for a critique of elite theories) and tended to agree with the anthropologist Fallers (1973:78) that, in the short run, extended kinship solidarities combined with the effects of economic modernization would inhibit the development of class distinctions.

Perhaps because of the strong influence of anthropologists (as opposed to political theorists), many of the writings on stratification (see especially Tuden and Plotnicov 1970) did not totally ignore women; but the infrequent references to them concentrated on marriage and family relationships. Even when women were mentioned as individuals, obvious questions were readily disregarded. In an essay on Nigeria, for example, Plotnicov (1970) gave a biographical sketch of an "elite" woman to exemplify the ambiguous status of some members of this category, yet he failed to discuss the relationship between the woman's status ambiguity and her gender or to consider the issue of whether and how women were able to attain "elite" status on their own. The few exceptions to the tendency to subsume women into the family are worth mentioning; Van der Vaeren-Aguessey's (1966) article on women traders in Dakar, Senegal, saw them as a social class in formation, while Ronald Cohen (1970:246), writing on the northern Nigerian state of Bornu, brought women into his discussion of stratification and drew attention to the problematic issue of defining status distinctions in the culture because of women's refusal to accept their inferior position. Most women, however, were consigned to the undifferentiated "masses," not an analytical concern of these studies.

While class analysis faded from academic studies in English during the 1960s, revolutionary theorists such as Frantz Fanon and Amilcar

Cabral kept the issue alive, as did francophone Marxist theorists such as Samir Amin. They left a tradition to be tapped by scholars and activists of the 1970s who sought new analytical insights to illuminate the tendencies they perceived in African societies. A full review of this rich body of literature would require a volume of its own (see Katz 1980), but it is important to note a number of concepts central to this work that have been influential in the study of African women: theories of underdevelopment; a concern with the impact of capitalism on African societies, including its influence on class formation; ideas of class struggle and class consciousness; and the concept of modes of production (see Stamp, Chapter 2 in this volume), particularly as a means of conceptualizing precapitalist societies.

Without this rebirth of Marxist analysis, feminist writing on Africa would be cast very differently. Unfortunately, the obverse of this proposition has not been true. The early phase of the new "radical" writing on Africa, often highly theoretical, paid little attention to women. (Meillassoux's work, though subject to feminist criticism, is an exception.)[4] The collection *African Social Studies: A Radical Reader*, provides a useful gauge of writing on social class in Africa during the first part of the 1970s. Published in 1977, not one of its forty-two articles by prominent Africanists stressing the themes of "class structure, class consciousness, and the struggle for socialism" is on women, nor is there any reference to women in its extensive bibliography. While it might be argued that serious study of women in Africa was only beginning on a large scale by the mid-1970s, the pattern found in most other disciplines seems to apply equally well to studies of class in Africa: research and writing on women develop independently of other scholarship, whether mainstream or revisionist, and remain largely a ghettoized field. While writing on women draws from the concerns of the discipline as a whole, as well as from many other sources, most writers, Marxist or otherwise, have failed to incorporate a concern for women or for gender relations into their own research. Not only did the content of most of these studies leave women outside of their accepted vision of African class systems, but the "gender-free" conceptualization of class and class consciousness left the relationship of women to the class system completely obscure; indeed, there was little recognition that the problem even existed.

The theoretical basis for the development of African women's studies came not only from Africanist writing but also from several other sources: general feminist theory, particularly Marxist-feminism; feminist anthropology; and other work on women in the Third World, especially Latin America. For purposes of the study of women and class, several aspects of this work are notable. The discussion of the origins of class-based societies stemming from Engels' work, *The Family, Private Property and the State* (see especially Leacock 1972 and 1978 and Sacks 1974), argues strongly in favor of a connection between class inequality and women's subordination and thereby posits an analytical orientation that relates the declining position of African women in the twentieth century to the development of new class systems in the colonial period. This decline in women's status

throughout the Third World was a major point of Ester Boserup's influential book *Woman's Role in Economic Development* (1970), which established a framework that retains an impact on most studies of women in these areas; work by Heleith Saffioti (1978) on Latin America discusses a similar theme in terms of the peripheralization of women under capitalism. Finally, the stress of anthropological work on the relationship between the public and the private spheres (Rosaldo and Lamphere 1974) posed another central problem to which later work continues to respond. It is the writings of Marxist-feminists that relate the two-spheres idea to the concept of social class.[5]

The central contribution of Marxist-feminist work (reviewed more specifically in Chapter 2 in this volume) lay in connecting the sphere of production to the sphere of reproduction, broadly conceived as including household labor, the care and socialization of children, and the reproduction of class-related attitudes that create both a new generation of workers and the value system necessary for the social order to survive.[6] In class terms, this work has stressed the necessity for capitalism of women's household labor and of women's role as a "reserve army" of workers that can be drawn into wage labor when necessary and then returned to domestic invisibility. These formulations have elicited intense debate and have been criticized in particular for their functionalism—for the assumption that institutions like the family necessarily mesh with the interests of capitalism (Bozzoli 1983, for example). While such criticisms are clearly valid, and some of this writing echoes the counterposed terms production and reproduction with a repetitiveness that explains little, the demonstration of links between the household and production outside the household underlines in a theoretically important fashion the major task of an analysis of women and class: how to formulate questions and a theoretical framework that fully take into account women's joint participation in both arenas of social and economic existence. Indeed, much Marxist-influenced literature on women in the Third World has been more concerned with the divisions between classes than with incorporating the division between men and women within the household into their analysis (see Guyer 1981 for further discussion of this point).

In expanding on the implications of these relationships between production and reproduction, public and private, several points about Africa require clarification. Our essays all concern developments of the twentieth century, a period during which the joint domination of formal colonial rule and capitalist hegemony has profoundly shaped changes in all aspects of life, establishing a pattern by which most of Africa became incorporated into the network of a far-flung Western industrial economy. Foreign domination with its extension into neocolonialism has introduced new class cleavages into African societies, sometimes onto a relatively egalitarian base, sometimes into previously stratified social structures. While earlier patterns of inequality usually intensified during the colonial period, new class systems also have developed in accordance with changing forms of capitalist penetration.

Many of these processes of social transformation have been detrimen-

tal to women. Their previously dominant role in food production has often been overlooked or ignored in the process of developing new crops and farming techniques, yet there have been fewer opportunities for them in newer capitalist enterprises than for men. This has left disproportionate numbers of women in economically precarious positions at the lower levels of the socioeconomic scale. These essays, then, explore the mechanisms and methods by which gender has articulated with socioeconomic structure to create a widespread feminization of poverty in Africa.

ACCESS TO CRITICAL RESOURCES

The underlying assumption of most feminist writing on women and class is that women's socioeconomic status is not necessarily congruent with that of related men. This point is particularly important with respect to Africa, since most African women neither routinely pool property with their husbands nor share resources equally with male lineage members. Thus, the Western assumption that women share, however marginally, in the class status of associated men has to be reexamined as do definitions of class in an African context. Here the definitions used vary according to the contributor, but most are Marxian in emphasizing relationship to the means of production as a primary characteristic. The essays in Part I, although dealing with diverse culture areas, all focus on the changing social and economic relationships between women and men during the course of the twentieth century. The central point that emerges is that, whether the economically significant resources in question are land, cattle, labor, or education, women's access to them has been substantially less than that of men. The chapters agree further that the processes of change associated with colonialism and capitalism since the nineteenth century that have undermined women's position have been beneficial to local ruling classes and often to male household members, as well as to the capitalist world economy. Thus, a primary aim of Stamp in Chapter 2 is to show how "an exacerbated form of sex-gender domination becomes an important element of the general peasant subsidy of capitalist accumulation." Yet an important strength of these essays is the way in which they also correlate the changing relationship of peasants to capitalism with the changing household relationships between men and women.

These links between the relationships of peasants to capitalism and of women to men within the family take many different forms. Stamp, writing on the Kikuyu of central Kenya, shows how peasant men have gained private title to lands once communally held, leaving women as a dominated class within the peasantry, just as peasants are a dominated class within underdeveloped African capitalism. Women are now expected to produce to support their husbands and children as before but also to produce a petty commodity surplus of food or goods that is expropriated by their husbands. Petty commodity production, rather than being an intermediate stage between feudalism and capitalism that would be swept

away by the rise of capitalism, as Marx would have it, has been intensified by further capitalist expansion, as Bujra argues in Chapter 7. In Chapter 3 Kettel, citing Engels, similarly centers her discussion around "differential access to productive resources," including land, livestock, and cash, of Tugen women of northern Kenya. She argues, however, that this relative deprivation is not inherent in pastoralism, as others have claimed, but is rather a product of the commoditization of resources that began under colonialism. The relative newness of the situation helps to explain the paradox of economically oppressed women who act with great self-confidence, a phenomenon also noted elsewhere in Africa. In Kettel's case and elsewhere in Kenya (see Okeyo 1980), the granting of land ownership to male heads of household represented the culmination of a process that has created new power distinctions within the household. Even in the limited number of cases in which women were able to gain title to small plots, this was usually a strategy designed for the benefit of prominent men.

Chapters 4 and 5, by Vellenga and Afonja, respectively, make similar arguments stressing household structure as a determinant of differential access to resources. Afonja, using comparative data from three different geographical areas of Nigeria, argues that women's limited access to land has been a critical factor in explaining gender inequality; she would classify women as "a lower stratum of the peasantry." Vellenga focuses on kinship systems in two different cocoa-growing areas of Ghana, finding that although women have access to land and labor, they are likely to have smaller farms than men and are less likely to acquire farms on their own. More dependent than men on nonfamily labor, women are more apt to work as laborers on their spouses' farms. Furthermore, they remain relatively uninvolved in the complex brokering and marketing systems that men can use to substantial economic advantage.

In tracing the emergence of contemporary class systems in which women form the lowest stratum of these predominantly rural societies, the authors all agree that this situation represents a significant change from precolonial systems often marked, as among the Tugen, by separate gender hierarchies with interlocking rights and responsibilities in production and reproduction. In these settings, age was often more significant than gender in determining status. In the case described in Chapter 2, control of women's labor, critical to precolonial lineages which held land communally, was carried out through parallel male and female authority structures, and women were able to exercise substantial informal political control. Neither Kettel nor Stamp describes a perfectly egalitarian precolonial setting, but in both cases parallel gender-based political structures gave women greater control over resources than they now possess.

Vellenga's essay deals with precolonial continuities through its concern with the impact of matrilineal and patrilineal inheritance structures on the access of Ghanaian women cocoa farmers to land and labor. Although one might expect that matrilineal inheritance would give women an economic advantage, this is not necessarily the case. Whether inherited matrilineally or patrilineally, most property is bequeathed to men. Ma-

trilineal women were more successful than patrilineal women in using entrepreneurial efforts to acquire farms; but Vellenga is uncertain whether this was a result of choice or of forced independence resulting from the greater ambiguity of inheritance practices in matrilineal areas. Moreover, the fact that more women inherited farms from their husbands in matrilineal than in patrilineal areas meant that access to land was dependent on marriage, an insecure relationship in Ghana. It seems, then, that having the theoretical right to own property on their own does not necessarily eliminate female dependence on men for access to resources; in Vellenga's sample, 58 percent of the inherited land in matrilineal cases came from male relatives, as did 81 percent of the land in patrilineal cases. But this right to hold land does help to make the class status of these women more independent of the class status of related men than in many other African cases. This issue is explored further in Part II.

Afonja's essay examines in detail the interplay between precolonial sociopolitical structures in the Yoruba kingdoms and subsequent changes in women's position, particularly in relationship to different systems of land inheritance. She shows that in Ile-Ife, a state with patrilineal inheritance patterns, preexisting property laws interacted with capitalist values to restrict women's access to land; as the growth of tenant farming has created new hierarchies among peasant men, peasant women have found land more difficult to obtain. In Ondo and Abeokuta, by contrast, where women were allowed to own land, they were better placed to enter into the new commercial economy in both the production and distribution of export crops. Afonja cautions, however, that more open inheritance patterns did not essentially wrest control of land from men. "It merely gave the women of the family and their offspring permanent rights to portions of family and community land." She argues that, for rural communities, the level of women's access to land is critical to an understanding of gender relations.

These essays, then, preclude blaming African women's deprivation solely on colonialism and capitalism and support the Western feminist argument that the household, as well as the international economy, is a prime locus of women's oppression. But household here must be more broadly defined to include household relations of production, which may be manifested in productive work done outside the home, thus blurring the public-private distinction proposed by Marx and supported by Rosaldo and Lamphere (1974) in their earlier work (for a reinterpretation see Rosaldo 1980). If in the cases described by Afonja, Kettel, and Stamp the husbands largely control the products of the women's labor, other African cases are not so extreme and women's earnings are more subtly converted to male use, as payment for sons' school fees, for instance (Robertson 1984:ch. 6). So, while a Marxian conversion of women's labor to the private profit of men does occur, it is not accompanied by a process of domestication that confines women to the home. Rather, the public labor of women is just as necessary as their domestic labor to the function-

ing of the economy, and proletarianization of men into wage jobs includes a forced subsidy from women's unpaid labor. If many governments define that unpaid labor in agriculture as "gardening" to make it seem domestic and unimportant, the fact still remains that it is productive, both in the sense of providing food and in the sense of generating surplus value that profits men and the upper class. Wage earners and nonwage laborers must be included in our analysis of the proletariat, thus creating a unitary rather than a dichotomous model for gender-class relations.[7]

The last chapter in Part I interprets "resources" more broadly, looking at access to Western forms of education, particularly for girls. Robertson first demonstrates that inequality in female access to schooling has continued, despite large commitments by African governments to the goal of universal primary education. Thus, women have difficulty achieving high socioeconomic status on their own, since Western education is a necessary qualification for many jobs. Robertson suggests that girls are sent to school less often than boys primarily because of the great value of their labor. She then discusses the economic dysfunctionality of women's education in Africa, where the least educated and the few highly educated women have the highest rate of labor force participation. Stiff competition with men for scarce white collar jobs, as well as discrimination in hiring, sexual harassment, and problems with child care, tend to limit the opportunities for primary and secondary school leavers. Furthermore, the content of girls' education focuses too often on skills that have no economic value. Rather than aiming at creating financially independent women, it seems to have the goal of forming suitable Western-type housewives for aspiring professional men. Ironically, then, as several chapters in Part II discuss, education may contribute to the prevalence of hypergamy (marrying up), an important strategy for women seeking to raise their socioeconomic status.

The second part of Robertson's essay further analyzes the content and consequences of women's formal education, which is depicted as training for subordination. While it usually does not provide useful economic skills, it does remove girls from possible apprenticeships with economic value. The result is that, whether or not most women go to school, they will find themselves in disadvantaged positions. If they attend school, they are more likely to be unemployed or to find insecure jobs that leave them dependent on men; if they do not, they may remain more autonomous economically, but in less remunerative situations, as self-employed traders or agricultural laborers. This issue of women's relative dependence and autonomy is the subject of Part II.

DEPENDENCE VERSUS AUTONOMY

The essays in Part I share a focus on structure and, in particular, on analyzing the way in which broad changes in social and economic organi-

zation have influenced the class position of groups of women. Most share an emphasis on the processes of change within particular ethnic groups. The evidence presented suggests overwhelmingly that the women in the case studies, primarily rural peasants, have considerably less access than related men to the resources necessary to improve, or sometimes even to sustain, their economic situation. The essays in Part II, by contrast, tend to view the subjects of their analyses in terms of class or occupational categories and to be more interested in the strategies of individuals within these categories. This analytical shift allows us to examine several issues more closely: the specific determinants of women's class status and, in some cases, of their consciousness; and the strategies of individual women in shaping their own economic choices. This discussion offers insight into the central question of Part II: the relative dependence or autonomy of women's class position as seen both in women's own perceptions of their class identity and in the degree of their actual economic autonomy.

The essays in Parts I and II bring out the complexities of determining women's class status, dependent not simply on the class position of related men but also on women's own relationship to paid and unpaid labor. Bujra, in Chapter 7, succinctly summarizes the analytical dilemma: "Women cannot be thought of as a single category, even though there are important and occasionally unifying struggles in which they may engage. At the same time women cannot be simply analyzed 'as men'; gender is almost invariably a relevant social category. The point is that gender differences find differential expression at different class levels—gender is qualified by the places which women occupy in newly emergent classes." In other words, while class position mediates the experience of gender, gender is an important determinant of class position, a relationship largely responsible for the high level of difficulty encountered in defining gender-class relations. But this cuts both ways: for men the situation is also more complex than most analysis has assumed; a man's class position may be raised, for example, by access to the labor and/or wages of his wife. Indeed, several chapters (2, 3, 4, 5, 7, 14) demonstrate the contribution of women's labor to the accumulation of male resources.

In approaching their individual topics, many contributors have found in the concept of access to critical resources a useful way to clarify women's relationship to the means of production, hence their class position. The resources in question may include jobs, wages, land, labor power, cattle, and livestock, as well as education or skills. Access to these determinants of class position may be direct, through self-employment or wage labor, or indirect, through the contributions of others. Although this concept does not provide a set of generally recognized class categories, it has some important advantages in refining the idea of relationship to the means of production, primarily because it is broader and more flexible. By allowing for a distinction between direct and indirect access, for example, it provides a better definition of the situation of upper-class women whose position is achieved by hypergamy; if they have complete or substantial access to their husbands' income, then they are, at least temporarily, full

members of the bourgeoisie, who control critical resources, even though the women do not *own* the means of production. Furthermore, the concept transcends traditional androcentric conceptions of class by allowing for the possible effect of women's resources on the class standing of men and permits comparative analysis of the differential status of women and men within traditionally defined classes or strata. Finally, and perhaps most important, it is a concept that can encompass the struggle for resources within the household as well as the struggle between classes in the public sphere.

In addition to suggesting an alternative means of conceptualizing determinants of class position, it is also necessary to distinguish clearly between the ownership, control, and use of resources. In a sense it does not matter who *owns* something; more important is who can *use* and/or *control* it, an issue that is particularly cogent in dealing with African land tenure and labor control. Thus, the upper-class status of the Ethiopian women landowners described by Crummey (1982) is questionable because they did not usually manipulate real estate or derive much income from it. Eurocentric male-dominated perspectives which assume that ownership and control are synonymous must be abandoned, since male owners are far more likely than female owners to have control over property. Conversely, in precolonial Africa women frequently gained a fair amount of power from controlling the labor of female slaves that they often did not own themselves (Robertson and Klein 1984). It may be argued that those who use only the means of production as workers without deriving the full benefits of their labor are in the worst position, while those who control the products of their labor are in a better position, even if they do not control or own the means of production. A logical tactic for many women, then, is to seek access to resources through manipulating the men who control them. Thus, African women may make all sorts of liaisons, from prostitution to different types of common-law marriage, in order to gain access to resources but retain economic autonomy and control that marriage would not preserve.

Here then is a modification of Marxian class theory that comes from studying African women. Bujra in Chapter 7 contributes to this analysis by proposing a model of the changing class structure of African societies that is an alternative to ethnocentric generalizations based on European case studies. She observes that three processes have been going on in Africa: proletarianization, rather than privatizing women's labor into the domestic sphere and depriving women of their economic independence, has intensified women's activities in, and struggles over, petty commodity production and commerce; foreign capital is often the carrier of cultural assumptions about appropriate work for women (often with unexpected results); and upper-class women have been actively involved in redefining the role of lower-class women to suit their own class interests. All three factors are manifestations of the intertwining of gender struggle and class formation, a phenomenon that most contributors observed. While Bujra's framework, which concentrates on the relationship of capitalism to

women's labor and consciousness, would imply a high degree of potential for women's economic independence, Parpart, MacGaffey and Obbo, in Chapters 8, 9, and 10, respectively, all bring into the picture women's economic relationships with men as well as their relationship to capitalism. Their focus allows us insight into the complexities of independence and dependency. In these essays the concern with resources becomes focused on the strategies of individuals or class-based groups to gain access both to the larger economic resources of the society and also to those of related men.

In Chapter 8 Parpart emphasizes the extent to which, on the surface, the wives of urban miners in Northern Rhodesia (now Zambia) adopted the dependent status of working-class wives. They fully supported their husbands' struggles against capital and even confronted management directly on issues of special concern to them, such as food and housing. Yet simultaneously they rejected male authority over their daily lives and used a variety of strategies to protect themselves from male domination on a domestic level. Lacking the right to share in their husbands' wages, many women created new opportunities for earning money independently, brewing beer, selling domestic skills and sexual services, and gambling; they also changed partners frequently in an effort to improve their class position. Although Parpart stresses the extent to which the class position of women's male partners determined their self-perceptions, her data in fact suggest that, although their consciousness was mediated through their husbands' class status, they struggled hard to make their own economic situation as autonomous as possible.

MacGaffey, in Chapter 9, discusses a small group of successful women entrepreneurs in Kisangani, Zaire, whom she describes as a rising independent class. With their commercial achievements independent of both male control and political connections, they appear to be very different from the miners' wives described in Chapter 8 and also from the "comprador" class that pillages the Zairian economy rather than reinvesting in local economic development. Yet the life histories of these women raise serious questions about their degree of economic independence, particularly with respect to their initial business ventures. Many of the women were closely linked in business partnerships with successful expatriate businessmen in legal or consensual unions that allowed them access to outside resources to establish their businesses. Their situation invites comparison with the Senegalese *signares* and Guinean *nharas* described by Brooks (1976; 1984), whose liaisons with European traders enabled them to better their own position and that of their children. Indeed, most of the Kisangani women were still involved in partnerships with men who played important roles in the businesses when they were interviewed. MacGaffey notes that even the women's business organization was subject to male control and was therefore ineffective in promoting women's interests.

Chapter 9 also raises several other important issues affecting women's economic strategies. One might speculate, for example, that if the Euro-

peans were willing to pool property in marriage, unions with expatriates would be attractive to Zairian women because they would gain greater access to resources than in comparable unions with upper-class Zairian men. When property is pooled, the woman's class position more nearly approximates that of her husband. MacGaffey also delineates another strategy used by women to gain resources. Her description of activities in the "irregular economy," which is outside legal, and therefore male, control is tantalizing and would bear further investigation. Does male control operate more strongly among legal economic activities, pushing women into illegal ones? Since laws generally serve the interests of those who make them, usually upper-class men, then the lower-class position of most women might suggest that a greater proportion of women's economic activities would be defined as illegal.

If MacGaffey presents a good example of women's manipulation of men (through their sexuality in many cases) to gain access to resources, thereby improving their class position, Obbo, in Chapter 10, deals more explicitly with the tension between women's dependence on men and on their own achievements. In a fascinating series of life histories of women in the network of an upper-class woman physician in Uganda, she illustrates how colonialism exacerbated the differences between men and women, and between women and women, as an integral part of the promotion of class differentiation. In describing the colonial use of established hierarchies to develop a new system of stratification, she sees women as firmly based within this system, and yet as insecure in their status to the extent that it is based on association with men. Not surprisingly, hypergamy became a primary tactic for gaining access to male-controlled resources. Obbo's eschewal of established class categories underlines her sense of the complexities of determining women's position.

Considerable autonomy for upper-class women is evident in Obbo's essay, but autonomy in itself is not evidence of higher class status in terms of access to and control over resources. Although compared to Euro-American women many African women have a strong tradition of economic independence, if their access to resources is limited, then the freedom to allocate those resources may mean only a desperate struggle for survival. As Geiger said in a Tanzanian context: "The assumption that women's income-producing projects would automatically enable women to meet their own and their children's needs . . . questioned implicitly, and did not seek to transform, a gender system in which men *control* the lives of wives and children but are not economically *responsible* for them" (Rogers 1982:34). In Tanzania, as elsewhere, any rise in women's income may force them to bear more of the burden for supporting the family and men less, thus making meaningless any equation of autonomy and ultimate control over the disposition of resources. For most women, there is little choice involved in allocation of resources when that choice is whether or not to feed their children. As in most work on the feminization of poverty, autonomous class position too often means lower-class position because of women's limited access to economic resources.

Obbo's work also leads into the debate of Part III by describing upper-class women who do not hesitate to use lower-class women to suit their own purposes. Her taxonomy of a class-conscious female hierarchy contradicts the theory that family links *counter* class formation. It also presents clearly the case against cross-class female solidarity and shows the social impact of changed conceptions regarding property. In Uganda and Kenya, land scarcity and privatization of land ownership are common, leading to a more European view of ownership and diminishing use rights for nonowners, an obvious result of advanced capitalist penetration in dependent economies. Several of the essays in Parts I and II also address two other highly significant and related issues: women's consciousness and women's formal and informal links with each other. Both Stamp and Parpart discuss women's mutual assistance, the former in organized self-help groups that aided women in their struggles to gain control over resources from their husbands, the latter as informal networks among neighbors who helped each other to provide food, child care, and other goods and services necessary to cope with the uncertainties of daily life in the mining compounds. Both are examples of what might be termed a woman-centered awareness that seems comparable to the cooperative gender-based groupings of many precolonial African societies. The contemporary petty bourgeois women's organizations that Bujra analyzes are more complex in their orientation; while advocating service to the needs of all women, they in fact serve class interests at least as effectively as those of gender. The Zairian upper-class women's organization discussed by MacGaffey has been co-opted by men, an issue Staudt explores in Part III. More common, however, is co-optation by upper-class women described by Staudt and Vellenga as well as Bujra, and symptomatic of the central issue in Part III.

FEMALE SOLIDARITY OR CLASS ACTION

Part III centers specifically on the relationship between female solidarity and class action, looking more closely at the way in which women's class position and their perceptions of class have affected their political actions. The relationships between class, gender, and nationalism are also a significant theme in several contributions. Staudt begins the section by contributing important general points to our discussion of women and class as well as a succinct overview of issues concerning politics, class, and gender. She suggests that three features of African social structure make it inaccurate to subsume women into class rankings based on male status: budgetary autonomy within households; impermanence in marital attachments; and female solidarity organizations. Although she speaks of the elite rather than the petty bourgeoisie, her chapter agrees with and elaborates on Bujra's contention that the political action of upper-class women, while organized in the name of women, serves in fact "to advance the interests of the already privileged." The higher a woman's class position, she argues,

the less female solidarity appears to play a role in her organizational affiliations. Staudt also stresses women's participation in their own oppression by sharing male-dominant ideology, an issue requiring further exploration in historical and contemporary contexts.

Yet Staudt's emphasis is rather different from that of Bujra. The underlying theme of her essay is the contrast between precolonial women's solidarity organizations—which were able to carry out significant political actions in defense of women's individual and collective interests (Van Allen 1972, 1976; Berger 1976) and to express and articulate the political nature of male–female relations—and the present-day situation. Reflecting the influence of political and economic developments during the colonial period, contemporary gender relations have been depoliticized; national governments disproportionately operate to the advantage of men; and those in power find means to invalidate women's political efforts and assert male control, whether by co-opting women's organizations or by scapegoating their members with charges of uncontrolled sexuality. Staudt believes that gender is now the key political constraint for women, concluding that the increasing number of women in the paid labor force may lead to a consciousness of women as an economically depressed group, thereby creating conditions for the renewal of female solidarity organizations.

In Chapter 12 Berger discusses South African women who are involved in such wage work, particularly in the garment and textile industries. She argues that the case of South Africa refutes the common assumption that working-class women, because of their domestic responsibilities and attachments, are unlikely to take an active part in organizations and activities that express a class-oriented ideological stance. She finds, instead, that a number of aspects of the South African situation, including the self-sufficiency of many women, wage discrimination, the subordinate status of some black unions, and the close relationship between class issues and nationalism, have helped to foster militant labor activity among women. Many facets of women's experience that might offer a basis for class-oriented gender solidarity—wage discrimination, sex-segregated hostel living, sexual harassment at work, and women's double burden—have not yet found overt political expression. But they have undoubtedly formed an important basis for trade union activity, helping to fuel discontent and providing a sense of women's solidarity that was not incidental to the strikes and stoppages she describes. Berger concludes that, although some of the issues shaping women's consciousness and their struggles might be depicted more explicitly as class issues than as women's issues, it seems clear that women's consciousness of themselves as women and as workers were very closely related.

Johnson in Chapter 13 moves to southwestern Nigeria to describe a situation in which urban women demonstrated an impressive degree of female solidarity through political organization. In contrast to the Kenyan situation, these women were able to carry over politically oriented precolonial solidarity into the colonial period, keeping a close guard over the

maintenance of female prerogatives. The resistance Johnson describes was triggered by colonial government attempts to tax and impose other controls over market women. Led by several upper-class women, they fought some issues successfully, including forcing the abdication of a Native Authority chief who had collaborated with the British and practiced extortion from the women. Well-educated women, the leaders were aware of relevant international events and made efforts to avoid problems they observed elsewhere.

Ironically, following a pattern outlined by Staudt, the power of these women waned with co-optation by male-dominated Nigerian independence parties, which largely ignored both equity issues (redistribution of wealth) and other issues of specific interest to women. After independence, male dominance became stronger and women lost out at all levels; their class position was weakened by unequal pay and unequal access to education and other resources. In this case, class differentiation disrupted female solidarity in a way that would be less likely in South Africa, where the legally mandated deprivation of access to resources acts to moderate the class divisions that have developed within the black community.

In general, the necessity to cooperate in order to survive facilitates the development of a gender-specific consciousness among lower-class women, although it may be hampered by illiteracy and the lack of time to develop organizational skills. Female solidarity seems to decline with higher class position, which may be partly due to increased individualism and increased dependence on men, but is also certainly linked to reduced interest in change among the privileged. Robertson (1984:ch. 7) discusses just such a phenomenon in Ghana, where poor women systematically share resources and demonstrate a high level of female solidarity, while the socially ambitious or well-off are more likely to manipulate men in order to obtain superior access to resources, dropping their loyalty to women in the process. It seems, then, that there is a relationship between gender consciousness and class consciousness. Women who have the education, leisure, and organizational skills to promote gender-specific class consciousness actively do not generally do so because it would threaten their male-dependent access to resources as well as their class position. As both Berger and Johnson illustrate, women's solidarity on the basis of both gender and class may bear a relationship to their direct access to resources unmediated by dependence on men within the household.

In the last chapter Presley returns to a rural East African situation, where Kikuyu women were involved in labor protests from the 1930s to the 1960s. Through a continuing series of work stoppages and strikes, usually aimed, as were the protests of South African women, at improving wages and working conditions, these women gained an enhanced confidence in the power of their collective efforts that was reinforced by the heightened political militancy of postwar Kenya. Female solidarity centered around informal women's networks that helped the women to organize collective action with little help from union officials. In Kenya, then, among a group of women who combined wage labor with peasant farm-

ing, gender, class, and nationalism seem to have formed a simultaneous basis for the expression of economic grievances. Yet ultimately the Kenyan nationalist government adopted a land registration scheme (described in Chapters 2 and 3) that virtually excludes women. Reinforced by the weakening effects of colonial rule on women, the alliance of male dominance and neocolonialism is illustrated very well in Kenya.

SUMMARY AND CONCLUSIONS

These essays, then, discuss three major aspects of the relationship between class and gender. Part I documents women's lack of access to critical resources and suggests that this provides a key to understanding the relationship of gender and class. In Part II, the ramifications of women's autonomy and dependence are discussed in terms of determining women's class position and influencing women's strategies for maximizing their class position. Part III relates female solidarity to class action, exploring the conditions that promote or hinder both forms of political activity and the relationships between them. The development of gender-based class consciousness is also discussed. Throughout, some authors considered all three issues worthy of discussion. An alternative method of approaching this book for those who wish to absorb the whole would be to read the broader theoretical chapters first (Stamp, Bujra, and Staudt) and then proceed with the various sections. It is precisely these overlappings that unify the whole and illustrate the complexity and interdependence of the main issues involved.

Together the essays contribute substantially to reconceptualizing gender and class relations. By expanding on and further clarifying the elements that contribute to an individual's relationship to the means of production through the concept of access to critical resources, they reveal more precisely the factors that shape women's class position, both independently and relative to that of men. The definition of class thereby becomes more sensitive to local conditions and social structure. By identifying and discussing the varied forms of access to critical resources, we have also been able to verify the precariousness of the class status of many women, to discuss the strategies (both direct and indirect) that women use to influence their class position and to raise the issue of male (female) mediation of the other gender's class position. We have also formulated a concept that applies equally well to class and gender struggle inside and outside the household. This reconceptualization allows a more nuanced discussion of African women. With exclusive use of the classic Eurocentric Marxist definition, most African women, as nonwage earners, would be consigned to an undifferentiated peasantry or lumpenproletariat, the latter group usually accorded little role in class struggles. Yet these essays demonstrate that female solidarity can play a strong role in promoting class action for women not in wage-earning positions (see Chapters 2 and 13 in particular).

Our approach deemphasizes the importance of ownership of resources in favor of control and use, a distinct necessity in the face of widespread communal land ownership in African societies. Without an understanding of precolonial gender stratification based on control of resources, both the colonial and postindependence situations become monochromatic—placing all causality in the hands of Europeans and creating a vague and inaccurately romanticized view of the precolonial situation as a time of universal equality in access to resources. Here our change in definitions has also reduced the distinction between pre-capitalist and capitalist formations in favor of a more finely calibrated continuum. Dispensing with ownership of critical resources as a sufficient criterion for determining class position also has the beneficial effect of removing the presumed superiority of socialist/communist countries regarding gender equality. Although women may in theory participate equally in state ownership of the means of production, they do not share equally in the control of those critical resources, which remains male-dominated. Both the precolonial African and the socialist forms of "communal" ownership/control of resources exhibit closely entwined gender and class inequalities.

This brings us to an assessment of the historical implications of our collective findings. One task that awaits scholars is the refinement of chronology with respect to women's status; a beginning has been made, but far more work is necessary.[8] Here certain patterns are evident. Although precolonial gender inequality existed on many levels, women nonetheless had more equitable access to resources than they did under colonialism, and parallel female and male authority structures often helped to protect women's interests. Such structures also promoted the authority of the old over the young, a pattern that Western education disrupted. While colonial policies occasionally benefited women indirectly by challenging forms of African male authority that impeded colonial control or profits, these policies were more frequently detrimental; they discriminated systematically against women in access to such new critical resources as Western education and wage labor and weakened the institutions that previously had insured their access to land and agricultural labor. The resultant decline in women's position has contributed directly to their unequal access to resources and to their limited political influence in the postindependence period. The economic marginalization of most women also furthers neocolonialism in Africa by fulfilling the needs of international capitalism for new sources of cheap labor. The liberation of women, then, involves not only the equalization of the sexual division of labor within the household but also the abolition of an economic system that strengthens gender inequity by forcing women into a narrow range of economic roles necessary to sustain the current system. Neither of these goals can be accomplished in isolation, however, since the superstructure rests on male control of female labor at the lowest level. Equalizing the sexual division of labor at all levels will not improve the overall situation of women unless control over critical resources is equal-

ized by their redistribution and by structures that democratize and decentralize their control, within and without the household.

An issue not dealt with explicitly here but which needs further exploration and refinement in African contexts is the concept of surplus value. Women's labor, in effect, subsidizes men through the unequal allocation of the product of women's productive and reproductive labor inside and outside of the household, whether in the form of cash crops, prepared food, or children. Thus, the fact that the household forms the locus for both production and reproduction is a precondition for women's exploitation and that exploitation involves men's appropriation of women's necessary labor (Mies 1982: 149) and of the surplus value it produces. At issue here is not a precapitalist or noncapitalist system, but rather people fully integrated into a worldwide economy in which the wives, to rephrase Engels, have become the peasantry to the husbands' proletariat, with women's labor absolutely necessary to maintain the whole system.

Women thus have considerable work awaiting them if they are to break the alliance of the local male-dominated upper class with the international capitalist bourgeoisie and regain or obtain a measure of authority and power. Because gender stratification is inextricably linked with class formation and serves the purposes of international capitalism, the only way that female solidarity can ultimately be used to overcome women's disabilities is in transforming these issues into class struggle, not as an adjunct to male-defined priorities, but as an integral part of the liberation process. There will be no liberation without women's liberation.

Notes

1. Gender is used here to refer to socially created identities, sex for a person's biological category. There is little material available on homosexuality in Africa, although the issue is discussed in *Connexions* 3 (Winter 1982) with reference to South Africa and Lesotho.

2. Ethiopia was unique in sub-Saharan precolonial Africa in having both Christianity as the state religion and private land ownership as dominant characteristics.

3. For a more thorough survey and analysis of women in twentieth-century Africa see Hay and Stichter (1984).

4. For a superb analysis and critique of the work of Meillassoux, Terray, and other francophone theorists in the light of Marxist-feminist approaches see *Critique of Anthropology* 3, nos. 9–10 (1977).

5. American sociological stratification theory, which has begun to cope with gender stratification, is still usually too Western-oriented to contribute significantly to the analysis of the African situation. For instance, Chafetz (1984: 13), in an effort

that gropes for universality, fails to consider the high potential for gender inequality among women who contribute materially to both subsistence and exchange production.

6. The best analysis of concepts of reproduction dividing it into component parts is in Edholm, Harris and Young (1977).

7. For a critique of dual models of gender-class relations in Marxist and other theory see Vogel (1983: 128ff.), Eisenstein (1978: 14), and Robertson (1984b: 3ff.).

8. Much painstaking work remains first to establish chronology in detailed studies of particular areas and then to correlate the findings and attempt some continent-wide generalizations. Some recent pioneering efforts are Muntemba (1982), Alpers (1984), Mandala (1984), and Robertson (1984b).

PART I

Access to Critical Resources

Chapter 2

KIKUYU WOMEN'S SELF-HELP GROUPS
Toward an Understanding of the Relation Between Sex-Gender System and Mode of Production in Africa

PATRICIA STAMP

WOMEN ARE THE backbone of the Kenyan peasantry. Since precolonial times they have performed the bulk of the agricultural work for subsistence, and in the contemporary era their tasks have expanded with male migration from the countryside, and with the intensification of petty commodity production.[1] As peasants, they are part of a dominated class within the underdeveloped capitalism that characterizes Africa today; as women, they are a dominated category within the peasantry. Under certain circumstances women in Africa organize to resist this double domination (Boserup 1970: 63–65; Cutrufelli 1983: 170–75; Van Allen 1976: 71–80). In postcolonial Kenya, Kikuyu women's customary age-grade organizations have developed into self-help groups with new functions overlaying the old. An examination of the activities of these groups in one part of Kikuyuland reveals concerted efforts by women to retain control of their work and the products of it.

In spite of women's centrality to peasant struggle in Kenya, and in Africa generally, peasant studies have not sought to explain the special conditions facing women as a category or to locate them in neocolonial class struggles.[2] Further, women's collective activity before, during, and after colonialism has gone largely unexamined. This chapter attempts to

This study was presented in its initial form as a paper for the annual conference of the Canadian Association of African Studies held in Toronto, May 1982. Research on women's self-help groups in Mitero Village, Kiambu District, was conducted in 1974 and 1981. The author wishes to acknowledge the assistance of the Social Sciences and Humanities Research Council of Canada and the York University Faculty of Arts for grants which made fieldwork possible. Research would not have been possible without the able assistance of Rebecca N. Chege.

provide some theoretical guidelines for understanding African peasant women and their organizations. In the first part of the chapter, relevant concepts are explored. They are then applied to pre- and postcolonial Kikuyu society; finally, contemporary women's self-help groups in Mitero, a Kikuyu village, are considered as an example of women's resistance to their dual exploitation based on gender and class.

The Kikuyu are a vigorous, Bantu-speaking ethnic group of over 2 million people that has dominated the Kenyan political economy for much of the postindependence period. Patrilineal and horticultural (that is, tracing descent through the male line and practicing hoe cultivation of crops), they were typical in many ways of African agricultural societies south of the Sahara. Their communally organized political economy and their gender relations based on bridewealth were shared by most Bantu societies for much of their history (and by many societies belonging to other linguistic groups as well). Thus, although certain historical experiences rendered the Kikuyu unique, we may tentatively draw generalizations from their example.

The failure to distinguish women from men in the peasantry relates to androcentric bias in the social sciences; a central aspect of this bias is the lack of adequate concepts for theorizing about women as peasants. However, current fruitful efforts in several branches of the social sciences provide the scope for the development of such concepts. On the one hand, studies by anthropologists, historians, and political economists of the transformation of precapitalist societies to a capitalist mode of production have led to a more precise conceptualization of peasants as an exploited class in underdeveloped capitalism (Foster-Carter 1977; Taylor 1979; Terray 1972; Mamdani 1976; Bernstein 1977). On the other hand, socialist feminist theory on gender relations has specified the differences between men's and women's relations to politics, ideology, and production in an increasingly sophisticated way (Barrett 1980; Ortner and Whitehead 1981; Leacock 1981; Sacks 1979). Both areas of study are grounded in Marxist theory while seeking to expand its parameters to provide a more rigorous and comprehensive framework for the analysis of society.

The literature using the concept of mode of production aims to overcome the ethnocentrism that developed in traditional Marxism, based as it was on the history of European class struggle (Hobsbawm 1972; Kiernan 1974). The class structure in twentieth-century non-Western societies is very different from that in nineteenth-century industrial Britain, for example. The aim of socialist feminist theory is to overcome the sexism of traditional (and even much contemporary) Marxism which analyzes the contradiction between labor and capital and uses categories that are "sex-blind" (Barrett 1980: 8, citing Hartmann 1979). As Leacock points out, Marx cannot be held accountable for these limitations in twentieth-century Marxist theory. "Marx analyzed the nature of exploitation itself as a principle, and as a principle it was and is colorless, raceless and sexless" (Leacock 1981: 14). The ramifications of this viewpoint were not pursued by Western scholars, and

exploitation somehow became defined as centrally of whites and men. . . .
The unifying power of the concept was destroyed by the hardening into
dogma of a pernicious dichotomization, whereby the exploitation of the
industrial worker, white and male, was pitted against the compounded ex-
ploitation and cruel oppression of the nonwhite as well as the nonmale. (ibid.)

This "theoretical separation of class exploitation from other forms of
oppression" (ibid.) is what both Third World and socialist feminist schol-
arship are attempting to overcome. The task is to synthesize concepts
drawn from the study of colonial and neocolonial exploitation on the one
hand, with those drawn from the study of gender relations on the other, to
arrive not only at a more thorough understanding of African women
specifically but at a better conceptualization of the African peasantry and
of class relations in general.

THE CONCEPTS

Central to the study of colonial and neocolonial exploitation is the concept
of mode of production, which Karen Sacks defines appropriately:

A mode of production is a particular constellation of *means* of production
(the tools and equipment appropriated from the natural world or con-
structed from its products for purposes of producing subsistence and mate-
rial needs), of the *forces* of production (the means together with the ways
people organize themselves to use them, their organization as producers),
and the *relations* of production (denoting how people stand in relation to
productive means and therefore to each other). Thus the organization of work
itself—for example, of people together with tools they use for the purpose of
clearing a field in a particular society—is a productive force. But the organi-
zation of ownership—for example, the fact that the field and its fruits belong
to some of those individuals while the rest have access to productive means
only through these owners—describes a productive relationship. (1979: 105;
see also Blumberg 1978: 118–19)

The concept is useful in that it makes possible the analysis of social
transformation in terms of changing forces and relations of production,
with all their contradictions, rather than in terms of linear, noncontradic-
tory progress from "traditional" to "modern." The peasantry, far from
being the "traditional"—and implicitly "backward"—sector of modern
non-Western societies presented in postwar modernization literature
(Hoselitz 1960), is seen as an impoverished class created by the relations of
production that were imposed on precapitalist societies in the colonial era
(Mamdani 1976). These exploitative relations of production have been
perpetuated in a new guise in the postindependence era, which is thus
termed neocolonialism.

Whereas in Europe the transformation to capitalism entailed the
dissolution of the precapitalist mode of production—feudalism—and the
formation of a purely capitalist class structure (with proletariat and bour-

geoisie as the great opposing poles), colonized societies are characterized by the articulation of precapitalist and capitalist modes of production.[3] Precapitalist elements, located in the peasantry, are retained in a domi- nated and distorted form. These elements include kinship structures and relations of production, age-based organizations, gender relations, and traditional ideologies. The transformed elements serve to subsidize under- developed capital through production of cash crops by both smallholders and plantation wage laborers. Surplus is not appropriated from landless "free" labor, as in the classic model of capitalism,[4] but from peasants who either own the productive land or who depend upon family-owned land for subsistence while earning a wage. Thus the primary contradiction in the relations of production is between capital and the peasantry rather than between capital and a working class.[5] The key to underdeveloped cap- italism is that subsistence activities are more important than wages or the returns from cash crops in the reproduction of labor power;[6] low prices of products and low agricultural wages reflect this element of peasant sub- sidy. Further, in Africa it is chiefly women who, as the primary producers, provide this subsidy. The modes of production literature stops at the level of the lineage or household in analyzing the articulation of precapitalist elements with capitalism (Terray 1972; Bernstein 1977); it is silent on the vital subject of gender relations.[7]

It is to feminist theory that we must turn for the concepts that can remedy this silence. Contemporary feminist theory may be categorized into four schools of thought (Jaggar 1977; Jaggar and Rothenberg 1984), of which socialist feminism is one.[8] Socialist feminist theory seeks to unite radical feminism's emphasis upon the centrality of gender relations ("the personal is political") with the theoretical rigor and focus on social organi- zation of Marxism. The principal theoretical thrust is toward a concept of relations between men and women that are grounded in biological gender but are expressed at the level of society in concrete, historically specific ways. Every society has "a set of arrangements by which [it] transforms biological sexuality into products of human activity, and in which these transformed sexual needs are satisfied" (Rubin 1975: 159). These arrange- ments, which Rubin usefully terms the sex-gender system, are separate from, but closely linked to, material production and reproduction.

Because of this link, the sex-gender system can be fully understood only through an exploration of "the relations between the organization of sexuality, domestic production, the household and so on, and historical changes in the mode of production and systems of appropriation and exploitation" (Barrett 1980: 9). Conversely, our understanding of any given mode of production, or of a society articulating several modes, is in- complete without some conception of the social relations of gender.

This study thus seeks to integrate the two concepts, articulated modes of production and sex-gender systems. It will be argued that contradic- tions in the social relations of gender have been sharpened with the emergence of underdeveloped capitalism and that these contradictions are an integral part of peasant struggle. Gender relations are seen both as

a site of underdeveloped capitalism's exploitation of petty commodity production and as a site of resistance to this exploitation. Men are in the contradictory position of undermining their peasant power in that they control petty commodity production and the returns from it and thus act as agents of capital accumulation from peasant surplus. Women, then, emerge as the fighting heart of the peasantry, struggling to keep control of their labor and its products.

The self-help groups of Mitero village, formed after Kenya's independence in 1963 for the purpose of cooperative cultivation, group savings and investment activity, and community development, can be understood as a base upon which women organize resistance to both sex-gender and capitalist exploitation. Their successes and failures in this endeavor are symptomatic of the nature of class and sex-gender struggle in Kenya and throw light on the nature of the relation between the two concepts under review.

THEORIZING SEX-GENDER SYSTEMS

A society such as the Kikuyu has traditionally been considered patriarchal, but an analysis of its gender relations demonstrates that the concept of patriarchy cannot be uncritically applied. A number of feminist theorists, seeking to explain what they perceive as the universal domination of women by men throughout history, have used the concept of patriarchy to designate the gender system under which all forms of oppression occur.[9] Some have sought to develop a materialist conception of patriarchy, referring to "patriarchal relations of production" (Delphy 1977). Rubin, however, believes that an overarching concept of patriarchy is confusing: "The term 'Patriarchy' was introduced to distinguish the forces maintaining sexism from other social forces, such as capitalism. But the use of 'patriarchy' obscures other distinctions. Its use is analogous to using 'capitalism' to refer to all modes of production" (Rubin 1975: 167). Patriarchy, then, is one of a number of sex-gender systems. Moreover, Rubin argues that "sexual systems have a certain autonomy and cannot be explained in terms of economic forces" (1975: 167).

By contrast, "sex-gender system" is a neutral concept that may be applied to many forms of gender relations, from patriarchal and oppressive to egalitarian. Focusing on sex-gender system as a sphere of human activity and relationships separate from, but intimately linked to, material production and reproduction, allows the restoration of gender relations to their rightful place at the center of political economy and more specifically, contributes to a better understanding of the complex relations between the economic, social, and ideological aspects of male–female relations in a society such as the Kikuyu, both in the precapitalist era and today.

Rubin's work provides a useful starting point for considering sex-gender systems. She looks to Freud for the roots of an understanding of the ideological production of sex-gender systems, and to Lévi-Strauss for

understanding their social and economic production. While she recog-
nizes their androcentrism and their failure to draw out the sex-gender
implications of their respective theories, she asserts that their ideas pro-
vide the conceptual space for such theorizing.[10] Lévi-Strauss' unwitting
contribution is his understanding of kinship. Kinship, which has marriage
as its organizing principle, is the mechanism by which males and females
are transformed ideologically into "'men' and 'women,' each an in-
complete half which can find wholeness when united with the other"
(Rubin 1975: 179). Kinship is also the basis for the social organization of
production: the division of labor, including the sexual division of labor, is
inextricably bound with it. Marriage itself can thus be seen as a prime
determinant of sex-gender system. Rubin uses Lévi-Strauss' pioneering
work on the "exchange of women," with its classification of types of
exchange (e.g., women exchanged for women, women exchanged for
bridewealth) as a basis for the categorization of sex-gender systems (Rubin
1975: 175; Lévi-Strauss 1969). She suggests that "the 'exchange of women'
is an initial step toward building an arsenal of concepts with which sexual
systems can be described" (177). There are problems with Lévi-Strauss'—
and Rubin's—emphasis on exchange, however.[11] As Kettel points out in
Chapter 3 in this volume, it is important to avoid viewing women as
"primordial pawns in the affairs of men," and specifically as a form of
"capital" controlled by men.

Leacock's critique of Lévi-Strauss' work is relevant here. She ques-
tions the current view that men are "the universal exploiters of women,
albeit at times gentlemanly exploiters, who graciously acknowledge
women as 'the supreme gift'" (Leacock 1981: 234; Lévi-Strauss 1969: 65).
On the basis of much ethnographic evidence, she asserts that:

> The authority structure of egalitarian societies where all individuals were
> equally dependent on a collective larger than the nuclear family was one of
> wide dispersal of decision making among mature and elder women and men,
> who essentially made decisions—either singly, in small groups, or collec-
> tively—about those activities which it was their socially defined respon-
> sibility to carry out. Taken together, these constituted the "public" life of the
> group. (Leacock 1981:24)

These decisions concerned marriage, among many other things. Thus,
women were not simply passive objects in their own exchange, but par-
ticipated with men to "make marriages" (Collier and Rosaldo 1981: 278),
organizing women and men into social relations for biological reproduc-
tion.

A categorization of sex-gender systems, then, will examine the dif-
ferent ways in which marriage is organized and seek to link them to
"important differences in economic and political organization, and . . . to
salient variations in the way gender is construed" (Leacock 1981: 241). In
turn, arrangements by which women circulate vary and can be correlated
with differences in their autonomy and authority from one society to
another.

Other authors have followed on Rubin's seminal work, notably Collier and Rosaldo. In a survey of what they term "brideservice societies," they provide "a model for the study of gender as a cultural system" (1981:275). Brideservice, whereby the groom gives his labor to his in-laws to legitimize the marriage, appears to be characteristic of most hunter-gatherer societies (although it is not confined to them); while bridewealth, whereby the groom and his family offer gifts to the bride's family, appears to predominate in most horticultural groups (278). By uncovering the connections "between personhood, politics and production characteristic of *all* brideservice societies" (280), Collier and Rosaldo confirm Rubin's proposition that there are regularities to types of marriage exchange by which we can precisely define sex-gender systems.

For the purpose of setting out the main features of the bridewealth sex-gender system, a simple comparison will suffice. In a society with reciprocal exchange of women between kin groups, such as the Lele of Zaire (Douglas 1963, cited in Rubin 1975: 205), a man must have a kinswoman whom he can give in marriage in order to get a bride himself. Further, each marriage incurs a debt. The web of debts and schemes for control of women leaves them little latitude for independent action. Where a woman's family receives bridewealth (which the family can use in turn to obtain a bride), such a web of debts and staking rights does not exist. "Each transaction is self-contained" (Rubin 1975: 206). But it places the bride in a network of *social ties* that constrains her action throughout her marriage. Bridewealth systems vary considerably, and some involve conversion of bridewealth into male political power. "The material which circulates for women also circulates in the exchanges on which political power is based" (206). But always, the fulfillment of the material contract depends upon a wife's performance as a procreator and producer; a number of political and economic considerations rest upon her marriage. Conversely, the success of her marriage depends on the ability and willingness of her affinal kin (her relatives by marriage) to fulfill their obligations to her family.

Thus a marriage, rather than being the concrete expression of a debt fulfilled or incurred, is the ongoing manifestation of contractual relations among a web of kin—and a woman's own actions have much to do with the furtherance of those relations. As Leacock puts it, "In some societies, women move back and forth as valued people, creating, recreating, and cementing networks of reciprocal relations through their moves, which are recompensed with brideprice" (1981: 241). The substantial rights of wives to control over the means of production and to ownership of the product of their labor is an indication of the power of their central position in the bridewealth system. Conversely, the bridewealth system may have been favored in those political economies where the nature of economic and historic opportunity fostered a structure of economic participation for women that allowed them such control. It is significant in this regard that the dowry sex-gender system, with its concomitant poor position for women, is associated with the plow societies of Asia, while the bride-

wealth sex-gender system is associated with the hoe cultivation societies of Southeast Asia, Africa south of the Sahara, and other parts of the world (Boserup 1970: 48, 50).[12]

The bridewealth sex-gender system is also correlated with polygyny (marriage of a man to two or more women). Contrary to the received truth that polygyny always oppresses women, the polygynous household may offer women a basis for solidarity and task sharing. At the level of the household, cowives cooperate to organize production, consumption, and child care. Although friction between cowives is widely reported, many studies also stress the economic and political advantages of polygyny, including the autonomy made possible by shared responsibility (Mullings 1976: 254; Obbo 1980: 34–35; Boserup 1970: 43).

Further, in societies with the bridewealth sex-gender system, there are often organizations that express women's power at the political level, such as the women's age-grade organizations of the Kikuyu.[13] Thus, while women come under the jurisdiction of their affinal kin—often oppressively so—they have, in the bridewealth sex-gender system, the material, political, and ideological base for relative power and autonomy. I would argue that women's relatively powerful position in African societies, compared with many other precapitalist cultures, is attributable to the prevalence of rich and complex kinship organization based on bridewealth.

THE KIKUYU: COMMUNAL MODE OF PRODUCTION AND BRIDEWEALTH SEX-GENDER SYSTEM

The Kikuyu are a polygynous, patrilineal, Bantu-speaking ethnic group inhabiting a pocket of fertile highlands in East Africa surrounded by lower, dryer regions. Oral traditions trace the migration of their ancestors into the region to some time between the fourteenth and sixteenth centuries and outline the basic features of social and political structure back at least as far as the sixteenth century (Muriuki 1974: 44). Production was primarily horticultural, but the Kikuyu also tended livestock and engaged in trade with surrounding societies—both for consumption and for the acquisition of "prestige" goods. Men controlled the ivory trade, in which they acted as middlemen, and which they could parlay into wealth for additional wives, thereby enlarging their households and their status (Ciancanelli 1980: 29). Women also traveled to neighboring pastoral areas bartering food they produced, as well as honey, pottery, and other goods for livestock (Clark 1980: 363). Ciancanelli states that men had sole control of livestock (26), but Clark argues that women had considerable control over the livestock that they brought back from their trading expeditions, as well as over the sheep and goats given to their care at marriage (363). This disagreement notwithstanding, women's trading activities, along with their primary tasks of producing and distributing food and beer, contributed substantially to the material resources of their families and to

the enrichment of the web of social relations within their society and with neighboring groups (Clark 1980: 364).

The Kikuyu were organized by descent into clans and lineages and by rank into age grades.[14] There were no chiefs or centralized political authorities—although individual men could become influential by manipulating material wealth to create political prestige. Women were affiliated with their husband's patrilineage through bridewealth, which legitimized the marriage and secured lineage membership for their offspring. The mode of production associated with this form of social organization in the context of pastoralism or horticulture has been variously labeled lineage mode of production (Terray 1972); domestic mode of production (Meillassoux 1972, 1980); "simple" or "complex" community mode of production (Bryceson and Mbilinyi 1978); kin corporate mode of production (Sacks 1979); or communal mode of production (Mamdani 1976). For its simplicity and inclusiveness, the latter is used here. The following discussion relates to patrilineal horticulturalists in general, and to the Kikuyu in particular, although many of the features described are applicable to pastoral and mixed economies as well.

In the communal mode of production, kinship is the basis of production relations. All people are members of a kin corporation—the lineage or the clan—which owns the chief means of production, the land. In principle all members stand in the same relation to the means of production and share decision making regarding political and economic matters (Sacks 1979: 115). Relations of production are thus cooperative rather than antagonistic in principle. The authority to make decisions, however, is vested in elders, who in practice exercise ideological, political, and juridical power. Moreover, it is male elders who have preeminent authority. Among the Kikuyu as elsewhere, elders were organized for the formal exercise of this authority by the age-grade structure (Muriuki 1974; Leakey 1977). Male elders had privileged status and were able to appropriate in large measure the labor of younger men and of women, as well as to make decisions regarding access to the corporately owned land. They thus exercised considerable control over the means of production.

The counterbalancing rights of different categories of people tempered this control. Sons had rights to land and stock with which to set up their own homesteads and to bridewealth; lineage wives had rights to the use of land and livestock, owned the produce they were responsible for growing, and controlled its distribution to a large degree. Further, they owned their own houses and controlled the resources of their sub-household within the polygynous homestead (Kenyatta 1938: 11–12, 171–72; Middleton and Kershaw 1965: 20; Routledge and Routledge 1910: 47). Women as elders had collective authority in a wide range of matters (Stamp 1976: 25; Kershaw 1973: 55; Clark 1980: 360; Kenyatta 1938: 108; Hobley 1938: 274), and it is probable that women had some say in the disposition of lineage resources both in their capacity as mothers and as sisters in their own lineage.[15]

Kikuyu society demonstrates the point that the communal mode of production, while fostering unequal relationships between elders and youths, and men and women, is fundamentally a classless mode of production, in that no group is free to appropriate and accumulate for its sole benefit the surplus produced by another group. The bridewealth sex-gender system was vital to the communal mode of production among the Kikuyu, and gender relations were a shaping force in the nonexploitative relations of production. It is important to note, however, that the sex-gender system has some autonomy as a social structure and is not a mere *aspect* of the mode of production, reducible to the material relations of production.[16]

As in most other sex-gender systems, however, the bridewealth sex-gender system involved an element of female subsidy whereby female labor could be transformed into male wealth or prestige. Clark (1980: 360–65) and Ciancanelli (1980: 26) both confirm this for the Kikuyu prior to British contact. The subsidy was an important factor in the development of *athamaki* or "big men" among the Kikuyu (Vincent [1971: 191, 198] notes a similar process among the Gondo of Uganda, as does Strathern [1981: 180–84] regarding the Hagen of Papua New Guinea). Men achieved the position of *muthamaki* (singular) by successfully manipulating the tangible and intangible assets of kinship contracts. Clark summarizes the means whereby gender relations were organized to yield such assets:

> Through exchange of bridewealth-livestock, marriages were legitimated, and women whose children increased the size of the group were incorporated into the family. These women put more land under cultivation, and enabled the distribution of more foodstuff. The mobilization of wealth in the form of land, livestock, and people is a single, though complex, process which collapses the division between subsistence and political economy. (1980: 361)

Women could enhance a *muthamaki's* position very directly by agreeing to cook and distribute the food and beer required to attract work parties of young men to clear new land. These men would then become his tenants and political followers (Clark 1980: 365).

It is clear that the very constraints and obligations of the bridewealth sex-gender system—to bear children for their husband's lineage, to produce food and offer hospitality, to act as the linchpin in a wide network of affinal kin relations—provided women the opportunity to exercise political power and the authority to make decisions. The age-grade system was a chief means by which women took up this opportunity. It provided the base for their strategies to generate resources and the forum for their collective decision making with regard to matters within their sphere of authority. Women's age-grade structure was simpler than the male system, based as it was on the childbearing cycle (Kertzer and Madison, 1981: 125–28, discuss the different relation of men and women to the life cycle as it pertains to age-grade structure). The two active age grades were *nyakinyua*, comprised of elders whose first child had been circumcised,

and *kang'ei*, women with uncircumcised children (i.e., younger than twelve to fifteen).[17]

The anthropological data on women's organizations in former times is meager and confused. However, women elders gave detailed accounts of ongoing organizations known as *ndundu* which had operated since before the time of their grandmothers and which combined economic, social, and juridical functions. *Ndundu* is often translated as 'council', and it is significant that the same word is used for the council of male elders. A central purpose of the *ndundu* was cooperative cultivation, but they provided women with organizational and affiliative bases for nonagricultural pursuits as well. *Kang'ei* women operated under the authority of *nyakinyua* and were required to perform services for the latter in order to progress through the organization's ranks. Thus, the control of younger lineage wives by their female elders represented a legitimate authority counterbalancing patrilineal control of women and also put considerable human labor at the disposition of women elders as a group. Clark gives an apt summary of Kikuyu gender relations: "Despite an ideology of male dominance pervasive in many kin relations and in areas characterized as the 'prestige economy,' Kikuyu women emerge as the actors with control over resources vital in a system in which relations of production enter into political strategies and are built into the social relations of power" (1980: 368).

TRANSFORMATION OF MODE OF PRODUCTION AND SEX-GENDER SYSTEM

In the same way that elements of the communal mode of production have been retained in distorted form under underdeveloped capitalism, elements of the bridewealth sex-gender system have been retained under the domination of the imported sex-gender system that accompanied colonialism. At the ideological level, the dynamic tension between formal patrilineal domination and both formal and informal female power has been snapped, and patrilineal domination has united with Victorian and Christian notions of male domination (Obbo 1980: 37–39). The loss of women's power in Africa at both the political and economic level has been well chronicled (Van Allen 1972, 1976; Okeyo 1980; Etienne 1980; Conti 1979). In Kenya, with the new overarching political authority of the state, the political institutions of precapitalist societies withered. Some place was found for male elders; for example, *athamaki* often became chiefs and subchiefs in the colonial administration. In Mitero village, male elders of the Mutego lineage preside over the customary judiciary, which operates parallel to, and in conjunction with, the British common law system (Ghai and McAuslan 1970). The ranking political elder of the Mutego lineage occupies the position of subchief. Women elders hold no political positions, however, and women in Kenya are largely absent from formal

political power. Direct and indirect pressure by church and state against
polygyny and the promotion of the nuclear family have also undermined
women's former power base.

At the economic level, the element of sex-gender subsidy remains and
has in fact been increased. Women are expected to produce to support
their husbands as before, but in addition, they are expected to produce the
petty commodity surplus, which their husbands then appropriate (Cut-
rufelli 1983: 117–20; Strobel 1982: 110–14). The network of laws and eco-
nomic practices that characterize the contemporary capitalist state
sanction, and in fact require, this appropriation. Two of the most impor-
tant factors are land consolidation and cash crop marketing organiza-
tions. Land consolidation, part of the colonial policy to increase
production and stabilize the peasantry, began in Kikuyuland in the 1950s,
when the colonial government abandoned the policy preventing Africans
from competing with settler cash crop production, and continued into the
early 1960s. Land was transferred from lineage ownership to individual
male heads of households.[18] Legally, therefore, the product of this land is
now the property of the individual husband, although women continue to
lay strong claim to their subsistence products and in practice attempt to
dispose of them as they see fit. Whether or not they succeed in retaining
this control depends on the nature of their individual relationships with
their husbands and on their success in participating in the activities of
self-help groups.

Cash crop marketing organizations, such as the Coffee Marketing
Board, facilitate the appropriation of women's surplus. As with other
parastatal enterprises, these organizations are oriented toward individual
male heads of households.[19] In other words, men now own the means of
production, with the balancing rights and obligations of female users
carrying relatively little weight. Women no longer possess the means of
production, the land, or its product, except for a disputed portion of the
reduced subsistence crops.

In discussing resettlement schemes in Burkina Faso, Conti (1979) has
explored the mechanism by which the subsidy provided by women is
increased under capitalism; her propositions are applicable to small-
holder petty commodity production in general. Export crop production of
this kind is usually characterized by low capital input, which, as others
have argued, is a distinguishing feature of underdeveloped capitalism
(Mamdani 1976: 144–55), and by "nonclassical capitalist relations of pro-
duction and reproduction, the basic feature of which is little or no outlay
on labor power." Capital has the need for a stable, skilled, but nonwage
labor force for this strategy. As a result of this imperative, she says,
"Capital reorganizes kinship in smaller units (i.e., nuclear families) which
dictate both production and reproduction relations. This organization of
reproduction involves a loss of economic independence for women and an
increase in their work load as producers and reproducers" (Conti 1979: 75).
Women's subsistence activities, rather than their wage labor, reproduce
labor power. The reorganization is achieved through the actions of the

colonial or neocolonial state such as land consolidation or the creation of resettlement schemes.

Women therefore carry the burden both of producton for no wage and of social reproduction without receiving capital input. Petty commodity production is thus a system that is "self-financed" through "the high contribution of female labor. . . . This 'subsidization' of capital represents one of the main sources of capitalist accumulation" (Conti 1979: 76; see also Bernstein 1977; and Bryceson 1980).[20] The subsidy is achieved by shifting control of women's labor from lineages and parallel female authority structures to individual male heads of household. In the past, even in those instances where the *muthamaki* parlayed his wives' labor into personal influence, he used that influence to enhance the well-being of his homestead and lineage, and not for personal material gain. Today, the capitalist ideology of personal wealth is a primary motive for accumulation—even if wealth itself is elusive for the peasant.[21] Thus, in many areas of Africa, an exacerbated form of sex-gender domination has become an important element of the general peasant subsidy of capitalist accumulation, thereby demonstrating the need to link the concepts of articulated modes of production and sex-gender system.

SELF-HELP GROUPS AS ORGANIZED RESISTANCE TO EXPLOITATION

In light of the double subsidy that peasant women provide, their self-help groups take on new significance, no longer appearing simply as cooperative development projects, or strategies for "coping with change": rather, they are vital organizations for resistance to exploitation.[22]

Mitero, a sublocation that corresponds roughly with the territory of the Mutego lineage of the Acera clan, lies in the fertile foothills of the Nyandarua Mountains north of Nairobi. It forms part of the late President Kenyatta's home area, Gatundu Division in Kiambu District, and comprises scattered homesteads with Mitero village as the administrative, economic, and social focus. The sublocation lies just to the west of a part of the so-called White Highlands—land appropriated in colonial times for large-scale European settler coffee farms. While a number of other Kiambu lineages lost their land, the descendants of Mutego, who established his lineage in the mid-nineteenth century, did not. His descendants engage in petty commodity production centering on coffee, which they cultivate on a family basis on a scale ranging from a few hundred bushes to plots of several acres. The community continues to engage in subsistence hoe agriculture on reduced acreage, growing maize, potatoes, and beans of various species for their own consumption and cultivating some food crops for cash as well.

While many men habitually leave the sublocation for work, in the typical migration pattern of neocolonial Africa, women represent the more demographically stable component of the community. Of the ap-

proximately one thousand women resident in Mitero between 1963 and 1974, only ten emigrated.[23] Women have less impetus to emigrate, in that there are fewer employment and educational opportunities for them; they therefore continue as the primary producers and as household managers and provide much of the labor for coffee production.

Women in Gatundu began to come together in the contemporary form of self-help groups in 1966, with the encouragement of community development officers and the Provincial Administration.[24] The original objective was organization for the utilization of new agricultural inputs, such as fertilizers. While informants stressed that the old style *ndundu* no longer existed, it is clear that the self-help groups are successors to these organizations. The ten groups in the sublocation perform the traditional functions of cooperative cultivation, *ngwatio*, and cooperative household management for women in childbirth, *matega*. Significantly, these terms now incorporate additional meanings. *Ngwatio* is organized to generate funds for self-help projects, such as a nursery school, water piping, and other amenities directly related to reducing the burden of women's labor, or to community improvement. Funds also have gone to establish small businesses, such as a dressmaking shop. *Matega* continues to provide group help to members—for weddings and funerals, as well as for childbirth. The term also designates a savings society that collects funds from the sale of surplus food crops and through the contribution of wages that women earn on coffee plantations in a neighboring location. This fund provides a lump sum for each woman in turn, with which she may buy a major household requirement, such as a cow, a water tank, or furniture.

As Wachtel points out regarding women's cooperative groups in Nakuru, Kenyan women have mixed success in their ventures into large-scale investment (1976:70–71).[25] At the local level they fare quite well, however. A small shoe factory started by one group in Mitero was thriving in 1981; another group had purchased a small plot in a neighboring town and planned to develop it as rental property. Interpreting the activities of Mitero women in terms of the analysis set out earlier suggests, first of all, that by channeling cash from crops into self-help organizations, they were preventing the appropriation of their product by their husbands, and secondly, that they were attempting to accumulate capital as a means of protecting and enhancing their fragile incomes and compensating for lost domestic production. With regard to the first purpose, women sought to counteract the onerous obligation to generate surplus for their husbands that arose with land consolidation and petty commodity production. Engagement in wage production on neighboring coffee plantations—which may appear as an incongruous activity for peasant smallholders—also makes sense in this context. While work on their own coffee bushes yielded cash for their husbands, wage work provided earnings, however meager, that could be channeled directly into group funds.[26]

Bernstein's point is useful here when he analyzes the struggle between capital and the direct producers of capital over the acquisition and distribution of the product. The resistance of such peasant producers may

take many forms, such as "refusal to adopt new cultivation practices. . . , refusal to grow certain crops or cutting back on their production" (Bernstein 1977: 69; see also Cutrufelli 1983: 119–20). I suggest that women's choices in disposing of their labor time and channeling their earnings into self-help groups may be seen as a form of such peasant resistance. Specifically, it is resistance to the appropriation of their product by capital through the agency of their husbands, and as such it is a resistance to dual exploitation, by the sex-gender system on the one hand and by underdeveloped capitalism on the other.

Informants indicated a considerable struggle over women's labor and earnings. They referred to male control of coffee earnings: "Men drink the coffee money." While coffee was seen as a valuable crop, it involved loss of control of their labor. Vegetable crops for cash sale in the market were preferred. Men's objections to women's appropriation of the products of their own labor were evident in informants' accounts of husbands who beat their wives for participating in the groups. "Men fear women when they are in a group." Overt hostility between men and women points to the dramatic sharpening of sex-gender contradictions within underdeveloped capitalism.

A further dimension is added to these contradictions by the fact that women's resistance is taking place under the banner of development ideology. Since independence, the Kenya government has encouraged self-help activity, known as *harambee* ("pull together"), which has served to supplement state development efforts in the social services. The ideology of *harambee* is thus a powerful tool for women's assertion of control over their labor and earnings. There is some evidence, however, that the state is attempting to channel women's activity, and even co-opt it. One agricultural officer in the district administration talked in a 1981 interview about efforts to have husbands registered as women's self-help group members and suggested that the burden lay on women to improve the deteriorating relations between husbands and wives.

A number of informants pointed out that men often disapprove of women's business activity and seek to undermine it on ideological grounds.[27] Such activity has become a major focus of tension in contemporary sex-gender relations; the widespread assimilation of the capitalist ideology of male dominance—by men, in any event—has added fuel to the fire. One prominent women's leader recognized the power of this ideology and the need for strategy to counter it:

> How does a man exercise power as head of the home? So he has to try all means to suppress women's group activity, to make it not succeed. . . . We try not to be too aggressive, or to break the link with the family and even community. We can't expect to break that myth right away—it must be gradual. If you want to change it abruptly, you encounter a stronger resistance. (Interview 1981)

While men protest in the name of "traditional" family values, women cautiously argue for the maintenance of their rights and for the improve-

ment of their economic lot in terms of those same family values; women's independent economic activity is, they say, in the service of children and the home, and progress in this sphere in the modern nation requires new tactics for the fulfillment of their time-honored tasks. The ideological discourse in sex-gender relations can draw on different elements of pre-capitalist sex-gender ideology because of the contradictions in this tradition: the ideal of men's dominance over women and of women's primacy in their own realms of authority were held simultaneously. The idea of male dominance is reinforced by Christian and capitalist values, but pre-capitalist African values regarding women's power in the political economy of the village remain a forceful weapon in the discourse.

Thus, women's self-help groups have fused precapitalist sex-gender elements—economic, political, and ideological—with contemporary practices to provide women with a basis for resistance to exploitation. The sex-gender system thus appears as a dynamic aspect of peasant struggle in general. Sex-gender exploitation is an integral part of capitalism's exploitation of petty commodity production, and women's relative success in resisting sex-gender exploitation can perhaps be seen as indicative of the strength of the peasantry in this class struggle. If women, through their organized activity, can retain even a part of their surplus, the peasantry as a whole is stronger in the face of capitalist exploitation. Certainly, women's groups appear to be the source of the most radical consciousness to be found in the countryside.[28] State efforts to contain and direct women's activity are an indication that this is recognized.

CONCLUSION

To return to the two concepts that have motivated this analysis, articulated modes of production and sex-gender system, we can begin to understand how they are related. In Kenya, underdeveloped capitalism has emerged through capitalism's domination of the communal mode of production in a way that has transformed and distorted the communal mode. In other words, underdeveloped capitalism is the result of the articulation of the capitalist mode of production with precapitalist elements. The bridewealth sex-gender system, which is associated with the communal mode of production (rather than being strictly a constituent element), has itself been retained in a dominated and distorted form under the capitalist mode of production. Further specification of the relation between mode of production and sex-gender system is an important theoretical task.

The way in which the two modes of production have been articulated has led to the retention and sharpening of the contradictions in the social relations of gender, especially in the realm of women's subsidy of male wealth and status. But the bridewealth sex-gender system, as found among the Kikuyu, offers women a relative measure of counterbalancing

political, economic, and ideological power. Where the conditions exist for the continuity of this power, women are able to utilize it to resist the dual oppression of the distorted sex-gender system and underdeveloped capitalism.

Notes

1. Petty commodity production refers to production of cash crops, usually for export, by smallholder peasants who own the means of production—land, tools, and their own labor. It is in contrast to plantation or estate production, where agricultural workers sell their labor for a wage, producing crops on land they do not own. Typical crops suitable for petty commodity production in Africa are coffee, tea, cotton, and groundnuts (peanuts).

2. Leys (1975) and Taylor (1979) are two important studies in the area that are silent on the subject, as is a recent extensive debate on the peasantry in Kenya in the *Review of African Political Economy* (1981, no. 20). Three scholars who have taken up the task are Bryceson (1980), Conti (1979), and Sacks (1979).

3. See Mamdani (1976: 138–45) and Cliffe (1976: 116–24) for clear discussions on the articulation of modes of production.

4. Free from ties to the land, that is; not free in the sense of unpaid labor.

5. Most African nations tend to have small, fragmented, and relatively powerless working classes. See Cohen (1976) for a useful discussion of the special features of African working classes that stem from the colonial experience.

6. It is important not to confuse biological reproduction with the Marxist concept of social reproduction, as is often done in feminist literature (see Barrett [1980: 19–29] for a critique). The latter refers to "the need of any social formation to reproduce its own conditions of production" (Barrett 1980: 20). In other words, social reproduction comprises the means—ideological and political as well as economic—by which a society perpetuates itself through time. Reproduction of labor *power* (i.e., raising, feeding, and housing the next generation of workers) is central to this concept of reproduction and is distinct from the biological act of bearing the next generation.

7. Molyneux (1977) gives an excellent critique of the theoretical and analytical limitations of this literature, especially of Terray's work.

8. The others are liberal feminism, with its roots in the eighteenth- and nineteenth-century liberalism of Mary Wollstonecraft and John Stuart Mill; radical feminism, born of the activism of the 1960s and based on the principle that gender domination predates and supersedes all other forms of oppression; and Marxist feminism, which sees gender domination as an aspect of class domination and looks to Engels' *Origin of the Family, Private Property and the State* (1884) for its founding inspiration.

9. Kate Millett's *Sexual Politics* (1971) is, of course, a classic in this regard.

Kuhn and Wolpe (1978) treat the concept as central. See Barrett (1980: 10–19) for a survey of the literature on patriarchy.

10. Her reading of Freud is valuable but not at issue here; her central point is that kinship—Lévi-Strauss' concern—"is the culturalization of biological sexuality on the societal level," while psychoanalysis—Freud's concern—"describes the transformation of biological sexuality of individuals as they are enculturated" (Rubin 1975: 189). The principal works cited are Freud 1965 and Lévi-Strauss 1969.

11. Rubin recognizes that "there is an economics and a politics to sex/gender systems which is obscured by the concept of 'exchange of women'" (1975:205). Nevertheless, she does not escape the vision of women as "sexual semi-objects— gifts" (196).

12. In the dowry system, goods are transferred to the groom by the bride's family as part of the marriage contract.

13. An age grade is a social organization with a series of stages through which an individual passes during her or his lifetime. An age set is a group of people affiliated by age: each set progresses through the age grades, from junior to elder status. Kertzer and Madison (1981: 121–29) summarize information regarding women's age sets in Africa, which are more common in West Africa. The scarcity of age sets recorded for women in East Africa may be more a function of ethnographers' bias than an indication of their absence. See Gessain (1971) for a thorough case study of women's age organizations.

14. A clan is a large social group that traces its ancestry to a common founder, through either the male line (patrilineal) or the female line (matrilineal). A lineage is a smaller group of kin, often a subgroup of a clan, that traces its ancestry by known links to a founder in the more recent past.

15. Obbo suggests this for the Ganda (1980:35). See also Van Allen (1976:64–70) and Okonjo (1976: 47–55) regarding Igbo women and the role of women elders. The anthropological sources are stunningly silent on women's political and legal position. Lambert (1956:96), for instance, is uncertain as to whether there are any formally constituted women's organizations among the Kikuyu and is satisfied to dismiss the topic with the following statement: "Men say they do not know for certain whether gatherings of women are merely called for specific purposes or whether they are ad hoc committees of permanent and organized *chiama* [multifunctional institutions with political social and judicial functions]." Hobley (1922:274) at least has the grace to admit that the women were probably more important than male observers thought: the "lack of information about the women is one of the weak points of any enquiry." Clark recognizes this problem and engages in a "hermeneutical or interpretive" reading of the sources, concluding that "the more respected published sources on the Kikuyu had misunderstood the nature of Kikuyu politics" (1980: 358).

16. Collier and Rosaldo (1981: 278–79) make this point in a different way, in demonstrating that while the "brideservice" societies *tend* to be correlated with hunting and gathering as a technoeconomic system, this is not a *necessary* correlation, and that in fact a number of brideservice societies are horticultural. The correlation between economy and sex-gender system is not a straightforward one, and much work remains to be done to specify the connection more precisely.

17. Girls as well as boys are customarily circumcised among the Kikuyu, although clitoridectomy was banned in Kenya in 1982.

18. See Sorrenson (1967) for a detailed treatment of the process whereby this occurred. He does not, however, discuss the impact of land consolidation upon

women. Okeyo's excellent study on the impact of land reform upon Luo women revealed that only 6 percent of her sample of lineage wives had the family land registered in their name, while another 6 percent were jointly registered with their sons. There was no report of coregistration with husbands (1980:206). Since gender relations among the Kikuyu groups are quite similar, the rate of ownership among the latter is probably comparable.

19. A good summary of the aims and activities of parastatal enterprises, including marketing boards, may be found in World Bank, *Kenya: Into the Second Decade* (1975).

20. Engels saw this connection a long time ago, as Leacock (1981: 160) points out. She quotes his remark that commodity production "undermines the collectivity of production and appropriation" and turns "the previous domestic relation upside down simply because the division of labor outside the family had changed" (Engels [1884] 1972: 221).

21. Capitalist accumulation was sanctioned once and for all in a major Kenya government policy paper of 1965, ironically entitled *African Socialism and Its Application to Planning in Kenya*. The manifesto states, "Every farmer must be sure of *his* land rights, and to this end consolidation and registration of title must be encouraged whenever people desire" (emphasis added; cited in Gertzel, Goldschmidt, and Rothchild, 1969: 138). Any issue of *Weekly Review*, Kenya's principal news magazine, confirms the strength of capitalist ideology in Kenya.

22. Here I am revising my original conclusions regarding the self-help groups (Stamp 1976), in which I saw the groups as an adaptation to change. The new approach to the meaning of the groups is also relevant to the similar conclusions reached by Wachtel (1976, 1977) regarding Nakuru women's groups.

23. Subchief Samuel Githimbo, who is also the village's *muthamaki* and ranking lineage elder, provided general demographic and socioeconomic information regarding Mitero in an interview in August 1974 (information that was not available in any official government source). He was more enthusiastic and informed about women's affairs than most local administrators, and the women considered him a valuable ally in the pursuit of their groups' objectives.

24. Eight of the ten women's groups in Mitero were studied during field research in 1974 and 1981. The chairwomen provided information regarding the history and activities of their respective groups. Forty in-depth interviews of up to two hours each were conducted with group members in 1974, and twenty-two in 1981; a number of the latter were follow-up interviews to the former. See Stamp 1976 (37–39) for the research method and for the opportunities and constraints posed by the project.

25. An object of investigation in my 1981 study was the umbrella organization, Kirimo Ngenda Women's Corporation, founded in the early 1970s for group capital accumulation. The self-help groups, with others in Ngenda Location, held shares in the corporation, which invested in rental property in Nairobi, among other things. By 1981 the venture into large-scale investment had failed, however.

26. One can speculate—although the question was considered too sensitive to ask—that women withhold cash from coffee proceeds from their husbands, in the manner discovered by Obbo in Uganda (1980: 39–48; see also Bryceson 1980: 19–20, 26).

27. Wachtel (1977:18) confirms that women's group business activity, once visible and successful, is a target for co-optation—or even sabotage—by male interest groups. She suggests that economic competition may be a reason for businessmen's

efforts to undermine women's enterprises. Political aspirations may lead male politicians to try to gain the support of women's organizations, however.

28. Ngugi wa Thiong'o's prison diary is eloquent on the subject of women's role in peasant struggle. His prison novel, written in Kikuyu, is about "Wariinga the Heroine of Toil" (1981: 166).

Chapter 3

THE COMMODITIZATION OF WOMEN IN TUGEN (KENYA) SOCIAL ORGANIZATION

BONNIE KETTEL

THE ISSUE OF PASTORAL PATRIARCHY

THIS ESSAY IS about cows and women. It deals with the impact of pastoralism on gender relations among the Tugen, a Nilotic-speaking people in the Baringo District of Kenya. Pastoralism is a strategy of subsistence production based on the herding of domesticated livestock. In East Africa pastoralism is frequently so important an aspect of subsistence that Herskovits labeled this cultural milieu the "cattle complex" (Herskovits 1926). The Tugen are cattle-keepers, and their social organization is marked by those features that are characteristic of East African pastoralism: patrilineality, virilocality, age organization (division into age groups), and a clear-cut although not exclusive division of labor based on gender. In the larger East African context herding is a masculine enterprise. While Tugen women are not forbidden contact with livestock, much of their productive decision making is assigned to horticulture.

In the emergence of pastoralism Engels saw a primary basis for the establishment of patriarchy, "the world historical defeat of the female sex"

This chapter was originally prepared for presentation at the meeting of the African Studies Association in November 1981. The following persons have contributed their ideas and critical support: Mari Clark, Phillip Gulliver, Jean Hay, David Kettel, Regina Oboler, Claire Robertson, Harriet Rosenberg, Patricia Stamp, and Margaret Strobel, none of whom should be held responsible for the rather heretical view presented or for any errors herein.

The research on which this chapter is based was made possible by a Predoctoral Research Fellowship from the National Institute of Mental Health (1 FO1 MH49166 01) and by a grant from the Center for International Comparative Studies of the University of Illinois. Permission to carry out the research was granted by the Office of the President, Republic of Kenya. The fieldwork was shared with my husband, David Kettel.

Substantial portions of this essay are based on my doctoral dissertation (Kettel 1980).

(Engels 1972: 120), a defeat based on masculine control over productive resources. Engels argued that property in livestock provided men with an initial source of power over women, one that reduced women's socially necessary labor to private domestic servitude and their sexuality to the misery of objectification and purchase. Engels regarded this subjugation of women by men as the first historical instance of *class*, as a social relation based on differential ownership of productive resources, and as a context of oppression (1972: 117–24, 129–221).

Schneider's *Livestock and Equality in East Africa* (1979) presents a contemporary version of this perspective. He argues that cows make men free by providing them with sources of "capital" that are so readily available and so easily reproduced that they cannot be monopolized by the few at the expense of the many, except by men to the exclusion of women (1979: 9–10, 221–30). Thus, like Engels, Schneider sees gender domination as a direct consequence of pastoralism and of masculine control over wealth in livestock. From his perspective women in East Africa are themselves a type of "capital" in which men invest and over which they acquire varying degrees of control, depending on the amount of livestock paid in bridewealth for them (1979: 82). As a result, women not only play a subordinate role in society but indeed are "extremely servile to men in most cases, even in the egalitarian societies" (1979: 255). Unlike Engels, who saw pastoralism as a primary opportunity for class oppression, Schneider regards the subordination of women in East Africa as a "special case" (1979: 221). His patriarchy is not historical, merely primordial, is now, has been, and apparently ever shall be, as long as the East African cattle-keepers have their cows.

How well this interpretation accounts for the nature of gender relations among the Tugen is the point at issue in this essay. In their introduction to this volume Robertson and Berger suggest that "Eurocentric male-dominated perspectives" have influenced scholarly attempts to understand the significance of ownership of productive resources in gender-based relations of production. Their comment is supported here by a new interpretation of the importance of pastoralism and of property in livestock in Tugen social organization. I suggest that research on gender relations among the East African cattle-keepers has been biased, not by insensitive male chauvinism but by a "received view" on the significance of property in social life, by the assumption that differential rights in property are inevitably associated with differential rights in society. This interpretation, which is explicit in Schneider's analysis, results from our attempt to understand social relations based on gender from the vantage point of developed capitalism, and thus with an ethnocentric set of assumptions concerning the importance of productive property in the allocation of power in society and in the household. It has caused us to read the present into the past and to assume that the male dominance which *is* characteristic of so much of present-day life in this context is an enduring feature of social reality that has somehow survived untouched by the impact of colonial rule.[1]

This essay focuses on labor, specifically the work of women, and the

importance of gender-based patterns of cooperation within the household. It argues that the division of labor and of control over productive resources characteristic of the Tugen at the turn of the century should not be viewed as a class relation of production and that Tugen women were not forced into a submissive role or a marginal status by Tugen pastoralism. Instead, it attributes the male dominance that is characteristic of the Tugen today to particular aspects of colonial rule.

The perspective offered in this essay is preliminary and is intended as a stimulus for further research. Discussion is based on fieldwork among the Tugen of North Baringo in 1968 and in 1971–72 (Kettel 1980). The Tugen are one of the Kalenjin-speaking peoples of Kenya. As such they are closely related to the other Kalenjin speakers, including the Nandi, Elgeyo, and Sebei. The Kalenjin are also linguistically related to the Barabaig of Tanzania. Together the Kalenjin and the Barabaig constitute the Highland Nilotes of East Africa. In turn the Highland Nilotes are related to two other important linguistic blocks: the Plains Nilotes, who include the Maasai, and the River-Lake Nilotes, including the Nuer of the Sudan (Sutton 1968: 80–81). All of these Nilotic speakers belong to Herskovits' cattle complex, as do the Bantu-speaking Kikuyu discussed in the essays by Stamp, Presley, and Staudt in this volume. Material on the various peoples listed here is used in this essay as background to the argument concerning the impact of colonialism on Tugen social organization.

The remoteness and ruggedness of the Tugen Hills, which rise precipitously from the center of the East African Rift Valley, cut them off from the initial advance of British imperialism. It was not until 1914 that a British officer was stationed in the Hills and the Tugen were brought directly into the colonial framework of taxation, labor recruitment, and missionization. In the years after 1914 the region was turned into a native reserve with an expanding population and an impoverished economy, and the Tugen became "peasants" in a new context of underdeveloped capitalism (for a review of this issue, see Chapter 2).

This process changed the nature of local production: property ownership acquired increased importance as a guaranteed source of access to crucial resources, as an ultimate basis of resistance to total impoverishment, and as an avenue of opportunity for the private accumulation of wealth. In this new context the relationship between men and women in the household came to be based on differential rights in property, and women were turned into "commodities," forms of property subject to the control of men. This analysis suggests, therefore, that patriarchy is not a simple consequence of East African pastoralism and that male dominance in this context must be understood, in some measure, as a consequence not of cows but of history.

PROPERTY AND GENDER IN EAST AFRICA

One of the interesting features of social life among the East African pastoralists is the behavior that women display in their interaction with

men. If these are "patriarchal" societies, surely we should expect women to be circumspect in their interaction with their male overlords. On this issue Schneider alone is consistent, dismissing all the variations and subtleties of gender interaction in this context with his encompassing assertion that women in these societies are "servile." This is not a conclusion clearly supported by the ethnographic data, however. Llewelyn-Davies suggests that Maasai women fight back against male supremacy through patterns of solidarity based in fertility and adultery, pursuits that entail not only cooperation but also the risk of physical punishment and some measure of "self-assertive pride" (1979: 232). But, she argues that neither of these avenues of solidarity challenge the unequal relations of production and reproduction that assign control over livestock, women, and children to men (1979: 229, 235). Furthermore, Llewelyn-Davies reports that Maasai women "diagnose their lack of autonomy as a consequence of their lack of rights over livestock" (1979: 213).

The Sebei women whom Goldschmidt knew are not servile. They have sharp tongues and they challenge their men, physically as well as verbally. Nevertheless, Goldschmidt believes that male dominance is a longstanding feature of Sebei "culture" which is enforced by the patri-orientation of kindreds, by the assignment of differential rights in property on the basis of sex, and by the payment of brideprice (1976: 226–41).

These perspectives illuminate a great deal about gender relations among the Tugen today. Contemporary Tugen women do live in a world controlled by men. Male participation and authority and the exclusion of women characterize all the major social, economic, and political institutions of Tugen society. Families are patrilineal and overwhelmingly virilocal. Men privately own the major factors of domestic production, land and cattle, and the major sources of income, farms and shops. A Tugen woman needs a husband and her children a father, a man who will provide her with the means of her own subsistence and her children with a social and economic heritage. As a wife a Tugen woman must care for her home, raise crops for the use of her family, collect water and firewood, and supervise her children. In order to be eligible for marriage and childbirth she must undergo clitoridectomy. As a woman she must accept the censure of men, not only for her own possible failings as a wife, but also for the apocryphal sins of womankind. At neighborhood meetings, which are attended only by men, local Tugen officials condemn the behavior of women who drink, neglect their children, commit adultery, and engage in prostitution. Women, they say, should stick to their homes and children. Furthermore, contemporary Tugen men expect obedience from their wives, and they assert this right with a justification based on their own access to property: "I married you, you did not marry me."

And yet this obedience is not readily obtained. In the company of other men, Tugen husbands talk a great deal about their difficulties at home.[2] And in the presence of other women, their wives dissect the foibles of men with eager relish. Men, they say, are "proud," a derogatory term that implies both arrogant and stingy, and no woman who has another

source of support should ever marry one—"better to live alone." Further-
more, while there are certainly differences in personality reflected in the
behavior of Tugen women, they display, on the whole, a rather bold self-
confidence in the presence of men.[3] Evans-Pritchard also commented on
the behavior of women among the Nuer, those well-known exemplars of
East African pastoralism. Nuer women, he said: "mix freely and with easy
assurance with the men, and they do not hesitate to argue with them
about matters in which they are interested as women" (1951: 134).

How can we explain this discrepancy between women's public roles
and their private personalities? Both Llewelyn-Davies and Goldschmidt
appear to view this assertive behavior as "the politics of the oppressed."
While this interpretation can certainly account for assertiveness, it does
not explain self-confidence or assurance. It also fails to consider the pos-
sibility that the anger women display at their lack of autonomy (see
Llewelyn-Davies 1981: 354) may result from a recognition on their part
that their rights as women have been and continue to be undermined in
the contemporary context (for an investigation of this issue among the
Nandi see Oboler 1984).

It is apparent that men and women occupied separate social catego-
ries in precontact Tugen social organization and that assignment of dif-
ferential rights of access to property was one manifestation of this
distinction. Productive resources were acquired through adult males, who
gained rights in land from their patriclan and rights in livestock from
their patrilineage. Men assumed these rights in the context of marriage
and shared them with their wives, each of whom acquired specific rights
of access to land and livestock in the form of house-property. For as long as
a man lived, these resources remained under his general control, and he
could prevail upon his wives and his married sons to allow him to use
these resources, particularly livestock, to build larger social networks. He
could not use those resources that he had assigned to one wife to establish
house-property for another, however.

Whether men's rights in livestock should be construed as "private
property" is a favorite topic of discussion in the literature on East African
pastoral societies. Both Schneider (1979) and Goldschmidt (1976) have
concluded that livestock were an important form of "capital," a com-
moditized source of individual investment used in the accumulation of
"profit." This assertion is central to their common understanding of gen-
der hierarchy. Even Goldschmidt, who sees Sebei women as vibrant social
actors in their own right, ultimately views marriage in this context as a
form of purchase in which one commodity, namely livestock, is exchanged
for another, in this case a wife, with subordination an inevitable condition
of the sale (Goldschmidt 1976: 211–20, 226–42).

Elsewhere I have offered a critique of the use of the term "capital" for
these indigenous rights in property and argued that access to livestock
was a sine qua non of male adulthood in Tugen social organization which
was maintained by stock partnerships, by clientage, and by theft (Kettel
1980: 75–80). But, Goldschmidt's perspective is valid for the contemporary

period. Land and livestock are the private property of individual men, and these forms of property are commoditized, i.e., they are subject to purchase. Furthermore, the contemporary Tugen, like the Sebei, pay bridewealth in livestock, and even in cash. Goldschmidt, who believes in the reality of "tradition," reads this commoditization of property and of marriage into the past, as does Schneider, whose analysis of pastoral capitalism is essentially timeless.

This same timeless quality also affects Llewelyn-Davies' analysis of female subordination among the Maasai. Llewelyn-Davies argues that Maasai pastoralism is organized by "patriarchy," by a system of rights in property that assigns men control over crucial productive resources, including livestock and the labor power of women and boys (1981: 335, 339). In her view the subordination of Maasai women is not a consequence of the fact that they do not own livestock but of the fact that in "Maasai thought" women are perpetual jural minors who lack significant rights in themselves as persons (1981: 341) and who, therefore, lack rights in other forms of property as well (1981: 334, 340). As a result, "they are given away in marriage as if they were passive objects of property to be transacted between men" (1981: 331). This is a view of social life in which the primacy of property does appear to be primordial and beyond the impact of history. The boldness of Tugen women led me to question this interpretation and to ask under what circumstances property acquires such centrality in social life that women may be forced, in spite of their assurance and confidence, into subordination and even oppression. In the Tugen case the commoditization of women is new, an artifact of contemporary Tugen capitalism, and not a simple consequence of pastoralism.

THE SIGNIFICANCE OF PASTORALISM IN TUGEN SOCIAL ORGANIZATION

One of the perennial fascinations of East African ethnography is the varied intersection of culture and ecological adaptation characteristic of the region. Nilotic speakers display a range of variation in productive specialization that ranges from a total dependence on herding to a very high level of involvement in cultivation. Nevertheless, East African ethnography has been characterized by an emphasis on pastoralism that dates back to Herskovits. Although he was certainly aware that many cattle-keepers were also cultivators, Herskovits argued that herding was the determinant factor in social life in cattle complex societies (1926: 651–52). Recently this assertion has come under attack. As Sutton points out, it is surely a misconception to regard pastoralism in East Africa as "historically separate from and essentially opposed to agriculture" (1968: 73). As the basis of subsistence, pastoralism requires a high ratio of livestock to people. All the East African pastoralists are, therefore, dependent to some degree on horticulture, either from household production, or from intra- or intergroup exchanges (Schneider 1979: 61–65). In the Tugen case this depen-

dence is based on gender, since the sexual division of labor within the household is the primary locus of productive specialization.

Like the rest of the Kalenjin, the Tugen are predominantly a highland people. In these regions, where rainfall is generally higher than on the dry plains of East Africa, cultivation and animal husbandry are not mutually exclusive activities but complementary aspects of household production. Like the other highland Kalenjin, the Tugen were, and are, dependent on food crop production as an ongoing aspect of their subsistence. Burton has emphasized the same point in a recent article on the Nuer:

> Maintaining a herd is in many ways secondary to the tasks of horticulture. Whereas the received stereotype of the Nuer is that of a people who are almost irrationally devoted to pastoralism, they would be unable to provide for their subsistence if women did not provide through their own labor the staple elements of the local fare, millet and fish. (1981: 158)

In view of the significance of horticulture and women's work among many of the East African cattle-keepers, why is it that arguments about the impact of production on their social organization have all centered on herding? Conant has suggested that pastoralism in East Africa is best viewed as a "metaphor" of production:

> The . . . credo is essentialist in that its metaphor is based on the single subsistence system, herding; it is elitist in that it refers largely to the activities of a minority; and it is sexist in that it refers largely to the activities of males. But although all of these things, the credo is not fallacious. It exists, as metaphor. (1974: 266)

This insightful suggestion furthers our understanding of the relationship between pastoralism and gender hierarchy. In this context livestock are more than a source of protein or a movable form of storage for grain crops. They are also symbolic goods, and as such they are central to the mediation of gender in the cattle complex societies, a fact that is surely represented in their use as bridewealth. As Conant suggests, the credo is best seen as a "metaphor," as an ideological assertion that accounts for the nature of social life. In the Tugen case "pastoralism" is not so much a basis *for* social organization as it is a statement *about* social organization, about a world in which resources are acquired through men and used by women, who sustain life through their own productive and reproductive activity.

GENDER AND CLASS IN TUGEN SOCIAL ORGANIZATION

In the period prior to European contact, the Tugen household was the primary unit of production and reproduction. It was here, in small, interdependent homesteads spread out across the Tugen Hills, that adult men and women came together to raise children, crops, and livestock. None of these pursuits can be understood in isolation. They must each be viewed

as an integral aspect of life within a Tugen household. Eligibility to
participate in such a life was marked by ceremonies of initiation (circum-
cision and clitoridectomy) and by acceptance into a system of age grades
within which the major passages of adult life took place. Men and women
brought separate resources into this unit, and within it they assumed
separate responsibilities. Productive resources, land and livestock, were
acquired through men. Reproductive resources, children, were acquired
through women, who also did the day-to-day work of horticultural produc-
tion. But their mutual task was to establish abundance, and they were as
interdependent productively as they were in the creation of children.

Should these gender-based distinctions be viewed as the foundation
for class oppression in the sense that Engels suggested? Were Tugen
women subordinated in their roles as wives and mothers because they
acquired rights in land and livestock from their husbands? To agree that
Tugen women were primordial victims of pastoral patriarchy implies an
acceptance of the neocapitalist assumption that the significance of prop-
erty is universal and that society is never founded on relationships be-
tween persons, but only between persons as owners or nonowners of
productive resources.

A social relation based on gender offers a powerful test of this assump-
tion. Although assignment of differential rights in property may be one
manifestation of the distinction, gender is located in a quality that is
intrinsic to individuals as persons, i.e., sex, which in addition to produc-
tion also shapes the very vibrant realm of human sexual intimacy. A
concentration exclusively on men and their rights in property limits our
understanding of gender to the narrow confines of the capitalist mar-
ketplace. Avoiding this ethnocentric interpretation requires an under-
standing of how men and women do come together, in what context and in
what manner. Throughout East Africa men and women come together in
the household. This context, which may well be divided between the
individual wives of a particular husband, is *the* domain of resource man-
agement and of gender interaction among the East African cattle-keepers.
Evans-Pritchard makes this clear in his description of Nuer households as
economic units within which there is "direct mutual assistance between
the sexes in the performance of tasks" (1951: 129):

> A Nuer home is run by the combined efforts of all its members. . . . No work
> is considered degrading, no one is a drudge, all have leisure for rest and
> recreation. . . . Indeed, the division of labour between sexes and ages accords
> with the social and personal freedom of women and children in Nuerland
> and with the recognition, so striking among the Nuer, of the independence
> and dignity of the individual. (1951: 130)

A Tugen household was established by marriage, which was a produc-
tive and a reproductive relationship between a woman and a man. Wives
were not "purchased," however, since the precontact Tugen did not pay
bridewealth in animals, only in items for immediate consumption like

milk and honey beer. One might say, as Schneider would, that they were purchased, but cheaply, and as a result a Tugen husband could not expect a high degree of servility from a wife (Schneider 1979: 82). Such an assertion only raises the question of why Tugen women married at all. Why didn't they just stay at home, since land was abundant in the precontact period, and take lovers for their own sexual pleasure?

To answer this question women must be viewed as independent social actors and not as primordial pawns in the affairs of men. There was an important transaction in animals at the time of a Tugen marriage, but it took place between the woman on the one hand and her husband and his patrilineage on the other. This was not bridewealth; it was rather an assignment of "house-property" which took place when a Tugen woman left her natal home on the day of her marriage and walked to her new home. She would stop as she went, at rivers and branches that lay across her path, and would not continue until she had been awarded an animal. These rights in property formed the herd that was attached to her "house" in both the domestic and the reproductive sense. These were, of course, delicate negotiations, and they were dependent on the bride's prior knowledge of the pastoral resources of her husband and his lineage. But women were certainly known to bargain right up to the homestead gate, and their interests in this regard must be described as "acquisitive." These transactions over livestock, which still take place, are an important topic of discussion among women. They are a source of personal pride and disappointment, and occasionally of domestic difficulty, if it turns out that the husband had hidden resources unknown to his bride.

Women, whose labor was central to household production, connected themselves through marriage to male control over livestock. In so doing they acquired substantial jurisdiction over animals for themselves. Once assigned, this livestock could not be alienated without her consent, and a woman could participate herself in the establishment of a herd as a productive and a symbolic good that would be used to create links of friendship for the entire household. These rights in property held by women were based on the significance of their labor within the household, but they were also a reflection of a larger social equality between the sexes that was shaped in the world outside the homestead. Tugen men and women were not "equal" in the sense of identical. They were different kinds of persons, and they had distinctly separate rights and responsibilities. Men were the ultimate owners of livestock; as such they were central to the pastoral "metaphor" and to decision making in the public realm. But Tugen women were not tied to the household. They had significant rights in the larger society as well.

WOMEN AND AGE ORGANIZATION

Age organization, the passage of age sets through age grades, has been one of the most significant areas of research in the cattle complex societies.

This is a facet of social organization often attributed to pastoralism and to a consequent militarism on the part of East African cattle herders. Needless to say, from this narrow point of view it would be an absurdity to suggest that the passages of women's lives are also structured by age organization. Nevertheless, there is evidence that Tugen age organization included both men and women. First of all, there were names for the women's age sets.[4] Second, Tugen women were initiated in large collectivities comparable to those of men. Finally, the Tugen shared with the Barabaig an institution known as the "council of women."

According to Klima, regulation of social relations between the sexes is largely the prerogative of Barabaig women. The council of women is a public moot within which Barabaig women elders act as a judicial body, passing judgment and levying fines on men who have violated certain rights held by women (1970: 88–94). Klima states that the council functions to "preserve the relatively high social and legal status of Barabaig women," but he also comments that this jural procedure is a "unique cultural phenomenon" that does not appear anywhere else in Africa (1970: 94). However, a young Tugen woman showed no surprise, but some bitterness, when I mentioned this institution in casual conversation: "Of course," she said, "we all used to do that. Tugen, even Nandi. But we don't do it anymore. These men of today would just laugh." It is all too possible, therefore, that ethnographic sexism has limited scholarly recognition of women's public rights in the pastoral societies of East Africa. The impact of age organization on gender relations is a critical area for new research in this context.

Llewelyn-Davies has made an important contribution to this research in her recognition of age organization as the context within which gender is constructed. She argues that age/gender organization defines relations between the sexes, as well as relations between different age categories within the same sex (1981: 330; see also Kettel 1980). However, Llewelyn-Davies sees the Maasai age/gender system as the symbolic context within which adult women are assigned to a status inferior to that of male elders (1979: 219). An important difference between the Maasai and the Tugen is that Maasai women do not become members of age sets. Neither do Tugen women today, but they must have in the past for the cycle of names to be retained by older women in the present. The general ahistoricism of her analysis raises questions about whether Llewelyn-Davies considered this possibility in her research. We cannot assume that all cattle-keepers are identical, however, and the absence of direct involvement in age/gender organization in the form of age-set membership is a variation in the public rights of women worthy of further attention.

Llewelyn-Davies also reports that Maasai women participate in a public ritual, "the blessing of the women," which takes place every four years (1979: 224). In the context of this ceremony, women carry on activities comparable to those in the Barabaig women's councils. Llewelyn-Davies interprets these rights of participation as a context within which men assert control over women and their fertility, in part because a male

elder assisted by his age-set mates gives the ultimate blessing (1979: 228–29). She argues that this form of public participation in the pursuit of fertility "celebrates" the gender inequality characteristic of Maasai life and that the Maasai case supports the suggestion "that there may be a direct association in many systems of thought, between women's inferiority and their role in biological reproduction" (1979: 230).

It is clear from Llewelyn-Davies' account that Maasai women encounter a fair level of male resistance and coercion in their attempt to enact their public responsibilities (1979: 226–29). Klima also reports that Barabaig men disparage and discredit the women's councils, complain bitterly about them, and want to see them abolished (1970: 91). The unhappy comment of my young Tugen informant ("These men of today would just laugh") indicates the need to view this phenomenon historically and to document the factors that allow men to begin to impose their authority over women. In the Tugen case, the combination of age-set membership and women's councils offers a clear indication of a set of public rights that have been eroded in the twentieth century, leaving Tugen women with an empty ceremony of initiation and clitoridectomy.

THE IMPACT OF COLONIAL RULE

Part of our received knowledge of colonial rule characterizes imperialist control as fundamentally ambivalent and contradictory, rooted in the necessity to reshape some elements of society while maintaining indigenous social formations in their "traditional" state as reservoirs of social welfare (Brett 1973). But the degree to which this contradiction penetrates the small world of the household and transforms the nature of social relations at the local level is not always made clear.

The precolonial Tugen did not live in a marginal environment. The Tugen Hills are relatively well watered and fertile, and productive resources were more readily available than they are today. Land was abundant relative to population and was not recognized as private property. While livestock were certainly vulnerable to drought and disease, access to animals was maintained by theft, by stock partnerships, and by clientage. In the colonial period this possibility of ready access to productive resources was altered, with significant effect on the rights of men and women within the household and on the status of women in the larger community. The benefits of colonial rule were very few; by 1940 Baringo District had become an impoverished outpost of underdevelopment with no cash crops, no local industry or manufacture, and a very vulnerable commerce based primarily on sale of livestock.[5] Two factors stand out in the history of this decline: the constant removal of revenue from the district; and the misery of two decades of drought, deluge, locusts, and disease. During the period prior to 1940 there were food shortages of varying severity for twelve years. One consequence of this starvation was that by the late 1930s few elders were left in the local population. At the

same time there was significant reshaping of power relations at the local level. The colonial government had co-opted certain prominent Tugen elders and turned them into chiefs and members of the Local Native Council. Political appointment brought new opportunities for economic gain, and Tugen life was altered by the emergence of a local elite with access to political support at the national level (Kettel 1980: 152–55).

Three features of colonial rule affected the access of Tugen households to productive resources. The first was the enforced cessation of raiding. In the precontact period a man who found himself without livestock might seek out a stock partnership, or he might attach himself to a large stock owner as a client. But he could also raid and replenish his resources through "self-help." The British imposed restrictions on theft; by the 1930s raiding from the Tugen Hills was effectively ended. At the same time the Tugen were faced with severe food shortages, which must have seriously depleted their livestock resources. In this new context a man who wanted to avoid social obligation as a source of herd replenishment would have a new alternative: he could purchase livestock with the cash obtained from the second new factor, wage labor. The Tugen were forced into wage labor through deliberate taxation. As the colonial period progressed, Tugen men turned increasingly to wage labor outside the reserve (Kettel 1980: 118–20). This meant not only that women carried an increased share of the task of production at home, but also that access to cash income was limited almost entirely to men right from the beginning. I suggest that it was these new restrictions on access to livestock and the increased presence of cash in the reserve that led to the explicit recognition of livestock as "capital," as profitable commodities owned by individual men.

The third factor was population growth and its impact on land tenure. The indigenous Tugen crop was millet, which required a new plot every year or two. Maize, which the British introduced, is now grown on a previously cultivated plot for up to about six years, or even longer. With a background of increasing population growth, characteristic of Baringo after 1940, the planting of maize provoked the privatization of land ownership, particularly of land of high quality. Continuous cultivation reduced the necessity for mutual aid in the clearing of plots and helped to restrict the organization of cooperative labor into small family networks tied to land (Kettel 1980: 162–68).

These factors shaped a new social reality in Tugen life, one in which particular households confronted the future as owners of a specific, generally limited set of productive resources, separated from one another in the highly atomized relations of production characteristic of underdeveloped capitalism. These changes also brought about a profound alteration in the relationship of men and women to one another. How could they fail to do so? The marital relationship, which had been shaped by gender, was increasingly marked by the differential access of men and women to property in livestock, cash, and land and by new power distinctions within the household. Furthermore, access to the labor of a wife assumed a new importance with male labor migration. It is in this context of

emergent commoditization that the Tugen began to pay bridewealth, which was first reported in the border areas in 1948 and was widespread in the reserve by 1953.

At the same time, changes in the structure of political authority undermined the public rights of association and jurisdiction that women held in the precontact period. Local Native Councils and Tribunals, appointed by the colonial government, were composed entirely of men; these bodies, in association with the new location chiefs, usurped the realms of responsibility that had been assigned to Tugen women in the precolonial period. The specific nature of those responsibilities needs to be established by future research. However, actual jurisdiction over issues such as rape is seldom exercised,[6] and as a result women have become increasingly dependent on the protection of their fathers and husbands rather than on the public authority of women.

TUGEN WOMEN TODAY

A look at the present lives of Tugen women shows a mixed picture, but one that has a disconcerting shape. While a very few women are acquiring rights in property, or even access to an independent life, many are increasingly subjected to the oppression that results from lack of access to property in a capitalist mode of production. There are, however, some improvements in the lives of women that are widespread in the community. Shortly after he became president of Kenya in 1978, Daniel arap Moi announced a new government policy by which a certain number of years of primary school would be free for every child. This policy will improve educational opportunities for young girls, who were often left out in the search for school fees. It is to be hoped that education will prove useful for them, not dysfunctional in Robertson's sense (Chapter 6 in this volume). Furthermore, in 1972 there was an emerging effort in Baringo to improve the supply of water to households and to decentralize health and maternity care. Tugen women are also acquiring new ideas about life, sexuality, and child care. While clitoridectomy was still common in 1972, adult women were beginning to question the desirability of this form of initiation for their daughters. Young Tugen women demonstrate a very high degree of curiosity about family planning, health care, and nutrition. They are an eager audience for information that will help them to care for themselves and their children with greater ease and success.

While some of these measures will undoubtedly enrich the lives of Tugen women, others have already worked to their detriment. The most serious of these is land tenure reform. In the small community in which I lived, land was consolidated and registered in the period from 1966 to 1968 (Kettel 1980: 168–77). It was a difficult and time-consuming process, not one which had the uniform approval of local residents. Nevertheless, the reform was carried out in the apparent hope of a consequent improvement in productivity, particularly in the growth of cash crops. Land registration

represented the culmination of a process of capitalization in the Tugen Hills in which productive resources were converted into commodities. But this process of commoditization also culminated in class-based relations of production at the local level. These new relations of production, which are shaped by the differential access of particular social categories to productive resources, salaried employment, and political support, are reflected in the allocation of land in the community.

In all there are 605 farms in the community. Of these, only 35 are larger than ten acres. In a community where agricultural development programs are based on an average farm unit size of five acres, about 76 percent of the male-owned farms are smaller than five acres. Although 105 farms were registered to women, they are among the smallest in the community, with an average size of slightly less than three acres. Many of them are very tiny, ranging down to one-fifth of an acre. Women who received title to land were generally second wives, old widows, unmarried mothers, or divorced women, all of whom received land for subsistence purposes, or the wives and daughters of influential men in the community. In fact, the registration of land to female dependents was a strategy that allowed certain prominent men to retain unconsolidated farms made up of separate but high-quality plots in an area where good land is at a premium.

One of the basic premises of the notion that individual tenure facilitates increased agricultural productivity is that a farmer with individual land ownership has greater incentives and security for the investment of skill, labor, and capital. In the Tugen Hills, however, much of the daily work of subsistence production, and a great deal of that connected with cash crops, is carried out by wives working land that now belongs solely and absolutely to their husbands. Not only will a woman who is divorced or "chased away" lose all access to the fruits of her own labor, but a wife who is still living with her husband may also be cut off from the results of her own work. Obolerʼs research on the economic rights of Nandi women is relevant here. She points out that modernization may actually have a negative impact on the rights to property traditionally held by women:

> In the modern setting, traditional definitions of all sorts are breaking down, not the least, definitions of womenʼs traditional economic rights. There is confusion as to the exact nature of traditional norms, and the ideology that all property should be held communally in a family with the husband as the ruler of all is in competition with more specific and qualified definitions of the rights of various family members. In fact, the people one might well expect to be the most progressive in their attitudes—the young and educated, particularly men—are those who are most likely to stress the community property ideology at the expense of traditional qualifications. Thus, there is some danger that modernization may actually reduce womenʼs traditional economic and property rights in some ways. (1977: 1)

Earlier in this essay I noted that contemporary Tugen husbands defend their right to obedience with a justification based on their own access

to property. In a telling piece of ethnographic reportage, Oboler shares the comment of a Nandi husband: "Always everything is mine, even that *wimbi* (millet) she plants. What do you think a woman is when she is here? She is a servant of mine. She is mine, and all that she does here is mine" (1977: 2; see also Oboler 1984). This is the private domestic servitude of women within their own households that Engels described. The patriarchy characteristic of Tugen social organization today is not a simple or a direct consequence of pastoralism; it is rather a consequence of history and of the commoditization of productive resources in class-based relations of production. In this social world, where a very few persons retain access to significant property, labor itself is commoditized. Men work for other men outside the household, and women work for men at home. The price of their subsistence is obedience or, as Schneider would say, "servility."

Notes

1. For an example of this tendency, see Kettel 1980: 42, 80, 82–87.

2. I am indebted to my husband, who shared a great deal of informal time with Tugen men, for this comment.

3. Although this is certainly a subjective comment, it is not an unseasoned one. At the time I carried out research with the Tugen I had already completed a short research project with the Kwakiutl of British Columbia, and I had worked for a year as the intake officer in the Family Court of Metropolitan Toronto.

4. These were Kusantja, Jelemei, Jepargamei, Jepingwek, Jesiran, Jemasinya, and Jesur. And for men, in corresponding order, Kablelech, Kimnikieu, Nyongi, Chumo, Sowe, Korongoro, Kipkoimet. The names for the women's age sets were shared with the Elgeyo, with one exception. Just as the Elgeyo do not have a set named Nyongi, which is instead Maina, they also have Selengwech rather than Jepargamei.

5. Specific chronological data in this section is based on the Baringo District Annual Reports, 1913–60 (Kenya. Baringo District 1913–60). Interpretation is based on Kettel 1980.

6. Reports of rape were a frequent aspect of my field experience. While Tugen women depicted some of these episodes as acts of consenting adultery that had been discovered, others appeared to be classified legitimately as sexual assault. Women have no public source of sanction against these occurrences, which are commonly ignored by local Tugen officials (Kettel 1980: 269–70, 298).

Chapter 4

MATRILINY, PATRILINY, AND CLASS FORMATION AMONG WOMEN COCOA FARMERS IN TWO RURAL AREAS OF GHANA

DOROTHY DEE VELLENGA

ECONOMIC AND FAMILIAL structures influence the emerging class system in rural Africa. A number of scholars have noted that the incorporation of West Africa into a capitalist, export-oriented economy did not completely destroy local precapitalist social structures (Meillassoux 1972; Grier 1981) or horticultural systems in which women were influential as economic actors. Will both the emerging family and class structures mimic the West, or will something unique emerge out of the differing situations? This essay will look at a matrilineal and a patrilineal area of southern Ghana to examine the way in which the cocoa cash crop system and family organization affect the transmission of resources and the organization of labor, focusing on the implications of these patterns for women both as economic actors and as family members. For purposes of analysis I will separate the economic and family variables, although undoubtedly each influences the other. The cocoa industry—in both its marketing and its production aspects—profoundly changed the lives of Ghanaians in the twentieth century. But, in turn, lineage and marriage systems also affected the ways in which new resources were transmitted, concentrated, and distributed,[1] and this has direct implications for class formation.

Goody has suggested that the different family systems in Africa and

This is a revised version of a paper presented at the African Studies Association meeting, October 21–24, 1981, at Bloomington, Indiana. The research reported here was assisted by a grant awarded by the Joint Committee on African Studies of the American Council of Learned Societies and the Social Science Research Council for 1975–76. In Ghana I was helped enormously by the Cocoa Production Division, by Benjamin Fordjour, my research assistant, by Kwesi Yankah for transcription and translation of interview tapes, and by the women of both these areas.

Eurasia, and particularly the transmission of wealth at marriage, had very direct implications for the stratification systems of both areas. In bridewealth systems, found mostly in Africa, wealth is transmitted from the man's family to the woman's family and dispersed among her lineage members (see Chapter 2 in this volume for further elaboration). In dowry systems, wealth is transmitted from the woman's family to the couple. Thus wealth is concentrated in the conjugal couple rather than dispersed through the lineage. Dowry systems tend to be linked with monogamy and class endogamy, so that marriage patterns reinforce the class structure. Bridewealth systems tend to be linked with polygyny and exogamy. A man may have wives from different strata of the population—e.g., royal, commoner, and slave. This system leads to more dispersal of wealth and to strata lines that cut through rather than separate families. Goody has argued that dowry systems tend to be associated with plow agriculture and greater use of hired labor, whereas bridewealth systems are associated with hoe agriculture and more utilization of wives as farm labor (Goody 1973, 1971).

But how egalitarian are lineage-based societies? At least among the Akan, the matrilineal society analyzed here, pronounced divisions existed historically within the society. In describing the Asante empire of what is now south central Ghana in the nineteenth century, Wilks commented:

> The distinction between rich and poor, between *asikafo* and *ahiafo*[2] was in fact all too apparent to those who visited the capital. While, for example, polygamy was the rule among the former, the freemen among the *ahiafo* seldom had more than one wife and the slaves remained for the most part unmarried. While the "higher orders" enjoyed a diet of dried fish, fowls, beef and mutton, the "poorer classes" lived on stews made from dried deer, monkey and animal pelts. Unlike their superiors who were "nice and clean," the "poorer sort of Ashantees and slaves" were neglectful of personal hygiene. (1975:443)

Wilks also notes that as Asante became a powerful empire, patrilineal offices emerged alongside matrilineal ones. He sums it up: "In ontological terms, it is descent which is important to the structure of the Oyoko dynasty; but in phenomenological terms, it is marriage" (1975:371).

The tensions between lineage ties, marital ties, and class divisions existed prior to the colonial period in Asante society. But the divisions may not have followed the same pattern as in class-endogamous, conjugally based societies. The coexistence of polygyny, lineages, *and* class divisions may create different dividing points in a society from those familiar in the West. They definitely create a built-in contradiction for women between their roles as lineage members and their roles as wives. As lineage members, they may participate in the dispersal of wealth through their lineage; as wives they may be required to work for their husbands. Both patrilineal and matrilineal systems have evolved a variety of marital forms to deal with this contradiction, with some marital forms putting the woman much more under the control of her husband and others giving her more

independence. Matrilineages tend to give women more freedom in this respect, except for slave and pawn[3] marriages, which put women entirely under their husbands' control.

One informant discussing the matrilineal Akan society listed as many as twenty-four forms of institutionalized heterosexual relationships (Vellenga 1975:52–83). Three were forms of concubinage that gave the woman freedom but little security; royal marriages gave women of the royal lineage considerable freedom, both in the choice of a mate and in activities such as trading and travel while married. Even arranged marriages and the traditional Akan marriage between two free commoners gave the woman protection through her matrilineage. Slaves and pawns had the least freedom in marriage since they lacked the protection of a matrilineage.

In fact, the study of matrilineal societies gives rise to real questions about the universal subordination of women. Some recent studies of matrilineages in Africa suggest that they provide a strong network for women that enables them to maintain an independent position vis-à-vis their husbands (Hagaman 1977; Poewe 1981). In some cases the men become dependent on the women for access to resources. Even within matrilineages, mother–daughter and sister–sister ties mitigate total male control.

How has Western penetration affected these relationships? As Boserup (1970) has suggested, early colonial contacts ignored women as producers. It was men who were trained or educated and who gained predominance in the production, trading, and administrative networks connected with export trade. In the rural areas it was largely the production of cash crops that reflected this incorporation into a Western-dominated world economy. To the surprise of many colonial administrators and scholars, women occasionally came to the surface as important participants in this overseas-oriented economy. Polly Hill (1958; 1959) found in the 1950s that nearly half of the sedentary cocoa farm owners in Akim, another Akan area, were women. Much earlier, in 1874 in Cape Coast in Ghana, also a matrilineal area, the only African trader who had sufficient capital to trade directly with England, without going through the local British traders at the coast, was a woman (Reynolds 1974:113).

Boserup's thesis requires modification, however. Some women as well as some men initially profited from the incorporation of African societies into a world economy. Many more—both men and women—became disadvantaged as conditions of servitude and labor, formerly familial in nature, were transformed into cash-based relationships. But European colonial penetration did not occur in a homogeneous, egalitarian African setting. Differences already existed, and with the greater penetration of Western capital, classes based largely on creditor–debtor relationships and on new labor arrangements began to transform the previous family-based lineages. Women could manipulate these changing networks in a variety of ways, many of them revolving around their different roles as lineage members and wives. Women in powerful and wealthy lineages could

obtain land and develop their own farms, and marriage to powerful and wealthy creditor-broker farmers could also give some women an edge. Their position as wives, however, was ambiguous and often temporary, for married women could be exploited as labor, without receiving compensation.

Questions arise, then, concerning the class position of women in rural areas that have been devoted to cash crops and in which class differences have been increasing between wealthy farmer-broker-creditors, sharecropping farmers, and farm laborers. Does the family system tend to concentrate wealth or disperse it? Are women becoming more dependent in their roles as wives or as lineage members? Do women react differently in such areas according to the prevailing pattern of patrilineal or matrilineal organization? To attempt to answer these questions, I shall first look at the way in which cocoa production shaped social differentiation in the southern Ghanaian countryside. The dynamics of these new relationships will be highlighted by an examination of disputes recorded at the Labour Department in one of the richest cocoa-growing areas of Ghana—Brong-Ahafo. Disputes between employers and employees on cocoa farms in this matrilineal area reveal the interaction of both the economic and the family system. I will then compare a sample of women farmers from this matrilineal area with a sample from a patrilineal Ewe cocoa-growing area farther east to determine the ways in which these different family systems affect transmission of resources and organization of labor for women farmers. Finally, I will discuss the implications of my findings for class formation among women in rural Ghana.

DIFFERENTIATION WITHIN THE COCOA INDUSTRY

Both Szereszewski (1965) and Hill (1963) stress the importance of the last decade of the nineteenth century and the first decade of the twentieth century in leading to structural change in the southern Ghanaian economy—changes that would establish the institutional framework in Ghana for another half-century. Cocoa represents the most dramatic change. Whereas in 1890 palm oil and rubber far outweighed cocoa in quantity of exports, by 1910 Ghana was the leading supplier of cocoa, producing almost 50 percent of total world exports (Szereszewski 1965:29, 67).

Polly Hill has detailed the way in which migrant cocoa farmers from Akwapim, southeast of Brong-Ahafo, spearheaded this production. Wives of both matrilineal and patrilineal groups went along to help with the farming. The family, in general, was the main source of labor. Hill notes: "In the earliest days before the emergence of a class of middlemen, the farmers had to make their own transport arrangements to get the cocoa to port, hiring carriers (of whom fortunately there was a more than adequate supply) when family labour was insufficient" (1963:170).

Mining and transport were the other two areas in which profound changes occurred in the southern Gold Coast in this time period. Rail-

ways, roads, and mining were, of course, highly capital intensive and almost entirely dominated by Europeans. Cocoa production, however, remained largely in the control of Africans, and Africans were also involved, in the early days, with export arrangements for this commodity. As Gunnarson points out:

> The cocoa trade meant a stimulus to all Gold Coast business, the African traders not least. Quite differently from most other countries of West Africa, where the only competitive element for the European firms were constituted by Syrian and Lebanese traders, the Gold Coast cocoa trade came to rest partly in the hands of African merchants. The export trade involved Africans to some extent, although small, and the intermediate trade between producers and exporters was controlled entirely by Africans. At the end of the First World War, the number of African firms engaged in direct export trade was estimated to be no less than 292. Of course, most of these firms handled only very small quantities, but the great number itself indicates considerable profit margins for the cocoa exporters during the pre-First World War period (1978:70).

This situation changed in the second phase of cocoa production. European firms centralized their operations into a more monopolistic structure, and most African export firms were squeezed out. Africans, however, still controlled the middlemen-broker roles as well as production. The European firms and African brokers developed a system by which the firms made cash advances to the middlemen, who lent it to producers during the slack season when cocoa was not produced. Such advances were put against the next year's crop. As Gunnarson states: "The chain of marketing from the individual cocoa producer to the final market was perhaps the most characteristic feature of the Gold Coast cocoa industry" (1978). The flow went something like this:

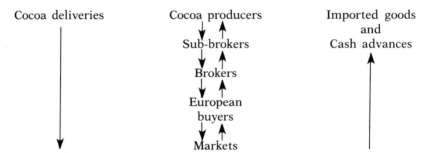

This increased differentiation in the marketing system was accompanied by an increasing differentiation in the labor force. Wage and contract labor, in addition to family and sharecrop labor, was incorporated into the system. Differences emerged between farmers who accumulated landholdings and required more laborers and small farmers who relied largely on their own labor and that of their families. Table 4.1 shows such a distribution, based on data gathered in 1970.

THE ABUSA SHARECROPPING SYSTEM

Polly Hill has delineated five types of labor that began to be used in the cocoa industry in pointing out that "systematic large-scale employment of farm labourers marked the second, not the first stage of the developing capitalistic process" (1963:187). She distinguished the *abusa* and *nkotokuan* laborers, who are thought of as pseudofarmers and who receive shares of the cocoa crop (one-third for the *abusa* farmer and a fixed sum for loads of cocoa to the *nkotokuan* farmer) from wage employees—annual laborers, contract laborers, and daily laborers. The latter group are largely concerned with establishing new farms, whereas the former are concerned with maintaining and plucking the cocoa crop. The former may, in turn, employ labor of their own or use wives and family members to help.

Such sharecropping systems as the *abusa* have a long tradition behind them. Relationships between owner and caretaker vary: the caretaker may be a family member, a member of the local community, or a migrant laborer who has moved up from contract or daily-rated labor. The dynamics of employer–employee relationships on cocoa farms become clear in an examination of complaints brought to the Labour Department in the Brong-Ahafo Region from 1957 to 1969.[4]

Of the 100 women who were involved in these labor complaints both as employees and employers, 33 were farm owners. Over half of these had

TABLE 4.1

Cocoa Production and Employment of Permanent Labor

Production (Loads per Season)*	Percentage Distribution of Farmers	Average Number of Permanent Employees		Percentage of Farmers Employing no Permanent Laborers
		Current	Desired	
Below 20	17.9	0.4	0.6	73.8
20–49.9	23.1	0.7	1.2	60.8
50–99.9	21.5	1.3	2.0	38.7
100–149.9	12.2	2.0	2.7	26.7
150–199.9	7.4	2.7	3.3	15.6
200–249.9	3.7	3.3	5.4	15.5
250–299.9	3.0	4.1	7.9	8.9
300–399.9	3.4	4.1	7.3	10.4
400 and over	7.8	6.1	8.9	2.3

Note: Covers both farmers employing permanent labor and farmers not employing permanent labor. Based on 81.4 percent response rate from the 3,726 farmers interviewed.

*A load is a 60-pound bag of cocoa, originally the amount that could be headloaded down to the coast, and still the unit of measurement in the cocoa-producing area. This gives a more accurate measure of productivity than farm size.

Source: Derived from Addo 1974: table 8.

abusa caretakers on their land. In a sample taken from these complaints, of the 69 out of 100 male employers who were farm owners, only one-fourth employed *abusa* caretakers. Men were better able to utilize other forms of agricultural labor, i.e., yearly contract laborers, piecework or daily-rated employees and wives. Only one female farm owner had her husband employed as a caretaker.

One aspect of the *abusa* contract is the caretaker's payment of *aseda* ("thanks" in Twi) or "rum" to the owner before acquiring a farm to work on as a sharecropper. *Aseda* is a custom that permeates other Akan institutions such as marriage agreements and hiring in modern bureaucracies. What may appear as a bribe to Western eyes is an integral part of the customary system of exchange, accepted as an essential part of the agreement by both owner and caretaker. The *aseda* used in *abusa* agreements may be actual drinks, money or sheep, but can also include specified additional work such as weeding, felling trees, planting food crops, or building a house on the cocoa farm (Cases C999, C825, C815, C1181, hereafter referred to by number only). One caretaker indicated its importance in a complaint against a female owner who had withheld his one-third portion of the profits; he had "originally worked with his brother in the Big Forest without pay as rum which we ought to have paid before she employs us" (C1843). Caretakers' willingness to offer the *aseda* indicates the potential profitability of the arrangement to both employer and employee. Exploitation occurs when the caretaker has provided both the "rum" and the labor and the owner then refuses to give the one-third share of the profits. This tendency to break the contract was the major complaint of caretakers in the Labour Department files.

Caretakers may themselves employ contract or daily-rated laborers or use their wives as workers. One caretaker complained that his wife had fallen ill. Although she was supposed to supply water and firewood as part of the "rum" agreement, he now had to pay £3 to employ someone else. He also engaged laborers to weed the farm and harvest the cocoa and hired a domestic servant for the farm owner. When the owner, a woman, refused to pay the girl, the caretaker had to pay the girl's parents himself. He also had to pay half of a fine exacted by the produce examiners. After all this, the owner still refused to give him his share of the cocoa profits. The case was eventually settled only when a male relative of the owner paid the caretaker (C1382).

Such a case illustrates some of the responsibilities put upon a caretaker. Some caretakers are able to buy farms and become owners themselves. One such caretaker was even asked for a loan by the owner of the farm with whom he had an *abusa* agreement. This man refused the loan saying that part of his one-third share had gone to open up his own cocoa farm and to "care for his wife and children and old father at home in the North" (C1643).[5]

Although the *abusa* contract is highly institutionalized by custom, the six- to twelve-month agreements made largely with migrant laborers are

the most formalized contracts. When these contracts are written, they are drawn up by the licensed letterwriters who can be found in any town, sitting under trees with their tables and typewriters. After having the contract read to them, the workers acknowledge their acceptance by a thumbprint. In the written records there was no indication of the payment of *aseda*.

Although these examples come from cases in which the employers were women, Table 4.2 indicates that men are more likely than women to use contract and daily-wage labor. Almost all of the contract laborers are men. If their wives came with them, however, they also participated in the work. In one case a woman and husband were employed as contract labor. The husband left, and the wife, with the help of some other laborers, completed the work (C881). In another case a woman from the North had entered into a contract agreement to fell trees, burn a farm, plow, and plant cocoa and corn. She was promised an *abusa* agreement later, but the owner reneged and refused to pay her for work already done. It is not clear whether there was a written contract in this case. Her work may have been an example of labor to make the *aseda* payment (C1128).

TABLE 4.2

Type of Labor Employed, by Sex of Employer

Sex of Employer	Type of Labor			
	Abusa	Contract	Daily Wage	Spouse
Female	19	7	7	1
Male	18	12	23	13

Another form of labor, much more temporary than the *abusa* or contract agreements, is a short-term contract for work done on a daily or piecework basis for a limited task, e.g., weeding a corn farm or felling trees. Such labor has much less security than the *abusa* or contract labor. Since most agreements referred to in the records assign lump sums for a specified job, e.g., £2 for weeding a corn farm, it is difficult to know the daily rate. In other areas of work, such as stone contracting or building, the daily rate in the early 1960s was four to five shillings a day;[6] in the mid-1960s it was raised to six shillings, six pence (6s./6d.) a day. In one case in 1964, however, where a farm laborer and the Labour Office were trying to calculate the wages due, the worker calculated a total of 6s./6d. a day, whereas the Labour Officer arrived at a total of 3s./3d. (C1600).

Some of these contractual arrangements are more desirable than others. The *abusa* contract has the most security and prestige, and allows some laborers who started out on a contract basis to move on to being *abusa* sharecroppers. The daily-wage and piecework laborers have the least security. These agreements have evolved in complexity over the past

half-century, although the *abusa* contract has a much longer history. One striking aspect of all of these cases is the heavy reliance on nonfamily workers. There is an important exception to this, however, in the utilization of wives for labor on cocoa farms.

WOMEN'S LABOR ON COCOA FARMS

In this matrilineal area reliance on the labor of wives generates severe conflicts in cases of divorce or the husband's death, when his matrilineage may then claim the farm. Although there is widespread feeling against the unfairness of this practice and attempts are often made to ameliorate the wife's situation, it is a persistent source of debate and controversy. Thirteen cases were brought before the Labour Office in which the wife was seeking compensation for her labor or continued access to the farm land she had worked. In one case the husband had married a younger woman and had neglected his older wife, who had worked on his farm: "The Complainant who is now old, about fifty-five years, is no longer the stuff the Respondent, a young man, requires and he has therefore denied her the normal family life." The husband wanted to give her one-third of the land, but she felt she deserved more and the Labour Office eventually saw to it that some elders divided the farm into four lots and gave the woman two of them (C715).

In a similar case, the man and woman had been married twenty-two years and developed nine cocoa farms. The husband divorced his wife when she became sick and refused to give her any of the farms. The Labour Office saw to it that a deed was drawn up to give the woman a share and ruled that she was to provide some *aseda*, i.e., schnapps and sheep (C945). In a third case when the wife was divorced, she thought that the husband would care for the children so she did not ask for part of the farms, but "he is not caring for them. When anybody goes into a debt, he dislikes to pay, but when one of his daughters gets marriage [*sic*] and they brought a head rum *(tia senna)* to him, he gets it while he did not care to look at them." In this case, a deed was written up, and one of the eight cocoa farms she had cultivated with the husband was given to her (C966). In other cases the husband had died and his successor refused to share the farms or care for the widow and children (C952, C955, C957, C958).

There was a single case in which a woman who owned a cocoa farm had her husband working for her as an *abusa* laborer. He had received this share in the farm's proceeds when he married the woman five years previously. She alleged that her husband had been disrespectful to her and her brother. He had already received his one-third of the profits, but his wife was going to give the farm to her grown children unless the man apologized and could then be "reinstated as husband and caretaker." As the case continued, it became apparent that the real conflict was between the woman's brother and her husband, who were members of opposing

political parties. This was an unusual case. All the other cases of spouses working as laborers concerned wives who worked for their husbands.

A complex system of differentiation has thus evolved in the countryside in the twentieth century. Women farmers have developed parallel structures to those of men in the ownership of land and the employment and utilization of labor. Research indicates, however, that women generally have smaller plots than men (Okali 1973; Okali, Gyekye, and Mabey 1974; Okali 1975; Okali and Mabey 1975). They also could rely less on family labor and were more dependent upon *abusa* laborers than upon contract and daily-rated workers. Perhaps most important, they were not involved in the lucrative and complex system of exchange among producers, sub-brokers, brokers, and European firms in the marketing of cocoa. Large farmer-creditors and broker-creditors make more profits than direct producers, while the cocoa export firms make the greatest profits.[7]

Cocoa farming has produced an emerging class system in the rural countryside in which the larger farmer creditors, brokers, and bureaucrats are at the top, the smaller independent farmers next, the *abusa* laborers next, and the contract and daily-rated laborers at the bottom. Women participate in this system both as farm owners and laborers and as wives and lineage members. As wives, they can benefit from marriage to wealthy cocoa farmers, but they also may be exploited as labor. As lineage members, they benefit from attachment to powerful and wealthy lineages that provide land for them; but if their lineage members are numerous and in debt, these resources do not benefit them as much as a judicious marriage. And in either situation, women have problems utilizing labor.

THE FAMILY SYSTEM AND ITS IMPACT ON CLASS FORMATION IN SOUTHERN GHANA

Interviews with women cocoa farmers in matrilineal and patrilineal areas of southern Ghana yielded a clearer picture of the relationship between family systems and class formation. The sample of women interviewed was selected from among attendees at meetings in several towns, 100 women in two matrilineal Brong towns (with more detailed interviews of 54 women in one of the towns) and 40 women in five Ewe patrilineal (Volta Region, southeastern Ghana) towns. The 100 Brong women owned 152 cocoa farms, and the 40 Ewe women owned 91 cocoa farms. In the interviews I asked them how they acquired their farms, what labor they used, how many loads of cocoa they produced each year, how many food farms they had, what labor they used on their food farms, whether or not they worked on another person's cocoa farm, and what compensation they received. In addition, I collected background information concerning their age, marital status, and dependents.

TABLE 4.3

**Employment Status of Women Farmers, Fishermen,
Hunters, Loggers, and Related Workers, 1967–1968
(percentage)**

Category of Employment	Volta Region	Brong-Ahafo Region
Employer and self-employed	78.1	69.9
Employees	2.1	1.3
Family worker	19.4	27.9
Caretaker	0.4	0.9

Source: Adapted from Ghana 1968: table 12.

In both the Volta and Brong-Ahafo regions of Ghana, census figures indicate differentiation among women working in the occupational category of farmers, fishermen, hunters, loggers, and related workers. This differentiation appears in Table 4.3. These statistics reflect a variety of labor forms; yet they fail to convey the fact that in both areas some women are involved simultaneously in several labor systems. A woman may be an employer of labor on her cocoa farm, self-employed on her food farms, and a laborer on another farm—usually her husband's. Because of the variety of labor forms in which women may be involved, it is difficult to put them into a hierarchy based on owner–laborer differences, giving credence to Robertson and Berger's (Chapter 1 in this volume) insistence on distinguishing clearly between ownership, use, and control of significant resources. Women cocoa farmers can, however, be differentiated on the basis of their productivity. Table 4.4 demonstrates this difference. Only a minority of women produced from 50 to 100 loads, with the majority producing 14 or fewer loads per year, which supports Okali's findings on the generally small size of women's farms.

The women had acquired their farms in a variety of ways. Some were inherited and some were self-acquired by investing profits from some other enterprises. These differences are spelled out in Table 4.5. Predictably, there are significant differences between the patrilineal and matrilineal areas in inheritance patterns. Women in the matrilineal areas inherit from a much wider variety of persons. Some of them are in the expected matrilineal line, e.g., mother, uncle, brother, grandparent, and child. Surprisingly, however, some of them are in the patrilineal line, e.g., husband and father. In the patrilineal areas, the father is by far the most important source of inherited resources, with mothers and husbands far behind, which helps to explain why more patrilineal women inherited farms than matrilineal women. Women, as noted earlier, tend to own less property than men. In a matrilineal inheritance system women must rely on their mothers and mothers' brothers for inheritance—33 percent of the matrilineal women received property from mothers or uncles, while 58 percent of the patrilineal women inherited it from their fathers. A slightly higher proportion of matrilineal women received property from their

TABLE 4.4
Distribution of Loads of Cocoa

Number of Loads	Matrilineal Town*		Patrilineal Towns	
	Number of Farmers	%	Number of Farmers	%
50–100	3	9	5	13
25–49	3	9	5	13
12–24	6	18	4	10
14 and below	14	42	21	54
No answer or not yet bearing	7	21	4	10
Total	33	99	39	100

*Based on one town.

husbands (26 percent vs. 20 percent), probably because, as will be shown later, more matrilineal than patrilineal women worked on their husbands' farms and matrilineal women often establish inheritance rights through the contribution of their labor.

Another significant difference emerged in the percentage of women who acquired farms through their own efforts. Among the matrilineal farmers, 43 percent acquired their farms by their own efforts, whereas only 34 percent of the patrilineal farmers did so.[8] Does this mean that the matrilineal women have more access to resources other than their lineage or husband, or that such an independence is a forced one—that they have less security in their lineage or marital ties? They seem, in terms of their inheritance patterns, to have less security in their lineages and more in their marriages, the opposite of what one might expect. Whereas 61 percent of the matrilineal women received property from their lineal relatives, 79 percent of the patrilineal women did. The difference between inheritance from husbands was smaller, as previously noted, with a slight advantage to the matrilineal women. Conversely, matrilineal women seem to do a bit better in acquiring property through their own efforts, since half did so compared to 47 percent of the patrilineal women, and more succeeded in getting loans.

In more detailed conversations, some of these matrilineal women spelled out their strategies. One woman described vividly how she would use the profits from her pepper farm to enlarge her cassava farms and then her garden egg (a form of eggplant) farms and so on. Eventually she used these accumulated profits to expand her cocoa holdings. Other women described their efforts at collecting kola nuts, which they would sell in the market. One woman recalled doing this in the 1920s, when there were only footpaths to the nearest town. She would then return with salt. Still other women were involved in processing raw food materials—maize into ken-key (a fermented and steamed corn dough) and palm nuts into palm oil. One woman even worked as a daily-wage laborer (not a family worker) on another farm and used her wages to begin to hire her own laborers.

TABLE 4.5
Method of Acquisition of Farms

Method	Matrilineal		Patrilineal	
	Number of Farms	%	Number of Farms	%
Self-acquired				
Loan	4	6	1	1
Proceeds from food farms	13	20	9	29
Proceeds from trade	11	17	3	10
Proceeds from other cocoa farms	3	5	2	6
Proceeds from food processing	2	3	1	1
Proceeds from wages as daily laborer	3	5	0	0
Source of funds not specified	29	45	15	48
Total	65	101	31	99
Gift or inheritance				
From husband	23	26	12	20
From mother	20	23	10	17
From father	10	11	35	58
From uncle	9	10	0	0
From brother	10	11	2	3
From grandparent	7	8	0	0
From child	1	1	0	0
Source not specified	7	8	1	1
Total	87	98	60	100

Note: Percentages do not add up to 100 due to rounding.

The two areas also show differences in the type of labor these women used on their cocoa farms, as shown in Table 4.6. Matrilineal areas use more of the traditional labor forms such as self, and sharecropping (61 percent), while the patrilineal areas use less of this labor (55 percent), and more family and hired labor (45 percent), again showing stronger family links.

In the matrilineal areas, many more wives work for their husbands (47 percent), compared to 26 percent for the patrilineal areas. Also, polygyny is more widespread in matrilineal areas. Seventy-eight percent of the matrilineal women were in polygynous marriages at the time of the survey, compared to only 34 percent of the patrilineal women, which suggests that the matrilineal areas are wealthier (as shown in Table 4.4), but also that their men rely more on wives for labor. In wealthier areas women may perceive a higher payoff in working the cocoa. Given the general instability in marriage in both areas, this pronounced difference in the practice of polygyny requires further investigation that goes beyond the scope of this essay.

CONCLUSIONS

There can be little doubt that the production of cocoa for a world market has led to a complex system of social differentiation in the southern Ghanaian countryside. Yet traditional forms of labor such as the *abusa* system and family labor coexist with wage and contract labor. A hierarchy of desirability exists along a continuum from farm ownership to sharecropping, contract labor, and day labor, but it would be hard to define these categories as discrete classes. As Goody has suggested, polygyny and land-based lineages keep class-endogamous, conjugal-based families from predominating. Yet, to disagree with Goody, lineages and polygyny do not necessarily disperse resources and lead to more equality. Instead, differentiation takes place within families, often along gender lines. While in some

TABLE 4.6
Type of Labor Used on Cocoa Farms

Type of Labor	Matrilineal		Patrilineal	
	Number	%	Number	%
Self	12	25	11	19
Family	4	8	10	17
Abusa (sharecropper)	17	36	3	5
Permanent laborer (paid by the load)	0	0	8	14
Contract (annual)	1	2	2	3
Day laborer	13	28	25	42
Total	47	99*	59	100

*Does not add up to 100 due to rounding.

ways women form a parallel hierarchy to men in owning farms and employing labor, they have access to less land than men do and also to less unpaid labor. They have more difficulty in acquiring farms on their own, are more dependent on nonfamily labor, and are more likely to be used as labor themselves on their spouses' farms. Women also are torn between their roles as lineage members and as wives. They can acquire farms through both their lineages and their husbands. The patrilineages seem to be somewhat more consistent in this respect, with the majority of women acquiring farms from their fathers. Among matrilineal women farmers, the husband and the lineage are both important sources of inherited resources. But in matrilineal areas, polygyny is more frequent and more wives work on their husbands' farms. Also in the matrilineal areas women farm owners seem to be more tied to traditional forms of labor. The matrilineal women, however, are also more independent in acquiring farms on their own through their efforts in other enterprises. But this may be a forced independence, given the greater frequency of polygyny and the ambiguity of inheritance practices in matrilineal areas.

Within the emerging class system in southern Ghana, then, women, because of their gender, clearly face different and more severe disabilities than men, although they may draw on lineages, husbands, and their own resources to try to improve their situation. Lineages are weakening, however, with the privatization of landownership, which then means that these kinship groups may no longer control the disposal of this most valuable resource in the future. And marriages are not very secure; commonly over half end in divorce or separation. Women's associations—of producers and traders—often are fragile and concerned only with local issues. Upper-class-dominated social movements led by women in postindependence Ghana often, as Stamp and Staudt document for Kenya (in Chapters 2 and 11, respectively), focus on strengthening the position of women as wives and mothers rather than as independent economic women. Yet lower-class women, in particular, provide much of family subsistence by growing food crops or buying food with trading profits. Even mild proposals to strengthen women's conjugal and maternal rights have been either defeated or weakened by male-dominated parliaments, which have expressed fear and outrage at the so-called independence of women (Vellenga 1977; 1982). As Obbo observed in Uganda (see Chapter 10 in this volume), the process of Ghana's incorporation into the world capitalist economy has possibly escalated male–female tensions, with rural women in particular bearing the main brunt of the disadvantages of "development." In Ghana these tensions have surfaced in attacks on independent women entrepreneurs, mostly petty traders, whom the government has blamed for Ghana's economic problems (Robertson 1983). The great cost of the willful destruction of the distribution system became even more evident with the recent drought and famine, which meant a reduction in rural areas to only one meal a day, mostly of starch. The gender-specific class formation that appears to be going on here, especially among women of low socioeconomic status, exacts a price from all members of the

society concerned. Only unity based on true equality can offset the negative impact of the international situation and local climatic conditions.

Notes

1. See Hill (1963) for a discussion of the different ways in which patrilineal and matrilineal groups acquired and divided land for cocoa farming in southern Ghana.

2. Christaller (1933) defines *ahiafo* as "poor men" and *asikafo* as "rich, wealthy, opulent men."

3. Pawnship was commonly practiced in West Africa. In it a person, usually a girl, was given to a creditor with the idea that the person's labor would serve as interest on the loan. If the loan was paid off, the person was returned to his or her family. Frequently, however, a pawn was married to her owner or a member of the owner's family, forgiveness of the debt serving as bridewealth.

4. These are complaints brought by an employee against the employer to be settled by a labor officer in the Labour Department in Brong-Ahafo. From 1952 to 1970, 1,389 such complaints came to the Sunyani Office and are now deposited in the archives there. By analyzing the names of the participants it was found that 100 women were involved. After the conflicts involving women and organizations were eliminated (355 cases), every tenth case of the remaining 1,034 cases was selected, to give 100 cases in which women were represented as both employers and employees.

5. The ethnic origins of the *abusa* caretakers are mixed. An examination of the names of the caretakers whose origins can be clearly identified indicated an equal division between local and migrant peoples.

6. A shilling equaled approximately fourteen cents in the early 1960s.

7. See Gunnarson (1978: chs. 1, 5) for an attempt to measure quantitatively the differences in profit margins of farmer-creditors, broker-creditors and direct producers.

8. The pattern of self-acquisition of cocoa farms reported for another random sample of women cocoa farmers in the Ashanti Region was as follows: 38.2 percent for Mampong; 43.2 percent for Konongo; 43.7 percent for Bekwai. This same survey found that a consistently higher proportion of the men's farms were self-acquired: 52.7 percent in Mampong; 57.9 percent in Konongo; 62.0 percent in Bekwai (Okali and Mabey 1975: table 7).

Chapter 5

LAND CONTROL
A Critical Factor in
Yoruba Gender Stratification

SIMI AFONJA

MODERNIZATION THEORY HAS guided research on gender stratifica-
tion in Africa as it has other aspects of social change and development.[1]
Yet this perspective has several problems as applied to women and de-
velopment: its neglect of history and of the conflict and contradictions in
the process of change, and its projection of a universal structure of gender
inequality onto all industrial and industrializing societies. As a perspec-
tive derived from functionalist theory, it merely incorporated women into
an existing conceptual framework without regard for the issue of gender
differentiation. Perhaps the greatest dilemma facing development plan-
ners is the persistence and increase in gender inequalities, even when
development projects are aimed at reducing these inequalities, and when
women's contributions to production and reproduction are obvious.

In the particular case of the Yoruba of southwestern Nigeria there is
now a wealth of ethnographic data on women's heavy responsibilities
inside and outside the home. It is now apparent that the most crucial
determinants of the existing inegalitarian structure rest in the sexual
division of labor and the accompanying social relations of production
since the precolonial period. A fruitful analysis of African women within
the emerging class structure therefore requires an understanding of the
division of labor and the social relations of production during the pre-
colonial, colonial, and postcolonial periods, showing how elements of a
previous era articulate with those of a later era to structure a completely
new division of labor and new social relations of production.

Studies of the sexual division of labor in rural and urban households
have dominated the field of women and development in Africa. Although
most writers acknowledge the relevance of changes in the social relations
of production to gender inequality, they give the topic less attention than
it deserves. The elements missing from most existing works, as identified
by Stamp in Chapter 2 in this volume, are concepts related to a sex-gender

system that go beyond the analysis of material production and reproduc-
tion and describe the social relations of sexuality. Crucial to such an
analysis is an understanding of the structural and ideological factors that
determine men's and women's control of the human and material re-
sources of a society.

In contributing to this consideration of sex-gender systems, this chap-
ter discusses the implications of women's limited control over land on
their position within the Yoruba stratification structure today. It shows
how women's precolonial property rights interacted with the new cap-
italist institutions that developed in response to export crop production to
restrict possibilities for capital accumulation among women and analyzes
the ways in which capitalist penetration of agriculture altered women's
position within the rural social structure. By incorporating the study of
gender inequality into the mainstream of work on class formation in
Africa, this essay seeks to develop a more comprehensive theory of social
change and development.

Researchers have looked to both Marxism and underdevelopment
theory for theoretical frameworks relevant to the study of Third World
women. The influence of capitalism on gender relations was first articula-
ted by Marx and Engels,[2] who described inequality between the sexes as a
phenomenon that evolved with the development of private property. They
proposed that the capitalist system of production altered the egalitarian
relations within the household by separating the roles of production and
reproduction and by restricting women from participation in those
spheres in which they could accumulate property and compete effectively
with men. This orthodox Marxist argument was recently revised in what
constitutes a major theoretical departure from the traditional develop-
mental perspective in Marxist thought. The new explanation goes beyond
conceptualizing the genesis of inequality solely as the outcome of the
separation of the public and private domains and the relegation of women
to the latter. It seeks instead to explain gender inequities in Third World
countries as a part of their underdevelopment, the process of extraction of
the surplus produced within these countries for the benefit of colonial
metropolitan powers.[3] This explanation is backed up in the literature with
data on the proletarianization of women as a means of ensuring a constant
supply of cheap labor within a capitalist economy.[4] Yet, using under-
development theory to explain gender stratification is another example of
the tendency to utilize an existing theoretical framework without suffi-
cient consideration of critical concepts relevant to a sex-gender system.
Underdevelopment theory stops with structural analysis and does not on
its own explain inequality between the sexes.

The shift to another model was due mainly to observed variations in
the development of capitalism and the search for an analytical system that
would account for the peculiarities of each society's experience, as well as
for other social and ideological factors.[5] Notable here are the works of
Hindess and Hirst (1977) and Taylor (1979), who highlight the structural
changes related to different forms and stages of capitalist penetration of

the Third World and at the same time account for the continuities between stages. This discourse in relation to Africa is best illustrated in the collection of articles edited by Gutkind and Wallerstein (1976), in which all the contributors consistently maintain the historical continuity between the major periods of change, emphasizing the centrality of economic institutions to the structural transformations they describe.

One of the most important aspects of this writing for the study of women and class formation in Africa is its elucidation of the structure of the division of labor and social relations of production within the lineage mode of production. Taylor describes this particular mode, under-developed in traditional Marxist thought (1979: 229), as characterized by the extraction of surplus labor in the form of elite goods from village units, in return for women and slaves. The mode of production, according to Meillassoux (1964) and Terray (1972), is made up of varying economic formations. But in all of them the process of capital penetration generally gave those in power an advantage over other groups, thus reinforcing social differentiation in the capitalist structure.[6] This model de-emphasizes economic determinism and by taking cognizance of cultural ideologies shows how noneconomic variables shape relations of production. Although it does not integrate gender stratification into its theoretical framework, it draws attention to the need to focus on women's relations to the means of production in order to understand contemporary patterns of social differentiation.

Applying this theoretical perspective to the study of African women will show that upper-class men, as the rulers in most areas, continue to maintain their traditional control over land, labor, and capital within the capitalist structure, aided by precolonial ideologies, which are used to limit women's access to resources in areas where women exercised some control over property in the precolonial era. This chapter specifically considers women's access to land, a means of production which has become very important since the introduction of cocoa as an export crop in Yoruba country in the nineteenth century. Since control and use of land, either as landlords or as producers, is significantly related to socio-economic status, access to land would appear to determine an individual's chance to accumulate property within the rural sector.

Traditional property laws define the rights of men and women in relation to land. The persistence of such rights, however, depends on the extent to which new capitalist institutions are able to penetrate such rights. Therefore, the central concerns of this analysis of gender stratification are the control of land, new capitalist institutions, and regional political economy; it suggests that women's access to land in the cocoa-planting region of Ile-Ife is strongly affected by the imposition of tenancy on principles of agnatic descent, the low diversification of the economy of the region, and the fact that tenancy evolves within a system of partial female participation in export crop production. The low level of women's incorporation into the new capitalist structure is supported by traditional

ideologies concerning the sexual division of labor and by a lack of varied opportunities for women within the regional economy.

A class-gender analysis, as stated by the editors in Chapter 1, should be concerned about women's access to critical resources and not simply with defining women's relationship to the means of production. The factors cited above are therefore important insofar as they appear to obstruct women's access to land in the new capitalist structure.

REGIONAL VARIATIONS IN PROPERTY RIGHTS

Early ethnographic data on the Yoruba depicted all Yoruba kingdoms as patrilineal. Most writers therefore assume that women were traditionally excluded from inheriting property in the precolonial era. Coker (1966), for instance, believes that the property rights of women have evolved over a long period of time aided to a large extent by the weakening of traditional rules. He observes that the exclusion of women from property ownership rests on the need to preserve family property within the lineage and to avoid its dispersal to the husband's lineage. Ward-Price (1933) had earlier made the same point, but he also recognized that the treatment of daughters in relation to property was not uniform throughout Yoruba country.

More recent ethnographies, however, recognize bilateral relations as one of the most important sources of variation in the social and political organization of the Yoruba states and also point to significant gaps between general principles of social relations and reality. In recognition of the variations in political constitutions Imoagene (1976) adopts a typology of political systems, based on the amount of mobility within each type. The maximum hereditary restriction system does not permit the mobility of commoners and is strongly patrilineal. Kingdoms of this type, Oyo and Ekiti, for example, theoretically exclude women from property inheritance. The second type is the minimum hereditary restriction system, in which the status of the lineage is politically insignificant and both male and female lines of descent are recognized. Examples are Ijebu and Ondo. The third type is the egalitarian system found in Ibadan and Egbaland, political systems with military constitutions and an emphasis on achievement as the means of attaining political office. Within the latter type, women were able to compete openly for political and economic resources, although other factors sometimes circumscribed their achievements. It is by chance, however, that these different types of societies have experienced different rates and kinds of capitalist penetration. The northern and northeastern regions, which are strongly patrilineal, are also the most economically backward areas. By contrast, the minimum hereditary restriction and egalitarian systems were incorporated quite early into the nexus of the Atlantic trade, export production, and missionary influence. The level of socioeconomic development has thus been higher in them

than in the strongly patrilineal areas, with contrasting results for women's property rights.

There is a dearth of data on property distribution between the sexes in these areas. But Lloyd, the most frequently quoted source, discusses the overlap between types of descent and types of political constitution. To him, cognatic (bilateral) descent differs from the agnatic (patrilineal) in that individuals have greater opportunity to manipulate to their own advantage relationships with the various groups of which they are members (Lloyd 1974:30). By contrast with the agnatic descent system, people are recruited into the Council of State either through a hereditary position or through titled associations that emphasize the norms of achievement. He suggests that such titles can also pass through the maternal line to sons where a daughter of the lineage cannot take the title. Lloyd does not, however, show the implications of these differences in social and political organization for gender inequality, even in his extensive analysis of landed property among the Yoruba. Rather he describes a pattern that he generalized to all the Yoruba, claiming that a woman on marriage retained full membership in her own descent group and had land rights that passed to her male children and siblings.

The danger with this explanation is that it fails to consider the implications of the differences between kingdoms in social and political organization, the variations in their exposure to capitalism, or how these factors affected women's property rights. The serious implications of these aspects of society for the status of women within their communities has already been discussed in an earlier paper (Afonja 1983), that assesses the kinds of power, authority, and influence that Yoruba women exercised. It suggests that the political economy of each period and the specific history of each kingdom affected the nature and degree of female participation, the type of control mechanisms available to them, and the degree of egalitarianism within each state. Thus, the kingdoms in the coastal regions encouraged more upward mobility for all citizens and more female participation in trade and in the political process than the less prosperous kingdoms in the hinterland.

More empirical ethnographic data gathered in communities representing the three types of Yoruba social and political constitutions support these propositions. The town of Oyo was selected to represent the maximum hereditary restriction system, Ondo the minimum hereditary restriction system, and Abeokuta, the open and egalitarian system. Descriptions of the political economy of these three communities in the literature show tremendous differences in their level of socioeconomic development. These differences are inextricably tied to differences in geographical location, in the timing of entry into and level of participation in the slave trade, in legitimate trade across the Atlantic, in export crop production, and in missionary influence.

Abeokuta, which has the most egalitarian structure, is the newest of the kingdoms[7] and is also the nearest to the coast. Its geographical location has in all respects given it an edge over the other areas. The Egbas

were, for instance, among the first to feel the effects of the slave trade since their warlords were actively involved as slave raiders and middlemen between the coast and the hinterland. Legitimate (non-slave) trade also flourished in Abeokuta earlier than in the other areas, and Egba farmers were involved in cash crop production as early as 1846. The prosperity from trade, export crop production, and the institution of modern education helped to enhance the position of Egbas within Yoruba society.

Ondo gained more prominence than Oyo because of its active involvement in growing cocoa and because it lay across the trade route from Ibadan to Lagos. Ondo made a relatively late entry into cocoa production; it was not planted there until 1906. The existing social and political organization, conducive to the requirements of capitalist enterprise, explains the rapid mobility of citizens within that social structure.[8] The principles of cognatic descent and equal access to community land helped to relax patrilineal principles, which are often a disincentive to the commercialization of land. Some male respondents had inherited fixed property such as farmland and urban land through the maternal line. There were also women who had inherited both fixed and movable property from their fathers. This pattern reflects the belief that men and women possess equal rights to fixed property.

Oyo, which represents the maximum hereditary system, presents a rather different pattern. A woman is believed to possess equal rights to her father's property, but in reality fixed property such as land or farms indirectly passed to men in order to keep it within the patrilineage. None of the respondents in Oyo had inherited real property from her mother or from her lineage, and, unlike respondents in Ondo and Abeokuta, none of the women claimed to have inherited land from her father. Respondents explained, however, that in more recent times real property was allowed to pass to daughters if there were no sons or to a woman's sons. This corresponds with the practice in Awe, which belongs to the same patrilineal belt as Oyo. Marshall (1964) observed that an Awe woman was traditionally entitled to a share of any property owned by her father, but in reality only the movable property passed to her. "The rights of women," she writes, "may be waived in favor of their brothers so long as the women had no adult male sons who required the use of land" (Marshall 1964:63). The significant points supported by Marshall are that real property is most valuable and necesssary for export crop production and that it was firmly controlled by men.

Property rights in Abeokuta are as relaxed as in Ondo. A good number of respondents inherited land through the maternal line and confirmed that men and women have equal rights to houses, land, money, and even items of clothing. The flexibility of the system is most apparent in residence and affiliation patterns described by respondents. It was possible for a man to live among his maternal kin, develop landed property, and participate in all affairs of that unit. It was also possible for women to exercise rights equal to those of the men of the lineage, to farm inherited portions with their children, slaves, and in more recent times, paid labor.

It needs to be stated, however, that cognatic descent, with its avenues for upward mobility, did not essentially wrest the control of land from men. It merely gave women of the family and their offspring permanent rights to portions of family and community land. The allocation and distribution of land are the responsibility of those who wield political power at the lineage level (the Bale) or the traditional ruler (the Oba) at the community level. The question at this point is, how did cocoa and its capitalist institutions adjust to these variations?

WOMEN WITHIN A TENANCY STRUCTURE: ILE-IFE

Ile-Ife is among the Yoruba states with patrilineal rules of descent, but here preexisting property laws interacted with the values of capitalist enterprise to restrict women's access to resources necessary for capital accumulation. As a less economically diversified region than Ibadan or Abeokuta, male control over land and over partially proletarianized female members of peasant families has intensified. Whereas tenancy exaggerated economic differentiation among peasant men, it more or less unified peasant women into a residual category, the lowest stratum of the peasantry.

The historical data collected by Berry (1974: 63) on the development of cocoa in the Yoruba country show that cocoa was planted in the villages close to Ile-Ife before World War I. Despite this late start, cocoa cultivation spread very rapidly to make Ife one of its most important centers. A significant element of social change accompanying the development of cocoa throughout the Yoruba country is the change in property laws. The value placed on cocoa as a new source of income necessitated new kinds of ownership rights and new ways of disposing of land. The changes varied from one region to another, however. In Ibadan and Ile-Ife, for instance, a tenancy system evolved quite early and became well entrenched in the social structure. It created a class of landlords who rented land to tenant farmers, who in turn paid a fixed sum annually as tribute to the landlord. In the initial stages, relations between landlord and tenant were both economic and social. But the growing prosperity from cocoa transformed their relationship into a purely economic one and generated conflicts over land ownership and the amount to be paid as tribute.

Tenancy generated competitive relations within lineages and communities, and within that structure women's rights were necessarily subordinated to those of men. The demand for land suitable for cocoa production was high, leading men to seek such land as tenants from other families. In Ile-Ife tenant farmers were both migrants from other Yoruba towns and local citizens. Although this change in land tenure altered corporate ownership, it did not change male control. In fact, Galletti, Baldwin, and Dina (1956: 118) described the tenancy system as a form of permanent lease found in areas settled or dominated by men of considerable influence and power who used it to keep control over tracts too large for the

immediate and prospective needs of their own families and lineages. Power within the group was thus largely dependent on the control of land.

The cocoa boom also created an entrepreneurial class, usually urban residents who purchased land and employed caretakers to look after the farms. The size of this group varied from one region to another. Permanent lease was more common where a very small proportion of scarce cocoa land was sold to such entrepreneurs. Where tenancy is restricted as in Abeokuta, a larger proportion of farmland was sold outright to prospective farmers and entrepreneurs based in towns. Land for cocoa production also was passed on through inheritance. But in most areas only a small proportion of cocoa land was transmitted through inheritance. Less land was inherited in the belt where tenancy was firmly established.

In the emerging system of economic differentiation in Ile-Ife, entrepreneurs and landlords constitute the upper class with superior access to critical resources through land ownership. Below them are the tenant farmers and caretakers, whose status derives from their control of the crops. Within the sharecropping system in which they operate, the caretakers control two-thirds of the annual yield from the entrepreneurs' farms and often rely on laborers as the tenant farmers do. The laborers and farmhands are the lowest group within the male hierarchy. They do not control land or its products but depend on earnings, which are specified in their contracts. Women fall below this lowest group because they neither control land or its products, nor earn any regular income from their input into the farm. The terms of employment of laborers are formally established, but women's employment is seen as part of their obligation as family members. Tenancy and traditional property rights deny them access to land but rely on their labor on an irregular basis for export crop production. The consequences for their socioeconomic status become obvious in their incomes, property, and expenditure as shown in data collected from peasant farmers and their wives at Iyanfoworogi, an Ile-Ife cocoa-farming village located sixteen kilometers from the town.

Cocoa was first planted in this village before World War I, but because of its proximity to the town, the village has for a long time been populated predominantly by Ile-Ife citizens. Historical sources suggest that Iyanfoworogi and other nearby villages, although founded by Ife citizens, have maintained the cosmopolitan character associated with Yoruba cocoa-farming settlements (Adejuwon 1971). At the time of the survey, there were Ife and non-Ife tenant farmers and a few laborers from neighboring Kwara and Bendel states resident in the village. The majority of the women interviewed (56.9 percent) were Ife citizens, 29.3 percent from nearby towns in Oyo State, 5.9 percent from Kwara, 3.9 percent from Ondo State, and 2.0 percent from Bendel State. Since tenant farmers and laborers have no permanent claims to land, their wives automatically lacked access to land, but they provided the additional labor required for increased production. The wives of Ife farmers, tenants, and owners had no more control over land than those of the immigrant farmers, because land and its products are usually defined as the husband's property. Community of

property is not practiced in marriage. Wives therefore have no direct right to the land, the crops, or the proceeds from their sale. Their rights are restricted to farms allocated for home consumption.

All the women interviewed were engaged in farm work, which was particularly heavy during the harvest season, when they spent from four to eight hours daily fetching water, carrying the harvested crops, and cooking for all others engaged in farm work. The time spent on household chores usually dwindled to as low as two hours a day during the harvest, with little time for any independent economic activity. Although these farmers' wives spend more time in the village than in town and are involved in farm work, they do not describe themselves as farmers. Their husbands classify them as traders who are only helping with farm work. It is thus not surprising that 84.3 percent of the women in this village claim that they are traders. Only 15.7 percent describe themselves as farmers. Trading, in a sense, operates as an excuse to exclude them from the profits of farming.

A close analysis of their wares, the amount of capital invested, and their income reveals that women's trading activity is on a low scale and provides only a meager supplement to the paltry sum received from their husbands. The income generated from such activities is spent for personal consumption and items of clothing for the women and their children. It was insufficient for purchasing any significant property or generating enough capital to start a large-scale business. The majority sold food and other items purchased from the town and resold to villagers, such as rice, plastic cups and plates, fish, salt, and bread. Less than one-third sold farm products such as peppers, oranges, palm wine, palm oil, and kola nut. Thus, women in this area did not derive as much income from food crop production as would be expected of wives of farmers. As Galletti, Baldwin, and Dina (1956) observed, women in Ile-Ife and Ilesha contribute less to family income than those in all other regions of Yoruba country because of the predominance of men in the production and distribution of export crops and the low emphasis on food crop production and large-scale commerce.

The initial investment in trade determines to a large extent the scale of business and the income derivable from it. The highest initial investment in women's primary occupation in this community was ₦100, and for some it was as low as ₦5 (a naira is worth approximately $1.34). The highest value is the exception rather than the rule; the majority had invested less than ₦50 in their trade. The amount reinvested varies with the initial investment. The data show that the majority was able to reinvest about half of their initial investment.

The most apparent index of the economic status of these women within the rural stratification structure is their level of income. As shown in Table 5.1, the majority have an annual income that is well below the minimum wage and lower than the income of the men interviewed, 45 percent earning between ₦5 and ₦100. Whereas the highest income for women was ₦600, the highest for men was ₦3,000. About 13.7 percent of

the women earn ₦100, the minimum earned by men, and 5.9 percent earn between ₦100 and ₦150. On the whole, men's average income (₦—1,075.8) was eleven times the average for women (₦98.4).

The low income of women is clearly reflected in the kinds of property they own. Both men and women agree that women's property has always been restricted to personal items of clothing and household utensils. It is accepted even within the more egalitarian structures that only a small proportion of women own fixed property. It is thus not surprising that women's property in this farming village is restricted to such personal items. Radios, alarm clocks, and cassette recorders are luxuries owned by very few (see Table 5.2) and low incomes make such items even further beyond their reach than that of the urban wage earner. While a very small proportion of the women (13.7 percent) claimed to own land, reinterviews showed that this was actually property their husbands owned. Since only one of those who claimed to own land had an income as high as ₦500, there was very little confirmation that women had significant access to fixed capital in the village.

It is not unusual for a Yoruba woman to lay claim to her husband's property if he gives her access to his resources. This single example may therefore be an illustration of hypergamy discussed by Bujra in more detail in Chapter 7. No broad generalizations can be drawn from it because most respondents clearly distinguished their property from that of their husband.

The income from cocoa in the Yoruba country is usually invested in children's education, and a substantial proportion in private houses and commercial property rented out to tenants within the fast-developing Yoruba towns. It also provides capital for new businesses or for strength-

TABLE 5.1

Men's and Women's Incomes in a Yoruba Farming Village

Income (nairas)	Men		Women	
	Number	%	Number	%
Less than 50	0	0	13	35.1
50–99	0	0	10	27.0
100–199	4	23.5	10	27.0
200–299	2	11.7	1	2.7
300–399	1	5.9	1	2.7
400–499	0	0	0	0
500–599	2	11.7	0	0
600–700	1	5.9	11	2.7
1,000–1,999	3	17.6	1	2.7
2,000–2,999	2	11.7	0	0
3,000–3,999	2	11.7	0	0
Total	17	99.7	37	99.9

Note: Nonresponses are excluded from the calculations.

TABLE 5.2
Men's and Women's Property in a Yoruba Farming Village

Property	Men (23)		Women (51)	
	Number	%*	Number	%*
Wristwatch	18	78.3	42	82.3
Alarm clock	10	43.5	8	15.6
Radio/cassette recorders	14	60.8	8	15.6
Bicycle	3	13.0	3	5.9
Motorcycle	2	8.7	0	0
Car/truck	3	13.0	0	0
Sewing machine	0	0	1	1.9
Grinding machine	1	4.3	0	0
Farm/town house	15	65.2	6	11.7
Land	18	78.3	5	9.8

*Percentages are calculated on the total number interviewed.

ening existing secondary sources of income. In Ile-Ife, the produce buyers evolved as a wealthy class, but women were not incorporated into this class because they did not possess the security required by the commercial agents. I tried to ascertain the proportion of urban landed property owned by women through the official records in one of the government ministries. But because such records were not adequately kept, it was possible to collect data for only one year, 1981–82. Only 21.9 percent of the landed property recorded in that year was registered to women; 21.6 percent of those women were wage workers, 9.2 percent wealthy traders, and 63.1 percent women contractors. Of all such property 95.1 percent consists of single plots of 450 square meters valued at between ₦4,000 and ₦5,000 (approximately $5,360 and $6,700). Such property was out of the reach of peasant women, whose incomes are considerably lower than those of men and of their urban counterparts. Whereas 15 percent of the total land registered belonged to male farmers, only 1.5 percent was owned by women described as farmers. The other 84 percent belonged to urban civil servants, businessmen, and traders. The scale of petty trading and the low incomes it provided in this village were not sufficient to permit women to accumulate urban property or to build up other businesses as some men did. Even when petty traders combined different items and reinvested what was not consumed, they found it difficult to push themselves beyond the subsistence level.

The predicament of the women in this village is also related to the declining volume of food production, a well-recognized phenomenon associated with the high volume of export crop production in the region. The women are not only unable to benefit from the sale of food crops but also unable to derive substantial incomes from their traditional food-processing industries. There were, for instance, only two women involved in palm oil processing, none in cassava production and similar processing indus-

tries. In fact, the majority of the women traded in items purchased from urban markets rather than in farm produce.

The differentiation of the peasantry in Iyanfoworogi is typical of that in the cocoa-producing villages in that region. Since the same set of structural determinants prevail in all the villages, women probably are similarly placed in the socioeconomic structure of the whole region. This conclusion cannot be generalized to other regions of the Yoruba country, however, in view of the differences in property rights, in new methods of land tenure and disposition, and in the regional economy. Ondo and the farming villages around it are a contrast to Ile-Ife because tenancy was not as widespread and citizens could buy or inherit cocoa land. Since land was owned by the community rather than by the corporate lineage, individual holdings through inheritance and the sale of land developed early enough to allow women access to land, cash, and food crop farms through their fathers or their husbands. Berry records examples of such women who have also increased their original holdings by purchasing cocoa farms from other families.

Another factor that helps to explain the differences between Ondo and Ile-Ife is the higher level of participation of peasant farmers' wives in the production and distribution of export crops. In Orotedo, one of the villages studied by Berry along the Ondo belt, women's labor was utilized in many more aspects of cocoa production than is traditionally expected. Although it produced a relatively high rate of female proletarianization, the farmers' dependence on family labor exposed women to the entire technology of production and distribution. To some female respondents, this experience provided the skills they needed to participate as entrepreneurs at a later time.

Abeokuta presents yet a different pattern. Tenancy did not thrive on a large scale because cocoa land was scarce and, as Galletti, Baldwin, and Dina (1956) indicated, this and other coastal regions were quick to adopt European land tenure systems. Individuals could therefore purchase land or inherit it through the maternal and paternal lines. A more important dimension, however, is that wives of peasant farmers did not engage in farm work on the same scale as in Ondo and Ile-Ife. In this region, slave labor and later wage labor relieved women of agricultural work. The individualistic ethos that developed rapidly after the eighteenth century therefore aided the incorporation of women into the entrepreneurial class of the rural and urban economy. They were in the export crop economy as middlewomen between farmers and male produce buyers and were well known for their involvement in the commercial life of the rural and urban centers. Ondo and Abeokuta women thus appear to be better placed than Ile-Ife women within the structure of export crop production and distribution.[9]

CONCLUSION

In exploring the range of factors that determine the position of women within the emerging class structure in Ile-Ife region, traditional property

rights and patterns of the division of labor by gender seem important. But the most critical determinants are export crop production and institutions such as the tenancy system and the paid labor that accompanied it in parts of the Yoruba country. All of these factors are important within this context because they directly or indirectly influence the relations of production between the sexes. Tenancy and paid labor, as capitalist institutions, introduced new ideologies and new social relations of production without necessarily eliminating preexisting patterns. Women are thus expected to continue to play their traditional roles in production and reproduction, but with limited access to critical resources. Men, as the dominant class, use the ideologies of the precapitalist structure to manipulate the reward structure in the interests of their sex, thus generating a relationship of competition and exploitation between the sexes. The effects of such manipulation are apparent in urban stratification systems as shown by Robertson (1977) in her analysis of sex differentials in educational opportunities in Ghana. What makes the case of peasant women particularly interesting to the issue of gender and class in Africa is their relegation to the fringe of a class considered the lowest of all classes and their slow incorporation into the world capitalist economy. An important factor relevant to this observation is the fact that the regional economy constrains the scope of available alternatives where export crop production is the dominant economic activity. The limited range of choices intensifies the competition between the sexes and the manipulation of one by the other.

In an assessment of the factors that influence the sexual division of labor in agriculture, Deere and Léon de Leal (1981) suggest that unequal access to land among peasant households is related to the process of proletarianization and differential labor participation by sex. Of particular interest to these authors and to others who have written on the peasantry is the presumed association between the level of capitalist development and the incorporation of women into wage labor. It is expected that the higher the rate of capitalist development, the more women are incorporated into the sphere of production and separated from the sphere of reproduction. These assumptions are not only untrue for Africa, but, the concepts on which they are based do not sufficiently explain gender inequality. Following traditional Marxist descriptions of the division of labor by sex, they do not account for inequalities in access to the means of production within the household itself, and therefore continue to measure the socioeconomic status of women in a household by reference to that of the male household head.

The data presented in this chapter, however, point to the need to reconsider the relationship of women to standard class categories. By showing the importance of women's lack of access to land for explaining gender inequality, they suggest the validity of focusing on women as one class among the peasantry. Perhaps the best rationale for this kind of emphasis is that capitalism as described in Marxist thought originates with the process of property accumulation, which leads to a restructuring

of the division of labor and of social relations of production. The starting point for the study of women and class should thus be their relative control over the means of production, land, labor, and capital.

Notes

1. See Afonja 1981a, 1981b, 1983.

2. See Karen Sacks (1974) for an extensive discussion of Engels' interpretation.

3. Concepts of underdevelopment theory feature in the contributions to the volume edited by June Nash and Helen Safa (1980) and other contributions on Latin American women, e.g., Arizpe's (1977) work on Mexican women in the informal sector of the economy.

4. See the contributions by Tilly, Safa, and Arizpe and Aranda to *Signs* 7; no. 2 (1981) for discussions of the proletarianization of women.

5. Taylor (1979) points out major structural differences between export commodity and merchants' capital as distinct forms of capitalist penetration of the Third World.

6. Kate Young (1978) and Carmen Diana Deere (1977, 1979) have applied this discourse to the analysis of women's position in Latin America.

7. Abeokuta and Ibadan evolved as military states in the Yoruba country in the nineteenth century. Their political constitution therefore differs from that of the older states.

8. Land tenure in Ondo differs from that in Ile-Ife because in the former land belongs to the whole community and is administered by the Oba on its behalf. In Ile-Ife, on the other hand, land is held by the corporate body, the lineage.

9. The forms used in previous years did not contain all the socioeconomic data required for this analysis.

Chapter 6

WOMEN'S EDUCATION AND CLASS FORMATION IN AFRICA, 1950–1980

CLAIRE ROBERTSON

THE GROWTH OF Western-type formal education in Africa has created a new dilemma for women, one in which both their absence and their presence in schools acts to their disadvantage. Their absence from schools puts them at a disadvantage in competing with men for scarce wage jobs. Their presence in primary schools in ever-growing numbers is economically dysfunctional in that it encourages their removal from the labor force both as children and adults and promotes their dependence on men. Rather than leading the way to equality and greater opportunity, then, education for most women in Africa functions as an instrument of oppression to reinforce subordinate roles.

This essay will document the growth of primary education in Africa and its impact on women. I have chosen primary education because it is most common and is even becoming universal for women in a few areas. Using UNESCO statistics I will first analyze factors that have determined the generally lopsided growth of primary education favoring boys and will then explore the ramifications of this growth for female subordination. Both sections support the argument that Western education in Africa is instrumental in promoting a gender-specific class formation that leaves women persistently underprivileged in their access to resources. On a continent where women do upward of 70 percent of the agricultural work and raise most of the food, such a process helps to explain the critical food shortages experienced recently which have led to the deaths of millions of people, especially women and children.

THE GROWTH OF GIRLS' PRIMARY EDUCATION

Authority within colonial African social structures generally shifted from the old to the young, with formal education for the young serving as a primary facilitator of that shift. In some cases the youth involved came from low status backgrounds, poor families, clients, or slaves. They were

sent to school by indigenous rulers who thought such education unimportant, or who sought to use the educated to their own advantage or to maintain control over the educated by educating only the powerless. In other cases, slaves fled to mission stations for refuge and were educated as part of the attempt to Christianize them. Such education, whatever its origins, often acted to the disadvantage of those rulers, because it gave young people new tools with which to break the power of gerontocracies. Ultimately it became a critical weapon used by the colonized to overthrow the colonizers and to achieve high status in rapidly changing African societies. Tardits (1963:268, my translation) commented, "Education, in giving access to the most desirable professions, has become the most important factor in social differentiation; the time is long past when the king of Porto Novo, asked to send his son to school, judged that this novelty was temporary, and sent along some servants' children whom he passed off as his own."

But one group was usually omitted from this transformation, since colonialists, missionaries, and local peoples all used gender as a criterion for deciding who would receive formal education. Girls usually were not sent to school; the few who were received an education that would not fit them for the more prestigious and better paid jobs that were opening up for men, or even for the less desirable wage occupations. But in the last thirty years this situation has changed dramatically with regard to primary education. UNESCO data allow a comparison of both the growth in the access of girls and boys to primary education and of the socioeconomic, religious, and political factors that have helped to determine the expansion of women's education, in particular.

Table 6.1 presents the percentage growth rates for girls', boys', and all children's primary enrollments, along with the ratio of girls' to boys' enrollment growth from 1950 to 1980. These figures indicate a strong commitment to increasing girls' education, both before and after independence, but generally higher preindependence growth rates. Before concluding that colonial governments showed greater commitment to girls' education than independent governments, however, one must consider the very low 1950 base rate (shown in Table 6.2) in many countries, especially for girls. Thus, the higher initial growth rates were an inevitable result of previous colonial neglect. But in the 1950s many colonial administrations finally expressed concern about providing skilled Africans either to satisfy the demands of reformers or to prepare for independence, so that the decade from 1950 to 1960 was atypical of colonial rule as a whole. After independence the annual growth rates in school enrollments were spectacular given the poverty of many African countries; it was not uncommon to find tripling or quadrupling of enrollments within five years, especially in the early 1960s. Nothing indicates more clearly the faith in education as a prime contributor to economic development.

A few countries had lower preindependence growth rates for girls than for boys, namely, Angola, Benin, Botswana, Lesotho, Malawi, and Swaziland. Except for Angola and Benin, these countries all follow a

TABLE 6.1
Primary Enrollment Growth Rates, 1950–1980
(percentage)

Country[a]	Annual growth, 1950–80				Preindependence				Postindependence			
	Total	Female	Male	Ratio F/M	Total	Female	Male	Ratio F/M	Total	Female	Male	Ratio F/M
Algeria	7.7	8.5	7.2	119	8.8	10.9	7.6	143	5.7	6.4	5.2	122
Angola	i	i	i	i	19.3	18.1	20.1	90	i	i	i	i
Benin	8.3	8.8	8.1	108	9.9	9.5	10.1	94	7.5	8.4	7.1	118
Botswana	8.1	7.6	8.8	86	9.5	8.7	10.9	80	8.1	8.6	7.7	111
Burkina Faso	9.4	11.0	8.7	126	15.3	17.5	14.6	120	6.6	7.9	5.9	133
Burundi	2.3	4.8	1.1	413	i	i	i	i	.5	2.5	-0.4	-565[b]
Cameroon	6.7	10.9	5.1	213	8.3	17.3	6.0	289	5.9	7.9	4.7	168
Central African Republic	8.8	12.9	7.7	168	13.3	18.6	12.3	151	6.7	10.2	5.5	186
Chad	11.7	17.5	10.8	162	25.4	33.2	24.7	134	5.5	10.3	4.5	232
Congo	7.8	12.1	6.1	199	11.1	20.5	8.3	248	6.3	8.1	5.0	162
Egypt	4.3	4.7	4.1	114	n.a.	n.a.	n.a.	n.a.	4.3	4.7	4.1	114
Ethiopia	11.3	14.6	10.3	142	n.a.	n.a.	n.a.	n.a.	11.3	14.6	10.3	142
Gabon	6.8	9.7	5.3	182	10.4	16.6	7.9	210	5.1	6.5	4.1	158
Gambia	8.5	12.5	7.4	167	7.8	14.6	6.2	236	9.3	10.4	8.7	119
Ghana	5.3	7.4	4.3	170	13.3	17.5	11.7	149	3.4	4.9	2.5	199
Guinea	9.2	12.4	8.3	149	13.1	22.6	11.2	202	5.0	6.3	4.5	139
Guinea-Bissau	10.5	11.8	9.9	118	10.3	13.5	9.0	149	7.3	6.6	7.6	87
Ivory Coast	11.9	15.1	10.8	140	22.2	27.5	20.8	132	7.2	9.4	6.1	152
Kenya	8.0	10.0	6.9	146	7.9	9.7	7.1	136	9.0	10.8	7.8	138
Lesotho	3.3	2.9	4.1	71	4.4	3.8	5.3	71	2.5	2.4	2.8	85
Liberia	6.9	9.3	6.0	155	n.a.	n.a.	n.a.	n.a.	6.9	9.3	6.0	155
Libya	10.3	15.7	8.4	188	i	i	i	i	9.3	13.8	7.4	188
Malagasy Republic[c]	6.5	7.3	5.9	124	6.7	7.9	5.8	138	6.3	6.8	5.9	114

TABLE 6.1 (Cont.)
Primary Enrollment Growth Rates, 1950–1980
(percentage)

Country[a]	Annual growth, 1950–80				Preindependence				Postindependence			
	Total	Female	Male	Ratio F/M	Total	Female	Male	Ratio F/M	Total	Female	Male	Ratio F/M
Malawi	4.4	4.8	4.2	114	2.6	2.3	2.8	84	6.1	6.5	5.9	110
Mali	8.5	10.8	7.7	141	9.9	14.2	8.6	165	7.8	9.2	7.2	128
Mauritania	13.0	19.9	11.7	170	17.2	30.8	15.6	197	11.0	14.8	9.7	152
Morocco	7.4	8.5	6.8	124	11.2	16.5	9.0	183	5.1	6.6	4.4	149
Mozambique	7.3	8.1	6.9	117	8.8	9.5	8.4	113	.3	1.3	−0.3	−389b
Niger	12.2	15.1	11.1	136	16.1	22.5	14.3	157	10.2	11.6	9.6	121
Nigeria	9.7	12.7	8.3	152	11.6	17.6	9.3	190	8.4	9.5	7.7	123
Rwanda	6.6	9.4	5.1	182	9.7	13.6	8.4	161	4.6	6.2	3.4	185
Senegal	8.1	11.7	6.8	171	10.8	19.9	8.2	242	6.7	7.7	6.1	126
Sierra Leone	6.5	7.6	5.9	129	9.6	11.3	8.8	129	4.0	4.8	3.6	133
Somalia	13.8	18.5	12.5	148	15.4	23.1	14.0	165	12.9	16.2	11.7	138
South Africa	4.1	4.0	4.3	93	n.a.	n.a.	n.a.	n.a.	4.1	4.0	4.3	93
Sudan	9.2	12.3	8.0	154	i	i	i	i	8.8	13.3	7.2	183
Swaziland	7.0	6.8	7.3	94	8.5	7.8	9.3	84	4.6	4.8	4.4	109
Tanzania	9.9	11.8	8.8	134	8.7	10.5	8.0	132	10.9	12.7	9.6	132
Togo	8.7	11.3	7.8	145	9.6	13.9	8.4	167	8.3	9.9	7.5	133
Tunisia	6.5	8.1	5.7	142	9.0	11.3	8.1	140	4.3	5.6	3.6	156
Uganda	5.8	7.5	5.0	152	9.0	11.3	8.1	139	5.8	6.5	5.3	122
Zaire	4.9	9.3	4.4	211	i	i	i	i	5.1	6.7	4.2	161
Zambia	6.2	7.5	5.4	138	5.9	7.9	4.7	168	6.1	6.6	5.7	115
Zimbabwe	6.8	7.2	6.5	111	6.8	7.2	6.5	111	i	i	i	i

[a]Countries with insufficient data omitted.
[b]Although mathematics dictates that this has a negative sign, a glance at the numbers involved indicates that a positive sign here is more representative of the disproportionate increase for females.

i = incomplete

n.a. = not applicable

Southern African pattern, where boys usually herd and then work in South Africa's extractive industries, neither of which requires formal education. Bridewealth, which is still important, is increased by girls' education. In these countries girls' primary education was mostly at or near parity with that of boys both before and after independence, an anomaly in the usual African situation that will be taken into account in later correlations.

Table 6.2 indicates the results of the differential growth in primary education for the sexes. The discrepancies between girls' and boys' enrollments might be somewhat reduced if the figures included private schools in more cases; several sources have noted parents' preference for sending girls to sex-segregated private schools (Yates 1981:134; Deblé 1980:89; Jones 1982:36). Increasingly, however, government schools dominate in providing education, as in Nigeria, where the government has routinely been taking over all missionary schools. With the exception of Burundi and Malawi, the increases in percentages of all children in school shown here from 1950 to 1980 are truly enormous, usually doubling or even quadrupling during this period. On the one hand this dramatic rise shows that, despite the belated colonialist activity in increasing enrollments in the 1950s, there was still a very long way to go to attain universal primary education. On the other hand, in most countries outside the Southern African complex there were still quite large discrepancies between male and female enrollments, averaging 15.1 percent. In fact, the differences between girls' and boys' growth rates were generally maintained in favor of boys after independence, thus explaining the large discrepancies between boys' and girls' education found in Table 6.2. The largest discrepancies favoring boys in school occurred in Guinea-Bissau and Togo—each showing a 46 percent difference. Next came a group including Algeria, Benin, Central African Republic, Congo, Ivory Coast, Liberia, Morocco, Tunisia, and Zaire, where there was a 20 to 30 percent difference between boys and girls. Around average were Angola, Cameroon, Chad, Ethiopia, Ghana, Guinea, Malawi, Mali, Mauritania, Mozambique, Senegal, Sierra Leone, Somalia, Sudan, Uganda, and Zambia. The smallest differences occurred in Burundi, Kenya, Malagasy Republic, Niger, Rwanda, Swaziland, Tanzania, Burkina Faso, and Zimbabwe, while South Africa was at parity, and Botswana and Lesotho showed differences favoring girls, the latter by 27 percent. In Burundi, Niger, and Burkina Faso the small differences were probably due to overall low enrollment, but in Kenya, Rwanda, and Tanzania the superior postindependence growth rate of girls' education probably reduced the sex differences.

It is not surprising, then, that in most countries women substantially outnumbered men among the illiterate population, the highest proportion being around two-thirds in Congo, Libya, Tanzania,[1] Uganda, and Zaire. Only in Lesotho was the proportion reversed. In fact, Africa fits into the worldwide pattern by which women make up a rising proportion of the illiterate population. In 1960, 88.5 percent of African women were illiterate, in 1970 82.4 percent, and in 1980 72.8 percent. The respective percent-

TABLE 6.2

Percentage of African Children in All Types of Schools and Percentage of Illiterate Population that Is Female

Country	Total		1980[a]		Female Percentage of Illiterate Population, 1970
	1950[b]	1980[a]	Girls	Boys	
Algeria	14	65	54	75	61.6
Angola	2	36	26	45	i
Benin	8	40	25	55	57.7
Botswana	18	73	79	66	57.9
Burkina Faso	2	11	8	14	52.7
Burundi	9	14	11	17	59.2
Cameroon	20	62	54	69	63.4
Central African Republic	6	41	28	55	62.5
Chad	1	19	10	29	58.6
Congo	20	i	i	i	65.1
Egypt	25	64	51	77	61.9
Ethiopia	3	28	20	37	53.4
Gabon	18	i	i	i	59.2
Gambia	5	32	22	42	53.2
Ghana	15	53	44	61	59.9
Guinea	3	26	16	35	57.8
Guinea-Bissau	3	60	37	83	56.6
Ivory Coast	6	48	36	61	58.4
Kenya	21	73	68	78	62.7
Lesotho	49	71	85	58	34.6
Liberia	10	46	33	58	58.2
Libya	11	i	i	i	65.2
Malagasy Republic	19	54	50	58	i
Malawi	38	44	36	52	60.6
Mali	3	19	13	25	54.0
Mauritania	1	23	15	31	i
Morocco	11	48	36	59	58.3
Mozambique	12	47	39	55	58.7
Niger	1	14	10	18	53.1
Nigeria	14	59	i	i	60.8
Rwanda	9	45	43	48	61.9
Senegal	6	28	21	34	56.9
Sierra Leone	6	26	20	32	54.3
Somalia	1	28	20	36	52.8
South Africa	49	73	73	73	52.0
Sudan	5	36	29	42	57.0
Swaziland	27	82	81	83	i
Tanzania	9	61	56	66	63.1
Togo	14	76	53	99	58.2
Tunisia	19	64	53	75	62.4
Uganda	16	32	26	37	64.4
Zaire	29	60	47	72	69.3
Zambia	34	67	61	73	63.9
Zimbabwe	43	71	69	74	58.9

[a] Or latest date available.

[b] Or earliest date available.

i = incomplete

97

ages for men were 73.4 percent, 58.3 percent, and 48 percent, meaning that
from 1960 to 1980 the ratio of female to male illiterates went from 121 to
152 (Haag 1982:129). Clearly, then, although most governments have made
concerted efforts to improve female education, they have not been as
strong as those in support of male education.

What factors account for improvement in the provision of girls' educa-
tion? To discover the characteristics most strongly associated with a high
rate of expansion in girls' education, linear regressions were done using
the annual rates of enrollment growth given in Table 6.1 and a number of
socioeconomic, political, and religious factors. I will analyze the results
using these three categories, classifying certain educational factors under
socioeconomic characteristics. Included in general socioeconomic charac-
teristics were total gross national product, per capita income, percentage
of national income spent on education, size of population, percentage of
the population that was female in 1980, the difference in the percentage of
population that was urbanized from 1950 to 1980, the percentage ur-
banized in 1980, and the difference in life expectancy from 1950 to 1980.
The sample size varied in different situations, but for the whole was from
thirty-eight to forty-four countries, meaning that a correlation coefficient
of above about .33 or below − .33 was statistically significant.

I initially expected to find a positive correlation between postindepen-
dence growth of girls' education, GNP, per capita income, and population
size. It seemed logical that richer and/or more populous countries would
have more resources to devote to educating women.[2] Many sources refer to
cost as a decisive factor in parents' decisions to educate children. However,
this was not borne out by the results regarding the growth of either girls'
or boys' primary education in relation to GNP, the percentage growth of
national income spent on education, or the percentage of government
expenditure devoted to education (latest date available), nor was it when
Southern African countries were omitted. Per capita income (latest date
available) showed only a weak positive correlation of .18 for girls and none
for boys, while life expectancy growth rate had a weak negative correla-
tion of − .23 for girls and − .15 for boys, although it was weakly positive
(.13) for the ratio of girls' to boys' rates. It is possible that the cost of
education is not a large factor for girls since they only began attending
primary school in large numbers when its cost diminished with the large-
scale development of public schools.

A number of sources refer to urbanization as a predisposing condition
for educating women, citing large disparities in urban and rural female
enrollments. For instance, Mbilinyi (1969:13) found in 1968 that the ratio of
boys to girls in rural Tanzanian primary schools was 177 and in urban
areas 122. In a Moroccan rural province recently only 6 percent of the girls
were in school compared to 40 percent in Rabat and Casablanca, and
Sierra Leone shows a similar pattern (Bowman and Anderson 1982:23).
The need for female rural labor, long distances to schools, low quality and
irrelevant schooling, seclusion of girls at puberty, and objections to coed-
ucational classes were cited by Jones (1982:36) as reasons for rural Tuni-

sian parents not sending girls to school. In Ghana economic conditions have forced the closing of schools in some sparsely populated areas (McWilliam and Kwamena-Poh 1975:116). Parents in urban areas are more liable to be able to afford education, to be conversant with wage job opportunities for their daughters, or to be more concerned that their daughters get a modicum of education in order to make suitable wives for educated men. Thus, while the correlation for the growth of boys' education was nil, the postindependence growth of girls' education correlated positively at .35 with an increase in proportion of the population that was urban (.33 without Southern Africa) and even more strongly with the difference between girls' and boys' growth rates at .56. Omitting Southern Africa, there was also a positive correlation between the percentages of boys and girls in school in 1980 and the proportion of population that was urban in 1980 (or latest date) of .49 and .45, respectively.

No correlation was found between the percentage of the population that was female in 1980 and the growth rates of girls' or boys' education. This factor was included to determine whether or not poor health conditions for women, including genital mutilation of females, affected the growth in girls' education (genital mutilation probably accounts for the low proportion of females, 47.1 percent, in the Sudanese population). However, there was a positive correlation between percentage population female and percentage of boys and girls in school in 1980 both with and without Southern Africa. For boys the correlations were .51 including Southern Africa and .52 excluding it, substantially higher than the girls' correlation of .32 including this region and .42 without it. Why would a higher survival rate for women favor sending boys to school, in particular? It has been widely noted in Africa that both women and men favor educating boys over girls. Female labor has great value for the family and is essential to survival. In many societies there is a relatively high marital instability rate and child custody goes to women (often in practice if not by law), meaning that women must pay school fees. If the mother is not around then it will be very difficult for the children to go to school.

Logically enough, some of the socioeconomic characteristics related to education, in particular, indicated strong relationships. For instance, the lower the base existing in 1950 of percentage of children in school, the higher the growth rates in education after independence for both boys and girls ($-.36$ and $-.52$, respective correlations). In fact, growth rates tend to be highest where the development of education is weakest; thus Chad, Mali, Somalia, and Mauritania have high growth rates but still have less than 25 percent of the children in school. Furthermore, there were negative correlations between the percentage of children in school in 1980 and the postindependence growth rates, $-.31$ for the girls' growth rate and $-.44$ for the difference between girls' and boys' growth rates. Thus, there was also no particular correlation of literacy rates for the whole population with the postindependence growth of girls' and boys' education, although the growth ratio had a weak correlation of .19. Growth rates alone, then, do not tell the whole story about access to education.

Equally important are the wastage and retention rates in primary schools. There is little value in increasing access to primary education only to have the pupils drop out before completion. A number of studies have shown a higher dropout rate for girls than for boys in various African countries.[3] Table 6.3 includes the percentage of female class repeaters, the total percentage of repeaters, and the respective percentages of girls and boys who begin primary school and manage to reach the final year (latest date available).

The repeater rates for boys and girls are not strikingly different in any instance, Mauritania showing the largest difference of only 3 percent. In eleven countries girls had higher rates than boys, in eleven they were the same, and in nine boys had higher rates than girls. However, girls are more likely to drop out than repeat, as Table 6.3 shows in the retention rates. With the exception of Morocco, the only countries where a higher proportion of girls than boys reached the final year of primary education were in Southern Africa. A few countries exhibited less than a 5 percent difference in favor of boys—Benin, Congo, Rwanda, Burkina Faso—with Burundi, Malagasy Republic, and Mauritania being about at parity. The mean average difference in favor of boys was 9.3 percent for the twenty-four countries where they had higher retention rates and 7 percent overall for the twenty-eight countries with data. In a few countries, Benin, Malagasy Republic, and Zaire, retention rates had declined from the 1960s, but in the rest they had improved (UNESCO 1975: table 18). High retention rates are positively associated with high postindependence growth rates, but more so for boys (.62) than for girls (.34).[4]

A number of causes have been suggested for girls' higher dropout rates. Dumont (1969: ch. 7) succinctly conveys their essence in his chapter title, "If your sister goes to school, you will have to eat your fountain pen." Deblé (1980: 65–93) documents a relatively high dropout rate for girls in both primary and secondary African schools in the mid-1970s which she attributes to early marriage, insufficient secondary places for middle school leavers, coeducation, cost of education, low quality of girls' schools, and the irrelevance of formal education to economic needs. Mbilinyi (1969:20, 28, 43) stressed cost and the labor value of women in her study of Tanzania, while Sanderson (1975:242) mentioned the lower quality of girls' schools in the Sudan. Jones (1982:36) referred particularly to long distances to rural schools in Tunisia and seclusion of girls at puberty as causes of high female dropout rates, while in Ghana teenage pregnancy was a factor among middle school pupils (Safilios-Rothschild 1979:5). In Burkina Faso, McSweeney and Freedman (1982:98) particularly stressed the labor value of girls, which not only impedes scholastic achievement but also decreases their level of attendance at school.

The last significant factor to consider is the effect of coeducation or single-sex schooling on growth rates. Specialists often assume that it is easier to expand girls' education if coeducation is the norm, because providing one school instead of two is cheaper (Safilios-Rothschild 1979:8). The results here did not generally support this position. When the

TABLE 6.3
Primary School Repeater and Retention Rates, ca. 1970–1980
(percentage)

Country	Repeater Rates		Retention Rates	
	Girls	Both Sexes	Girls	Boys
Algeria	11	12	67.8	75.7
Benin	22	20	53.3	57
Botswana	i	3	79.3	76
Burkina Faso	18	17	55.4	58
Burundi	28	29	12.8	13
Cameroon	29	29	46.5	52
Central African Republic	32	30	28.6	44.9
Chad	36	38	22.2	36.9
Congo	25	26	57.3	61.8
Egypt	9	8	i	i
Gabon	34	35	33.9	42.4
Gambia	13	13	i	i
Ghana	2	2	i	i
Guinea	i	22	i	i
Guinea-Bissau	36	33	i	i
Ivory Coast	19	19	45.9	63.9
Kenya	i	6	68.5	76.8
Lesotho	16	16	45.5	32.2
Liberia	12	11	i	i
Libya	14	15	82.1	90.5
Malagasy Republic	24	24	20.1	20.7
Malawi	17	17	26.9	45.9
Mali	28	27	42.7	48.8
Mauritania	17	14	52.5	53.6
Morocco	28	30	63	57.9
Niger	13	12	49.7	55.3
Rwanda	6	6	33	37.1
Senegal	16	16	63.1	72.3
Sudan	i	2	i	i
Swaziland	10	11	64.4	59.3
Tanzania	0	0	49.3	65.6
Togo	32	31	52.8	66.9
Tunisia	19	21	33.7	48.1
Uganda	i	10	i	i
Zaire	21	20	28.1	42.4
Zambia	1	1	64.3	84.8

i = incomplete

difference in postindependence growth ratios was calculated according to whether schools are mostly coeducational or single-sex, the average post-independence growth ratio for countries with predominantly single-sex schools (Algeria, Egypt, Libya, Sudan, Uganda, and Zaire) was highest at 142; next came systems that were about equally mixed (Gabon and Malawi) with 134; and lowest were the majority (thirty-five countries), which were predominantly coeducational, with 102, a striking and perhaps puz-

zling difference until the situation is examined more carefully. The discussion of coeducation becomes inextricably entwined with that of religion. Countries with a strong Christian or Islamic bent tend to favor single-sex systems. Western-type formal education was generally introduced by missionaries who often believed in segregating the sexes. Thus, in Zaire and Uganda, where Catholic missions had a strong impact, the tradition of single-sex schools has been perpetuated at every level, although government schools are often coeducational. In ex-British colonies like Ghana and the Sudan, the single-sex tradition has generally been upheld in the secondary schools, and in the case of the Sudan, at the lower levels also. In these and other cases like Malawi, the most prestigious secondary schools, which give the best Western-type education, are usually boys' schools, putting girls at a disadvantage. Also, when sex segregation is maintained at the upper levels it is easier to skimp on expansion of higher education for girls, as Ghana has done. In Nigeria and Somalia recent governments have made a strong commitment to coeducation; Nigeria has been integrating previously segregated missionary schools as the government takes them over.

The effect of coeducation on girls' enrollment in certain Islamic countries is more problematic. Colonial governments tended not to provide Islamic areas with missionaries as part of their policy of indirect rule; Koranic schools often supplied Muslim needs. The contrasting situations in Nigeria are a good case in point, where the south, believing predominantly in indigenous religion, was inundated with missionaries, while in the Islamic north the emirs were promised that missionaries would not try to convert the Muslim majority. The result in the Sokoto area of the north was that relatively few Western-type schools were started (none for girls) until after 1933. Enrollments of girls were very low into the 1950s. By the early 1970s parents' opposition to sending daughters to school had dwindled, but the schools themselves had secularized considerably (Yeld 1961:160–74; Trevor 1975:247–70). Here, then, is the explanation for disproportionate growth rates in some Muslim countries. They started with low bases, especially for females, and developed primary education strongly only with postindependence secular single-sex schools. The result in terms of overall enrollments in 1980 (or most recent date) was that, in countries favoring single-sex schools, 41.4 percent of the girls were in primary school and 60.6 percent of the boys, compared to 38.7 percent of the girls in coeducational countries and 53 percent of the boys. Predominantly Muslim countries had demonstrably higher postindependence growth ratios, averaging 144, compared to 132 for predominantly indigenous religion countries (Zambia, Burkina Faso, Togo, Sierra Leone, Malawi, Mozambique, Madagascar, Liberia, Ivory Coast, Guinea-Bissau, Ghana, Benin, and Cameroon), and 58 for Christian countries (Lesotho, Burundi, Central African Republic, Zaire, Gabon, Kenya, Rwanda, Swaziland, and Uganda). Subtracting Southern Africa and Burundi, whose disproportionate growth rate due to its very low base skews everything, predominantly Christian countries come out with a very different

postindependence growth ratio of 158, yielding a ranking of Christian countries highest, Muslim second, indigenous religion third, and Christian Southern Africa fourth, with the first three being fairly close together.

Religion does not make a large difference in the growth of girls' education, then, and the case of Sudan points to the danger of making facile generalizations on the impact of Islam on Africa that ignore local variations. Sudan also has a strong Muslim north and an indigenous religion/Christian south, but girls in the north, especially in rural villages, were more often sent to school. School attendance in the south was also lower because of the impact of war and lower urbanization rates. The first southern woman entered university only in 1967 (Osman 1983:pers. communication). Sudan, in fact, contradicts several of the statistical regularities observed for Africa as a whole.

The correlations also point to a high growth rate in girls' education for Muslim countries. Correlating the percentage of the population that is Muslim with the postindependence growth ratio of girls to boys, the difference in growth rates for girls and boys (as opposed to the ratio), and the boys' and the girls' growth rates, one comes up with a range from .19 to .38, the latter figure representing the girls' growth rate. However, there was a strong negative correlation between the percentage of population that is Muslim and the 1980 percentage of girls in school among those of school age ($-.41$), a more refined measurement than the crude averages given in the preceding paragraph. So, while Muslim countries have been making an effort to educate girls, they still have a long way to go. One reason for this may be that, while the secularization of schools may have appealed to Muslim parents, coeducation frequently did not. When the governments of ex-French colonies, sometimes in collaboration with the French, assumed a commitment to secularize and reform education, they also promoted coeducation (Gardinier 1974:530). The expansion of the education systems in the 1960s and 1970s took the form of coeducational primary schools, which were also economically more sensible to meet the goal of establishing village schools. But in strongly Muslim countries, rural parents in particular often object to sending girls to coeducational schools (Jones 1982:33). In Chad, although most pupils attend coeducational public schools, private mission schools had more luck recruiting girls because they have well-qualified European teachers, sex-segregation, and home economics-type instruction offered at the lower levels (Gardinier 1974:529). Thus, coeducation may have decreased female enrollment in some cases, while promoting urban–rural differences.

In general, the impact of coeducation on girls' enrollment is difficult to assess.[5] There may be a great deal of hidden sex segregation; sometimes schools that are technically coeducational separate boys and girls into different classes most of the time. Sex segregation, of course, facilitates differentiation of the curriculum by sex; Masemann (1974:483) described a typical girls' secondary school in Ghana, which had a strong emphasis on home economics that was absent from boys' schools. In truly coeducational schools there are some courses differentiated by sex, but boys and

girls more often participate in each others' courses. In a Lomé, Togo, secondary school, boys could remain for girls' home economics courses and sometimes did, but girls, who were theoretically allowed into the boys' mechanics courses, did not participate (Biraimah 1982:189). Coeducation seems to be the best way of equalizing curriculum content for girls and boys, but it does have the drawback of facilitating damaging in-class discrimination against girls and of placing girls in a situation where they sometimes find it difficult to speak up. Their social conditioning has taught them not to do so. Coeducation, then, definitely appears to be a mixed blessing for African girls, with perhaps more negative than positive aspects.

An overall assessment of the countries in Table 6.3 with the highest differences favoring boys compared with the Table 6.2 figures concerning percentages of girls and boys in school shows that Central African Republic, Chad, Ivory Coast, Togo, Tunisia, and Zaire all exhibit male advantage to a high degree; Central African Republic, Ivory Coast, Togo, and Zaire are the worst in terms of discrimination against girls in provision of education. It is noteworthy that the latter countries are generally not among the poorest, nor are any of them predominantly Muslim; rather they generally share a Catholic missionary tradition (with a strong element of indigenous religion in Togo and Ivory Coast), and a Francophone colonial past. Moving on to the effects of geographical and political factors on the growth of girls' education, a regional breakdown produces the following mean average postindependence growth ratios: Central Africa 160, North Africa 154, West Africa 142, Northeastern Africa 135, East Africa 134, and Southern Africa 76. These results highlight the degree of preindependence underdevelopment of girls' education. The lowest growth rate occurred in an area where primary education was already well developed at independence, Southern Africa. However, this was not true in other areas. For instance, if one separates out the sixteen West African countries according to percentage of children in school in the 1950s, one finds that those having less than 10 percent of the children in school then averaged a 128 postindependence growth ratio, compared to 156 for those with higher percentages (Cameroon, Ghana, Liberia, Nigeria, and Togo). The West African commitment to Western education grew geometrically; the more students there were in school, the more demand and enrollment grew.

A breakdown of the results according to colonial power involved, as in Table 6.4, draws attention to political and economic factors. The British rate of increase was generally lower because of the Southern Africa complex, which, however, was only the most extreme manifestation of the generally higher level of development of education in British colonies in 1950. For instance, if the mean average percentage of all children in school in 1950 was highest for British colonies at 23.3 percent, and lowest for Portuguese and Italian ones (except for Italy, these statistics include only colonies belonging to the country in 1950), by 1980 the rankings had

TABLE 6.4

Average Annual Primary Enrollment Growth Rates and Ratios for Colonial and Excolonial Powers, 1950–1980

Country	Overall			Preindependence			Postindependence		
	Girls	Boys	Ratio F/M	Girls	Boys	Ratio F/M	Girls	Boys	Ratio F/M
Belgium	7.0%	3.5%	200	13.6%	8.4%	161	5.2%	2.4%	217
France	11.4	7.7	149	18.4	11.2	173	8.3	5.8	145
Great Britain	8.2	6.3	128	10.0	7.6	132	7.3	5.9	124
Without Southern Africa	9.2	6.4	143	11.0	7.3	147	8.3	6.4	134
Italy	16.3	10.4	159	23.1	14.0	165	14.9	9.8	156
Portugal	12.7	12.3	109	13.7	12.5	117	4.0	3.6	111

changed somewhat, with ex-Portuguese colonies second in terms of enroll-
ments of all children, French and Belgian ones very similar, but the
British and Italian ones still respectively on the top and the bottom. Table
6.5 illustrates the situation.

The 1950 situation is largely attributable to the relative wealth and
development of the colonies controlled by each power (colonies were
largely self-financing), as well as to the ideological commitment of the
metropole concerned. British colonies generally had more missionaries
and were less often dominantly Muslim than French colonies, for instance.
Belgium prided itself on the provision of colonial elementary education,
but did virtually nothing about higher education. Portugal and Italy were
the poorest of the metropoles and the least efficient in terms of economic
development.

The 1980 figures illustrate the impact of postindependence policy in
most cases. Here the ideological commitment of governments comes into
play. A crude classification was made of the expressed ideology of postin-
dependence governments into conservative, moderate, or socialist. Then
average growth rates were calculated according to category. Predictably,
socialist countries had the highest annual postindependence growth rates
for boys and girls—6.1 vs. 8.6 percent—and also higher average govern-
ment expenditure on education as percent of all government expenditure
for the latest date available—21.9 percent. Moderate countries were next,
with boys' average annual growth rates of 5.8 percent, girls' 8.2 percent,
and government expenditure at 21.6 percent. Conservative countries had
boys' annual growth rates of 5.4 percent, girls' 7.2 percent, and govern-
ment expenditure at 21.7 percent. Socialist and moderate countries had
almost identical average growth ratios and also identical differences be-
tween boys' and girls' annual growth rates, whereas conservative countries
had both a lower ratio and difference, indicating less of a commitment to
girls' education. However, and this is a very big however, subtracting the
generally conservative Southern African complex from the calculations,
conservative countries come out with a boys' growth rate of 5.7 percent,

TABLE 6.5

**Average Percentage of Children Enrolled in Primary School, by
Colonial Affiliation, 1950–1980**

Country	Total 1950	Total 1980	Girls 1980	Boys 1980	Ratio F/M 1980
Great Britain	21.4	60.9	53.9	59.8	90
Belgium	15.7	39.7	33.7	45.7	74
France	9.6	39.9[a]	31.3	51.1[a]	61
Portugal	5.7	47.7	34.0	61.0	56
Italy	5.0	28.0[b]	20.0	36.5[b]	55

[a] Gabon and Congo not available.
[b] Libya not available.

girls' 8.3 percent, and a ratio of 146, putting them above both moderate countries with 141 and socialist ones with 139. Given the relatively high level of development of primary education for women in Southern Africa, albeit for an unfortunate reason, with both high percentages of girls in school and approximate parity of enrollments with boys, socialist governments have not performed at a significantly higher level. They are mainly responsible, however, in ex-Italian, -French, and -Portuguese colonies, for substantial rises in overall primary school enrollment. But their commitment to girls' education remains problematical, most strikingly in Guinea-Bissau, whose postindependence record is worse than that of any other country of any political persuasion. This is particularly surprising in view of the vital roles women played in the long war of liberation from the Portuguese (Urdang 1979).

In examining the growth of primary education, then, it is evident that for a variety of reasons girls are not attending school in numbers equal to boys. Quantitative analysis shows that the most salient factors related to girls' enrollments and dropout rates are degree of urbanization, which goes along with provision of facilities, the value of female labor, indigenous and imposed religious factors, and the colonial tradition. Neither the relative wealth of the country nor its political ideology made an important difference. A more qualitative analysis will show, in addition, that the value of female labor is not only a strong reason for girls' absence from school, but also the clue to the economic dysfunctionality of Western-type education for women. The issue of dysfunctionality inevitably entails a consideration of the quality, as well as the quantity, of girls' education.

THE DYSFUNCTIONALITY OF WOMEN'S EDUCATION AND CLASS FORMATION, OR, "YOU'RE DAMNED IF YOU DO AND YOU'RE DAMNED IF YOU DON'T"

Formal education is an institution in which developmentalists, governments, and educators have placed ultimate faith. It is expected to bring many benefits: promoting equality within a society by widening access to education; contributing to economic development; raising consciousness to promote and consolidate the goals of a revolution; and developing human potential to satisfy both individual and social purposes. In developing countries, large proportions of annual government expenditure (often 15 to 25 percent) have manifested a strong faith in the economic worth of formal education. But the economic wisdom of large investments in education for poor countries began to be questioned in the late 1960s, as people saw that African nations had indeed taken to heart the 1961 report of the Addis Ababa UNESCO conference and were working to establish universal primary education by 1981 (Heyman, Lawson, and Stamp 1972:140). The rapid educational growth contributed to serious problems: due to lack of wage sector expansion, unemployment rose among the educated population, the labor market and the political system were

manipulated by the upper class so that inequality increased, and a de-valuation of educational credentials meant that more and more education was required to obtain even poorly paid jobs (Farrell 1982:40). If the dysfunctionality of universal formal education under such conditions was beginning to be recognized, the analysis was still largely male-centered. But the dysfunctionality of women's education in most African countries, which is particularly linked to their gender and has strong implications for their class position, is probably more important given current eco-nomic conditions.

A striking aspect of educational dysfunction, suggested by high pri-mary dropout rates, is the lack of access by most females to higher levels of education. Ly (1975:221) found in Mali in 1970–71 that there was a sharp dwindling in the percentage of girls engaged at each higher level of formal education; thus, females were 35 percent of the first-cycle primary stu-dents, 23 percent of the second-cycle, 24 percent of technical/vocational students, 20 percent of normal school students, 12 percent of preparatory secondary school students, and only 9 percent of university students. As a poor country, Mali shows in an exaggerated form the problems besetting women's access to education elsewhere: a wide pyramidal structure with a very narrow top that especially hinders the advancement of women. Smock (1982:239) showed similar structures in Ghana, Kenya, and Egypt. Bowman and Anderson (1982:16) calculated for 1980 that in Africa 59 percent of the boys vs. 43 percent of the girls age six to eleven were in school, 39 percent vs. 24 percent of those aged twelve to seventeen, and only 3 percent of young adults aged eighteen to twenty-three (approx-imately 15 percent of whom would be women). Such discrimination in access to higher education means that women generally cannot compete for scarce wage jobs; in many countries over 95 percent of wage workers are male.

But the problem is not only access to education but also its quality and orientation. The labor value of women is higher without primary education. Gardinier (1974:531) described a "lumpenbourgeoisie," a semi-educated product of poor schools in equatorial Africa who cannot obtain white collar jobs. Their position results from the rapid expansion of school enrollments, which created a number of low quality schools in many countries, while the economies did not expand to provide wage employ-ment for their students. In the case of women, discrimination in hiring and the quality of education make their wage employment even more prob-lematical. There is a broad consensus that Africans generally seek educa-tion for economic reasons; in most countries the rate of return on girls' education is lower than on that of boys. In Kenya, for instance Ram (1982:222) found that the rate of return on boys' primary education was three times that on girls' (21.7 vs. 7.1 percent).[6] In general, uneducated women are more active economically, working in such areas as agriculture and trade. They must be because they more often than not supply most of their families' food. Therefore, many countries have U-curves for female labor force participation according to education level, whereby the

women who are in the majority, the least educated, and the best educated tiny upper class have the highest labor force participation rates (Smock 1982:243–45). Primary and middle school leavers have the highest unemployment rates, partly because the girls are competing with better-educated boys for scarce jobs. The enormous sex differences in secondary school enrollments give girls a great disadvantage in obtaining white collar jobs. Nor are girls at the primary level taught skills useful for finding a job; and the vast majority do not progress beyond primary school.

African women generally perform important economic functions in bringing in household income. However, the type of education most women receive in terms of its quality, quantity, and content neither prepares them for the stiff competition for jobs requiring formal education nor provides alternative skills. Thus, vocational schools tend to be home economics-oriented for women, teaching cookery, household economy, health care, and handicrafts, but seldom with a view to their marketability (Ly 1975:240–41). In Accra, Ghana, vocational school enrollment for women in 1976–77 was concentrated almost entirely in business and catering, technical and craft training being left to men (Robertson 1984b:table V-1). Eliou (1973:36) commented, "The road which leads [girls] to school is in fact only a detour, which leads them back to the home."

African women perform most of the agricultural labor, but one of the most salient aspects of women's education in Africa is their exclusion from agricultural education, which has been well documented for a number of countries (Yates 1982:131; Eliou 1973: 39; Grabe 1975:342; Gilpin and Grabe 1975:551; Jones 1982:46; Staudt 1981:207–24). Carter and Mends-Cole (1982:153) argue convincingly that "not sending girls to school in the context of contemporary rural Liberia is a rational choice," because it does not help their agricultural skills and may unrealistically raise their aspirations. Now it may be accurately said in the African context that the practical skills required for factory or agricultural work can best be taught through on-the-job training or in an apprenticeship system. But women are not often offered wage work; instead they are usually self-employed, earning very low incomes indeed. This means that their training comes as apprentices, usually to other women. These apprenticeship systems have been shown to be viable, flexible instruments for disseminating new skills at low cost (Robertson 1984a; Rousseau 1975:41–52; Callaway 1975:26–38).[7] But if most girls are sent to primary school, they neither receive sufficient apprenticeship training nor skills that are relevant for finding a wage job. Their aspirations may rise, even though with the expansion of low quality primary education, many may finish primary school still functionally illiterate. Lewis (1977:165) commented on the dilemma of such women in Ivory Coast, "Caught between the paucity of salaried employment available for women of their educational level [primary, middle, or secondary school] on the one hand, and their employment aspirations along with the expectations of kin who schooled them on the other, they are unwilling to accept less than salaried work." The

result—they (and many others in other countries) are not likely to provide essential labor for their illiterate mothers, but rather will look for a man to support them or get them a job. But since most spouses do not practice community of property in marriage and marriage is often fragile in any case, women cannot count on it to provide sufficient security. Informal liaisons allow women more autonomy and may help to find them jobs, but both situations increase the dependence of women on men and therefore women's subordination to men.

This dilemma suggests that education is not only economically dysfunctional for women but also that it prepares them for subordination. The paradigm can be found in the Luapula region of Zambia or Accra, Ghana, where older generations of women who were independent entrepreneurs send their daughters to school to become secretaries or nurses and good wives for upwardly mobile husbands, or in Northern Nigeria, where girls' schoolgoing hinders accumulation of independent resources by their mothers, whose seclusion inhibits their participation in trade (Poewe 1981: 114–15; Robertson 1984b: ch. 5; Schildkrout 1982:55–81). In Zaire, formal education has reinforced gender as a legitimate basis for differential treatment, facilitating the imposition of limited Western concepts of women's appropriate roles on diverse African views, and has fostered women's economic marginality by not teaching economically useful skills (Yates 1982:150). In Dahomey (now Benin), female education was seen as threatening to male authority because it would upset the traditional limits set for women's aspirations (Tardits 1963:279). Tunisian government officials view male unemployment as more disruptive than female unemployment, so that women's education suffers in quality (Jones 1982:44). Where female education seems to threaten male authority, the solution is to keep girls' education lower in quality and quantity than that for boys: from this defensive perspective, the limited economic value of girls' education would be a strength. Freeman has described the purpose of Western women's education as being "less to eradicate a distinct women's subculture than to create and perpetuate a culture of femininity (read 'weakness' and 'wiles') and motherhood (read 'bearing' or 'rearing'). . . . [Women are educated for the purpose of filling] subordinate societal roles that serve the interests of men" (1978:210). Women's formal education in Africa, then, logically pursues the same goals as part of the neocolonial tradition, which remains useful for furthering male dominance in the present.

Contributing to the dysfunctionality of women's education is discrimination against women in access to wage jobs, or sexual harassment of those who are fortunate enough to get them[8] (Berger ch. 12; Robertson 1984b). Both enforce female subordination. If the substantial progress toward universal primary education has become dysfunctional for men in Africa (it has been called an "expensive luxury" [Hunter, Borus and Mannan 1974: 103]), it has become a disaster for women both by reducing their labor force participation and by increasing their subordination to men. Both their access to formal education and their exclusion from it contrib-

ute to segregating women into dependent class positions. Western analysts have often assigned women to classes according to the socioeconomic status of related men. In the past this categorization would not have worked for many African women because of their independent access to the means of production. Now it may be a more accurate vision of reality, except that women do not have equal access to the resources of those men.

But men and women are not segregated in this world, so that harming women ultimately harms men as well; and the contradictions of education only weaken Africa vis-à-vis the rest of the world. The situation described by Carnoy is becoming a reality with the expansion of African education:

> The large number of dropouts and illiterates in a particular society may, in fact, be accompanied by an *overdeveloped* school system, in which numbers of children go to school but are henceforth unable to find employment different from that which they [or their parents] had before. This is not the result of irrelevant or low-quality schooling, as is often claimed, but the result of a dependent economic system that is dominated by the international division of labor. The kind of economic structure able to absorb all the educated is not possible under the conditions of the dependent situation. Thus, a system of schooling that complements all people's social utility is also not possible. (1974:57)

Foster's observation about Ghana in the mid-1960s, that the economy simply could not absorb the steadily rising output of the schools, has been constantly reiterated since then for other countries (Foster 1965:8). Domination by a rapacious world capitalist economy has materially helped Western education in Africa to become dysfunctional, an irony perceived by few who promote education as a panacea for development problems.

Continuing in the same manner to provide more education for women, then, will not remedy the situation for them or for African economies in general. In a number of Third World countries, improvements in women's educational access from the mid-1950s to the mid-1970s have neither raised their economic participation nor broken down sex-stereotyping either in education itself or in the labor market (Smock 1982:249). It is perhaps significant that the countries where education has been made most available for women are also the most dependent economically on an exploitative white-controlled neighbor, South Africa. Carnoy gave women as the prime example of the disjunction between outcomes of education and levels of schooling; women "with the same amount of schooling and the same cognitive ability get into much lower status occupations than men on the average and receive much lower incomes." He goes on to emphasize the lack of relationship between expansion of education and equality of incomes. "Even when the society invests more in schooling for the poor . . . , the labor market values that schooling less than before the poor were getting it"[9] (1974:345, 364).

What is to be done, then? It is very difficult to restructure dependent local economies without restructuring the international economy. However, enlightened self-interest dictates that both must be done. Abernethy

(1969:282–83) gave some cogent suggestions arising out of his study of Nigerian education; they necessarily involve restructuring the whole economy, not just reforming the curriculum or expanding education further for underprivileged groups. He recommends (1) shifting government expenditure away from social services and toward directly productive activities, economic infrastructure, and rural development, (2) reducing the inequitable salary structure and perquisites that overcompensate white collar workers, (3) concentrating on creating opportunities for productive employment with the emphasis on rural labor-intensive public works and small industries, (4) emphasizing nonformal, informal, and adult education and on-the-job training, and (5) making curricular reform with economic goals in mind. Some programs developed in socialist countries like Mozambique have been successful in pursuing these goals. But reforms, if they are to be effective, must take into account women's economic functions, and put female adult education under women's control. Too many national and international factors militate against these reforms, however, and experience so far leads one to doubt the commitment of both the world's power brokers and African upper classes to evolving "a truly egalitarian society," despite the fact that everyone's long-term interests would be served by doing so.[10]

African women's primary education or lack of it will continue to make them an underclass unless they themselves act to break the pattern. But most women are too desperately busy assuring the survival of themselves and their families to spend time either on self-improvement or political action and their illiteracy may limit the awareness and self-confidence that would facilitate their involvement in either activity. And so the Hobson's "choice" continues for most women: stay illiterate and keep earning an independent income at a very low level; get a primary education and become a hairdresser, a seamstress, or a petty bureaucrat (if you have the capital for training or equipment and earn enough to afford child care); or remain unemployed and dependent on irregular earnings from men in various relationships. Many women will do all of these things in their lifetimes in the struggle to stay afloat. Somewhere in this process many will be seeking other options, but without further training little remains except to go back to trading or agricultural labor, which many find unacceptable as careers. If, in this situation, African women gain a measure of dignity, respect, and self-respect, it will be against the odds using their great strength and resilience. But they should not have to bear so many of the penalties of "development."

Notes

1. Given Tanzania's efforts to increase women's education, this proportion may have dropped after 1970.

2. Harbison and Meyers (1964:40) found a positive correlation of .67 between GNP and primary school enrollment ratios, and an even higher one (.82) for secondary enrollment ratios.

3. Deblé (1980) gives the best summary of the results.

4. These are single-sex correlations, i.e., girls' growth rate with girls' retention rate.

5. In order to ascertain the degree of sex segregation in the school systems of various countries, both private and public, I was forced to conduct a small survey among Africanist students and faculty at Indiana University. Only with great difficulty can such information be deduced from government documents. The results are only as strong as the knowledge of my informants, which varied considerably. They are not good for assessing rates of change, since they concern only the present situation in the countries.

6. There was a smaller disparity for secondary education (23.6 percent vs. 19.5 percent).

7. For a (somewhat outdated) review of nonformal education for women in Africa see "Out-of-School Education for Women in African Countries" (1973:7–18).

8. There are fairly widespread reports of sexual harassment of women wage workers in Africa, a few of which are making it into print, such as Lewis (1977), Robertson (1984b: ch. 5), and Berger (ch. 12 this volume).

9. Thurow (1977:325–35) has made this argument definitively in an American context.

10. The quotation is from Fafunwa and Aisiku (1982:260), an excellent survey of African educational needs which, nonetheless, in common with most of the literature on African education, gives no attention to the economic necessity of meeting the particular needs of women.

PART II

Dependence Versus Autonomy

Chapter 7

"URGING WOMEN TO REDOUBLE THEIR EFFORTS . . ."[1]
Class, Gender, and Capitalist Transformation in Africa

JANET M. BUJRA

FEMINIST THEORY has recently been accused (with some justice) of being "Eurocentric," of assuming "that it is only through the development of a Western-style industrial capitalism and the resultant entry of women into waged labour that the potential for the liberation of women can increase" (Carby 1982:222). Certainly it is true that many of the debates in modern feminism concern themselves with the dramatic transformations in women's lives which accompanied the emergence of capitalism in Western Europe. This chapter discusses issues central to women and capitalist transformation in Africa, not with the intention of presenting capitalism as a means to women's liberation but rather with the aim of showing that capitalism does not everywhere have the same effects for women.

A consideration of capitalist transformation inevitably raises the question of emerging class divisions and their implications for women. For capital (the organized and effective control of the means to produce concentrated in a single class) always requires exploitable labor power: to work machines; to pack goods; to file letters. This labor power has to be created and set to work. This essay looks first, then, at the process of proletarianization in Africa (the creation of a working class with no choice but to sell its capacity to labor), noting the limited extent to which women have been drawn into this process and why. Insofar as women do become part of the wage labor force, it also considers the extent to which their labor is differentiated from that of men—the forms, in other words, in which capital specifically exploits *female* labor power.

An earlier version of this paper was first presented to the British Sociological Association Annual Conference, in Cardiff, 1983. I am grateful to those who offered constructive criticism of it there, also to Pat Caplan, Caroline Ramazanoglou, Annie Whitehead, and Gavin Williams who made helpful comments.

In the process of proletarianization, labor is subordinated to capital. But capital does not always, or even usually, confront labor directly. This is especially the case in Africa, where capitalist enterprise is dominated by foreign capital and the indigenous capitalist class is small. Capital works through intermediaries, at the point of production or within state institutions, to ensure that labor is effectively controlled to produce profits. In Africa, as elsewhere, these intermediaries are generally male, so that when women workers begin to be aware of their common class interests this does not oppose them directly to other women. This is not to say that women are not implicated in the political and ideological processes whereby labor is subordinated. In Tanzania, as Bryceson and Mbilinyi note, "Wives of men in government and parastatal posts [parastatals are economic enterprises run by the state], many who rose from the ranks of the peasantry, have newfound class interests. . . ." What is the nature of these class interests and how do they manifest themselves?

To discuss the implications for women of capitalist class formation is consciously to reject the simplistic notion, often found in the literature, of "African women" as a homogeneous category. The condition of women in Africa has of course always been culturally diverse. My concern here, however, is specifically with emergent class divisions between women consequent upon capitalist transformation. From this perspective, women cannot be thought of as a single category, even though there are important and occasionally unifying struggles in which they may engage. At the same time women cannot be simply analyzed "as men": gender is almost invariably a relevant social category. The point is that gender differences find differential expression at different class levels—gender is qualified by the places women occupy in newly emergent classes.

In what follows I am conscious of the dangers of appearing to generalize for Africa as a whole. It is evident that the processes of capitalist transformation at issue here are concretely manifested in a variety of national situations that require concrete investigation. This essay puts forward various hypotheses that gain some backing from available evidence, but they are intended as an agenda for research rather than as definitive statements.

Class is conceptualized here not as occupational stratification or socioeconomic differentiation but as a set of historically determined relations forged in the sphere of production—relations that are essentially contradictiory and potentially in conflict.[2] This theoretical construction of class raises considerable difficulties, however, when applied to women. In studies of class in developed capitalist societies, women have often been invisible, or treated as members of a class only by extension: "the worker and his family." Class position, in other words, has usually been seen as deriving from the location of male heads of households in the ensemble of production relations. Feminist writings have questioned this view of the class system from two directions. On the one hand, they have pointed out ambiguities, where husbands and wives are both employed but at different levels in the occupational hierarchy (Oakley 1974: ch.1; Garnsey

1978; Stanworth 1984). By "class," however, such accounts have often meant no more than occupational status. Another view has focused on the class relevance of the domestic labor usually performed by women in capitalist society. While some suggest that domestic laborers occupy a distinctive (class) place in the structure of production (see, e.g., Dalla Costa and James 1972:21), it is more frequently argued that women's experience of the class system (whether direct via their own employment or indirect via the wage/income of the head of the household) is mediated by their location in the relations of reproduction in the home (Barrett 1980; West 1978).

In Africa, where class differences are in the process of formation, and capitalist enterprise coexists with noncapitalist forms of production, these ambiguities—both conceptual and real—are accentuated. One example is suggestive. Remy, describing the experience of a group of women in Zaria, Northern Nigeria, refers to them as "working-class women" by virtue of their husbands' employment in the Nigerian Tobacco Company. Many of these women, however, were "active in Zaria's indigenous economy" as petty traders and craftswomen.[3] While often dependent on their husbands for the initial capital to buy stock or tools, a few were now economically independent (Remy 1975:361). This kind of combination, within a single household and with marked gender overtones, of persons with quite different relations (wage labor compared to petty commodity production and commerce) to the dominant form of production (capitalism) reappears again and again in Africa. The link between this pattern and women's roles in the reproduction of labor power in Africa has hardly begun to be discussed.

CLASS AND CAPITALIST PENETRATION IN AFRICA

If capitalist penetration in Africa generates forms of women's oppression distinctively different from those that characterized the rise of capitalism in Europe and America, one reason for this is the limited nature of capitalist transformation in Africa.[4] African economies are not developed capitalist economies, even though capitalist relations of a sort have been established in certain strategic sectors. The introduction of sophisticated technologies, revolutionary methods of work organization, and large-scale forms of enterprise hiring wage labor has not been accompanied by a general transformation of relations of production in society. Capitalist enterprise operates side by side with noncapitalist forms of production based on the household. Such noncapitalist forms are particularly likely to be found in the agricultural sector, with peasant production persisting in most areas. The first concern of peasant cultivators is to secure their own subsistence, and they do this mainly by producing directly for use, but also by producing a surplus for the market to generate a cash income to satisfy additional subsistence requirements and to pay taxes. Peasant agriculture relies first and foremost on family labor, though in certain

areas differentiation among the peasantry has thrown up a category of peasants whose scale of operation is large enough to require the hiring of labor. The other form of noncapitalist production that is still significant in African economies is the petty commodity production of nonagricultural goods and services. Artisans and purveyors of personal services scrape together a living in urban areas alongside capitalist enterprises, and petty commodity production finds expression in extensive petty commerce.

In Africa, in other words, capitalism has implanted itself *without* the process of struggle that in Europe led to the effective dispossession of the means of production from the majority of the people—that struggle, in Africa, is only in its inception.[5] Capitalist enterprise in Africa did not develop out of indigenous forms of production and commerce but rather was one instance of the internationalization of capital with its centers in Europe and America. The first phase in this process came with the intervention of European merchant capital. This was later reinforced by colonial rule, which entailed the more direct extraction of a surplus from politically subordinated peoples. The postcolonial era has merely ended the monopoly of particular national capitals that characterized the colonial phase.

Capitalist enterprise in Africa today is still dominated by foreign capital, whether in the form of expatriate or multinational private investment or in the form of aid or loans. One reason for the predominance of foreign capital is that most capitalist production is designed not to satisfy internal demand, but to exploit African resources (raw materials and relatively cheap labor power) in a way that serves the expansion of capital in the imperialist centers. The home market in most African countries is in any case limited, a reflection of the persistence of subsistence production, low incomes, and the export of profits. While noncapitalist forms of production survive, they are put under sufficient political and economic pressure either to produce raw materials for capitalist production proper (locally or for export) or to offer up the labor to run capitalist enterprises. Noncapitalist forms persist not only because they serve capital but also because they are strongly defended by those who find in them alternative modes of survival that do not entail total subordination to capital. The significance of noncapitalist production as a form of resistance is particularly relevant to the discussion of women.

The nature of African capitalism means that in most countries on the continent there is only a very small indigenous capitalist bourgeoisie and that proletarianization is limited and incomplete. Most workers are also members of peasant households, relying on the land to feed and reproduce their families, and to support them in times of hardship, illness, or old age. Capitalist relations of production counterpose this semiproletariat against foreign rather than indigenous capital. The ruling classes of African social formations are not a capitalist bourgeoisie proper. They may be struggling to exert a more direct (though generally bureaucratic) control over the national economy, or they may be content to act as intermediaries for international capital. Such state or bureaucratic bourgeoisies have

spawned an expanding category of bureaucratic functionaries whose rewards are many times greater than the incomes enjoyed by workers and peasants. While they retain the security of salaried positions, they launch into entrepreneurial ventures "on the side." The success of such petty capitalist elements may create divisive tensions within the ruling class because they develop interests that may be antithetical to those of foreign capital.

Capitalist penetration in Africa has created class divisions that differ from those of developed capitalist countries precisely because the "pygmy property of the many" has not yet been transposed into "the titan property of the few" (Marx 1983:835). Capitalist production is parasitic on pre-capitalist forms, which sustain and reproduce a laboring class as well as producing cheap raw materials for the use of capital.

CLASS AND GENDER IN AFRICA

At what points does class formation in the underdeveloped capitalist economies of Africa intersect with gender? This is an area that needs a good deal more research, so any conclusions can only be tentative. First of all, however, it seems that where proletarianization draws on *male* labor, it does not so much reconstitute women as privatized domestic laborers dependent on the male wage, often argued to be one of the effects of the rise of capitalism in the West,[6] but rather intensifies their activities in, and struggles over, petty commodity production and commerce. Where women are drawn into wage labor, it is thus not as part of a reserve army of labor hidden in the household, but more nearly on the same (miserable) terms as men. Secondly, while foreign capital often transmits cultural assumptions about appropriate work for women, the effects are sometimes unexpected. Finally, women with petit bourgeois class interests appear to be actively involved in redefining the role of women at lower class levels in ways that serve the interests of their class as much as their gender.

Women and the Proletarianization of Male Labor
It is now more than a decade since Ester Boserup commented, "In Africa, the modern sector is virtually a male preserve" (1970:190). Basing her conclusion on statistics gathered in the 1960s, she showed that women formed a very small proportion of the wage labor force in most African countries. Does this generalization still hold true? While overall statistics for Africa are not available (and even those statistics that are available must be treated with extreme caution[7]), examples in Table 7.1 are suggestive. In spite of rising levels of capitalist penetration in various parts of the continent, women's wage labor remains marginal. This pattern is more marked considering that in manufacturing industry, the most dynamic sector of capitalist enterprise, apart from Tunisia and Swaziland, women's participation is in most cases less than 10 percent of the labor force. In this

respect Africa is to be contrasted not only to developed capitalist countries but also to other parts of the Third World, particularly Asia and Latin America, where female labor is increasingly sought by local and international capital for its cheapness and assumed docility.

In the most recent phase of global capitalist development, international companies have begun to establish what have become known as world market factories in various parts of the Third World. Such factories produce goods, not for local consumption but for export to the developed capitalist world—textiles, ready-made clothes, toys, and electrical goods. Factories of this kind have been sited in countries all over Latin America and Asia, but to a much lesser extent in Africa. Tunisia, Swaziland, Mauritius, and Morocco are locations for such development, however (Froebel, Heinrichs, and Kreye 1980: app.).

Foreign capital is interested in establishing such concerns chiefly to tap sources of cheap and compliant labor, which will allow it to undercut its competitors operating from high-cost labor areas in Europe or America. In addition, the low-price consumer goods it generates help to keep down the wage costs of European and American labor. In world market factories, women workers are preferred (70 percent of those employed are female: because in many areas of the Third World they can be "forced to accept lower wages and a higher intensity of work than men" (Froebel, Heinrichs, and Kreye 1980:344, 348). Such factories often capitalize on skills that women have already learned in the domestic arena. In Morocco, for example, "in six weeks, girls (who may not be literate) are taught the assembly under magnification of memory planes for computers—this is virtually darning with copper wire, and sewing is a traditional Moroccan skill" (Sharpston 1976, quoted in Elson and Pearson 1981:93).

If the advantages of female labor seem self-evident, why has such "development" lagged behind in Africa? The answer suggests a more general understanding of why women's participation in the wage labor force in Africa is so low. There is nothing in fact *intrinsically* cheap (or docile or dextrous) about women's labor. It is cheap relative to men's labor only where it is readily available and politically weak and where all or a part of its costs of reproduction are borne elsewhere—from the wages of other members of the family (generally husbands or fathers) or outside the capitalist sector altogether. Froebel, Heinrichs, and Kreye note that the wages paid to workers in world market factories "are often insufficient to cover the reproduction . . . [and] the psychic recovery of workers exhausted by highly demanding work". High rates of labor turnover and the frequent relocation of industrial activity is one consequence of such low wages—exhausting the labor supply in a very real sense. Alternatively, they note, the reproduction of labor power can be assured by "the subsidizing function of the rural sector" (1980:353), whereby workers supplement their cash wages with food provided by peasant families. In Africa, however, the supply and cost of female labor is determined to a large extent by the fact that it is women who perform this "subsidizing function" for male labor. This subsidy takes two forms, both entailing the

TABLE 7.1

African Women in Wage Labor

Country	Total Economically Active Population[a]	% Women in Economically Active Population	% Economically Active Population in Wage Labor	% Women Among Wage Laborers	% of GDP in Manufacturing	% of Women among Employees in Manufacturing
Cameroon (1976)	2,757,899	40.0	14.2	9.8	13.0 (1977)	6.0
Mali (1976)	2,235,157	16.9	4.1	11.2	11.0 (1977)	11.3
Algeria (1977)	3,371,023	8.9	47.0	7.9	11.0	7.4
Malawi (1977)	2,288,351	46.0	17.7	9.3	12.0	5.3
Kenya (1979)	NA[b]	NA	NA	16.9	12.0 (1977)	8.3
Gambia (1976)	NA	NA	NA	9.4	10.0 (1979) (All industry)	4.0
Botswana (1979)	NA	NA	NA	22.0	5.0 (All industry)	18.0
Liberia (1979)	NA	NA	NA	31.0	5.0 (1979)	13.4
Zimbabwe (1980)	NA	NA	NA	16.9	17.0 (All industry)	7.2
Tunisia (1975)	1,621,820	19.5	53.6	12.9	11.0	29.0
Swaziland (1979)	258,511 (1976)	55.4 (1976)	25.6 (1976)	28.2 (1976)	9.0 (All industry)	23.8

Sources: For all except percentage of GDP in manufacturing: ILO 1981: tables 2A/2B, 3B, 5A. For percentage of GDP in manufacturing: World Bank 1979.
[a]"Economically active population" includes members of the armed forces and the unemployed, but excludes "housewives, students and economically inactive groups," and tends to underestimate female participation in labor force; see Beneria 1981.
[b]NA = not available

intensification of women's labor in the noncapitalist sphere. The most significant of these is the pressure on women's labor in peasant agriculture, but a subsidiary form is found in women's activities in petty commodity production and commerce. The extension of capitalist relations of production has simultaneously reinforced and undermined these modes of survival adopted by women outside of capitalist production.

In most of Africa capitalism confronted a precapitalist sexual division of labor in agricultural production for subsistence in which women played the major role (see Boserup 1970:16; also Bujra 1982b:148–49). Demands for *wage* labor therefore drew initially on men rather than on women, setting up a symbiotic relationship in which some areas of Africa became, in effect, labor reserves for capitalist or semicapitalist production. Male labor was drawn off from the subsistence economy to work at low wages in urban areas, in mines, or on plantations or settler farms. There was no question of a "family wage" here, no question of capitalism absorbing the reproductive costs of the *class* of wage laborers. Wages were intended to cover only the day-to-day reproduction of labor power. Sickness, unemployment, old age, the reproduction of the next generation of wage workers—all these burdens were borne by the rural subsistence sector. This meant that women's labor in agriculture and in domestic tasks—as well as the labor of children and less active men—effectively lowered the value of men's labor power in the capitalist sphere (Deere 1976).

Examples of this pattern of male labor migration, found all over Africa, are particularly extreme in Southern Africa (see Gregory and Piché 1982: 27–30). Nearly 40 percent of the working-age male population of Lesotho, for example, are away at any one time working in South Africa. Their wives and families remain behind as subsistence farmers, on land whose fertility is declining year by year (Mueller 1977:157–59). What look like exceptions to this common pattern are perhaps more apparent than real. In Chapter 8 of this volume, Parpart describes how the mining companies in colonial Northern Rhodesia actually encouraged their workers to bring wives to the mines (compare mining in the rest of Southern Africa, where the opposite was true[8]). Miners' wages were not thereby higher in Northern Rhodesia than elsewhere, for wives also became producers contributing to family subsistence by cultivating small gardens or by making and selling handicrafts and cooked food. Once a man became unemployable, through layoffs, sickness, or old age, families were expected to return to their rural homelands. This labor force policy was designated "stabilization without urbanization."

Thus, whereas in Europe capitalism drew its labor force from families already forcibly separated from land as a means of subsistence, and in the earlier years drew indiscriminately on the labor of men, women, and children, in many parts of Africa capital confronted individual male wage laborers physically separated from their families. What effect has this pattern had on the lives of women? Even though women had always played the major role in agricultural production, the departure of men has inevitably intensified their burden of work without in most cases enlarg-

ing their freedom to make decisions. Where cash remittances from absent males are minimal or irregular, women must generate cash incomes themselves, in addition to shouldering the major burden of cultivation. Unlike men, they turn in the first instance to petty commodity production or petty commerce to generate such income, precisely because such activities can be combined relatively easily with responsibility for young children. Where this income too is inadequate, they may turn to casual labor on neighboring farms. An example from Kenya illustrates this process. Mønsted (1976), in a study of the Kakamega area of Kenya, showed that 36 percent of households were headed by women, who were managing, as best they could, to support their families in the absence of husbands. These women were not only growing food crops but also harvesting the cash crop—tea. While the profits from cash crops generally go to men in Africa, women increasingly do much of the labor. Thus, in Kakamega women had no rights over the income produced by selling tea from bushes their husbands had planted—they were expected to hand over the proceeds. A woman whose husband was away working might expect to receive 20 to 25 percent of his wage in the form of remittances, but this was rarely enough to cover school fees, taxes, and other expenses. Hence women were forced to sell part of their precious food stocks or illegally brewed beer. In the last resort they would hire themselves out to better-off farmers as casual laborers (Mønsted 1976).

Similar situations occur elsewhere in Africa. In Lesotho women sell fruit and vegetables from their gardens, rear pigs and chickens to sell, brew beer, and produce handicrafts for the market, all to supplement their basic food supplies from cultivation with cash to buy extra sorghum and maize (Mueller 1977:157, 161). Luo women in Kenya have adapted to a striking absence of men by growing crops for the market as well as food for home consumption; by making ropes, pots, pipes, or mats for sale; and by becoming actively involved in trade (Hay 1976:108).

The process whereby men become wage laborers therefore intensifies women's work in subsistence production, but also draws them into production for the market. Women's labor in production and in domestic tasks such as child care and cooking is vital to the process of reproducing a class of (male) wage laborers over time. When Gregory and Piché refer to labor migration as "the proletarization of African rural masses: they sell their labor to those who have capital, agricultural land, and mineral exploitation rights" (1982:29), it is as well to remember that this process of class transformation involves men rather than women and individuals rather than families, while at the same time it depends on the intensification of female labor power expended in noncapitalist forms of production. Women are forced to work harder because of the absence of men; conversely this noncapitalist sector continually reconstitutes a reserve army of male labor for capital.

There are areas of Africa where men rather than women play the major role in agriculture, or where urban living excludes agriculture as a mode of life. In such areas women's contribution to the subsistence of their

families has always centered on craft production and petty commerce. An example will indicate the extent to which, here too, women's labor may come to subsidize the commoditization of male labor power. In Central Accra, Ghana, a cooperative division of labor used to operate between husbands and wives, with men farming and fishing and women processing and selling the products. As urbanization progressed, most men were forced out of farming and fishing and into self-employment as artisans, or increasingly into wage labor. Women continued to be traders, but the productive mutuality of the family was eroded. Robertson (1976:131) found that as a result of low pay and unemployment, "husbands are increasingly tending not to fulfil their support obligations," and "the burden of educating [as well as feeding and clothing] children has fallen heavily on the women." This pattern, which prevailed in spite of the fact that women's income from trade was "only enough to get by," led one woman to insist, "My children were educated through the sweat of my brow. The children are my assets" (128). Part of the value of this asset, however, is transferred to the capitalist sector or its administrative infrastructure, as educated or willing labor power available for employment.

In petty commodity production and commerce, then, as well as in subsistence cultivation, women's labor underwrites the reproduction of labor power for capitalist enterprises. But the extension of capitalist relations of production has in various ways eroded the viability of these modes of ensuring familial reproduction. Remy noted that because the women in her study were the wives of migrant workers, they were cut off from the wider network of kin—and especially from other women—whose cooperation made trading and craft work practicable. Young women often learned craft skills from older women in the household (1975:364). Robertson (1984b) points out that cooperation among female kin in a single compound in Accra was declining due to the education of young women and their entry into paid employment. The expansion of manufacturing may threaten the market for craftswomen's products; in Zaria "the demand for factory-produced printed cotton cloth has drastically reduced the market for the cloth woven by Hausa women" (Remy 1975: 365). In commerce, as women's operations tend to be localized and limited in their scope for capital accumulation, large-scale capital monopolizes the more profitable ventures of wholesale trade and import agencies (Pine 1982:398–99). Although petty commerce and craft production in Africa is by no means limited to women, in many areas it is women who are primarily involved, giving the dissolving influences of large-scale capital a gender significance.

The same influences appear in subsistence agriculture. In areas where the colonial pattern of male migration continues to be the norm, there is considerable pressure on family life. The effects of this pressure are worst in Southern Africa (Murray 1982), where in labor reserve areas family survival depends vitally on both the income from wage labor and on subsistence production. This perhaps explains a contrast noted by Kimble

and Unterhalter: "Whereas women in the West have identified the family as a site of women's oppression, women in South Africa point to the destruction of 'normal family life' as one of the most grievous crimes of apartheid" (1982:13). However, there is evidence from elsewhere in Africa where these coercive forms of labor control do not apply, that, given other alternatives, women will not endure such a familial division of labor forever. Obbo describes how "Luo men [who] have been in Kampala for twenty years or more . . . only visited the villages when there was a marriage, death, or major illness in the family. The responsibility of maintaining the rural base fell heavily upon the shoulders of women" (1980:84). Husbands did not send money home; instead their wives went to town to claim it, fitting in their trips between work on the farm. Obbo reports that women in this situation became restless, "asserting that there was 'no free labor, even in the villages.'" Rwandan women in similar circumstances were beginning to insist on accompanying their husbands to Kampala (1980:72).

There are other processes at work which simultaneously reinforce and undermine the rural subsidy that women contribute to male wage labor. In the agricultural sector, the hiring out of their labor by some women in response to inadequate remittances from absent husbands may mean the hiring in of labor by other women. Kitching (1980:106, 241, 338) has shown how in Kenya the labor migration of men can feed into the process of increasing social differentiation among peasant producers, which is manifested in women's labor. Where men are able to obtain high-income jobs they can send home money to purchase extra land and to employ labor to work the expanded farm, thus leading to an increase in income from the sale of cash crops. On such farms the migrant's wife is able to reduce her own labor input in cultivation and to concentrate on the management of the farm or on petty entrepreneurial activities. Conversely, where the male migrant is in low-paid employment, his wife is left to cultivate the farm alone and is unable to purchase extra land or to hire labor. On the smallest plots she must concentrate all her energies on subsistence with no margin for sale, and therefore no cash income. Such women are often forced into part-time agricultural labor for others.

These then are the beginnings of women's wage labor, and they coincide with the emergence of capitalist relations of production out of what in most parts of Africa had previously been relatively egalitarian societies. "At a certain point, the voluntary and mutual help on the farm from neighbours, relatives or beer parties is subtly transposed into the hiring of casual labor" (Cliffe 1982:263).

The Commoditization of Female Labor Power

Not enough is known about the forces that propel women out of subsistence farming into full-time wage labor. Under colonial rule a wage labor force for plantations and settler farms was coerced into existence by exerting various forms of pressure on the subsistence sector to yield up surplus labor. In most cases such enterprises drew on male migrant labor,

as did industrial establishments in the towns. But they also built up a resident "tied" work force of families bonded to the farmer by their lack of land and dependent on him for housing. This form of bonded labor persists in some areas, though in its most extreme form in South Africa. In Zimbabwe in 1980 a young woman described her life on a white-owned farm, where she worked a nine-hour day processing tobacco, in return for one room and a small wage (unlike male workers on the farm she received no "rations" to supplement wages): "we are forced to work on the farm. If you refuse to work . . . the farmer sends you away. . . . I cannot think of anywhere else I could go if I were driven away" (Zimbabwe Women's Bureau n.d.:23).

In postcolonial Africa, capitalist relations in agriculture are being extended partly by indigenous enterprise, partly by the establishment of foreign-owned plantations. In some cases women form a sizable proportion of the work force. In Malawi, for example, wage labor in agriculture is the largest single form of employment for women (29 percent of female workers: ILO 1981). While little is known about these processes whereby women become part of a rural proletariat, it is evident that they do not join the wage labor force on the same terms as men. It is women who face the problems inherent in combining domestic responsibilities with wage labor. In West Africa, women traders have for generations managed by way of mutual help among female relatives and by carrying young children with them. The same kind of social arrangements have allowed women to cultivate distant fields and to gather wild foods far away from home. Mackintosh (1979) describes how, in Senegal, the entry of women into wage work on plantations tested these time-honored strategies to the limit. This example also illustrates the way in which capitalist transformation propels some women into wage labor, others into petty commodity production.

In 1973, when foreign-owned plantations were established in the area of Senegal Mackintosh studied, women were drawn into the work force in almost the same numbers as men, but not on the same terms. Women "added their plantation work to their non-agricultural tasks which they undertake all the year round, thereby stretching their physical endurance almost to breaking point" (1979:49). Women's performance as wage laborers was undermined by prior responsiblities in the domestic sphere, to the extent that they presented themselves as a casual rather than a permanent work force, and were usually paid less. Women's domestic labor consisted not only of bearing and caring for children but also of spending hours every day fetching fuel and water, pounding millet, and preparing food without benefit of labor-saving devices. The women best able to enter into paid labor were those who had daughters old enough to take care of younger children in their absence at the plantation. Otherwise they called on the help of elderly female relatives or neighbors. The process of proletarianization for women is thus dependent on the organization of *other* unpaid female labor to shoulder domestic burdens. Mackintosh also describes how in more commercialized rural areas in Senegal, certain tasks

of food production and processing are becoming commoditized. Some women in need of cash become petty commodity producers of domestic products, while others purchase these commodities in order to "buy time" to perform wage labor.

Women's entry into wage labor on farms, plantations, and food-processing factories sited in rural areas seems to be motivated by the need to supplement *family* income. The exploitation of a supply of labor that has a preexisting, if inadequate, source of income/subsistence, as well as domestic commitments, seems to allow employers to draw on women as a reserve of casual *cheap* labor. In Kenya, the Brooke Bond Liebig Tea Factory and Plantations at Kericho, among other companies named by Feldman, exploited female labor, but mostly on a casual or temporary basis: "The company's assumption was that women only worked on the plantation as wives of male employees, who were the ones who were "seriously" involved in employment. Nevertheless they conceded that some women came to work independently from neighbouring reserves, and did not live in the camps" (1981:44).

In these circumstances the cheapness of women's labor relative to men's depends partly on the degree to which whole families have become proletarianized (i.e., lost their precarious hold on land for subsistence). Where they retain this hold, then the cost of women's labor appears to relate to the sexual division of labor in agriculture. Evidence from Nigeria (Williams n.d.: 26–27) suggests that rural wage levels for women are higher in the southeastern Igbo areas, where women's work is central to agricultural production, than in the north and west, where women play a less important role in cultivation.

One might expect that in urban areas too, women would be drawn into wage labor as participants in a process of *familial* class transformation. But judging from existing studies, most women in towns get by in the same way as they get by in the rural areas—by generating incomes *outside* the sector where capitalist relations of production predominate; hence class loyalties may cut across families, as Remy's study of northern Nigeria suggested. Parpart's account of Northern Rhodesia in Chapter 8 also describes miners' wives support for (male) working-class action while at the same time they promote class interests of their own relating to subsistence and petty commodity production of food, beer, and handicrafts.

In urban and mining areas in Africa, women are more likely to turn to petty commodity production than to wage work. This is not only because employers, accustomed to hiring men, offer few opportunities. It is also because women actively choose to engage in work that will not stretch them beyond endurance and that will allow them to combine domestic responsibilties with earning a cash income. Such petty commodity production often means capitalizing on domestic skills in cooking, beer brewing, or caring for children. It can also mean prostitution or petty commerce. In putting such skills to economic use women often serve the men who come to town as single migrants, cut off from the domestic labor

they have taken for granted as part of family life in rural areas. While these ways of making a living appear to be independent of capitalist relations of production, they in fact constitute important ancillary services that assist in the process by which male wage labor in urban areas is cheaply reproduced.

Why do more women not find employment as wage workers in the so-called formal sector? One reason seems to be that the rewards from petty commodity production and commerce are often commensurate with those of wage work, at least for women who have nothing to offer but unskilled labor power. Indeed, in certain circumstances, such activities can lead into profitable ventures, as described by MacGaffey (Chapter 9 of this volume). Conversely, wage work is difficult to combine with domestic responsibilities, which perhaps explains the preponderance of single women in such jobs (Bryceson and Mbilinyi 1978; Berger, Chapter 12 of this volume). Such women may either be young women not yet married or older women who are divorced, widowed, or separated. Often such single women have put themselves outside systems of rural familial reproduction. When women migrate independently to town it is often because divorce or widowhood has disturbed their rights to land (Bryceson and Mbilinyi 1978:41; Obbo 1980:77: Bujra 1982:126). Even women who come to towns with husbands may be deserted. What Bryceson and Mbilinyi term "husbandless women" are not necessarily childless, however, and consequently they face the problem of combining childcare with work.

In Dar-es-Salaam, Bryceson and Mbilinyi found that women were resorting to various expedients to resolve this problem—reliance on relatives, and in some cases the employment of other women. "Thirty percent of women workers hired an ayah [nursemaid]. Wages . . . ranged between sh.40 and sh.75 a month, a considerable amount of money for women themselves receiving only minimum wages of barely over sh.300" (1978:45). Two points emerge from this discussion—responsibility for child care is always seen as residing with women, so that men do not have to consider such costs in consuming their wages. Secondly the wage labor of some women in capitalist production entails the wage labor of other women (paid even more miserably) in the "unproductive" sphere. Women's wage work brings in its train a degree of commoditization of domestic labor.

Given the generally low level of male manual wages (predicated upon the maintenance of the single worker, and the "subsidizing function" of the rural sector) it may be that the gap between men's and women's earnings in Africa is not as great as it is in developed capitalist economies. For example, in Kenya in 1977, women's average wage earnings were 89.8 percent of men's, and even unskilled women workers were earning 78 percent of male wages (Feldman 1981:39), compared to the United Kingdom in 1980, where women's earnings averaged only 65 percent of men's (Webb 1982:124) and the United States in 1980, where women earned 59 percent of men's earnings. Where women's labor (as single persons and often with dependents) is not merely a supplement to male wages, and

where women have alternative modes of economic survival, then wage rates for women cannot fall much below those for men. From the point of view of employers, even where women present themselves as potential wage workers, there may be no marked cost advantage in employing them in preference to men.

Sexual Stereotyping in Women's Wage Work

Looking more closely at the minority of women employed in industrial and infrastructural occupations raises the question of the extent to which capital has reproduced forms of gender-based occupational stratification in Africa comparable to those in developed capitalist societies. In Europe and America female workers are clustered together in certain occupational categories, characterized either by the lowest levels of skill and reward or by location in the routine white collar sector of the economy. They are less numerous among skilled manual workers or top professionals or in the higher reaches of management. And certain jobs—nursing, secretarial work, shop and domestic work—are heavily sex-stereotyped as women's work. The existence of stereotypes is not in itself an explanation of the sexual division of labor—rather, such ideological devices constitute a rationale for existing practice, whose explanation has to be sought in the interrelation between the spheres of production and reproduction.

This same occupational gender distribution reappears, with minor exceptions, in Africa, not because it is a natural or necessary way of dividing up the work force but perhaps because foreign employers carry their prejudices with them. In the colonial period in Tanzania, an official statement declared, "it is contrary to native custom and to general practice for native women to be employed at all, except in the transformation of domestic necessities and in . . . agricultural pursuits on tribal or on individual native lands. . . . The native woman at her present stage of mental development is totally unsuitable for partaking in any industrial undertaking involving mechanical knowledge" (ca. 1930, quoted in Bryceson and Mbilinyi 1979:17). While this statement calls on "native custom" for its ideological backing, other ideologies defining women's place clearly lurk in the background—most "native men" would have been equally unfamiliar with mechanics at this period.

These attitudes persist in present-day Tanzania, so that factory managers "generally viewed women workers as incapable of handling machinery of any complexity" (Bryceson and Mbilinyi 1978:38) and called upon men's labor to effect the shift from production by hand to production by machinery. In the late 1960s and early 1970s when a match factory and a coffee-curing factory were automated, women lost their jobs to men. In general, labor-intensive operations in industry, designated as "unskilled," are seen as the most suitable work for women. The ideological rather than objective construction of the concept of "skills" is evident here—compare the usual association in Europe of production by hand as the preserve of "skilled craftsmen," while machine minding is merely a semiskilled occupation, appropriate in many cases for women. In Kenya, too, female

manual workers are disproportionately employed on the most tedious and unmechanized operations, offered few opportunities to learn skills, and rarely taken on as supervisory staff. Feldman quotes a company executive at Kenya Cashew Nuts Co. explaining why women are employed on routine labor-intensive work: "They are more careful and do the job quicker than men." When asked why there are so few women in more responsible positions the reply was, "Probably women don't have the qualifications. One has to show initiative for these positions" (1981:45).

Such attitudes are not limited to foreign companies. Dennis (1982), describing a locally owned textile factory in Nigeria (Odu' atex), established in an area where both men and women had a tradition of making handwoven cloth, argues that its management "had set aside an essential but repetitive, low-paid job [sorting out the thread for the looms] with little prospect of promotion, as 'suitable' for its women employees. From whatever source, management had acquired a stereotype which it proceeded to realize and reinforce. It provided the kind of work which did not require much concentration" (1984:7).

If these stereotypes of female manual work are common in Europe, other patterns are not. Given the relative paucity of women in towns offering themselves for wage work, and the lesser likelihood of girls' attending school to learn the colonial language, it was common in the colonial period for men to be employed as domestic servants (Kenya was a good example of this practice, though in South Africa domestic work seems nearly always to have been "women's work" (see Boserup 1970:102; Gaitskell et al. 1984). Although women are now increasingly taking on this work, male domestic servants are still found all over Africa.

Sexual stereotyping is also evident in jobs higher in the occupational hierarchy. This is indicated in Table 7.2 for Kenya, which shows the proportion of female workers in each occupational category. According to these statistics, the vast majority of secretarial staff were female, and women constituted almost half of all medical functionaries and a third of all teachers. It is worth noting, however, that women form only a small proportion of clerical and sales staff—occupations which in the West are dominated by women. With regard to medical personnel, where women are predominantly employed in nursing, Schuster's view of similar patterns in Zambia seems applicable: "In the postindependence era indigenous women become 'natural' recruits to systems in which colonial or other expatriate women were employed" (1981:77). A simple transfer of Eurocentric models might seem to explain women's important role in education, were it not that in the colonial period in most African countries, teachers were overwhelmingly male. In Senegal (and in Kenya) the vast expansion of formal education after independence led to a dire shortage of staff. Men with the requisite educational qualifications were now easily able to achieve more prestigious and better-paid occupations in government and administration, so female labor had to be utilized (Barthel 1975:8).

In another distinctly African pattern, men's predominance in clerical

TABLE 7.2

Female Wage Workers in Kenya, 1978

Occupation	Females as Percentage of Workers in Each Category	Number
Medical professions	44.3	940
Teachers	33.5	34,116
Other professions	9.1	710
Managerial	5.9	1,808
Secretarial	90.4	11,347
Clerical, bookkeeping, etc.	11.7	7,515
Sales	13.9	1,051
Skilled workers	5.4	4,716
Unskilled workers (including agriculture)	13.4	58,742

Source: Adapted from Feldman 1981:38.

work and women's in secretarial work has its roots in the colonial period. In all African countries the first to attend school were boys, and young educated men eagerly sought clerical work for colonial governments. Women have not yet been able to break this male monopoly. Sales assistants, similarly, were originally male clerks of a kind. Secretarial work, however, which has expanded dramatically since independence,[9] places a higher premium on a certain sort of femininity than on clerical skills. In Senegal, secretarial work is regarded as a glamorous job (Barthel 1975), and in Kenya secretaries receive higher pay than male clerks. Nairobi is full of commercial colleges, catering overwhelmingly to female students. In the short term, "secretarial skills" are scarce for, in addition to good looks and typing qualifications, young women must know how to dress fashionably (usually in Western style) and to speak well (usually in the excolonial language). In Obbo's account of Agnes the typist (Chapter 10 of this volume) clothes and accessories swallowed up the major part of her salary. Becoming a secretary, then, entails definitive cultural resocialization, not simply in the skills of the job, but also in terms of *what it is to be a woman.* Such women are forced to create a model of womanhood often culled from imported films and magazines, that has no precedent in African society. Carmel Dinan has argued that in Ghana, women with white-collar and professional jobs enjoy a freedom to forge new life-styles. They often choose to remain single, while enjoying boyfriends and an active sex and social life, and to restrict their relations with kin so as to cut down on onerous obligations. These women thereby assert a measure of independence unknown in traditional society. These new roles for women are not without their contradictions, however. On the one hand, they allow women more autonomy of action; on the other, this autonomy is often cast in a narrowly individualistic mold militating against solidarity with other women.

Patterns of occupational distribution by gender in Africa thus expose

in various ways the historically and geographically specific character of Eurocentric stereotypes. The availability of female labor at various stages, as well as imported cultural assumptions, has determined the pattern that has emerged in Africa. While some men hold jobs which in Europe are thought of as women's work (clerical and shop work, domestic service), women in occupations which in Europe are thought of as naturally female are not building on existing cultural stereotypes of women but are creating *new* ones.

The perpetuation, in many areas of Africa, of colonial salary scales based originally on racial privilege has meant that inequalities of reward between workers at various levels in the occupational hierarchy are more marked than in developed capitalist societies. A general shortage of personnel with even minimal educational qualifications—especially women—has reinforced these patterns of inequality in the postcolonial period. Hence skills such as nursing and typing are in short supply, so that even though the work itself may be tedious, the rewards are high. In Kenya in 1976, whereas the average monthly wage of an unskilled female worker in the private sector was sh.304, the average wage of a secretary was almost five times as high (sh. 1,494), the wage of a teacher more than three times as high (sh. 1,067), and the salary of female medical professionals averaged out at nearly seven times the unskilled wage (see Feldman 1981:40).

Differences in occupational status do not constitute class differences. Most privileged white collar "mental laborers" are engaged in reproducing the conditions—ideological and organizational—within which capitalist production may be profitable. On the whole they do not exercise authority over other workers or in other ways share in the control and surveillance of subordinated labor (Carchedi 1975). Where income differentials are so marked, however, and particularly where, as in Africa, the process of producing this "superior" labor power entails such sweeping cultural resocialization, there are very real effects at the level of subjective awareness that divide women one from another. As one Senegalese female social worker put it: "Insofar as the woman is educated and thinks herself superior, she becomes separated from her true self and from her Senegalese sisters." And indeed, a patronizing attitude is often taken toward the poor. One secretary said: "The women in the bush don't have the same problems [as we do]. In the bush the peasants are not forced to imitate fashion. . . . The women of Dakar are obliged to follow present styles. . . . Women in the bush are content with what they have. There the only problem is to grind the millet and make *couscous*" (Barthel 1975:12–13). Writing of political initiatives to emancipate women in Mozambique after independence, Isaacman reported: "Among the small number of women who had gained relatively prestigious jobs as civil servants, bank clerks, and secretaries, most opposed any alliance with illiterate peasants, whom they considered to be distinctly inferior" (1982:63). Such contemptuous sentiments may well be reciprocated. One woman, describing her move from a slum area to a "middle-class" housing estate in Nairobi, expressed

this feeling forcibly. There, "we used to help each other with things—salt, a cup of sugar and so on. But these *makarani* [literally, "clerks"—she meant educated men and women] here would give you nothing" (Bujra 1973:104).

Class Privilege and the Control of Women

Minute numbers of African women are members of the state ruling class (the occasional minister in charge of social welfare or education)[10] or employers of labor in capitalist concerns. More commonly, women with petit bourgeois class interests occupy social categories whose position is closely tied up with the fortunes of the ruling class, especially its professional and commercial elements (see Chapters 9 and 10 in this volume), or are the wives of men in these privileged strata.

In Africa, petty bourgeois wives are rarely immersed in domestic concerns. To begin with, they almost universally employ domestic servants to carry out all the "dirty work" of the household and to nurse and tend young children. Such servants, now often women, are among the worst paid of workers. To some extent this devolution of responsibility allows petit bourgeois wives more leisure to act as ornaments to their husbands' success: to engage in what Papanek has called "family status production" (1979:775). More often, though, such women utilize paid domestic help in order to free themselves to work in high-income white collar or professional jobs or tó engage in petty entrepreneurial activities such as trade, shopkeeping, or running bars. When Ghanaian migrant workers were recently expelled en masse from Nigeria, some of the loudest complaints came from petty bourgeois women: "Thousands of Nigerian women were only able to take up jobs because they could rely on their alien [i.e., Ghanaian, and in this case mostly male] house helps—often paid a meager wage with most of the payment going to the middleman who imported them—to look after their young children and do other household chores," reported Esther Ogunmodede in *New African* (April, 1983). How servants feel about their employers is illustrated by Obbo (Chapter 10 in this volume); during the Amin years servants "betrayed" their employers to be robbed or killed, while in the late 1970s "elite women had trouble finding or keeping domestic servants, especially women." Employers were accused of underpayment and overwork.

During national liberation struggles in Africa petty bourgeois elements articulated the grievances of colonized people as a whole. In the course of struggle, emerging class differences between African women were submerged in a common opposition to colonial domination. Some women became consciously aware of this process through their own experience of active involvement in the struggle. One Zimbabwean woman recalled, "When you get to a [guerrilla training] camp, everyone becomes the same . . . whatever the class one considered oneself to be before . . . they become the same" (Zimbabwe Women's Bureau n.d.: 13). This woman had enjoyed a good education and secretarial training abroad. But in most African countries such women were not actively involved in the liberation struggle, and their "natural" assumption of leadership roles relative to

other women after independence is a function of their superior place in society or that of their husbands.

In the postcolonial era, national women's organizations have been set up in many African countries, purporting to speak for the interests of all women. To what extent do such organizations transcend the differences between rural peasant women, urban women in wage work or petty commodity production, and petit bourgeois elements? What role do such organizations play in class terms? The Kenyan Women's Association (Maendeleo ya Wanawake) is typical of many. With branches throughout the country, in both rural and urban areas, on the surface it promotes "women's role in development." In practice, as Wipper shows, its leadership is composed of women "from the developing middle class—professional, commercial and civil service sectors" (1975:104), often related by marriage or kinship to influential members of the government. Such women organize fashion shows and craft and cookery exhibitions; they travel abroad, attend receptions, and dispense charity. They are increasingly cut off from the rank-and-file membership of rural women, whom they address in a contemptuous and antifeminist tone. This is very evident in Wipper's account of a Maendeleo leader's speech:

> "No husband would like a dirty and lazy wife not prepared to contribute to the betterment of the home." Urging women to redouble their efforts in building Kenya, she said that while some women elsewhere helped to develop their countries, it was shameful to note that some women in Kenya preferred to gossip instead of doing something useful (Wipper 1975:110).

Such views (applauded by male government ministers) expose the true class purpose of this association, which is to press poor women to work harder and longer in order that they, the petty bourgeoisie, might live better. In Africa petty bourgeois elements flourish by exploiting or oppressing direct producers either via the state or via mercantile or petty capitalist enterprise. This intention is sometimes disguised by the philanthropic activities and ideology of concern for the poor that characterizes this organization. "Philanthropy" here involved well-publicized donations to presidentially sponsored charities (e.g., a hospital in the late President Kenyatta's home area)—it did not extend to effective or generous financing of activities to help women in its rural branches. Charity, as has been noted before (Caplan 1978), is often but a means to keep the poor in their place and to emphasize the social distance between them and the better-off. These associations thus play a role of social control on behalf of this class as a whole; they do almost nothing to transform the position of the majority of women.

The Gambian Women's Federation, which I investigated briefly in 1976, provides another example. It was composed of several organizations, the most important of which were expupils' associations of girls' secondary schools situated in the capital. Its representativeness was thus in doubt in a country where only 27 percent of the population of five to

fourteen year olds attended school and where the proportion of girls was almost certainly much lower. In a country 90 percent Muslim, its officers were 100 percent Christian. An interview with the president pinpointed the major concerns of the association: charity work; reforming *Muslim* marriage law; finding employment for educated girls; and preventing female juvenile delinquency (a euphemism for prostitution).

In Tanzania the national women's organization was also engaged in many activities designed to curb and control women and to remind them of their "domestic duties." It organized classes in sewing, knitting, and cooking and backed up the government's drive against "provocative" women's dress (miniskirts, wigs, makeup). Mbilinyi argues, "Underlying that campaign was an extreme reaction against the growing number of young, unmarried working women in towns who engaged in liberal sexual practices and were no longer under paternal control" (1982:9). The association also initiated petty entrepreneurial enterprise in the form of cooperatives, but excluded most of the members by charging entry fees. Mbilinyi's general characterization of this association is an indictment of its class and political role. Whereas it presents itself

> as an organization to unite all women, regardless of different class or other interests, [it] is accountable to the party and functions to organize women in support of the party and the government. The possible conflict between this goal and that of women's liberation is obvious. Thus far, its political practices . . . speak the message: "women, work harder and behave yourselves." (1982:8)

The existence of *women's* organizations in Africa is not, in other words, unthinkingly to be equated with the existence of any specifically *feminist* consciousness, or any desire to transform the class or economic structures of postcolonial society. Women's liberation is *disruptive* in its challenge to male prerogatives; organizations such as these reinforce the status quo. They serve petty bourgeois class interests more than they serve women. To dismiss them out of hand because of this would be short-sighted, however. For, despite their primary significance as institutions of class control,[11] such organizations, in bringing women into communication with each other, can provide arenas of struggle within which women who are poor and subordinated can speak out and exert pressure on those who enjoy the rewards of postcolonial society.

CONCLUSION

This chapter has shown that capitalist transformation in Africa has had only a limited effect in drawing women into wage labor. Rather than relegating them to an "unproductive" and privatized sphere of domestic labor, it has indirectly channeled their energies into petty commodity production and petty commerce. In the short run this is in line with

women's interests, even though it also serves capital's needs, providing cheap agricultural commodities, cheap consumption goods for male wage workers, new generations of cheap male labor power, and the circulation of commodities produced in the capitalist sector. In the longer run, the fact that women have not been exploited by capital to the same degree as men has limited their struggles to localized outbursts in defense of precapitalist forms of organization of production.[12] In Nigeria the Igbo Women's War of 1929 followed rumors that women were to be taxed and seems to have been led by market women (Van Allen 1976; Bujra 1978b:36). In South Africa in 1959, women protested against a ban on African beer brewing at a shanty settlement in Durban: "2000 women gathered to tell their grievances to a local official; and the police . . . charged the women with batons, striking the women to the ground, often hitting the babies tied to their backs" (Bernstein 1975:48). In Nairobi in 1969, prostitutes protested against attempts to "repatriate" them to rural areas as vagrants (Bujra 1982a:159–61). Such struggles cannot be explained away as merely the persistence of precapitalist relations of production (see Carby's strictures, 1982:227). They represent rather the struggles of women to survive and retain control over the conditions of their production and reproduction at a time when the encroachment of capitalist relations threatens all such petty production, be it in peasant farming or in artisan activities. The success of such struggles depends on women's base in the community—a base that is often strengthened by ties of mutual help in both production and domestic labor (Bujra 1982a; Chapter 8 in this volume).

Levels of unionization among women wage workers in Africa cannot be ascertained, but they often work in nonunionized occupations. For example, even though South Africa is the most heavily industrialized of all African countries and provides some examples of organized militancy among black women workers (see Chapter 12 in this volume), the majority of women workers are domestic servants or agricultural laborers; very few in these occupations are unionized. Bernstein argues, "Because of their comparatively small numbers in industry, black women in general lack the experience in work-solidarity relationships that have often provided a training ground for male political leaders. Domestic servants cannot join together to ask for high wages or better conditions; each has, individually, to deal with an individual employer" (1975:43).[13] A female trade unionist in Zimbabwe (a worker in the textile industry) complained, "Women are reluctant to go on strike because of fear of losing their jobs. They may be the sole breadwinners of their families with many children to support. Since jobs are scarce for women, it is the lucky few who get them and so they must keep them at all costs" (Zimbabwe Women's Bureau n.d.:28).

The relative paucity of women in wage work and the localization of women's struggles over petty commodity production has left the mass of women vulnerable to exploitation by petty bourgeois elements, among whom are other women eager to promote and preserve class privileges. But perhaps one of the most paradoxical features of class formation as it affects women in Africa is that two contradictory processes seem to be

taking place. As the extension of capitalist relations of production renders noncapitalist forms less viable, women are drawn into processes of capitalist class formation as members of *families*—some families that are partially proletarianized by male migrant labor or fully proletarianized by the loss of land, others that are establishing themselves as a new petty bourgeoisie. But as labor power becomes a commodity, women too become aware of its value: there is "no free labor," some are beginning to assert, "even in the villages." And children "produced" by women's labor are beginning to be seen as their "assets." Hence there is another process of transformation that is very often the outcome of struggles *within families*—between husbands and wives, fathers and daughters—whereby women, in asserting their autonomy and making a living, individually become members of emergent classes. Gender struggle and class formation thereby go hand in hand.

NOTES

1. Mrs. Kathleen Kibiego, chairman (sic) of a local branch of Kenya's official Women's Organisation, quoted in Wipper 1975.

2. This Marxist definition of class should be distinguished from Weberian and more orthodox sociological usages. For Weber, class is defined in the marketplace, where people arrive differently endowed in terms of skills or ownership of assets—it is via the market that evaluation and allocation of people to class positions takes place. A more common sociological version of class draws on Weber's concept of status: it sees society as stratified into sets of people with contrasting social attributes (variables such as income, occupation, attitudes, or life styles are commonly taken as definitive markers of "class" here). The Marxist concept of class is very different, though it may draw on some of the same data. Class is defined here not by "attributes" but by "relations." For example, the bourgeoisie is not a stratum owning certain assets or enjoying a certain life style; it is defined in terms of its exploitative relationship to the proletariat—it *becomes* a bourgeoisie by way of this relationship. Capitalist class relations are determined not in the marketplace but in the course of production, where people who own or control the means to produce come into relation with those who sell their labor power. Class relations cannot be understood simply by detailing existing inequalities; they must be seen as the outcome of unfolding historical contradictions. The Marxist concept of class (as opposed to that of orthodox sociology) also insists that classes are essentially conflictual and that the historical process whereby members of a class become aware of their common interests as against other classes is as central to Marxist analysis as the uncovering of the basis (in production relations) of these antagonistic interests.

Applying class analysis to pre- or noncapitalist societies raises certain problems, as there are societies without classes (in the Marxist sense) as well as forms of class relations very different from capitalism. Here I will look at the impact of capitalist transformation on noncapitalist forms of production in Africa. The two

major noncapitalist forms considered here are subsistence production and petty commodity production. In Africa, the latter is generally a development of the former, whereby people who originally produced their own needs (as families or wider kin groupings) now produce a surplus for the market and purchase some of their needs in the market. This production of goods for sale, while generally exploitative of peasant and artisan families, should be distinguished from pro-letarianization, where it is *labor power* (or the capacity to labor) which becomes a commodity for sale and where the worker's hold on her or his own means to produce (such as land or tools) is weakened. The working out of this process as it affects women is the main theme of this essay.

3. Compare, however, the invisibility of women in Williams' account of the political consciousness of the poor in Ibadan, Nigeria. Although in Ibadan women's participation rate in trading and crafts is on a par with that of men (Mabogunje 1968:220–21), in Williams' account traders are, with one exception, referred to as "men" or "he" and artisans as "craftsmen" (Williams 1980:110–35).

4. The following account draws on various sources: Amin 1976; Cliffe 1982; Ake 1978; Arrighi and Saul 1973; Sandbrook and Cohen 1975; World Bank 1981.

5. This is not to deny the many struggles which have taken place in Africa—both broad-based anticolonial uprisings—as well as resistance to, and in some areas protracted guerrilla warfare over the alienation of land. My point is that, whereas considerable pressure was brought to bear on the subsistence sector, it was not totally destroyed.

6. Michèle Barrett, for example, argues that the transition to capitalism in Europe led to "a far greater degree of dependence of women on men within the household" and that capitalism "constructed a wage labor system in which the relationship of women to the class structure came to be partially mediated by an assumed or actual dependence on a male wage" (1980:254). See also the debate on domestic labor, and its role for capitalism, discussed by Barrett 1980, also Fox 1980.

7. See Beneria 1981, and Rogers 1980: ch. 4 on the biases in statistics.

8. See First 1983 and Van Onselen 1976 for accounts.

9. In South Africa, however, apartheid ensures that African women are hardly employed in clerical or secretarial work (less than 2 percent of female African workers). Bernstein (1975:37, 67) notes that "black office workers are seldom accept-able to their white colleagues." Black nurses are employed in almost equal numbers with white female nurses, to deal with black patients.

10. In Tanzania there are three women ministers (one of education, one of state, one of justice; Mbilinyi 1982:9); in Zimbabwe a woman is minister of youth, sport, and recreation; in Ghana a woman is minister of education.

11. Such a view of national women's organizations in Africa may have to be qualified where socialist ideologies are being actively promoted, as in Mozambique or Guinea-Bissau (see Kimble and Unterhalter 1982; Urdang 1979), but as the example of Tanzania suggests, reality does not always match rhetoric.

12. For a discussion of the "class" consciousness of petty commodity producers, see Bujra 1982a and 1978a.

13. A view repeated (with qualification) in Gaitskell et al. 1984, but thrown into doubt by my own material from East Africa which shows that *male* domestic servants were early and militant trade unionists. The Zimbabwean woman quoted may be nearer the real reason for women's relative industrial passivity.

Chapter 8

CLASS AND GENDER ON THE COPPERBELT
Women in Northern Rhodesian Copper Mining Communities, 1926–1964

JANE L. PARPART

WESTERN SOCIOLOGY GENERALLY assigns women the class position of their fathers or husbands on the assumption that the male monopoly over productive forces makes women dependent upon men. Women are members of the working class because they depend on the wages of male workers. This approach assumes that women automatically take on the class position of their male protectors and therefore adopt the class consciousness and class action of their protectors as well (Bottomore 1966; Parkin 1971).

In Africa, this approach seems nowhere more applicable than among the wives of Zambian copper miners. Brought to the mines in order to help guarantee a low-cost, stable, and productive African labor force, a woman's very presence in the mine compounds, whether legal or illegal, depended upon her attachment to a mineworker. Although some miners' wives had sufficient economic autonomy to warrant their own class position, most depended largely on their husband's income and thus can be legitimately assigned to his class position. These women spent most of their day ensuring the daily reproduction of labor. As with their husbands, capital–labor relations defined much of their lives. And as one would expect, they steadfastly supported collective action against management. Thus, on the surface, most African women in the copper mining areas seemed truly working-class wives.

And yet, a closer look reveals anomalies that have important implications for the class analysis of women on the Copperbelt and elsewhere. While willing to engage in class struggle against capital, these women also

The research for this chapter was carried out in Zambia during 1975–76 and in England during the summers of 1982 and 1984.

wrestled with their "male protectors" for access to family income. African wives in the copper mining areas, like most wives in the industrial world, had no legal right to their husbands' wages. On the Copperbelt, where the mining companies supplied housing and food until the mid-1950s, many miners considered their wages their own, expecting wives to provide spending money for themselves and their children. As a result, although a woman's potential prosperity depended largely on a husband's wage, higher wages alone did not guarantee a woman's financial position. Consequently, while women supported workers' struggles against capital and even confronted management directly over issues like food and housing, women on the Copperbelt also adopted an impressive number of strategies to ensure their own position, strategies that pitted gender against gender and even occasionally transcended class lines. This chapter examines these gender-specific strategies and their implications for the class analysis of women in the Northern Rhodesian copper mining areas and Africa in general during the colonial period.

WOMEN IN THE MINE COMPOUNDS

When the copper mining companies in the Northern Rhodesian Copperbelt began constructing the mines in 1926,[1] they faced a shortage of black labor, particularly experienced labor. The Copperbelt mines competed for this labor with Union Minière du Haut Katanga (UMHK) in Katanga, with Broken Hill in Northern Rhodesia, and with the higher-paying Southern Rhodesian and South African mines. Unlike employers in the rest of Southern Africa, then, both UMHK and Broken Hill permitted miners to bring dependents to the mines as an inducement for employment. The popularity of this policy forced the Copperbelt companies to follow suit, especially at Roan Antelope Copper Mine (RACM), where less accessible ore demanded a higher component of skilled labor (Mwalwanda interview).[2]

Initially, the copper companies were reluctant to encourage the employment of married labor; they resented the cost of housing and feeding women and children.[3] Anglo-American, with its South African tradition of migrant labor, tried to limit the percentage of married workers by relying primarily on unskilled labor. However, by 1943 even the compound manager at Anglo-American's Rhokana mine, William Scrivener, admitted that "the married employee is undoubtedly more contented than the single, he is better fed, looked after and clothed and has the rudiments of a sense of responsibility which tends to make him a more suitable and efficient worker."[4] Married workers averaged thirty tickets (a month's work), compared to the twelve tickets for single men. By 1944, both companies agreed that married labor's greater stability and productivity more than compensated for the extra costs and decided to maintain a maximum level of married strength.[5]

As the mining companies began to recognize the profitability of a more skilled and stable black work force, they became increasingly committed to married labor.[6] As a result, both the percentage of married workers and the average length of employment of black miners rose steadily throughout the colonial period. In 1931, some 30 percent of the mine employees lived with their wives at the mines. At Rhokana, for example, 42.8 percent of the miners were married in 1946, 46 percent in 1951, 69.4 percent in 1956, and 82 percent in 1961. At Mufulira, 57.3 percent were married in 1946, 62.1 percent in 1951, 73 percent in 1956, and 71 percent in 1961 (Northern Rhodesia 1931, 1951, 1956, 1961). The labor turnover rate fell accordingly. In 1951, about half of the 8,426 workers at Roan had worked two years or longer, and 2,321 had worked over four years.[7] In 1952, the turnover rate for black miners in the copper industry was 60.1 percent. By 1959, that figure had fallen to 27.9 percent, and by 1964 to 8.3 percent, even lower than that of European labor (Zambia 1966: app. 7).

If anything, these figures underestimate the degree of stabilization on the Copperbelt. Many miners circulated between mines without returning home, thus appearing on company records as short-term employees while actually living for long periods in the Copperbelt. As one missionary noted in 1938, "I suspect that unwittingly or wittingly, the mines are badly misled on the subject of the temporariness of their employees by the way they move from one camp or company to another."[8] This seems to have been particularly true for women on the Copperbelt, many of whom did not want to return to the rural areas. Lynn Saffery, a Labor Department researcher, discovered in 1943 that 33 percent of the women living in Nkana mine township had been there for three years or more, and many had not visited home since moving from the rural areas (Northern Rhodesia 1943:41).[9] This trend continued throughout the colonial period.

GOVERNMENT POLICY: WOMEN IN THE MINE COMPOUNDS

The Northern Rhodesian government was less willing than the mining companies to encourage women in the mine compounds. The government relied on chiefs to maintain order in the rural areas, especially during the financially constrained years before 1949. Throughout the colonial period, rural African leaders complained bitterly about women running away to the Copperbelt. They feared loss of authority over women, which both threatened food production and decreased their control over young men. Rural leaders wanted traditional laws enforced in the urban areas and all unmarried women collected and sent home (Ault 1976; Merry 1982: 68–69; Northern Rhodesia 1946).

In order to help the chiefs, government officials tried to control the movement of African women into the urban areas. In 1930, the newly established native authorities were given the right to issue marriage cer-

tificates, and after 1939 women without valid certificates, or chiefly per-
mission to visit the urban areas, were removed at checkpoints along the
major bus routes into the Copperbelt.[10] Government officials also encour-
aged chiefs to visit the mines in order to pressure unmarried women and
children under twelve to return home and urged the mining companies to
cooperate by permitting only registered wives and female guests in the
mine compounds.[11]

In 1936 the government set up urban African courts to increase chiefly
control over urban Africans. Court representatives were appointed by
rural leaders. These urban assessors spent much of their time (about 70
percent) on matrimonial cases, trying to enforce traditional norms and
improve marital stability. The courts began registering urban marriages,
which involved sending a certificate of marriage to the village of the
proposed wife to obtain permission from her elders. The courts dis-
couraged interethnic marriages and supported higher bridewealth (which
had to be returned upon divorce) to make divorce more expensive and
therefore more difficult. They fined adulterers heavily and frequently
ordered quarreling couples to reconcile rather than divorce, supplying
traditional wisdom as a guideline for reconciliation (Merry 1982: 81–84;
Epstein 1954; Chanock 1982).[12]

The urban courts were designed to increase the traditional au-
thorities' control over African women in the urban areas. Court assessors
opposed women coming alone to the Copperbelt without permission from
their chiefs and encouraged government and mine police to search the
compounds for such women, fine them £10, and have them repatriated.[13] A
woman who had married three times was branded a prostitute and ban-
ned from the Copperbelt. If a woman admitted committing adultery, she
had to pay the court a £5 fine, was declared immoral, and could therefore
claim no damages from her husband.[14]

Colonial authorities also tried to limit female income in the urban
areas, on the assumption that African women should be in town only as
dependents. Independent women were potential troublemakers. Since
beer brewing was a major source of money for African women in the early
1930s, the government prohibited private brewing in the urban areas and
established official beer halls instead, whose profits paid for welfare and
recreational schemes designed to maintain order in urban areas at
minimal cost (Stubbs interview).[15]

The government also opposed the establishment of a permanent ur-
ban African population in Northern Rhodesia. While some stabilization
was accepted as inevitable, it was not encouraged. Government officials
wanted Africans to remain tied to the rural economy in order to protect
indirect rule and to underwrite the costs of reproducing labor by provid-
ing low-cost social support for both potential workers (youth) and retired
wage labor. Except for encouraging a small African middle class during
Federation (1953–64), this policy continued until Zambian independence
in 1964 (see Berger 1974).

COMPANY POLICY: WOMEN ON THE COPPERBELT

While concerned to maintain good relations with government, the mining companies were determined to protect their profit margins as well. To placate government while maintaining a stable labor force, the mines adopted a policy of stabilization without urbanization. They pressed long-term workers to make regular visits home and to retire to rural areas. In this manner, the companies hoped to maintain a cheap, reliable labor force without creating a costly permanent African urban population.[16]

The mines refused to repatriate women but did agree to encourage traditional control over marriages in the mine compounds. Initially a woman only had to live with a man for a week and cook his food to be recognized as a wife (Spearpont 1937:37). However, in 1944 the mines agreed to follow the recommendations of the African Regional Council and the colonial government and began asking African employees to produce marriage certificates from rural authorities before granting them married accommodations (Heisler 1974:71).[17] Some compound managers would not let a man register another wife until three months after a divorce.[18]

The mines also agreed to issue passes to women visiting the compounds. The compound managers were fairly lenient about these passes, believing that "a certain proportion of free women is healthy as a safeguard to legitimate wives."[19] But, the mine police regularly swept through the compounds looking for unauthorized women, who were then turned over to the government police. Evictions of unauthorized persons increased in the 1950s in an effort to isolate the miners from the tumult of African nationalist politics.

In order to control women in the compounds, management also encouraged miners and their families to take marital problems to their tribal representatives (TRs) on the mines. The representatives were elected by members of each ethnic group—one for every twenty-five people. In 1940, all the mines adopted the system. Although the urban native courts handled serious marital cases, the TRs often settled small domestic disputes. They discouraged intertribal marriage and advised couples to solve problems along traditional lines. Like their counterparts in the urban courts, the TRs wanted independent women who divorced frequently to be censured and returned to the rural areas.[20]

Although reluctant at first, the mines agreed to prohibit beer production in the compounds. The companies preferred the permit system in which different sections of the compound produced beer on a rotating basis. Drinking occurred in small groups, and since married women usually produced the beer, its sale provided extra money for married labor, thus supplementing the men's marginal wages and rations (Scrivener, evidence to Russell Commission 1935:463). However, the government's offer to let beer hall profits underwrite mine welfare costs and the realization that beer halls facilitated control over leisure activities in the com-

pounds soon mollified management, and the mines began to enforce
government beer hall regulations in the compound (Taylor and Lehmann
1961:45).

PROGRAMS FOR WOMEN IN THE MINE COMPOUNDS

After two major strikes in 1935 and 1940, the mining companies and the
Northern Rhodesian govenment recognized the need to increase control
over the Copperbelt labor force. Unoccupied bored women appeared to be
a major source of trouble in the compounds. In 1940, for instance, a short
strike and near riot had occurred at Chingola when a woman quarreled
with a compound official in the food lines (*The Forster Report* 1941). Prod-
ded by the colonial office and Northern Rhodesian officials worried about
maintaining copper production, management at both Copperbelt com-
panies decided to support programs to teach women skills that would
stretch their husbands' meager wages while keeping them busy and out of
mischief. The mines turned to the United Missions in the Copperbelt
(UMCB), an ecumenical, urban-based group concerned with African edu-
cation and welfare. First brought in after the 1935 strike, the UMCB settled
in Kitwe in 1936 and soon began welfare work among Copperbelt women.
After the 1940 disturbance, the companies stepped up support for the
missions as a low-cost method of labor control (Cross, evidence to the
Forster Commission, in Northern Rhodesia 1941:286).[21]

The UMCB classes emphasized practical skills and Christian values.
Classes were offered in hygiene, baby care, laundry work, sewing, knitting,
cooking, and other domestic skills. While never reaching all compound
women, the missionaries often had several hundred women in their
classes. In 1944 the UMCB reported, "Everywhere more women than we
can teach came to be enrolled in handwork and domestic science
classes."[22] Classes were set up for those few women interested in learning
to read and write English, some of whom organized discussion groups as
well (UMCB 1938–44).[23]

The missionaries kept in regular daily contact with their students. As
one wrote, "much of the greatest value in our efforts is the influence we
can exert by personal contacts and friendships helping to smooth out
difficult relationships between husbands and wives, discussing with the
women some of the problems of their lives, and occasionally having cases
referred to us by the Boma for sympathetic dealing" (UMCB 1938–39:4).
All of this advice, of course, was framed in traditional Christian terms,
particularly emphasizing marital fidelity and family stability. But it was
also based on the belief that African women who accepted these values
deserved support.

After 1953, mine welfare services increased dramatically for all Af-
rican workers. The establishment of the Federation of Northern and
Southern Rhodesia and Nyasaland, high copper prices, and the end of
wartime controls over copper freed the companies to attack white labor.

As a result, they began to substitute cheaper black labor for some of the less skilled European miners. The mines thus became ever more committed to stabilization and to services assisting long-term adjustment to compound life. The companies took over women's work, along with other welfare programs. Classes for women continued much as they had in the past, but in 1953 the TRs were voted out by the miner's union and so could no longer assist with marital problems. Consequently, social welfare case workers in the African personnel departments on the mines increasingly dealt with marital disputes.[24] For example, in the late 1950s, Roan established a Citizens' Advice Bureau to handle problems, particularly domestic quarrels. Entirely run by Africans, the bureau reported spectacular reductions in divorce cases. Out of 525 cases handled in the first six months, 427 couples reconciled (Harries-Jones 1964).[25]

In order to control women in the compounds and to minimize disputes, the African personnel departments emphasized the importance of marital stability, fidelity, and frugality, and condemned prostitution and adultery. Personnel officers urged women in the mine compounds to be "proper wives," to respect their husbands, and to help make them healthy, contented workers. As the Rhokana welfare supervisor put it:

> By changing their [Africans'] norms and educating them to appreciate the necessity for health, hygiene, family discipline, and a rigid adherence to moral codes, and the rewards to be had from honest endeavor and self-help, we will aid them in developing a new culture, which, based on our ideology and concepts of Christianity and democracy, will be within their concepts of tribal social life and therefore understood and acceptable to them.[26]

The wives of better-paid (supervisory-level) Africans received special attention to encourage loyalty and to teach them about European living. As the Roan welfare supervisor, Dick Howie, said, "we contemplate a course especially designed for these women so that they will be able to keep apace to a small degree with the husband and more especially to introduce her to some form of budgeting and careful spending."[27] The companies encouraged the adoption of European living styles and behavior, both to assist the adjustment of these women to low-density housing (formerly entirely European) and to prepare them to provide models of "correct" behavior for the wives of daily paid miners. Some of these women were trained in welfare work and became case workers in the mines' African personnel departments—a more direct attempt to influence behavior in the compounds (Musumbulwa, Morris, Katongo, and Howie interviews).

RESPONSES OF THE WOMEN

The colonial state and the mining companies clearly wanted African women in the urban areas only as long as they served state or corporate

goals. Both wanted African women in the mine compounds to be loyal working-class wives who would foster increased labor productivity while making minimal demands. Thus, government and company officials tried to inculcate in miners' wives the values of thrift, obedience, and loyalty to one's husband. Above all, they opposed African women who could support themselves and therefore could ignore government and company pressures and cause disruption among the miners. These officials agreed with rural African leaders that such independent women should be returned to patriarchal control in the rural areas.

Did women accede to government and company pressures? Were they simply a loyal support group for their men? On some levels one would have to say yes. Women in the mine compounds spent much of their time involved in the daily reproduction of labor—feeding and caring for miners and their children. They spent long hours waiting in food lines, gathering firewood, preparing meals, and using the various skills learned at the women's centers to stretch family budgets. They also gardened to provide more food, and some cash, for their families. Often the gardens were a considerable distance from home, so that tending them used up much of the day (Musumbulwa interview; *The Saffery Report* 1943:12–13).

To the surprise and consternation of management, African women at the mines actively supported their men in the class struggle. They joined the early strikes, gathering food from the gardens, cooking for the strikers, and cheering on the strike leaders. After the establishment of the African Mineworkers' Union (AMWU) in 1949, women regularly attended trade union meetings. They recognized the antagonism between management and workers and the importance of the strike as a weapon for improving wages and living conditions. In 1954, for example, some women at Roan started shouting at the assistant compound manager, Chris Cook, accusing him of shortchanging their mealie-meal. When Cook tried to dissuade them, the women refused to be appeased, claiming, "No, no this is not good, that is why our husbands went on strike, because you and your fellow Europeans are very bad." Cook summoned an African trade union leader, Jameson Chapoloko, who failed to mollify them either. Chapoloko admitted, of course, that women were harder to convince than men and advised Cook to leave, adding that he would try to solve the problem through their husbands.[28]

When the companies tried to divide the black work force by creating a staff association in 1954, a number of the potential staff wives pushed their husbands back into the union. One man who returned to the union after joining the Mines African Salaried Staff Association (MASA), explained that the staff association did nothing for him, but "another thing that is bad is that all people hate you as soon as they hear you are a member, even women. My wife used to quarrel with me for not attending union public meetings. She forced me to attend because all her friends were laughing at her, and saying that her husband was an informer."[29] Since most welfare workers were staff employees, women also protested by avoiding the welfare centers.[30]

Once the staff association was organized, staff wives were alienated from other workers and their wives. The antagonism between staff and daily paid miners spilled over into the women's lives forcing staff wives to huddle together to avoid the ridicule and hostility of union supporters. Staff children were ostracized:

> Even if you were just buying some food you were called *bamakobo* [informer] . . . It was very difficult. Even during the strikes, the mass of workers could go on strike while the staff were trying to control the masses and things like that. Sometimes you can get stoned. It was very hard to be an informer's wife. Even for children, you could see the children shouting at your child the same insults. It made the staff people keep to themselves. When you get together with the other staff wives you talk about the nasty things the other women are saying about you, and you comfort yourself (Musumbulwa interview).

Thus, as predicted by most sociological theory, in relations between classes, the actions of women on the Copperbelt largely reflected the class position of their husbands.

However, the behavior of women in the mine compounds cannot be understood simply along class lines. Many of these women had evaded both rural and colonial male authorities in order to get to the Copperbelt. Despite chiefly and government efforts to block access to the urban areas, women continued to pour into the Copperbelt. They bribed bus drivers, walked around checkpoints, and got back on the bus. They went to "visit" relatives fully intending to stay. When police searched the compounds for unauthorized women, they temporarily "disappeared" (Musumbulwa and Katongo interviews).

Once in the urban areas, most women recognized the need to find a male "protector," especially if they wanted to live at the mines. A woman had to have a "husband" in order to reside legally in the compounds. Initially this was relatively simple and temporary "Copperbelt marriages" flourished.[31] Company and government efforts to stop illegal liaisons reduced their number but did not end them altogether. Some women brought fictitious relatives to the urban courts in order to register their "marriages." Forged documents were common as well. Mine officials could sometimes be convinced to look the other way. Some men lived with two wives but only registered one (Nyirenda and Lehmann interviews). As late as 1964, the Roan Antelope town officer admitted that "anyone who could produce a 'wife' and some 'relatives' could get married housing. Also, many men, if their wife leaves, just find another. Often they remain in married quarters as a bachelor, or with a succession of girlfriends. The only punishment is being sent to single quarters,"[32] hardly a deterrent since single men lived there anyway.

Once "married," wives living in the mine compounds faced new problems. Whether legal or illegal, marriage provided only limited security. While housing varied with a husband's job, women struggled with insufficient rations[33] and uncertain access to their husbands' earnings. The men controlled the money.

The men didn't give enough money to the wife for food. A man does not contribute to school fees and food if his wife is working. Sometimes a second wife is taken and the money goes to the second wife. Also, sometimes the man drinks too much and spends money on drinking. There is no tradition of the woman getting a certain amount for food. The women had no say. If the women protested they would be beaten (Musumbulwa interview).

Even wives of the more highly paid miners could not be assured of money. One woman with a rich husband told Epstein, "We just suffer as those who are married to poor people. Even when they are given sufficient sums of money, it is not every time and always that they are given the same amount of money [as poorer women]" (Epstein Papers n.d., "Anna Mwamba").

Some women just resigned themselves to their powerlessness and did the best they could. "The traditional woman especially kept quiet, even if her husband shouted at her. If she gets beaten, she would keep quiet" (Epstein 1981:112–13; Musumbulwa interview). Still, most had ways of protecting themselves and their children from some of the vagaries of domestic life. They grew extra food in small backyard gardens and looked to female relatives and neighbors for comfort and assistance. Epstein discovered that women in Ndola had strong ties with next-door neighbors; similar patterns developed in the mine townships. Women cooked together, borrowed from each other, and even ate together. They discussed family problems, offering each other advice and support. Neighborhood solidarity emerged around a common concern for children and each other (Epstein 1981:69, 103–4, 168). While difficult to quantify, these ties undoubtedly eased compound life for many women.[34]

The insecurity of compound life, especially the uncertain access to husbands' earnings, drove many women to new forms of action. They discovered and exploited new opportunities to make money in the compounds. Beer brewing, initially legal, continued illegally. Management complained of constant illegal brewing and sent the mine police on regular sweeps through the compounds to arrest offenders (Cook and Phiri interviews).[35] Despite the hazards of being caught, fined, and even jailed, beer brewing flourished. Beer could be produced at home and so readily combined with domestic duties. Home-brewed beer was popular, and women sometimes made as much profit in one beer brew as their husbands' monthly pay checks (Chauncey 1981: 149). In the 1950s, only 7s/6d worth of ingredients could be sold the next day for about 15s (Epstein 1981: 61). Beer production thus remained a quick, relatively lucrative method for raising cash, and many compound wives braved the threat of arrest rather than give up their beer income.

Women sold other skills for money as well. Gardening supplied food for the family, but excess produce could be sold for cash. In 1934, women at Roan sold the company more than 600,000 pounds of vegetables for £1,000. After 1935, the government insisted that the number of plots be reduced because they were supporting unemployed Africans, but some

gardening continued (*The Saffery Report* 1943: 12–13). Firewood was also an easy item to sell. For a small fee, some married women prepared meals for single miners.[36] Women learned skills at the women's centers to help earn money. UMCB and company welfare workers encouraged women to put their newly developed skills to practical use, on the assumption that some economic independence would improve family living standards. The companies also recognized the economic attraction of prostitution for single women, and in 1956 Rhokana tried to counter this attraction by setting up a "Polley's Shop" with sewing machines available "for women with no visible means of support."[37] While difficult to quantify, informants agreed that many women gained income from the sale and/or barter of handicrafts (Lloyd and Musumbulwa interviews).

Some women picked up extra money through gambling, which caused elders to complain in the 1940s. In 1948, tribal representatives reported charges that "women were spending most of their cooking time and money in bead gambling." They asked the compound manager to arrest anyone playing that game or gambling with cards. The manager reported that the mine police had been told to bring any women caught gambling to the office.[38] It is doubtful that these efforts halted gambling, an activity that could easily move underground; informants recalled gambling in the mine compounds during the 1950s and 1960s.

Women also sold sexual services for money. Most prostitutes were single, economically independent, and thus entitled to their own class position. Before passes became mandatory in 1944, easy access to the mine compounds made prostitution a profitable business. The compound managers accepted the need for some "loose women" in the single quarters to keep miners happy. Prostitutes earned about 2s/6d to 5s per encounter (Chauncey 1981; 148–49)[39] and were often ruthlessly businesslike. In 1941 a UMCB missionary reported, "On several occasions I have seen a girl of fourteen or fifteen drag out a man who refused to pay her so that he can be jeered at by the whole compound" (Moore 1940: 38–39). Even after pass regulations tightened, prostitution continued. Women charged with unauthorized residence were fined 5 or 10s. They could return to the compounds and earn that in a single night.[40] Occasionally men became involved. In Chingola, for instance, a special grade miner earned money from five Kasai prostitutes who worked from his three-room house (Lehmann interview). But such pimping was the exception rather than the rule. Most women controlled their income from prostitution, which freed them from male domination and undoubtedly enhanced the profession's attractiveness.

Many of these women sold domestic as well as sexual services to single miners. They cleaned a man's clothes and room, prepared special meals, and even accompanied him to the beer hall. Some seem to have developed regular relationships, making their single status more ambiguous (Chauncey 1981; 148–49). Even with pass regulations, women frequently lived in the single quarters. In the 1950s a UMCB missionary recalled that many single men had women in their rooms.

During the day I don't know what they did with all these town women. They must have clustered together into a few huts where it wasn't illegal for them to be, but in the evening time every house had a woman or two cooking in front of the house. Gabbitas [the compound manager] ignored it because I think he knew these men were not willing to stay there without female help with cleaning and cooking (Lehmann interview).

Sexual favors provided income for some married women as well. Adultery was so common in the 1930s that Roan elders rejected the suggestion for a compound dance "because it would encourage immorality by wives whose husbands worked during the dances" (Spearpoint 1937: 34). Adultery remained commonplace in the 1950s. Sexual intercourse, or "playing" as it was known, provided married women with bits of cash and presents. Sometimes husbands even encouraged adultery so they could reap the profits from damage claims.[41] As Anna Mwamba told Epstein in 1953, "Those who normally commit adultery are those who lack money to buy clothes and other things which are necessary to a woman . . . Other women who are likely to commit adultery are those who are too much fond of money and particularly those who have no children" (Epstein Papers n.d., "Anna Mwamba").

A few African women in the mine compounds obtained regular jobs in the welfare centers and hospitals. While African women objected to working as domestics in European homes, women respected welfare and hospital work. Training schemes proliferated in the 1950s, and the number of African women employed by the mines increased dramatically.[42] Sometimes these women earned as much as their husbands, which gave them a new independence. They could support themselves and their children if necessary, and some chose to do so. One informant claimed, "Many educated women I know . . . say we will leave a man, we have our own salary now, we can bring up our own children, we will do better without."

Most women in the mine compounds still depended largely on their husbands' wages, however, a dependence that often led to domestic conflict. Women soon adopted urban living standards and pressed their men for clothes and other European goods. As early as 1934, a well-known anthropologist railed against the materialism on the Copperbelt claiming, "The women on the mines feel they are living the life of princesses."[43] Scrivener reported that the women complain they have nothing to wear and the men grumble that the women spend all their money.[44] Over the years, conflicts over money continued to plague male–female relationships in the mine townships. In 1958, for example, a group of women in Chingola agreed that "money spoils the relationship between husband and wife. The men never give us enough of their wages. Husbands take the money they earn and spend it on beer."[45]

Women in the mine compounds displayed remarkable ingenuity in the battle for their husbands' wages. They cajoled, bribed, and bullied their men, and when that didn't work, they turned to the authorities for help. Disgruntled wives demanded that tribal representatives force their

husbands to give them more money. The elders applied traditional rules of conduct in their efforts to maintain marital stability and traditional authority. They assumed certain basic obligations for both husband and wife and insisted that both sides carry them out. Of course, these obligations were somewhat altered by urban circumstances, especially in inter-ethnic marriages, but elders did at least pressure miners to give "responsible" wives some of their paychecks (Northern Rhodesia 1946; Musumbulwa and Morris interviews).

After 1953, when the TRs were abolished, women in the mine compounds turned to the African personnel departments for assistance. Both African and European case workers believed miners should support their families and were prepared to pressure miners into doing so. Until the mid-1950s, the companies provided rations and housing for all dependents legitimately registered in the compounds. After that, malnutrition rose among the families of men on an inclusive wage (those who received extra money in lieu of rations), and case workers became increasingly concerned about family welfare (Fisher interview).[46] A routine developed for handling marital cases at Roan:

> Mainly a woman would complain through someone below a *changa changa* [compound manager]. They would come to me [a case worker], then Howie [in charge of welfare], and then to the compound manager if very serious. I would try to help. If there was no improvement after a period of time, then I would put it [the case] up the ladder. This gave women some recourse in the mines because the men were afraid of being fired. (Musumbulwa interview)

Case workers lectured errant husbands on familial responsibilities. Regular home visits monitored the progress of problem cases, and husbands were warned that continued "irresponsibility" could lead to dismissal—a threat they took very seriously. While husbands could, and did, complain to case workers about their wives, most complaints came from women, no doubt because they had less access to wage labor (Chiwila interview).

When elders or mine officials could not solve marital problems, women took their complaints to the urban courts. Like the TRs, court members expected miners to support their wives. The courts opposed easy divorce and frequently forced unwanted reconciliations. In one case, for example, a woman asked for a divorce because her husband didn't clothe her properly. The court refused to grant the divorce, demanded that the couples reconcile, and assigned a government welfare officer to monitor the agreement. The court lectured the husband on responsible behavior and insisted that he take better care of his wife. Women more than men seem to have sought redress for marital problems through the courts—either to get divorced or to demand better treatment (Epstein 1953: 10; 1981: 115, 298). According to one witness, men just took another wife and neglected the first, hoping she would leave of her own accord (Sinyembe interview).

Changing partners was another time-honored avenue for self-im-

provement. Since only married women could be long-term residents in the mine compounds, women wanting to stay at the mines had to find another spouse. In the 1930s, this was an easy task. The ratio of men to women was two to one in Chingola and roughly similar at other mines.[47] There were plenty of opportunities to meet new partners in the compounds. Men and women socialized together at the beer halls, recreation centers, and other community events. Many marriages were temporary, and finding a new spouse was relatively easy. Women recognized their bargaining power and used it. One source even claimed, "When a husband fails to pay a woman after pay day, she frequently goes on to another man" (Moore and Shaw 1939; Wilson 1942, pt. 2: chs. 11, 13). Changing partners was both common and easy—so easy that in 1938 Agnes Fraser expressed the hope that Mr. Cross (leader of the UMCB) "will eliminate his expression of producing 'progressive wives'—it sounds like a game of frequently changing partners—a danger that is only too real here."[48]

Despite efforts by the urban courts to encourage marital stability, changing partners continued to be a major source of upward mobility for women in the mine compounds. Changing mates may have slowed down after 1938, but it certainly did not cease and opportunities to meet men remained high. With sex ratios in the mid-1950s of about 142 men to every 100 women (Mitchell 1954: 5), adultery flourished, often leading to divorce and remarriage.[49] Marriage continued to define a woman's status for the most part, and "marrying up" was highly regarded. As one trade union leader's wife put it, "Her first husband was not important." She was glad to have "moved up." Her present husband "is as important as the general manager is in this township. My husband [Nkoma] and Chapoloko [another union leader], they rule you in this township."[50] While few women improved their lot as dramatically as Mrs. Nkoma, women in the mines recognized their value to men. Many refused to endure patiently their husbands' abuse, resorting instead to divorce. One woman would not accept her husband's refusal to sleep with her during her co-wife's pregnancy, telling the court, "She was still a young women, and there were many men about, so she could not be troubled in this way (Sinyembe interview).[51] This woman recognized her value on the Copperbelt marriage market and willingly abandoned marital security for the chance to improve her status through remarriage. The records suggest that such behavior was the rule rather than the exception (Epstein 1981: 77, 317–19; Powdermaker 1961: 163–65).

SUMMARY AND CONCLUSION

The Copperbelt case suggests that, except for economically independent women, a "husband" or father's class standing was an important determinant of women's class position and class consciousness in the mine compounds during the colonial period. Despite uncertain access to their "protector's" wages, miners' wives realized that wage increases at least

potentially raised their standard of living. As a result, women wholeheart-edly supported the struggle against capital. Many went to union meetings. During strikes they marched in picket lines, organized food and support services, and kept up morale. Indeed, some women seemed more com-mitted to the class struggle than their men. During conflict over the staff association, some wives forced reluctant husbands to remain loyal to the union.

The position and privileges of the supervisory miners also affected their wives who were isolated in the compounds along with their men. Women who had been active union supporters were ostracized by former friends. As a result, most staff wives reluctantly drew apart from the wives of daily paid miners and clung to each other, focusing on the material benefits of supervisory status rather than on the hostility of "jealous" neighbors.

Women on the Copperbelt recognized the importance of a man's class by their desire to marry a high-status male (hypergamy). Even women with their own income desired marriage and agreed that marrying a "big man" was every woman's goal. Parents educated daughters, hoping they would marry an important man—preferably a trade union leader, higher grade miner, or white collar worker. Women in the mine compounds understood the class system emerging in the urban areas, and the link between their status and that of their "husbands"; they acted on that knowledge by seeking the best available "bargain" in the marriage market (Musumbulwa interview).

Class alone cannot explain women's behavior on the Copperbelt, how-ever. Women recognized a common vulnerability to men that transcended class lines. No rules guaranteed women a share of their mates' wages. Affluent or poor, a wife still largely depended on her husband's generosity for survival. Rarely able to use relatives to pressure their husbands, women turned to elders, welfare officers, urban courts, church leaders, and other supporters. Sometimes they ignored class lines, seeking out the very people they fought against during strikes. If management would squeeze money from their husbands, women willingly cooperated with them. Thus, at times, the battle between the sexes eclipsed the class struggle on the Copperbelt.

Women also protected themselves by seeking their own income and by changing partners. As we have seen, women in the mine compounds developed a remarkable variety of skills to obtain income. They brewed and sold beer, grew extra food, sold domestic services to single men and used skills learned in the welfare centers to make marketable handicrafts. Married and single women sold sexual services to miners, both on a short-term and a long-term basis. When a man failed to reward a woman for her services, she usually looked around for a more generous partner—not a difficult undertaking given the ratio of men to women on the Copperbelt.

Women also cooperated with each other in the urban areas. They helped one another get to the Copperbelt. Once there, they supplied sup-port and assistance. Neighbors helped each other out with food, child

care, and other services. They cooperated in the gardens, covered each other's illegal beer brewing, taught one another skills learned at the welfare centers, and generally supplied a back-up system that eased the uncertainties of compound life. These informal support networks offered important alternatives to women in the mines, alternatives that freed them to some extent from their dependence on men.

The Copperbelt case thus reveals considerable tension between the sexes. Women were caught between the insecurity of family life and the educational, occupational, and cultural barriers to female autonomy. Although most women made some money from petty trading and small-scale production, only a few could live comfortably on their own income. As a result, both economic and psychological dependence on men inhibited formal organization among women in the mine compounds. Even women who recognized the need for solidarity assumed that an all-female organization would fail. As Anna Mwamba stated in 1953, "Even if we had a strong organization as women, I don't see how this can last because our strength is vested in our husbands, the men" (Epstein Papers, n.d., "Anna Mwamba"). Since most women continued to need and want male protection, a man's class position remained the key to prosperity. Improving oneself depended on individual solutions, especially finding a richer man, or pressuring a man to be more generous. For most women, then, collective action was ineffective, and consequently male needs and demands cut into their commitment to female-oriented organizations. The battle between the sexes could be carried out with great ingenuity and determination, but women's identity remained linked to men as long as women could not fully support themselves.

And yet, during the colonial period independent economic activity and female solidarity at least began to challenge male dominance in the mine compounds. Although only partially successful, women on the Copperbelt doggedly and often successfully sought ways to increase their autonomy. Their efforts disprove any notion of Copperbelt women as mere passive reflections of their men. Rather, they highlight the complex interaction between gender and class and the need to examine women both as members of patriarchal families and as independent actors struggling to gain autonomy in order to define their own class position.

Notes

1. Two mining companies dominated the Copperbelt: Anglo-American (AA) and Rhodesian Selection Trust (RST). The two major RST mines were Roan Antelope Copper Mine (RACM) and Mufulira Copper Mine (MCM). The two major AA mines were Rhokana Copper Mine (Nkana) and Nchanga Consolidated Copper Mine

(NCCM). They are located in the towns of Luanshya, Mufulira, Kitwe, and Chingola, respectively.

2. Roan Consolidated Mines (RCM) WMA 65 file 205.5: compound manager (CM), C. F. Spearpoint, RACM, to general manager (GM), 16 November 1938; RCM file 202.7 (2A): C. F. Spearpoint, "Native Labour Policy," 25 August 1942. A list at the end of the Notes gives details on all interviews cited.

3. The extra cost for a married man at that time was estimated at about 6 pence per day. RCM/KMA 17: Northern Rhodesian Chamber of Mines (NRCM), "Memo on Native Labour Policy," September 1944.

4. RCM file 202.7 (1 and 2): W. Scrivener, compound manager to GM, Nkana, 20 March 1943.

5. RCM/KMA 17: NRCM, "Memo on Native Labour Policy," September 1944. This was later made general policy at the Johannesburg Conference of the two mining companies. RCM file 202.7 (1 and 2): NRCM to all GM, 19 December 1946.

6. In 1942, H. H. Field, the Mufulira CM, admitted that unskilled black labor cost the company 1s/9d per day, while white unskilled labor cost 7d/6p to 10d per day. He believed, "whites in the underground, especially of handiman quality, are overpaid." RCM/KMA 17L H. H. Field, CM to GM, MCM, 1 September 1942.

7. RCM/CSD/202.7, no. 2: African timekeeper, MCM to assistant mine secretary, 30 October 1951.

8. London Missionary Society (LMS) Box 32B: Agnes Fraser to B. D. Gibson, 5 December 1938.

9. Council of British Missions (CBM) Box 1213: LMS London to Agnes Fraser, Luanshya, 15 March 1935.

10. SEC/LAB/57: Repatriation of Unmarried Women from Industrial Areas, District Circular, chief secretary to all provincial commissioners; Zambian Archives (ZA)/SEC/1350: NR police inspector, Fort Jameson to deputy commissioner of police, Lusaka, 1 February 1940.

11. RCM/CSD/WMA 139: CM, RACM to CM, F. Ayer, "Visit of Nzomani, Son of Paramount Chief Mpezeni," 7 January 1937; Colonial Office (CO) 795/91/45109/3: Minutes of the Native Industrial Labour Advisory Board, 26 July 1937.

12. *Annual Report Upon Native Affairs*, 1938; Acc. 72/13: Minutes of a Conference of Assessors of the Urban Native Courts Western Province, district commissioner's office, Kitwe, 14 May 1941.

13. SEC/NAT/264: Meeting of the Urban Court Assessors, at Ndola, 5 April 1945.

14. Acc. 72/13: Minutes of a Meeting of the Native Courts of the Copperbelt, district commissioner's office, Mufulira, 12 May 1939.

15. ZA 1/9/83/2: chief secretary, Livingstone to secretary of native affairs, 27 November 1929.

16. RCM/KHB 14: Notes on the Johannesburg Conference, 9–14 December 1946.

17. SEC/LAB/57: NRCM to provincial commissioner, Ndola, 12 July 1944. In 1953, urban native courts were permitted to issue marriage licenses, which facilitated the migration of women to towns where they could marry whom they pleased.

18. SEC/LAB/45: P. J. Law, labor officer, Monthly Report, October 1941; RCM/KMA 17: NRCM, Memo on Native Labour Policy, September 1944.

19. SEC/LAB/45: labor officer, Report on Visit to Nkana and Mindolo, 7–11 April 1942; SEC/LAB/57: NRCM to provincial commissioner, Ndola, 30 August 1944.

20. RCM/KMA 5: TR meetings, 4 October and 3 May 1943; Acc. 72/13 Minutes of a Meeting of the Native Courts of the Copperbelt, Mufulira, 12 May 1939.

21. LMS Box 28, R. J. B. Moore to Foreign Secretary for Africa, C. T. Brown, 30 December 1934. Some earlier welfare work was done by mine officials for women, but it was either not very effective or expensive.

22. CBM Box 1211, "Evangelism Amongst Women in Urban Areas," *General Missionary Conference of Northern Rhodesia,* 1944.

23. CBM Box 1213, A. Fraser to B. D. Gibson, 17 January 1943.

24. Rhokana (R)-D.4: T. W. Jones, welfare supervisor to N. Conway, social welfare officer, 27 January 1954; RCM file 203.5, no. 1: E. Bromwich to GM, RACM, "African Welfare," 23 November 1953.

25. Roan Antelope (RA)-M.10: Citizen's Advice Bureau, 11 April 1962.

26. (R)-W.9: Welfare supervisor, memo to African personnel manager, July 1957.

27. RCM file 203.5, no. 2: D. Howie, RACM to Department of Welfare and Probation Services, April 1956.

28. Private papers of A. L. Epstein, Sussex University, England (Epstein Papers): interview with W. Munthali, Ngoni clerk, U/G, 1 April 1954.

29. Epstein Papers: interviews with staff association members, 27 February 1954.

30. Copper Industry Services Bureau (CISB) file 100:60:1; no. 2 African Welfare, 1955; RCM file 203.5, no. 2: NRCM. On African Labor Boycotts, 30 August 1956.

31. SEC/LAB/45: Labor Department Report, Mufulira, October 1941.

32. (RA) file 7: Town officer to acting assistant personnel manager, 24 January 1964.

33. In 1935 women received six pounds of mealie-meal a week, and each registered child received two pounds. ZA10/2/2/1: Ben Schaeffer, evidence to the Russell Commission, 1935, 31. In 1940, this improved so women received ten pounds and each child received five. SEC/LAB/45: Labor Report, visit to Nkana and Mindolo, 16–21 September 1940.

34. Epstein even mentions a case where women and children (not the husband) got food from neighbors when the husband was short of money. RCM/KMA 5: Boss Boys' Meeting, Mufulira, 12 March 1945. The boss boys said women like to stay in the same house in the mine compound to be near friends.

35. The hazards were reduced a little by African pressure on mine police to overlook illicit beer production. Some wives of the police brewed beer. Still, in four months during 1945, seventy-nine women were prosecuted for making beer in Mufulira, and thirty-seven were sent to prison for not paying their fines. SEC/ NAT/299 vol. 2: Extract from the minutes of the African Provincial Council: Western Province, 8–9 October 1945. In 1954 fines for beer brewing could even reach £20. Epstein Papers: interview with Shi-Malonda, 28 May 1954.

36. ZA1/9/82/10: Tour report, acting secretary for native affairs, minute no. 608–99, 7 August 1934.

37. Rhokana (R)-W.4: Welfare supervisor to African personnel manager, 8 March 1956; R-W.9: N. Conway, "Vocational Training Amongst Women and Girls," 1957.

38. RCM/KMA 8: tribal representative meeting, 17 May 1948.

39. SEC/LAB/57: provincial commissioner, Ndola to the chief secretary, 23 May 1944.

40. SEC/LAB/45: Labour Department, Nkana Report, 29 February 1944; Com-

plaints continued in the 1950s about prostitution in the compounds. R-T.15: Meeting of the area committee, Mindolo, 15 October 1958.

41. Epstein concluded that in the 1950s African men in the Copperbelt generally believed "that women were not to be trusted, that unless kept under constant surveillance, they would seize every chance to be off in search of lovers" (Epstein 1981: 74, 317–19).

42. Company evidence to the Morison Commission, "Training of Welfare Staff" (Lusaka, 1962); R-W.9: P. G. Lendrum, Rhokana, Report on Welfare and Associated Activities, 1957. He listed three European welfare officers, eight female African welfare officers, and forty-eight part-time African women on the staff at Rhokana.

43. CBM Box 1213: Talk by Audrey Richards at the Africa Circle, London, November 1934.

44. R-A.11: W. Scrivener, compound report, January 1937.

45. D. Lehmann (personal notes): Report on a Discussion of the Young Wives' Club at the Mine Welfare Center for Women, Chingola, 10 March 1958.

46. CISB 40:4, vol. 1: Eighth Meeting of the African Personnel Managers' Committee, 29 August 1952.

47. SEC/NAT/66G: District commissioner, Annual Report, Chingola, 1939.

48. Methodist Missionary Society (MMS), MII: Agnes Fraser to B. D. Gibson, 12 May 1938.

49. In a 1951 survey of Luanshya mine and town locations, Mitchell found 62 percent of men and 55 percent of women were remarried (Mitchell 1957: 3): Mitchell's figures probably underestimate the frequency of partner changes. Many men simply replaced a previous wife without obtaining a marriage certificate. Powdermaker claimed stable marriages existed on the Copperbelt in the early 1950s, but "they seemed to be a minority" (Powdermaker 1961: 162, 169).

50. Epstein Papers, interviews at Roan, 18 March 1954.

51. D. Lehmann Papers, interview with Simyembe; Epstein Papers, Urban Native Court Case #37, Luanshya, 1953.

Interviews

Chiwila, Sandford. Personnel Department, Rhokana. In Kitwe, 30 August 1976.

Cook, Chris. Personnel Department, RACM. In East London, South Africa, 4 October 1976.

Fisher, Dr. A. Charles. Medical doctor, RACM. In Kitwe, 21 August 1976.

Howie, Richard. Personnel Department, RACM. In Johannesburg, 10 October 1976.

Katongo, Theresa. Case worker, RACM. In Luanshya, 3 September 1976.

Lehmann, Dorothea. Scholar and former UMCB missionary. In Lusaka, 21 April 1976.

Lloyd, Mavis. Social welfare worker, RACM. In East London, South Africa, 4 October 1976.

Morris, Sheila. Social worker and wife of UMCB missionary. In Luanshya, 3 September 1976.

Musumbulwa, Fanny. Case worker, RACM. In Luanshya, 1 September 1976.

Mwalwanda, Alfred. Personnel Department, RACM. In Luanshya, 13 September 1976.

Nyiranda, Wrighton. Miner, interview by D. Lehmann. In Chingola, 9 September 1958.

Phiri, Chembe. Management and former union leader, RACM. In Luanshya, 3 September 1976.

Simyembe. Miner, interview by Dorothea Lehmann. In Chingola, 2 March 1958.

Stubbs, William. Northern Rhodesian colonial officer. In Oxford, England, 25 October 1976.

Chapter 9

WOMEN AND CLASS FORMATION IN A DEPENDENT ECONOMY
Kisangani Entrepreneurs

JANET MacGAFFEY

ZAIRIAN SOCIETY IS male dominated, which imposes both social and legal disadvantages on women in urban situations. Women have low levels of education compared to men and are therefore poorly represented in government and the professions. They suffer from male restrictions and control over their economic activities. In the colonial period few opportunities existed for them in the urban environment to become wealthy independently of men. Since independence, however, some women have not done so badly in the struggle between the sexes, and some of them have evaded male control and overcome their social disadvantages to achieve autonomy as successful and wealthy entrepreneurs.

A close look at Kisangani, one of Zaire's three principal cities, shows that a few women have managed to escape the fate of the great majority of African women; instead of becoming increasingly impoverished, they are in fact doing very well for themselves. The same has happened elsewhere in Africa also; in Senegal, for example, Grandmaison details the acquisition of means of production by wealthy women traders (1969: 149–51). Little (1973: 44) mentions the enormous economic success of individual women merchants in Nigeria and Ghana, and Sudarkasa (1973) documents the autonomous business activity and substantial wealth of some Nigerian women. But the success of the few does little for the position of women in general in these societies. In Zaire, such women find it more in their interest to establish their own position as members of the middle class than to further female solidarity across class lines. They bear out Staudt's conclusion that commercialization, upward mobility, individualism, and competitiveness motivate some women more than female solidarity (Staudt 1982: 152).

In Kisangani some women have achieved success in business and commerce independently from men; others have manipulated their connections with men to get a start in business but have thereafter achieved

161

enough autonomy and success in managing their affairs to make them significant in business in their own right. They have thus succeeded individually in attaining a position in the small commercial middle class that is emerging in the city. The processes of formation of this class have been gender-specific, and the data presented here show the intertwining of gender struggle and class formation, one of the major issues raised in Chapter 1 and given particular emphasis by Bujra in Chapter 7.

THE FORMATION OF A COMMERCIAL MIDDLE CLASS IN KISANGANI

Class is used here to refer to positions in the system of relations of production; classes are not necessarily recognized as such in the consciousness of the actors. In any capitalist society, divisions and conflict exist within the two great classes of Marx's abstract model, the bourgeoisie and the proletariat. We are concerned here with sectors, or fractions, of the dominant class ("bourgeoisie") in Zaire. The small, commercial middle class that is emerging in Kisangani is a new sector of the dominant class. But it is distinct from the rest of this class because it represents the beginnings of an indigenous local capitalist class, an embryonic true bourgeoisie in the classical Marxist sense, in contrast to the "comprador bourgeoisie" that forms the rest of the dominant class. I refer to this comprador class as the political aristocracy (Callaghy 1983:66–67) rather than as a bourgeoisie because its members exhibit neither the attitudes nor the economic practices of classical capitalism; they pillage the economy rather than investing their wealth in its expansion (Gran 1979; Schatzberg 1980).

The political aristocracy in postindependence Zaire derives power from partnership with the international business concerns which continued to control the economy after independence in 1960. Unlike the classical Western bourgeoisie, therefore, the interests of this class are based on control, not of the economy, but of the state. It has invested in distribution or in foreign bank accounts rather than in production and has dissipated its wealth in conspicuous consumption. Zaire's economy is a typical example of dependent capitalism. It produces raw materials (principally copper and other minerals) for the external markets of the developed countries, upon which it is dependent for capital, technology, and manufactured goods (D. J. Gould 1978; Verhaegen 1978, Gran 1979). Gould and Verhaegen conclude that such dependent capitalism is self-perpetuating and prevents the development of local capitalism, stating, "The national bourgeois elite . . . have in effect absorbed the commercial bourgeoisie" (D. J. Gould 1978: 3), and "at present there is no economic bourgeoisie forming in Zaire" (Verhaegen 1978: 377; author's translation). Data from Kisangani, however, lead to a different conclusion.[1]

In Kisangani a small but growing class of substantial business owners is emerging to constitute the beginnings of an indigenous local capitalist

class. They invest in enterprises producing for the internal market as well as in production for the external market, and through educating their children, enjoying a middle-class life style, and investing in inheritable productive property and real estate, they are reproducing themselves as a class. This small commercial middle class of men and women do not hold political position and are relatively independent of politics. Such independence can only be relative, it must be noted, because in Zaire today, in order to function at all, personal connections of some sort to politicians and bureaucrats are essential. These entrepreneurs, however, do not hold political office, with official salaries and the massive opportunities for fraud and extortion that even minor offices afford, but rather derive their wealth from business.

The approach of Leys, Brenner, Portes, and others goes beyond the dependency perspective and better explains the situation in Kisangani. They stress the centrality of internal class relations in the development of capitalist relations of production. In Leys' view, peripheral capitalist countries may experience capital development within the situation of dependency; he analyzes the conditions under which this development does or does not occur by investigating "class relations and class struggles and the process of capital accumulation that forms the basis for the constitution of one particular class" (Leys 1978: 244). In Kisangani, the basis of the newly emergent commercial middle class is capital accumulation in wholesale, retail, and transport businesses, plantations and ranches, fisheries, manufacturing, processing and services, and investment in the expansion and acquisition of such concerns. A process similar to that described by Swainson in the rise of a national bourgeoisie in Kenya is noticeable here: a rapid increase in indigenous accumulation of merchant capital and a gradual move into the sphere of production (Swainson 1977).

Kisangani is a particularly suitable place to investigate the process of class formation. Strategically situated on the Zaire River at the head of navigation, 1,000 miles upstream from Kinshasa, the capital, it is the major administrative, commercial, and transportation center for the region of Upper Zaire, and its hinterland is rich in natural resources. The city mediates between the rural hinterland and Kinshasa, the country's economic and political center; opportunities for profit in export-import trade between center and periphery are particularly evident.

Coffee and other agricultural products are exported through Kisangani, which in turn serves as a distribution center for manufactured goods, foodstuffs, fuel, and construction materials. The city has some light industry, forty wholesale firms, many retail stores, and a large central market. In 1980 its population was about 280,000 nationals and 1,500 foreigners. The number of languages spoken in the city indicates the ethnic diversity of its population: in addition to French, the official language, two linguae francae, Swahili and Lingala, and at least eighty-six other African languages are spoken.[2] No ethnic group dominates.

Kisangani owners of large businesses fall into several categories:[3] twenty-three are Zairian politicians and military officers; twenty-eight are

big national and international import-export firms, both foreign and Zairian; twenty-five are Greeks, twenty-four Asians and a few come from other foreign countries. Thirty-two are nationals who do not hold political office, nine of them women. Research focused on these thirty-two nationals, a relatively small number but substantial enough in comparison to the other numbers just given; 22.5 percent of the total. The larger enterprises of these thirty-two had several hundred employees; the smaller under thirty. Forty-seven of their businesses operated in the productive sector, and fifty-four in the distributive sector. In their productive enterprises we find some development of production for the internal local market: furniture and work uniform manufacture, fisheries, meat, rice processing, and palm oil, all for local consumption; rubber for the Goodyear factory in Kinshasa; and milled lumber for the furniture factory and local construction. Timber and coffee, from plantations owned by the majority of these entrepreneurs, are exported. In the future some of these entrepreneurs plan the development of production for the internal local market: a pharmaceutical factory; sisal plantations; expansion of livestock rearing; and the manufacture of jewelry and sacks.

Opportunities to get started in business for those who did not hold political office came from particular events and circumstances that men and women were able to take advantage of in different ways. They arose as a consequence of the political chaos of the 1960s, the indigenization of foreign capital in the 1970s, and the expansion of the second economy since the late 1970s. This sector of the economy consists of unmeasured and unrecorded economic activities; some are illegal, but even the legal activities are organized so as to avoid taxation and enumeration. It is also referred to as the underground, parallel, or informal economy.

In the 1960s the political upheavals that followed independence caused many foreigners to abandon businesses, plantations, and real estate and flee the country (Young 1965: 330–40). Some of the independent entrepreneurs in Kisangani started in business by taking over these concerns and buying real estate for very low prices. The disruption of the local economy and the resultant shortages that followed the rebellion, the mercenary uprising, and the 1964–68 army occupation (Young 1965: 594–98) provided opportunities for other individuals with enterprise and some capital to start successful businesses. The Zairianization decree of 1973 handed over foreign businesses and plantations to nationals, mostly those with political positions or connections (see Schatzberg 1980: ch. 7), but some of Kisangani's independent enterpreneurs also benefited directly from this indigenization of foreign capital. Others benefited directly when many of the new owners proved incompetent and went out of business, creating an expanding market for those who remained. In 1976 the "decree of retrocession" returned failed businesses to their former foreign owners in partnership with nationals, again providing an opportunity for some people to get into business.

These events provided opportunities for women as well as for men, but it is particularly in the activities of the second economy that women

have found possibilities for capital accumulation. The activities of this economy are by definition outside the control of the state. Its recent rapid expansion is attributable to Zaire's deepening economic crisis since 1976, which has caused acute shortages of food, fuel, and manufactured goods (World Bank 1980), and to the weakening of the state. The failure of public institutions, which support male control over women by such devices as the rule that a woman may not open a bank account without her husband's authorization, has enabled women to preserve in second-economy activities the freedom of action that they traditionally enjoyed. Gender is thus a specific factor in the processes of formation of the commercial middle class in Kisangani.

GENDER AND CLASS FORMATION

The part played by women in the emergence of this new class sector accords with Bujra's suggestion in Chapter 7: these women in Kisangani have succeeded in asserting their autonomy and have become members of this emergent class individually and not just as dependents of men. The processes of class formation are gender-specific here because women have faced different problems from men and have been able to take advantage of different opportunities.

Women got off to a bad start in Kisangani. Colonial law ordained that they could only migrate to town as the dependents of a resident, and married women without work could stay in town only as long as their marriages lasted. Since few had any education, they were disadvantaged in getting jobs. In 1952 only 15 percent of women sixteen years and over, compared to 50 percent of the men, had received any formal schooling and less than 2 percent of the women, but 90 percent of the men, were in wage-earning employment (Pons 1969: 37, 52). Of the 110 women out of 20,334 in the city who were wage earners, 65 were employed in the cigarette factory, the rest as nurses or nurse's aides, teachers, or maids (Xydias 1956: 287). Unlike women in West Africa, few women in Kisangani (with the exception of the Lokele) were involved in trade (Pons 1969:214). Indeed, foreigners dominated commerce and business, and all nationals, regardless of gender, were subject to restrictions.

In these early years the only occupation that enabled women to remain in town legitimately was prostitution. "Urban feminine roles inevitably came to be defined as more specifically sexual and domestic than the tribal roles to which most women had been reared in youth" (Pons 1969:219). In his 1952 study, Pons found a number of divorced or widowed women who had spent their young lives as prostitutes and who later became shopkeepers and landladies; other more fashionable women were the relatively independent mistresses of wealthy African men or high-status prostitutes with small changing sets of lovers (1969: 248, 215). La Fontaine refers to such women, more appropriately, as "courtesans" (1974:99).

Thus, finding wage employment or entering the professions has al-
ways been much more difficult for women than for men. In Kisangani in
1979 there were no women in law, medicine or government. Few employ-
ment figures exist, but the numbers of male and female office workers are
available for just two years: in 1976 3,563 men and 176 women were
employed in office work; in 1977 2,342 and 210, respectively (*Rapport
Annuel Administration du Territoire* 1977.[4] Therefore, unlike men, women
cannot accumulate savings from salaries, gain knowledge of management,
or build up business connections by working in large enterprises. Further-
more, completing school or university is still much more difficult for girls
than for boys (Schwartz 1966; T. Gould 1978).

Since independence, however, the situation has improved and some
women have moved into commerce and business. This change was largely
a result of the rebellion and the violent events of 1964–68 which took
numerous male lives, leaving many women alone with children to sup-
port. Since this time women have outnumbered men in the city, reversing
the demographic trend of the colonial period.

High inflation also helped women to move into commerce. Commer-
cial activity on a small scale was always acceptable, but formerly men did
not want their wives in employment, fearing that it would increase oppor-
tunities for infidelity (Bernard 1972:276–77). Men now find it necessary for
their wives to bring in an income and contribute to family support be-
cause of the high cost of urban life. By 1965 some women had become big
traders, bringing food from Kinshasa to Upper Zaire by boat and more
expensive goods, such as cloth and radios, by plane. A few with larger
capital engaged in importing food, or in trade to the interior (Comhaire-
Sylvain 1968:187–88). By 1979 women were achieving renown for their
success in business; some were known to be millionaires, others to have
bank accounts of ₣100,000–200,000. In Kisangani in 1980 a busi-
nesswoman was elected to the regional committee of the Chamber of
Commerce. Lack of education is no longer the block to advancement that
it was. One woman with a university degree abandoned a professional
career to take up potentially more lucrative commercial activities, and
another who was completely illiterate engaged in a flourishing commerce,
making more money than her father, who had a wage job. Thus, in
Kisangani, for a few successful women, education, or the lack of it, is
irrelevant, contradicting the hypothesis of Chapter 6 in this volume that
women are always in disadvantaged positions relative to men, whether or
not they go to school.

Thus, by 1980 the situation for some women in Kisangani had greatly
improved. Nine of the substantial business owners not connected with
politics, or 28 percent, were women, specializing in long-distance retail
and semiwholesale[5] trade, exporting and importing goods to and from
Kinshasa or to the interior by boat, plane, and truck. Women formed a
significant proportion of the retailers with fixed stores in the central
commercial and administrative zone of the city, numbering 24 out of 113

(21 percent) in the rough survey that I made, and they dominated market trade.

The most profitable commerce, shipping fish, rice, and beans down-river to Kinshasa, is carried on by five of the nine substantial business owners but also by many others who do not appear on any official lists of businesses. For this reason I have not attempted any assessment of their numbers or the extent of their activities here. Even if a woman has a commercial license, she does not necessarily use the bank, keep accounts, or report all her commerce, even though it may be on a very large scale. One of the women on the official lists shipped 100 to 200 sacks of beans down to Kinshasa every month or two. Beans in 1980 cost ₹200 a 90 kg sack and retailed for ₹ 300 in Kinshasa. Even after deducting river transport fees of ₹ 24 a sack, transport to and from the docks, and losses from theft, which she assessed typically as 15 sacks out of 200, net profit was around 30 percent, higher than the 20 percent most wholesalers and retailers hope to be able to make. Other women brought ₹ 30,000 to 50,000 ($6,000 to 8,000) of smoked fish at a time to take down to sell in Kinshasa.

Women with substantial business concerns in Kisangani were clearly businesswomen in their own right, successful by virtue of their own effort and business acumen. Data to quantify this statement is impossible to obtain because so many business transactions are unrecorded; but available data and my observations supported people's perceptions of women as important in business in their own right. Of the eleven women for whom there is information, six acquired their initial capital from petty trade, one from her salary as a teacher, one by gaining credit, and one from working as a prostitute. Only two had obtained the money from their husbands. Some women had relied on men at some point in their careers, but such assistance did not necessarily imply continued dependence. Some women saved up their initial capital from their own commerce and did not marry or remained entirely independent of their husbands in business affairs; others married after they had independently established themselves as successful businesswomen and thereafter operated in business partnership with their husbands but managed their side of the business independently. Some who received initial capital from their husbands then built up the business with no further assistance; for others the husband was clearly the subordinate partner in the business. Some women were able to exploit connections with their lovers.

These assertions come, in part, from case studies (including family and career histories and details of businesses) obtained from seven of the nine women owners of substantial businesses, seven retailers, four owners of market stalls, and two members of the Lioness Club who were involved in business but were not business owners, a total of twenty in all. These women were in their thirties and forties, relatively young compared to the successful West African traders studied by Sudarkasa (1973) and Robertson (1984b).

The first history concerns an owner of a substantial business who is completely independent of her husband. She started in commerce on a small scale on her own, then benefited indirectly from Zairianization when her retail business expanded rapidly because many new owners of businesses went bankrupt.

Madame W. is married to a Zairian businessman, but they are not business partners: her enterprises are her own and managed by her. In 1971, after five years of secondary school, she started in commerce by trading manioc downriver from Bandundu to Kinshasa. After two trips she had realized ₹ 500 to put in the bank. She did not want her husband to know she was trading and to interfere in any way, so her elder brother signed as her husband giving her the necessary permission to open a bank account. On her third trip 100 out of 107 sacks of manioc were stolen. Her sister, a big trader, helped her to get credit from the bank for a forty-five-day loan; she bought fresh fish (the much prized *capitaine*), an unusual item, and sold it all at the dockside in Kinshasa, spending ₹ 300 and making ₹ 1,500, a profit of ₹ 1,200, and paid the bank back in ten days. The bank manager was delighted and increased her credit. Further theft discouraged her, however, and she decided to follow her sister in selling wax-print cotton cloth, sold in lengths for making blouses and wraparound skirts. She began to trade all over the country, traveling by plane and selling wax-prints in Lubumbashi, Kisangani, Kivu, and Mbandaka. By 1973 she had ₹ 30,000 capital and bought a house and a store in Kisangani. Her younger sister managed the store when Madame W. traveled.

In 1974 she started in transport, buying a truck and opening a store in Bunia, in the interior. By 1979 she had opened three more stores in Kisangani, one of them a luxury boutique selling imported wax-prints, liquor, shoes, and men's shirts, with the decor of a European store. The shelves in the display cases were covered with pebbles on which a few pairs of shoes were arranged, interspersed with Christmas tree ornaments. She has fifty employees, including seven members of her family, and owns five trucks, four cars, and four houses to rent out. In 1979 she ran a bus service for a while. She supplies her stores by going to Kinshasa every two months to buy from wholesalers, gets a relative to buy wax-prints for her in Brazzaville, travels to Rwanda on buying trips about once a month, and also buys from the Kisangani wholesalers. Her son and daughter attend Catholic schools. She and her husband share household and educational expenses.

Madame W.'s business in Kisangani expanded rapidly because of the lack of competition after Zairianization. Her history reveals other factors contributing to her success. She received help from her brother and sisters, both in starting out and in assistance in her business, and she is innovative in choice of goods and type of store. The profit she made on particular transactions and the rapidity with which she accumulated capital reflect an economic situation in which an enormous differential exists between wholesale prices and the prices the consumer can be forced to pay, so that large profits are made from shipping goods from one part of the country to another where they are scarce and charging a high markup. Her experience of massive theft illustrates one of the most prevalent problems in the transportation of goods. Her history also shows that a successful businesswoman can have good credit with the banks and can also make unofficial arrangements to deal in foreign currency.

The next two histories concern women who established themselves in business and then married foreigners. If a woman has a foreign husband or lover, his business ties outside Zaire, holdings in foreign currency, business experience and contacts, ease of getting credit, and the mutual assistance networks among members of the foreign business community all offer potential opportunities for the expansion of a woman's enterprise. As a Greek remarked, "Foreigners are a resource in Zaire."

Madame F. is one of forty children of a customary chief. She had only a few years of primary education but is spoken of as one of Kisangani's biggest businesswomen. She started in business by running a bar. By 1961, with the help of a loan from the government agency for business assistance, Société de Crédit aux Classes Moyennes, she was able to buy two coffee plantations from departing Belgians. After the rebellion, she opened a nightclub and sold alcohol wholesale, which was popular and profitable in a town full of soldiers. She thus already had substantial business concerns in 1965 when she married a foreigner who owned a fishery. They operate their businesses in partnership, but she manages the ones that were hers. They own a transport firm (that until recently had eighteen trucks), stores in Bunia and Kinshasa, and ten houses for rent (she told me with pride that she had personally supervised the building of six of them), as well as the fishery, plantations, and nightclub. They have 264 employees. She had a license to begin exporting coffee in 1980. In her house she has photographs of President Mobutu presenting her with two gold medals for her plantations and businesses, an indication of her importance and reputation as a businesswoman independently of her husband. Their son is at secondary school; their daughter manages their Kinshasa store.

Madame B., also one of the best-known businesswomen in town, completed secondary school, then went into commerce by buying a truck on credit and trading all over Upper Zaire, Kivu, and Kasai. She acquired a store in Kisangani after independence, when "it was easy to get a store there were so many left empty." She married a Kenyan who made his money in transport and now imports fish, helped by a family connection in Mombasa. They are partners in business and very wealthy. Like Madame F., she manages and carries out her enterprises in the partnership independently. She goes to Kinshasa once or twice a month, exporting fish, rice, and beans on a large scale and importing food, cloth, and other goods. They have invested their profits in coffee plantations and real estate. One of their daughters is studying medicine in Brussels.

In the following history a woman's husband helped her to get started, but she developed her own business thereafter.

Madame L. had one year of university education. Her husband is a wealthy professional; through his European connections she was asked to be a partner with a Greek woman in a women's dress store. The Greek went home but is still co-owner of the business. Madame L. has been running it on her own since November 1979. In early 1980, when other businesses were almost at a standstill after the demonetization of December 1979, Madame L's store was usually busy with plenty of customers: the changes she had made showed an eye for a good market that had clearly brought success. The Greek had left her unsalable merchandise rather than money, but Madame L., with the help of her husband, put in ₴ 1,000 and started buying dress lengths of material from Kinshasa and making it up on order into European

style, high-fashion dresses, skirts, and blouses. She also sells clothes and other items for children and accessories such as leather purses. She employs two tailors on the premises.

Madame L. observes that she has the only shop that sells European-style women's dresses and that wealthy women love to buy smart clothes for themselves and to dress up their children. After only a few months in operation, she had a clientele of about thirty regular customers who liked to wear clothes they did not see other people wearing and who encouraged her to buy costly materials.

She has a sister in Kinshasa who buys and sends up material for her, and she also goes there herself. Her mother is an expert seamstress who supported herself and seven children by running a store after her husband, a government official, was killed by the rebels. Madame L. says she learned how to run a retail business by helping her mother.

Madame L.'s business opportunity came from retrocession; her husband supplied the necessary initial capital and foreign connection, but her own enterprise and innovative ideas were important to her success. This success is itself evidence of the wealth of some women in Kisangani today: her store caters to the dominant class that provides a new and expanding local market for luxury goods. Her history shows, in particular, the importance of successful innovation as a factor in business.[6] Like the other women discussed above, she makes use of her family in business. Her mother provides an example of a woman who turned to commerce when left without means of support after the rebellion.

Another woman who works in partnership with her husband is clearly the dominant figure in the business:

Madame S. had two years of secondary school, then worked two years as a teacher. She is in the retail business and she also ships fish, rice, and beans to Kinshasa. She has two stores and two boutiques. She began by selling doughnuts in 1974 until she had ₴80 with which she started a boutique at her house for doughnuts and gradually other things as well. She was successful enough to start a second boutique in the market the same year and by 1975 to rent a store nearby. In 1979 her business had expanded enough to rent an additional newly built store, in a good location. She sells food, household goods, blouses and wax-prints, and cosmetics. Her suppliers are the big Kisangani wholesalers or traveling merchants, and she gets cosmetics from Kinshasa, going there by plane every three or four months. She employs ten salesgirls and three sentinels. Her husband, a Zairian, is a partner in her business. They own one truck, two cars, and two houses, one of which they rent out. She is on the committee of the women merchants' association. She complains of the lack of goods since 1976 which forces her to buy third hand at high prices from the traveling merchants and local speculators: "The problem is that we have the money but no means to deal directly with foreign suppliers."

One woman was able to use her connection to her foreign lover to acquire his business through Zairianization. She paid for it out of her own savings, however, and she, and others, commented on how hard she worked to bring about her success:

Madame K. had three years of secondary school. She traded on a small scale on weekends, learning from her mother. She then worked as a teacher for four years. She had a child acknowledged by a Portuguese, which entitled her to claim his business in Zairianization. She paid for his store and three trucks using ₤ 2,000 of her own money: ₤1,000 as a downpayment for the business and three trucks and ₤ 1,000 to work with. She continued paying money each month to the bank until the business was paid for. She built it up successfully enough to buy five houses in 1976 and 1978, and also the building, which includes another shop besides hers and two apartments above. She has nineteen employees. She ships beans every one or two months to Kinshasa and travels there herself to stock her store about four times a year. She also trades to Bunia in the interior, where she has her own agent.

Madame K. built up the business she took over by herself without help from husband or kin; she mentioned lack of family for help in child care as a problem. She invested her profits in real estate and in educating her daughter at the Belgian primary school.

It is particularly through activities in the second economy, which enables some women to become very wealthy, that women have evaded the control and bypassed the specific restrictions imposed on them by men, such as the need for a woman to have her husband's permission to deal with the banks or obtain a commercial license. The new Civil Code, Book III, deals with the family and consolidates a man's control over his wife's wealth. Article 45 specifies that the management of the wife's goods is presumed to be in the husband's hands, even though the marriage contract may specify separate ownership of goods by each spouse. A woman may only take over management in cases of proven incompetence of her husband (Article 510). She may manage goods acquired in the exercise of a profession, but her husband is allowed to take them over in the interests of the household (MacGaffey 1982). Hence the importance for women of second-economy activities which are undocumented, not governed by law, and thus outside the control of men. When they operate in this economy, women do not use bank accounts, bank credit, or commercial licenses, and they do not keep records. This evasion of male control had started by 1965 (Comhaire-Sylvain 1968:187). By 1979 many women were conducting large trading operations that they never reported to the authorities, taking advantage of the situation of scarcity in Zaire. In Kisangani it was very difficult to obtain individual histories of careers founded on such activities or talk to many individuals who engaged in them, but it was clear that they provided widely utilized opportunities.[7]

A precise account of women operating in the irregular economy came from a man whose own money was apparently made in *"affaires personelles"* (a euphemism for irregular activities). He observed:

These businesswomen [*femmes d'affaires*] are different from women traders [*femmes commerçantes*]: they make enormous amounts of money. There are many of them, but they do not make their wealth and success as obvious as do men, although they may be richer. They are difficult to find and talk to because they distrust anyone

inquiring into their business. They may have commercial licences, but they usually do not keep accounts or record transactions because they want to avoid taxes.

These women specialize in particular kinds of goods, many of them in wax-prints, and they are expert in women's current taste in colors and patterns. Some deal in fish, especially the Lokele in Kisangani; others, for example, in flour, if they have a relative among the big suppliers.

They are mostly older women who started in business because they found themselves in difficult circumstances, such as losing their husbands, and who achieved success because of some particular advantage, such as having a relative or connection among the authorities.

I did succeed in talking to a few women who do such business, such as Madame N., who has a retail store run by her mother and sister while she travels and brings back merchandise to sell retail and semiwholesale to other retailers:

Madame N. began in 1975 by sewing infants' dresses at home and selling them. Soon she hired a tailor and they worked together. By the end of the year she had ₴ 500 and began to travel [*faire la navette*], trading between Kinshasa and Kisangani. There was a shortage of sewing thread in Kisangani, and she started out buying a lot of it in Kinshasa and selling it easily in Kisangani. Then she turned to wax-prints and was able to open a shop. In 1979 she moved to a better location, and business has gone well. She sells prints, women's blouses, baby clothes, beauty products, household goods, alcohol, and shoes for men, women, and children.

She goes to Europe three times a year, to Brussels for wax-prints, to Bologna for shoes direct from the factory, and is continually away on trips in Zaire or to the Sudan or Rwanda. She goes to Lubumbashi, Kivu, Isiro, and Bunia in Upper Zaire, and Kinshasa. On trips to the Sudan or Rwanda she goes with a truckload of rice or palm oil to sell and buys wax-prints. These prints supply her store but are also sold to other retailers. "If you do not have goods to interest your customers, and plenty of them, business does not go well," she says. Contacts are also essential to do well in business. Her husband was formerly an official in Lubumbashi and she has good connections there as a result, as well as in Brussels and Italy. Otherwise she has gradually built up her own business connections in different places. She is lively, attractive, and intelligent, speaks good French and also Italian, although she only had two years of secondary school because she married at sixteen. She would only say that she had "arrangements" to get foreign currency. I learned later that she had a bank manager for her lover.

Madame N. built up a successful business on her own from a small start, made use of her highly placed lover to expand her enterprise, and has international dealings, indicating the considerable scale of her activities.

Traveling commerce starts on a small scale with minute calculations and quick responses to supply and demand. Success does not always follow, and most women do not achieve large-scale operations. Whether they do so or not depends on their circumstances, their connections, and the opportunities that come to them. The following example is of a young woman who is trying to get started:

Madame H. is married to the manager of a local branch of a Kinshasa store. She has a stall in the market and carries on trade between Kinshasa and Kisangani, working with her husband's brother's son in Kinshasa. One of the items she trades in is cigarettes, which are always in short supply. For example, on one trip early in 1979 she bought four cases of cigarettes at a cost of ₴ 3,400 in Kinshasa and sold them in Kisangani for ₴ 4,000. Her plane ticket cost ₴ 252 and the air freight charges ₴ 60, so she made a profit of ₴ 208. But then they raised the air fare to ₴ 500 so such a trip was no longer profitable.[8] She also trades in other goods as opportunity offers. At one time there was a shortage of soap in Kinshasa, so she bought soap originally imported from Kinshasa in Kisangani at 200K a packet, took it to Kinshasa and sold it for 420K a packet. . . . But an attempt to repeat this success failed when the price dropped in Kinshasa and they suffered a loss. On another trip they had a loss because of theft.

Risks in this speculative trade are thus high and success is by no means sure, but, considering that in 1980 the monthly wage of an unskilled laborer was ₴ 60, that of a clerk ₴ 109.80, and that of a government department head only ₴ 384, the profits to be made in this trade are alluring. A profit of ₴ 208 on one trip to Kinshasa is very good money. Some, however, try it and fail on the first attempt, which discourages them from trying again. The situation in Kisangani is like that in the Copperbelt, described by Parpart in Chapter 8, where women may sometimes make more money in the second economy than their husbands do in wage employment. As Bujra suggests in Chapter 7, one reason some women do not work for wages may be that they find commensurate rewards elsewhere.

Women may exploit their sexuality to operate in the irregular economy. Some obtain scarce goods for their trading through sexual liaisons; others use such connections to get purchase vouchers for goods, fuel, or beer at the official price then sell these vouchers at 20 percent or more profit to other intermediaries or retailers. These activities are not controlled by men. They can be compared to those by which women in Nairobi described by Bujra attained middle-class position; 46 percent of the landlords in Pumwani location were women. Through prostitution and beer brewing they accumulated savings that equaled or surpassed those of men and invested them in building or buying houses or in petty trade. These women played an independent role in the process of class formation and formed an important element of an embryonic African "petty bourgeoisie," partly because "institutions of male control over women were unable to develop effectively in this situation" (Bujra 1975:234).

Details of the careers of businesswomen reveal the individual characteristics and socioeconomic factors that contributed to the successful careers of the women of this new commercial class: business acumen, hard work, and a sense of a good market opportunity; the use of successful innovation; the help of kin, husbands, or lovers in starting and operating enterprises; and an economic situation of scarcity in which large profits

may be made but in which many problems, such as theft, speculation, and the high cost of transport, increase the difficulty of getting goods. Commerce is thus potentially lucrative but also risky, and many who enter it fail or have only small success.

THE USES AND ABUSES OF SEXUALITY

These case histories show that some women take advantage of their sexuality to manipulate men to their economic advantage. Some barter sexual favors; others get capital, business connections, or other assistance from their husbands or lovers. This use of their social position by women is another factor differentiating them from men in the process of class formation. Sexuality is a weapon that men, by virtue of their dominant position in society, do not generally need to use.[9] The idea that women can succeed in business only by sleeping with some man is prevalent among men in Kisangani, and when discussing businesswomen they generally equate success with sexual promiscuity. They say: "women prostitute themselves to further their commerce"; "a successful businesswoman must be a *femme libre*"; "a woman cannot be successful without the assistance of some man"; "if a woman is to get a good supply of merchandise she must sleep with her supplier." The male equation of successful businesswoman and *femme libre* reflects the increasing economic independence of women in the urban economy since independence, as well as men's ambivalence about this success and the sense that they are unable to control women as they would like to. Sexual harassment is one way that men can take advantage of women's ambitions and assert power over "uppity" women.

In a study of Atu, Kenya, Bujra concludes: "Without equivalent access to productive resources and without active participation in the productive processes of their economy, women cannot gain an equal footing with men. They are forced back to utilizing their sexuality as their sole resource" (Bujra 1977:38). As shown above, women in Kisangani found themselves in this situation initially because prostitution was the only widely available urban occupation for single women. Verhaegen describes the way the colonial government contributed to this situation while fully exploiting it. In issuing identity cards, the government made no distinction between the status of *femme libre*, prostitute, and single woman; except for the elderly and widows, all were taxed, whether they practiced prostitution or not. From 1939 to 1943, over 30 percent of the adult women of Stanleyville (the colonial name for Kisangani) were registered as *femmes libres* and paid a tax which was the second highest source of revenue in the African urban area. Since nearly 50 percent of the men of the town were unmarried, many of these women must have been concubines or partners in temporary unions, so the translation of *femme libre* as "prostitute" is misleading (Verhaegen 1981:55–57). Little points out that what in the West may be called prostitution overlaps with other kinds of

relationships in the modern West African town. He proposes to confine the term to "women whose livelihood over a period of time depends wholly on the sale of sexual services and whose relations with customers does not extend beyond the sexual act." Some women may have relations with clients that have quasi-uxorial qualities, or may earn money by this means only periodically (Little 1973:84–87). In Nairobi, prostitutes offered various kinds of domestic services (White 1983). The term *femme libre* covers all these types of relations and is perhaps best translated literally as "free woman." Taxes on these women represented 80 percent of revenues in Lubumbashi in the African urban area (Malira 1974:66,71).

In a study of the free women of Kinshasa, LaFontaine points out that the term *femme libre* refers to a new type of feminine success because it applies to women not bound by rules of wifely behavior, who are more sophisticated and free of the stereotypes of feminine subordination to men: "It is thus intelligible why the term *femme libre* is applied to any woman who supports herself in a job in the modern manner, be she ever so virtuous" (LaFontaine 1974: 96).

Many women do not wish to exploit their sexuality and consequently suffer considerable sexual harassment from men. One said it was a problem to get goods from wholesalers because they wanted sexual favors in return. She felt it was particularly difficult for a married woman like herself. Another spoke of the difficulties girls had going through school: "In order to pass exams a girl must sleep with the teacher, and the school directors are just as bad so it is no good complaining." Facing the same trouble at the university, she dropped out after one year. Another businesswoman gave talks on the radio on the sexual harassment that confronted young girls trying to make their living.[10]

These male attitudes and actions circumscribe women's acitvities in various ways. For example, the members of the Lioness Club, founded in 1979 and including several businesswomen, have to meet in members' houses, instead of in a hotel as does the Lions Club, "so our husbands won't object." The club began by enrolling only wives of Lions Club members, since such husbands would not be suspicious of the club's purpose.

FEMALE SOLIDARITY VERSUS CLASS INTEREST

Do women in Kisangani organize themselves to cooperate and unite in the face of male antagonism and economic difficulties? Their attempt to do so by forming a women merchants' association, the Association des Femmes Commerçantes (AFCO), has not been very effective. This organization promotes the interests of the middle-class women who organized it, thus providing an excellent example of the trend, discussed by Bujra in Chapter 7, for class interests to override female solidarity in women's organizations. AFCO also functions as an instrument of male control, so that, in this case, male dominance accompanies the promulgation of women's

class interests. However, the organization also provides a forum in which the less successful women who make up the majority of its members can become aware of their common interests and begin to articulate them.

AFCO was founded in 1972 to combat price rises and speculators, to represent women merchants to the authorities, and to provide mutual assistance for funeral expenses. Members must pay an initial contribution of Ⱬ 50, and Ⱬ 10 a month thereafter. Conditions of membership show that the organization is subject to male control; a married woman requires her husband's consent to belong, and members must have a commercial license. The cost of a license was raised in 1980 to Ⱬ 2,500, an amount that will inevitably make it more difficult for women to start out in legal commerce. The association's dealings with the authorities sometimes function merely as a forum for male domination; Kisangani's daily newspaper, *Boyoma*, reported that in 1976 at a meeting with AFCO members, the regional commissioner urged them to combat tribalism among themselves, maintain their wards better, and pay more attention to their children (*Boyoma*, 29 September 1976).

The ineffectiveness of AFCO in serving the interests of all women in commerce is made clear by the fact that the president arranged to supply her own business from the wholesalers rather than working for a fair distribution among the members (Nzinunu 1978). Members complain that the association is useless because the authorities ignore it and it does not succeed in the vital matter of increasing the supply of goods from the wholesalers. Cooperation is lacking and "an unpleasant atmosphere prevails among the members" (Nzinunu 1978: 52). One woman expressed the lack of solidarity in her comment: "They are not nice, I stay on my own."

CONCLUSION

Gender must be qualified by a specification of women's position in the newly emergent classes of African countries. This account of businesswomen in Kisangani reinforces Bujra's point in Chapter 7 that African women cannot be treated as a homogeneous category. Kisangani has provided some women with opportunities for capital accumulation on a considerable scale. Dinan's description of Ghanaian professional women who "partly by their own occupational skills and endeavors and partly by the skillful manipulation of their social roles and networks . . . are achieving a considerable level of financial and social independence" (Dinan 1977: 69), is also an apt description of these Kisangani businesswomen. In spite of the social disadvantages and legal restrictions imposed on them, they have become important members of a newly emergent middle class based on success in business and investment in productive enterprise.

Notes

1. September 1979–June 1980 I was a research associate of the Centre de Recherches Interdisciplinaires pour le Développement de l'Education (CRIDE), Kisangani. My research was aided by a grant-in-aid of research from Sigma Xi, the Scientific Research Society.

2. No official figures exist, but eighty-six languages are listed in the records of the mental hospital.

3. They were identified from sources that included the inaccurate lists supplied by the Town Hall, my own investigations, the list of businesses Zairianized and then retroceded, and the membership lists of the Chamber of Commerce and the Lions, Lioness, and Rotary clubs, all of which involved only people of substance and importance in the town. The high dues of the Chamber of Commerce means that small businesses do not join. Dues vary according to the size of the enterprise, but the minimum in 1979 was ₴ 600. (The unit of currency in the zaire, ₴ 1 = US$0.34 as of February 1980. The black market rate was ₴ 1 = US$0.20.)

4. The census showed the adult population of the city for these years as follows: 1976, 67,574 men, 73,119 women; 1977, 70,400 men, 74,042 women.

5. *"Demi-gros"*: wholesale dealing in small quantities.

6. In a study of Zambian businessmen, Beveridge and Oberschall found that innovation, in the sense of exploitation of an untapped market before others, often led to success but was not necessary for it (Beveridge and Oberschall 1979: 216).

7. I have given another account of the operation of the second economy, the opportunities it presents for capital accumulation, and its implications for class formation and class conflict elsewhere (MacGaffey 1983).

8. In October 1979, it increased again to ₴ 800 and in March 1980 to ₴ 1,176.

9. There are some exceptions. The director of an important national institution got the job solely because he was the lover of the woman who was minister of culture at the time.

10. Women in Zambia suffer comparable problems. In a study of educated women in Lusaka, Schuster found these town women to be exploited and oppressed by men: "Male politicians, like male university students, cannot believe that women can achieve greater success than they through merit, only through sleeping with some important man" (Schuster 1979: 101).

Chapter 10

STRATIFICATION AND THE LIVES OF WOMEN IN UGANDA

CHRISTINE OBBO

THE INTERACTION OF people in groups inevitably generates tendencies toward both social integration and social differentiation. In the former instance laws, regulations, and social practices emphasize implicitly the dependence and compatibility of groups with one another. In the latter case, biological differences are elaborated to explain or mystify social differences (see, for example, Svalastoga 1965: 1). The processes of social differentiation seem to be generated and sustained by the fact that whatever is scarce and desired will be differently distributed, that people will perform different jobs, and finally that appropriate behavior is situationally regulated. North (1924) referred to such social processes as differentiation by rank, function, and custom (Svalastoga 1965: 1).

Most studies of social change and urbanization in Africa include material relevant to stratification, analyzing it in structural, ideological and cultural terms (Tuden and Plotnicov 1970: 10–11; Rigby 1976; 117; Solzbacher 1968: 3). In order to understand social stratification in Uganda, two aspects of the colonial encounter need to be appreciated. First, colonial officials encouraged individual ownership of private property, particularly by parcelling out land as a reward to collaborating chiefs. This attempt to create or in some cases to increase the power of the chiefs was understood by the "common" people, shaping the perceptions of differentiation that are explored below. Second, formal education became a prime criterion for measuring one's place in society. Wealth, power, and honor (Weber 1947) became predominant as markers of social ranking. Today when one views property ownership and economic, social, or occupational prestige, the striking feature is that educated people possess the economic wherewithal to acquire property, which in turn gives them the economic clout to enjoy lifestyles associated with high social status. In other words, the common people perceive the educated minority as entrenching their political and economic hold at the expense of the majority. The latter include tenants, cultivators, or landless wanderers who often end up as the urban unemployed and those who regard rural areas as dead-end situa-

tions and therefore determinedly manage to hustle a living from the interstices of the urban economic structure.

This is the scenario within which gender stratification must be examined. There are many reasons for the past neglect of gender stratification, but the most relevant for the purposes of this essay is the notion of derived status, the idea that women's social ranking in most instances derives from the occupations of their husbands or fathers, and that men determine a family's life cycle and standard of living. These assumptions are valid as long as patriarchy (rule of the father) goes unquestioned and as long as household and family relations involve the appropriation of women and their labor by men (Kuhn 1978:65). According to this view, women cannot achieve independent ranking outside of the family, and families are of course assumed to be entirely dependent on men. These assumptions accurately reflect certain aspects of East African family life: the fact that most marriages are hypogamous for men, i.e., they marry women who rank below them socially and economically; that women are often economically dependent on their husbands; and that men's earnings are not likely to be shared equally within the household. Uneducated rural women in most East African societies enjoy usufructuary rights in land by virtue of being wives and mothers since women must produce food if they are to fulfill their nurturing role. In urban areas a working woman's life is precarious when it comes to earning decent wages or sustaining a job or even creating employment opportunities for herself.

It is therefore not surprising that both rural and urban Ugandan women stress earning and investing money in their own names. Land, which represents the most worthwhile investment for both women and men, is of primary concern. As one urban woman said, "I want to eat and I want somewhere to be buried." Women went to a great deal of trouble to ensure that their bank accounts, their plots of land, or their businesses were in their own names as rightful owners in order to make appropriation by their male relatives or husbands impossible. The low-income women of Kampala, Uganda, used approximately four months' income to secure trading licenses in their own names. Surveyors and other land office employees supplemented their incomes generally from people seeking land titles but charged much higher fees in cases involving women. The women complained of exploitation, and the civil servants often unwittingly confirmed the validity of their charges. One surveyor put it this way:

> I do not know why women need land. Married women have access to land through their husbands and unmarried women will do so as soon as they marry. I think the biggest threat to the African family are [sic] women who are not content with what their husbands own. I survey women's land for a little more pepsi cola [bribe] than the men's but women always pay. Women have money and I do not know where they get it.

Women sacrificed in order to pay the bribes because they felt that the goal of ownership was worthwhile. Since some men found women's claim to

property rights divisive and disruptive to marriage because "a woman who has money to buy anything she wants becomes too big-headed to remain married," women kept their property deals secret in order to avoid anxiety and marital problems. The threat of divorce or desertion has become a constant fear with men, although women rarely contemplate either, a happily married female landowner noted. However, women often cited "the rainy day" as a common reason for owning property independently from men. Divorce and widowhood were seen as negatively affecting the rights of women to so-called family property. In some societies childless women may receive little land or marginal land, but even those with children may have to depend upon the charity of their male in-laws to keep enough property for a bare subsistence. In other societies, where women can rightfully own land through inheritance from fathers or brothers, women stressed the need to be "resourceful and tough" to deal with encroachments by male neighbors and relatives. In one instance a woman had been in and out of courts to protect her land for the past twenty-five years.

Sacks has argued in a seminal paper (1974) and in her book (1979) that the development of the state takes away the autonomy of women as equal social producers of wealth and instead makes them the property and unpaid laborers of individual men who mediate between the women (the domestic domain) and society (the public domain). Women's labor becomes mystified as necessary labor when they bear, mother, and socialize the children, as well as when they grow, process, and provide food for their families, thus reproducing wealth in people and labor of men. When wives and mothers produce more than is needed for domestic consumption, they are still regarded as contributing labor value, although the surplus they generate may be exchanged in the marketplace. Thus, it is not surprising that women generally fare poorly with the spread of capitalism (Boserup 1970; Vincent 1982:162). In pre- and early colonial Uganda, resourceful women related to powerful men could carve out riches for themselves. In the kingdoms, the queen mothers and king's sisters owned estates in their own right that they used as a power base for attracting clients to work for them, thus liberating themselves from cultivation and other messy chores. Kiganda political ideology, for instance, insisted that there were three kings—the king, the queen mother, and the king's sister—with the former ruling and the latter two enjoying, within the dominant male ideology and its constraints, such prerogatives as having the right to commute a death sentence (Roscoe 1911:237). Outside of Uganda the Fipa magistrates (Willis 1981:180–84) and the Barabaig women's courts (Klima 1970) are but a few examples of visible women. The majority of women, however, remained shadowy, if not completely invisible, even when it was clear that their labor created the surplus that was distributed or exchanged in the public domain to create differentiation.

In order to pay colonial taxes, Ugandans had to either grow cash crops or labor on public works or plantations. The colonial administration promoted the development of cash-cropping and labor reserve areas.

Cash-cropping was usually concentrated in fertile areas but particularly in the region surrounding the administrative capital. This area had a head start in educational, medical, transport, and other services. Labor reserve zones were situated upcountry and provided labor for the cash-cropping areas, the plantations, or recruits for the army. Upcountry areas were neglected and underdeveloped, despite the fact that their labor and taxes contributed to the general development of the capital and the cash-cropping region in which it was situated (Vincent 1982:151). In both areas, however, women's work increased as they assumed men's workloads in addition to their own.

Women increasingly failed to fulfil their duties satisfactorily as food providers. In cash-cropping areas the acreage for food was being squeezed out in order to expand production for cash. In the reserves, women were expected to produce enough food to feed two households—one rural and one of their migrant husbands in an urban or cash-cropping area. Women in both areas subsidized the colonial economy as the major producers of cash crops which provided taxation money for the men. Women in the reserves also managed the rural production units that supplemented the wages of the underpaid male workers.

Nonetheless, the impact of colonialism on women is often ignored, as in some otherwise good general discussions of the political economy of Uganda (Jorgensen 1981; Mafeje 1973; Mamdani 1976; Brett 1973). But women were there and suffering accordingly, exploited both indirectly by the colonialists and directly by male dominance within the household. For example, Atanda shows that, in order to evade the hut tax, the peasants in the Buganda District of Uganda argued that only married men were obliged to have huts and therefore should rightly be taxed. Apparently during the tax collection period peasants would send away their wives and live as bachelors, usually with an elderly married couple. One country chief dealt with the problem by holding hostage in a large camp all women whose husbands were absent; their release depended upon their husbands either paying cash or going to work in the hated Kakumiro public works camp (Atanda 1969:155). The chief was aware of the damage to the household that would result from the absence of women, particularly with regard to food preparation, child care, and the war against weeds. Thus it was known that behind every taxable peasant there was a toiling woman to help him fulfill that obligation.

STRATIFICATION AND WOMEN'S LIVES

In the absence of census and other data dealing specifically with intra-gender stratification, the extended situational case study method will be used here as a vehicle for unraveling the different aspects of the problem. Not only do women have a complex set of characteristics determining their class status, some of which are independent of men, but also the differences between women furthered by colonialism probably militate

against cross-class female solidarity. The ideology of helping family members may disguise exploitative relationships, however. This essay therefore presents arguments relating both to the issues of autonomy and female solidarity raised in this volume. An elite Ugandan woman's contacts over a period of two days are outlined and elaborated on in subsequent case studies to show the multidimensionality of stratification. The relationships among women of different socioeconomic status are highlighted by describing women's perceptions of their disparity.

Outline Case Study: Dr. Mukasa's Interaction Network

Day 1: Dr. Mukasa had a hectic morning admitting and attending to patients in the children's ward at Mulago, the national hospital situated in the Ugandan capital of Kampala. Her sister Mary, a nurse, came to her office because she needed someone to talk to about two problems: a doctor who was blaming her for the death of a patient; and the increasingly difficult state of her marriage. They arranged to have lunch in one of the exclusive hotels. As Dr. Mukasa returned to the ward, a nurse pointed to two women who had been pestering her to be allowed to see Dr. Mukasa. She told the nurse to escort them to her office, where she would see them as soon as she finished attending to a critical patient. On returning to her office she found two neighbors and friends of her mother sitting on the floor, although there were three empty chairs. She bent while they knelt and held her hands in greeting. After chatting for about fifteen minutes, Dr. Mukasa told them she had to attend to patients, although she would have liked to have them visit longer. Just then, one of the visitors unwrapped a cloth parcel to reveal a newly made basket containing sweet bananas and passion fruits. She said they were for the doctor's children. She also unwrapped a bottle from her sash and quietly asked whether it would be possible to get some cough medicine for her grandchildren. Her companion also unwrapped a mat woven in an intricate design. Dr. Mukasa thanked them and obtained the cough syrup. Dr. Mukasa knew that the basket-giver was expressing gratitude because two months previously she had literally walked her through the hospital, thus saving her from the slow queue and rude attendents. In the end she had had a hernia operation. The mat-giver probably wanted to be in good favor with her just in case she had cause to come to the hospital. Both women were her mother's friends, and Dr. Mukasa offered to drive them to the bus park, where she took them to a restaurant/tearoom *(hoteli)* to eat steamed bananas with meat stew while they waited for the bus to take them home.

Dr. Mukasa always enjoyed lunching with her sister Mary. This time they talked about their husbands, male doctors, and men in general. They also talked about their brother's wife, who had become notorious for declaring war upon relatives and acquaintances who wandered into their home expecting food and board or financial handouts for transportation. Worst of all, she begrudged the gifts of clothes her husband gave their mother and grandmother.

In the afternoon, Dr. Mukasa attended two meetings, one with the

Family Planning Association Board and the other in her department. She also conducted a clinical class for second-year students. On the way home she collected her son and daughter from primary school, picked up some groceries at the supermarket, and went home. When her husband John returned home, tea was served with roasted groundnuts and plantains. When the cook came to remove the tea things, he informed them that the former babysitter, the daughter of Dr. Mukasa's mother's friend, was in the kitchen and that she had been waiting for them all afternoon. They summoned her to the sitting room, where she said that she had come to beg for her job back. She had been brought to work as a babysitter and her monthly salary was banked for her in order to prevent her from wasting it. One day she informed Dr. Mukasa that she was leaving to work as a shoe seller. Six months later she came and requested all her money. "We gave it to her and shortly afterwards we learned that she had had a 2,000 shilling abortion." The babysitter did not get her job back because a poor distant cousin of Dr. Mukasa's husband had taken it. She was referred to another elite family.

Day 2: Dr. Mukasa had the day off from the hospital, but it was a day for personal and social obligations. This was her fortnightly or monthly routine, depending on how busy she was. After dropping her children off at school, she went to her dressmaker, Malyamu, to pick up a dress and to deliver some materials for two others to be made. Dr. Mukasa's dressmaker had just awakened and was washing her face so there was quite a stir finding her the best seat in the room. Next she visited the hairdressing salon of Elise, her father's brother's daughter. The latter was just driving off to visit her farm. It took one and one-half hours to have her hair styled. Just as she was leaving, she ran into Jane, her mother's brother's daughter, who was on her way to a private day school,[1] by way of the hairdressing salon. Dr. Mukasa's parting shot to her was, "I hope you are taking your studies as seriously as you take beautifying yourself." Dr. Mukasa next stopped at the market. She went to a stall belonging to Adikinyi, a Luo market women who always gave her discounts or generous portions of produce. Her next stop was at the supermarket to pick up gifts she was going to take to her sister at boarding school and to her mother and grandmother in the village. She went home to drop off the market supplies and change her clothes. She arrived at the school during the lunch break and only managed to stay a few minutes to receive a list of the things her sister needed, which she promised to bring at her next visit. Her sister expressed much gratitude for the skin cream, butter, bread, and sugar she had brought.

She arrived at her mother's and grandmother's at about 1 P.M. Her grandmother was sitting on the veranda shelling green beans, assisted by three little foster girls. When Dr. Mukasa arrived, one girl was asked to bring her a chair, another ordered to put on the kettle for tea, and a third sent to fetch the mother from the garden. Her mother and grandmother washed and changed from their garden-soiled working clothes. Some neighbors on their way to fetch water stopped to say hello and then stayed

for tea because they knew it would be served with lots of milk and bread with butter and jam. They also stayed for lunch, which was not ready until 3:30. At 5 P.M. her car was being loaded with green banana leaves, bunches of sweet roasting and cooking bananas, yams, and sweet potatoes. Her grandmother had a special gift for Dr. Mukasa's husband, a rooster, and the grandchildren were sent a bundle of edible white-winged termites known as *ngwa*. She arrived back home at dusk, just in time to change and accompany her husband to a Chinese Embassy party.

Case Study 1: Dr. Mukasa

Dr. Mukasa trained as a pediatrician in Uganda, the United Kingdom, and the United States. She came from a prominent family that had played an important role in establishing and maintaining colonial rule in Uganda at the turn of the century. Her grandfather had been brought up as a page in the king's court during the nineteenth century. By the time the colonialists arrived, he was already an accomplished political manipulator. His collaboration with them gave him a head start over everyone else. He learned the new tools of reading and writing. By virtue of being a chief he received large parcels of land; his services were remunerated and his children were able to attend school in England. While the majority of peasants still went barefoot, wore bark cloth, and as children rode stick bicycles or played with banana flower or fiber dolls, his wife and children enjoyed manufactured clothes, toys, and bicycles handed down to them by missionaries. However, no such luxuries were enjoyed by the poor relatives who performed the household maintenance jobs such as food production, preparation, and serving; babysitting; mat and basket making; and hauling water for all household necessities.

Dr. Mukasa's father was employed in the colonial administration; when she finished high school in the late 1950s, her name was among those submitted for further training overseas. At the eleventh hour, before granting political independence, the colonial government was anxious to increase the number of African professionals to run the country after they left. While no one doubted that becoming a doctor was an individual achievement, some of Dr. Mukasa's contemporaries felt her family background was crucial in getting her the scholarships to the United Kingdom and the United States. On her return, not only did she land at the highest level of the income structure but she also married a senior civil servant who directed a government department. They lived in a high-income neighborhood. Professionally and socially they were part of the cosmopolitan elite of Kampala.

Case Study II: Nurse Mary

Mary was Dr. Mukasa's younger sister, who had entered nurse's training after failing her high school entry exam. After she had worked for five years, Dr. Mukasa, who at that time sat on a scholarship board, arranged for her further training in England. On her return she was promoted. She moved from a government estate to a high-income neighborhood and married a political sycophant with a dubious educational background. While her husband spent a large portion of his money on other women and drink, Mary bore the responsibility of running the home and maintaining the family at a decent standard. The fact that they had no savings worried her because "one does not know what the future holds." In 1971, with the change of government, her hopes that her husband would achieve an important

political office were dashed. Despite this, her husband appeared to be in the category of rich men as he drove around town in a government-owned Mercedes-Benz.

Case Study III: Businesswoman Elise

Elise was a primary school teacher before her marriage to an Edinburgh-trained secondary school teacher. She took short trips with her husband to England and America and was a member of several women's organizations. Some of her elder children had received secondary school education abroad. She owned a successful hairdressing salon in Kampala, the capital of Uganda, and managed two farms outside the city. She gave the following details of her life.

I grew up seventeen miles from Kampala. My father was an Anglican priest, and when he died he left each of the six children two acres. Technically the land belonged to the church, but I suppose no one remembers. Then, about fifteen years ago, my mother told me that one villager had abandoned his land and his relative wanted to "sell" it to someone, and another villager was moving to another country and wanted to sell his rights to the highest bidder. So I occupy five acres and I pay the rent to the landlord promptly each year.[2] I planted more bananas and coffee. I built a brick house on one of the plots and invited a landless widowed maternal aunt to come and stay. I come and collect food at weekends and employ two Rwandan laborers to help her. She works very hard, and I use some of the money from coffee sales to educate her children, who are very bright. I opened the hair salon with money from coffee too.

In 1967 my husband also acquired four acres five miles from the city center for a dairy farm. We planted bananas and coffee and built a weekend house. He invited a school dropout nephew to stay in the house, milk the five cows, and deliver the milk to our customers in the surrounding areas by bicycle.

When Amin usurped power in 1971, people went and cut down our banana and coffee plants, they killed all our cattle, and ate it as roasted meat. It was terrible. The neighbors said that a group of people "incited" them to do so. We suspect some of my husband's jealous colleagues. The crops grew back, and we have been harvesting a lot from them.

I am glad I had my own land during the 1970s, when living in town was almost impossible. In fact, when Amin was overthrown we hid there. Ten families subsisted on my three acres of land. My friends with no land were paying 200 to 300 shillings for a bunch of bananas. When labor became scarce, we asked the relatives to help out with the farm work instead of coming to visit us in town for long periods. This resurrected some latent resentment we had not suspected. You see, since we got married in 1947 at least thirty people must have stayed with us. Parents would come and beg us to accommodate their children because they knew that my husband and I would be good supervisors because we used to be teachers. Some of the people we have looked after have done well for themselves and are grateful. However, those who dropped out of school or obtained jobs which they feel are beneath them are resentful of children of relatives and acquaintances. Apparently, some of them were dissatisfied with having to help out with the chores that feeding and taking care of them involved.

Since the mid-1970s it had been difficult to get servants. Even my old trusted servant once threatened that if I did not reduce her workload she would go and start a business as a banana seller. I was upset because I pay her well and she enjoys privileges envied by the underpaid servants of my friends. During the Amin years some people who were killed or who were

robbed were betrayed by their servants. A neighbor lost his car after his servant had been bribed to provide the key, but he recovered it (with the color and license plates doctored) through buying information from another neighbor's servant.

HIGHLIGHTS OF THE CASE STUDIES

Gifts, Bribes, and Deference

The case studies illustrate the different kinds of ranking that are the subject of this essay. The rural women who are relatives, acquaintances, or friends of prominent women cultivate the good will of those in high positions so as to make their lives easier. The Ganda say that one does not go to visit others empty-handed, particularly if the host lives in the city. Much of the luggage on buses or taxis going to the city contains food items, poultry, or handicrafts that are intended as gifts for superiors, as is the custom. This tradition explains why laws were passed in the early twentieth century to protect Ganda peasants from paying excessively high tribute to chiefs. People think it is proper for them to bring gifts, but they grumble at the bribes exacted by civil servants. In the former case, the choice of the gift is defined by the giver, but in the latter case the receiver's demands have to be met. The two village women would have spent the whole day in queues before obtaining medication, but having a contact sped up their stay at the hospital, which they viewed as a social visit.

According to Kiganda tradition those with less status kneel when serving, greeting, or talking to those in power or to their elders. The peasants prostrated themselves before the king, wives knelt before their husbands and other men, and children knelt down to everyone. With the introduction of Western education, teachers, nurses, and others are treated with great respect and deference. This automatic high ranking because of one's educational attainment explains why the two women knelt down to Dr. Mukasa, who technically should have knelt to them because of their age.

Dr. Mukasa, Mary, and Elise belong to the general category labeled elite, and they and others like them constitute a tiny percentage of the female population. They, rather cynically in some cases, profit from the cheap labor and services of lower-status women, often masked by an ideology of "helping" family members. However, there are distinctions among the elites that are not apparent when one evaluates them according to residence in high-income neighborhoods or according to the prestigious cars they drive, the schools their children attend, and where they spend their free time. Doctors, university teachers, civil servants, executive secretaries, hotel managers, and women married to elite men are definitely upper-class. Dr. Mukasa and Elise belong to this class. Mary belongs to what we might call a precarious elite, sometimes referred to as a sub-elite. Her substantial earnings as nurse and midwife mostly went to maintain

social prestige. Her children went to the right schools, they lived in a good neighborhood, and her husband owned two Mercedes-Benzes. Mary did not take her elite status for granted because, "Supposing I get very ill, what will happen to my children?" Part of the problem is that Mary belongs to that class of women who marry hypogamously. These marriages are the best-kept secrets all over the world. Some women also are de facto household heads because their income is higher than that of their husbands. The men usually use their money for their own leisure, and the women do not assertively demand that they contribute to the financial running of the household for fear of being labeled domineering. Thus Mary occupies a stratum slightly below that of Elise and Dr. Mukasa.

In contrast, Elise married hypergamously because her husband, a secondary school teacher, enjoyed more pay and prestige in the community than she did. Hypergamy (marrying up) has, of course, been the most common way for women worldwide to rise in social and economic status. Until the mid-1960s there were far more educated men than women. Since there were not enough educated African women to go around, some men married foreigners. When the number of educated women increased, some were seen as unmarriageable, particularly when trained in professions other than teaching or nursing. Some men deliberately avoided educated women whom they would have to treat as equals. At the time of political independence during the early 1960s, the most eligible women had gone through mission schools where they had been trained to be good wives to educated men, knowing something of Western hygiene, nutrition, sewing, baking, and the social graces of tea drinking. Politicians who had less sophisticated wives either sent them for "social graces training" or banished them to village homes while they lived in the cities with educated women as second wives or concubines.[3]

The case study of Elise illustrates a definite trend among women who hold good jobs, women who do not work because their husbands earn enough to maintain a high living standard for the family, and women with poor education but who are married to influential men. These women may be efficient managers of their husbands' businesses such as farming, cattle keeping, or retailing, but they also often engage in successful entrepreneurial ventures of their own. Women of this class have been the beneficiaries of the "development decade." Lack of access to labor, information, and credit are the major reasons often put forward to explain why African women have not been integrated into recent development schemes, but they do not apply to these manager entrepreneurs.

Resourcefulness or being married to influential men accounts for the ability, capacity, and access to resources enjoyed by these women when it comes to furthering their education, traveling abroad to learn new ways of doing things, or obtaining loans for starting or expanding their business projects. These women either hire labor or exploit the services of the numerous poor relatives who flock around those perceived to be better off. Sometimes people in certain jobs such as teaching become patrons for

nonrelatives as well. If education provides the best possible opportunity for success, then the teacher is the best possible influence on one's children.

The first set of case studies represented the lives of women in the two upper classes. A third stratum that emerged in the early 1960s includes urban salaried women (secretaries, bank clerks, nurses, and teachers) and others such as market retailers, owners of rental housing, shopkeepers, distributors, bar owners, diviners, prostitutes, and wives of some office workers. Although nursing and teaching used to be ranked higher because they attracted the few educated women, in the 1960s the girls who trained for them were those who had failed to go either to secondary school or college.

Before independence the colonial administration depended for clerical services partly on African and Asian men, but mostly on the formidable army of European secretaries. The serious training of African girls for clerical jobs began only on the eve of independence. Thus, the 1960s represent a point of departure because upwardly mobile girls began to have choices other than teaching, nursing, and hypergamic marriages. Not only secretarial positions but other jobs like banking were Africanized and educational opportunities for girls were extended. Many women soon found out that it was not enough just to be able to read and write, but that they needed other skills to enable them to perform well on jobs. Furthermore, not all women completed their education or were absorbed in professional office jobs. Many attended private schools and then secured low-paying jobs or created employment for themselves. Those who work for wages are seen every morning in the buses and taxis heading toward the modern offices of the city, and in the evening returning to the low-income government estates and residential areas. Economically they struggle to make ends meet, but much of their income buys clothes and pays for transportation. The preoccupation of the women in this category is to marry men who earn more than they do. While competition between women for men is divisive and common, it is most noticeable among women in this category. They assert themselves directly as social actors competing for wealth and influence.

The women who do not succeed in achieving hypergamic marriages turn to concubinage relationships, another conventional way for women to improve their status. As male power has become more entrenched, the women in this category often find themselves in vulnerable situations. While it is considered prudent to be deferential to men who control access to job training and opportunities, wages and promotions, this attitude creates a patron–client situation in which women form a pool of playmates for powerful bureaucrats. Most women comply, but those who refuse run the risk of having their earning power reduced to the level of unskilled or unschooled urban women, who constitute the struggling self-employed. While some who marry continue with their previous jobs, others married to not-so-wealthy men manage as lieutenants to their husbands. Still others may carve out their own status as business or land owners either in

the rural or urban areas. Some women in this category may become successful enough to rise in status. The hard work put into getting husbands and protecting the marriages against "predatory women" makes these women supporters of the status quo when important issues concerning women arise.

In rural areas the women in the third stratum include teachers, midwives, successful diviners, wives of politicians, and women formerly affiliated with important colonial chiefs. Manjeri and Malagalita, whose stories are given below, are typical. The villagers recognize the fact that such people belong only to the local elite, but they associate them with the rich national elite—a class usually occupied by the children or relatives of the local elite. One informant described some people in this group in the following manner: "When they want to travel to visit their friends, the hospital or attend funerals, they are either fetched by big cars that have us covered with dust or they take taxis. They eat and sleep well. But the rest of us either walk or hitch rides on our husbands' bicycles or spend the whole day in the hot sun waiting for a bus."

Case Study IV: Adikinyi, Market Trader and Wife of a Luo Urban Migrant

My husband has lived in town since he was fourteen years old. He went to visit an uncle in Kampala and decided to seek work. We married when he was twenty years old and I was nineteen. He had built a house near his parents' compound in East Kano. In ten years he only returned to the village four times. I used to visit him often: to take him food (maize flour), to ask him for money to maintain the children, and to give him the latest news from home. The best years were when he worked for some Europeans who were kind enough to give secondhand clothes every Christmas. Things became bad when they left and he decided to take up shoe repairing from an Asian cobbler. He worked hard, but the money he received was barely enough to pay his rent. He was writing to his cousins in Nairobi to borrow money, and I would hear about it only occasionally or by accident. He told me to grow more maize so that I would have surplus to sell and generate more money for us all. In fact I was already growing surplus maize and selling a *debe* (four-gallon tin) whenever I wanted to buy milk, bread, and meat for my children. As you know, it can get boring eating fish (caught at the local river) and greens.

When his parents died, I was all alone and I could not cultivate more than I was already doing. I had no money to hire anyone, and I was upset as even his relatives wanted to be paid. Then one day I was visiting a cousin in South Nyanza when I got an inspiration to start selling maize and groundnuts at the Kisumu City Market. This would involve traveling a lot to buy supplies. I sent the children to stay with their father in Kampala and left my husband's younger brother to look after our home whenever I had to make a long-distance journey. At first traveling by bus with sacks of maize and groundnuts was tiring and frustrating, but I soon got used to it. Whenever possible I would hop on the train to visit my husband for several days while a friend of mine minded my business. In 1970 we decided to bring my business to Namuwongo [a low-income suburb of Kampala] because my husband felt that it would be profitable. We rented a two-room house with the back for the home and the front for business. My husband operated his shoe repair business in the front room and I conducted mine on the veranda. When I had to go for supplies

at the market, he attended my customers. Two years ago I finally managed to obtain a license to operate in the city market, and I have cultivated a steady clientele.

Case Study V: Malyamu the Dressmaker

Malyamu lived in a low-income Kampala neighborhood called Wabigalo. She had migrated to town when her marriage to an unambitious poor cultivator failed in 1964. At first she lived with a friend and hawked lunch food to workers on construction sites in the industrial area and outside government offices. She regarded the peeling of bananas, the main staple, as messy and tiresome. "I was all the time either hauling the bananas from the market or peeling for the next day's meals or washing and wrapping them in banana leaves for steaming." This she did in the morning and evening. She worked as an apprentice to a male tailor—sewing on buttons and hemming while learning the mechanics of cutting cloth and sewing. Within two years she had saved enough to buy a secondhand Singer sewing machine. In her one-room home she slept, cooked, entertained friends, and conducted her business. Cloth curtains partitioned the different space areas. She was able to attract many elite customers because her work was good and she charged a mere 50d, or $2.50. But if the design was complicated she would insist on charging more. The customers usually brought magazine pictures from which Malyamu fashioned the dresses. By the late 1960s her clients were predominantly university students. They considered Malyamu a diligent, reliable, and reasonably priced dressmaker.

Case Study VI: Malagalita and Manjeri, the Cultivators

Manjeri [a widow in her late sixties] was Dr. Mukasa's mother. She lived with her mother, Malagalita, who was in her early eighties, on a farm twenty miles from the city. They maintained one square acre of banana grove, which provided the staple for their daily use as well as occasionally those of their urban-dwelling relatives. In other gardens they intercropped sweet potatoes, yams, groundnuts, and many different kinds of spinach. Their coffee requirements and cash needs were met by harvests from a poorly kept coffee plot. They lived on the edge of a forest, from which they obtained firewood and water. They took care of their small quantities of sugar, tea, meat, and soap, but their medical, clothing, and travel expenses were met by Dr. Mukasa and Mary.

Although they considered themselves poor women, no one in the village perceived them as such. First of all, the only tiled house in the village was Malagalita's. It was built in the 1940s while her husband was chief, and the interior walls are decorated with photographs of the family taken at Asian studios in the city or by visiting missionary friends. Meat and fish were regular items of the menu, and tea was not only served in Wedgewood china but always with milk and occasionally with bread. Their neighbors regarded them as being of a higher class than everyone else in the village, except perhaps the teachers and the midwife.

The richest men in the village were a taxi owner, the owner of two private schools, one of the teachers, and the ten men who commuted on bicycles from the village every morning to work as clerks at a nearby township and in the capital. Their wives cultivated and supervised hired labor. The largest proportion of their income, that sustained the home and paid for the clothing and school fees, came from farming. The largest coffee and banana gardens in the village belonged to two urban-dwelling civil servants. They sprayed, mulched, and meticulously pruned their crops and had bumper harvests. During the harvest season, they usually employed the poor cultivators or their wives.

Although Dr. Mukasa's mother and grandmother wore work clothes like other women, their Sunday clothes were mainly satin and silk purchased by Dr. Mukasa on her many trips abroad. They were envied by their neighbors, but at the same time people were always taking advantage of them because they were women. Whenever they hired a man to help with the heavy garden work, after a few months the laborer would start cheating them. Furthermore, Malagalita was a familiar figure at the county court, where at least once a year she successfully sued those encroaching on her land. They called her a "cantankerous tough" woman.

The majority of women in East Africa fall into the fourth stratum. They are rural cultivators or traders trying to make a better life for their families, small businesswomen operating in the informal sector of the urban economy, or women in low-level paid employment with the government or private firms. Included in this category are urban women in domestic and janitorial services, municipal road sweepers, garden maintenance and factory workers, wives of factory and other unskilled employees, as well as women who manage shops and small businesses with their husbands; rural women who manage the farms while husbands commute daily to work in the city as clerks in low-level white collar jobs; and finally women like Adikinyi, who manage the rural household while their skilled or unskilled husbands migrate to work in the towns. If the husbands do not obtain jobs or create employment for themselves or if they are underpaid, the women have to compensate for lack of remittances by selling food—eggs, tomatoes, chickens, and vegetables—to generate some income. Eventually some women do join their husbands in the urban areas.

The lowest stratum includes the poorest women, who may be married, unmarried, widowed, or divorced. Those in the rural areas may lack access to resources such as land or cattle. Their economic status fits the distinctive features of a rural proletariat described by Lenin: "Insignificant farming on a patch of land. . . . Inability to exist without the sale of labor and an extremely low standard of living" (1964: 177). These three features acquire relevance in different rural situations. The Ganda recognize this class of the poor as a distinctive social category, the *bawejjere*. They are distinguished by the way they earn their living as *banjalananda* (hoers of weeds); how they dress when cultivating, *banakadde* (female wearers of dirt-soiled clothes);[4] or what they wear when harvesting bananas for beer brewing, *katema mabidde* (a short, unbleached, cheap cotton gown that soon becomes soiled with dirt or stained with banana sap); and, finally, by the way they travel from place to place, which characterizes them as *bakasimba bwala* (i.e., walkers or those who plant their toes down).

The picture of the *bawejjere* is very vivid, and most people lazily lump all rural smallholders into this category. While agricultural work is the lot of most women with no schooling, some young women escape the restricted economic possibilities and the social controls they perceive as the lot of *banjalananda* and seek other opportunities in urban areas. Some find domestic service jobs through relatives and acquaintances. Many, how-

ever, after failing to secure paid jobs, create employment for themselves in the unenumerated urban economy often referred to as the informal sector, which, although uncontrolled and unprotected by legislation, is highly elastic. The poorest of them live in tiny single rooms, conducting their small volume of trade outside their rooms. Beer and food selling are some of the common multiple activities of these women. Prostitution is a common means of supplementing the meager incomes of the self-employed or the underpaid women of this class who work as barmaids and for some of the salaried women belonging to the fourth class. The issue was seen by most women as "survival in an economy where nothing is free. Rent, water, food, fuel, and school fees for children are constant demands." The latter demand usually proved unaffordable after a few years.

CONCLUSION

The rigid system of stratification created by colonialism and the connection between Christianity and education gave some men, as well as women associated with them, a head start (Vincent 1982). New systems of stratification appeared among formerly unstratified people; and some older hierarchies based on sex, age, and power became entrenched. The local view of the stratification system evaluates most positively, "social status 'based' upon a good educational achievement and the resulting 'good job' [in the city]." Success is also owning a piece of land, a building, a good house (Rigby 1976: 122). People are aware of the widening gulf between the ruling "dominant minority—well dressed, well fed and town dwelling [and] the ill-fed, ill-clad, village swelling majority" (p'Bitek 1973: 7). The so-called development decade can be said to have benefited the former. In the words of one woman, "They drive the big cars; we swallow the cloud of dust they leave behind." Examples from Uganda during the 1970s illustrate the resentment against the elites and those in the higher strata very well. An undisputed aspect of Amin's reign of terror was that some people died because underlings (or competitors) betrayed them to the soldiers. The motivation was usually envy over jobs, land, houses, or women. Thus the issue of "keeping up with the Mukasas" became important for the underpaid servants or distant poor relatives who resented what they perceived as exploitive relationships between them and the rich. It is a recurrent part of the Ganda political scene. Malagalita and Manjeri were among the people whose banana and coffee trees were cut down during the 1945 and 1949 economic boycotts aimed at the colonial administration's commercial policies. In 1971 many welcomed the military *coup d'état* as a victory for those who "have not," and consequently the coffee, bananas, and cattle belonging to the elite were looted or vandalized. Elise was one such victim, and she does not want to dwell on it. Again during the 1970s elite women had particular trouble finding or keeping female domestic servants. In many cases servants accused their employers of underpaying and overworking them, and demanded that their jobs be

clearly defined. For example, some would refuse to walk or fetch the children from school because "today is laundry day," or they would refuse to make tea for a guest because "I am getting the children ready for bed" or "I am not feeling well." In such cases either the servant quit or was fired. The women who left their jobs to work as banana sellers or shoe sellers may have misjudged the realities of urban employment as shown by their failure, but those who took up the municipal jobs of sweeping roads or attending flower gardens successfully escaped the situation they resented.

The goals of most African women are twofold: to establish their own economic and social credibility, which were eroded by colonialism (Rousseau 1975), and to protect themselves against what they perceive as material and status vulnerability that results from divorce, widowhood, or remaining single. This chapter has shown that although the details of women's experiences may differ, the social and economic factors that they and others use to classify women in various ways are pertinent issues with regard to stratification. Thus, for example, women in the nursing, banking, and clerical professions are not automatically of the same strata, nor do members of the same family necessarily belong to the same rank. In this chapter, Dr. Mukasa is a member of a super elite but her sister is not, nor are her mother and grandmother. The critical factor is the amount of education Dr. Mukasa obtained, partially as a result of her family's privileged position during colonial times. Without Dr. Mukasa's help, her sister, grandmother, and mother would have a much lower status than that which they currently occupy and enjoy.

Some scholars claim that the practice of helping family members and other less privileged relatives distributes wealth and privileges and therefore blurs class distinctions among Africans, particularly among women. Both elite and ordinary women, however, recognized class distinctions as real. Elite women, in agreement with or contrary to their husbands' wishes, managed to stop the flow of wealth to people other than immediate family members. They profit from the cheap labor and services of poorer women and relatives. The latter, feeling that they have a right to share the elite wealth and privileges, may justify their demands by referring to their service to elite family members. For example, I heard claims like, "My mother wiped your behind as a baby," or "My mother used to dry your nose." This is surely a moral claim, and therefore difficult to dismiss out of hand when it is a well-known secret that the old and new elites use their influence and connections to push some of their incompetent children through good schools, to obtain local and overseas scholarships for them, and to find them decent jobs. This is one of the causes of resentment against the elites whom poor people perceive as becoming entrenched. "A poor person has a difficult time ensuring a good future for her children because the rich will not let us," one woman lamented.

Nonetheless, women try and often succeed in improving their social and economic status by trading and cash crop production in the rural areas and by self-employment in the informal sector of the urban areas.

Those who succeed credit their hard work, skills, and luck for their success. Indeed, it would seem that these are the ingredients that make up women's strategies, whether they decide to marry well, to remain unmarried, to become professionals, or to become agricultural or commercial entrepreneurs. Meanwhile, the women studied were very conscious of the different strata to which they belonged. Like men in the upper strata, elite women were bewildered when the poor, particularly women, were resentful of the advantages enjoyed by exploitative relatives and employers, who respectively paid in kind or underpaid them. The poor say that they need decent incomes so as to enjoy the same educational and employment options as the elite. But the elite expect the poor to have modest aspirations, which they can help them achieve and which support rather than threaten the elite's position. This chapter, then, has explored the multidimensional and complex system of stratification as perceived by Ugandan women. Although the case studies concern a small fraction of the networks of a Ugandan doctor, the data are sufficiently representative to suggest a regional generalization of the findings.

NOTES

1. These are schools started by entrepreneurs to cater to pupils who have failed in the government or missionary schools. The teaching staff are usually unqualified.

2. The 1927 Bussulu and Envujjo law specified that the landlord could not evict tenants as long as their dues were not delinquent for at least three years. Most tenants enjoy occupier rights that they bought from other tenants or inherited.

3. This continues to be a point of pain for some wives of Ph.D. students abroad. The less educated wives are constantly threatened with deportation to make room for sophisticated foreign women. In some cases the threats are carried out; in others the women are frequently reminded of their privileged position in accompanying their husbands abroad.

4. *Kadde* is the generic name for gardening clothes. It can be an ordinary calico print or an old dress. However, the name refers to the tough cloth peasants bought their wives at marriage; a woman would be justified in refusing to work in the garden if her husband did not buy her a "church," an "after work," and a "digging" dress. She would also be entitled to leave him if he bought her the latter only.

PART III

Female Solidarity or Class Action

Chapter 11

STRATIFICATION
Implications for Women's Politics

KATHLEEN STAUDT

STRATIFICATION, OR THE different economic rewards and distributive patterns that accrue from power, prestige, and privilege, is an important lens through which to view the effectiveness and redistributive results of political action. As a result of new market economies and colonialism, the distributive process in Africa was altered in many ways: among emergent classes; between men and women; and within households.[1] Since independence, African governments have done little to alter prevailing stratification patterns. To the extent that political and economic power overlap, government decision-making and resource allocation has reinforced existing inequality. However, that overlap is not total, and class differences and ideological contradictions continue to present challenges to established political-economic structures.

Gender stratification,[2] differentiation between women and men, is parallel to, yet connected with economic stratification. In a stratified society, social groups are ranked hierarchically in relatively permanent positions. They have differential control over the sources of power and distinct cultural traditions. Yet members of all groups may share an overarching ideology that provides a rationale for the established hierarchical arrangement (Tuden and Plotnicov 1970:4). Nonetheless, gender differentiation has no place in most analyses of stratification. Indeed, stratification methodology *diverts* attention from gender; measurement is based on rewards to households rather than to individuals (Tyree, Semyonov, and Hodge 1979), implicitly assuming that resources are shared within households. Gender-based inequalities are taken as axiomatic.

Only more recent feminist approaches place gender stratification at the forefront of their analysis (Schlegel 1977; Acker 1973), especially in the U.S. (see Acker 1980 for a review). Some anthropologists argue that women are universally subordinate to men (selections in Rosaldo and Lamphere 1974; Lamphere 1977) but that subordination varies in degrees. Certainly, however, the penetration of capital, which creates and enhances class differentiation, has also produced differentiation among women.

197

Clearly, gender and class differentiation interact, requiring more complex and comprehensive analysis.

The purpose of this chapter is to review studies of women's politics in Africa to determine the consequences of both class and gender stratification for the effectiveness of political action and for the probability of articulating and realizing redistributive goals. Before undertaking that analysis, gender stratification in Africa is discussed for what it reveals about the shortcomings of traditional stratification analysis and for the insights it provides on the transformation of relatively egalitarian systems. The inclusion of a case study from the Kakamega District of Kenya will provide in-depth material to supplement the more general overview of the continent.

The transformation of a relatively egalitarian tradition of relationships between men and women during the twentieth century may provide explanations for a process that took place generations—even centuries—ago in other regions of the world. That the transformation process is still incomplete also suggests the possibility of maintaining egalitarianism. A key question then becomes: How do women act politically to alleviate, acquiesce to, or transform stratification?

GENDER STRATIFICATION IN AFRICA

African women cannot be ranked in terms of simple ascriptive subordination based on sex. Three features of African social structure make that ranking more complex: budgetary autonomy within households; impermanence in marital attachment; and female solidarity organizations. Under such structural conditions, analysis that ranks families by male status, subsuming analytically indistinct females, reveals little more than male stratification and indeed distorts even that by ignoring the resources that men acquire from women. Research from various parts of Africa supports the following three generalizations.

First, women's status is not derived solely from men, and extensive resource sharing within households cannot be assumed. In parts of West Africa, analyses have documented the budgetary autonomy that exists between husbands and wives (Dey 1981; Fapohunda 1978; Lewis 1977; Oppong 1974; Robertson 1976; Simmons 1976; Venema 1978:111ff), indicating independent female control over economic resources.

Second, divorce and remarriage are quite common in some areas. Most Hausa women, for example, have three to four marriages before menopause. This absence of long-term conjugal loyalty fosters the development of solidarity among women and the impermanence of their husband-linked position in the class structure (Jackson 1978). Over two-thirds of a sample of women from southeast Ghana reported being divorced at least once and 42 percent of households were female-headed (Bukh 1979:42–46). Indeed, female-headed households, their numbers growing as a result of male outmigration, are a special category of women,

left out of most stratification analysis. A careful study of Botswana rural households documents that female-headed households, numbering over 40 percent of a large sample, have an average of half the income of male-headed households (Kossoudji and Mueller 1983). In addition, female autonomy is inherent in many polygynous systems, common in Africa.

Third, and possibly most important, Africa is the world region with the most extensive female solidarity organizations, an indication of the importance among women of ties outside household boundaries. Formal women's associations abound from coastal West Africa to East and Southern Africa. Women's secret societies are reported in Sierra Leone (Hoffer [MacCormack] 1972) and Cameroon (Lebeuf 1963). Women preside over markets and community development activities in Nigeria (Leis 1973; Nelson 1979). Women's age-segmented organizations in Kenya are involved in judicial, income-earning, and initiation activities (Stamp 1975–76; Holding 1942). In the Ivory Coast, Liberia, and Kenya, women also organize rotating credit societies (Lewis 1976; Seibel and Massing 1974; Pala 1976) agricultural communal labor groups (Staudt 1980), and religious and cultural associations (Strobel 1979). Sharing common—often economic—interests is implicit to collective expression; indeed, women use independently controlled resources to facilitate networks and build organizations (Lewis 1977) and to create survival strategies autonomous from governments (Nelson 1978; Staudt 1978).

Participation in production and control over the fruits of labor are generally recognized as important status indicators (Friedl 1975; Blumberg 1978), as is collective participation in production and in solidarity organizations (Sanday 1974; Sacks 1974). Of course, *access* to resources is essential to both forms of participation. African women have varying degrees of this access through their extensive involvement in agricultural production (including planting, weeding, harvesting, and processing food) and in water and fuel collection. In selective areas, they engage in short- and long-distance trade. In the reproductive sphere, African women use their capacity to increase female value. "It's a woman who gave birth to a man; it's a woman who gave birth to a chief," says an Ashanti proverb (Aidoo 1981; also see Steady in same volume).

Still, one must temper an evaluation of women's apparently "high" status with some consideration of their heavy work obligations and of longstanding male control over women. The labor value of women has some bearing on status, as an analysis demonstrating a curvilinear relationship between proportional female contribution to subsistence and status in twelve African societies demonstrates. When women contribute either minimally or maximally to subsistence, their status is low, but with more balanced contributions from both sexes (40 to 50 percent of subsistence), women's status is high (Sanday 1974). Another analyst argues that men control women's production and that production serves men's interests, thereby perpetuating male power, authority, wealth, and leisure. Indeed, women's very participation in agricultural production *prevents* them from entering the modern education and wage sectors in numbers

proportional to men (Huntington 1975). As Obbo further elaborates: "The need to control women has always been an important part of male success in African societies" (1980:4).

As important, the contextual meaning of individual status is inextricably altered in changing conditions of production and politics. Once production is no longer for subsistence and community organizations are no longer central to politics in state societies, one must assess the larger political-economic structure in which women and men are situated and the relative differences in male-female access to and control over valued resources. Men have been able to "capture" new contacts and resources that penetrate a locality. As women's independent access to resources is undermined, dependency on men is increased, thereby tying women's political interests to men of wealthier strata.

STRATIFICATION IN THE STATE

Whatever women's status in anthropological studies or in studies divorced from the larger state structure, the colonial and contemporary periods are fraught with changes detrimental to women, distributing disproportionate resources to men and thereby generating greater female dependency on men. Educational opportunities, made more available to males than to females, were laden with a gender ideology appropriate to the ideas of female domesticity in the Victorian era, but virtually useless in wage employment (Weis 1980; Robertson, Chapter 6 in this volume). Historically, agricultural training and credit were provided largely to men, despite women's extensive involvement in agricultural production (Boserup 1970), a pattern continuing now as case studies demonstrate (Bukh 1979; Fortmann 1982; Muntemba 1982; Staudt 1978). Perhaps most importantly, as land becomes scarce, individualized and commoditized, it falls largely into the hands of men (Whyte 1978:161ff; Pala 1980), even in allegedly socialist societies (Brain 1976). Revolutionary land reform in Ethiopia has transformed women from "tenants of tenants" to "tenants" still lacking any independent or joint control over land (Tadesse 1979).

Only recently has there been much attention to the political dimensions of these changes, which are as important as economic changes, given the allocation of resources and values that take place through the political process. Women exercised power and authority in precolonial Africa in many ways, both directly over women and indirectly over the whole community when their sphere of influence governed the behavior of others; examples include their role in regulating markets in West Africa or in acting as titled officeholders in politically stratified societies (Lebeuf 1963). In parts of West Africa, authority structures were distinctly sex-separate, forming what Kamene Okonjo terms a "dual-sex political system" (1976; also see Awe 1977; Leis 1974; Holding 1942; Kettel, Chapter 3 in this volume; and Stamp 1975–76). These institutions implied recognition of a well-grounded sense of differential interests based on sex.

Whether fully institutionalized in authority structures or organized more loosely in female solidarity organizations, both reflect an indigenous gender ideology that legitimizes and fosters political action on matters relevant to women.

Yet embedded in colonial state structures and policies was a public–private ideological distinction that meshed with gender.[3] In this conception, men are public actors in the political process and economic breadwinners on whom women depend, while women support men in the private domestic sphere, articulate consumer demands, and stabilize a political process in which they have little direct stake. Aspects of this ideology remain embedded in law and public policy, including the longstanding women's programs in home economics and community development and the disregard for direct outreach to women who are ostensibly the responsibility of male breadwinners.

Perhaps colonial officials were oblivious to women's politics. When an historian queried Ashanti elders about women in the indigenous state hierarchy, they responded: "The white man never asked us this; you have dealings with and recognize only men, we supposed the Europeans considered women of no account and we know you do not recognize them as we have always done" (Rattray, cited in Rogers 1980). But women's mobilization emerged periodically, reflecting strong solidarity bonds, effective tactics, and redistributive goals. Yoruba women contravened colonially imposed market regulations, forced a ruler to abdicate, and promoted cross-class, redistributive educational efforts (Johnson, Chapter 13 in this volume). The issue of direct taxation of women especially stimulated action, as the protests of Yoruba market women, the Igbo Women's War (Van Allen 1972), and the Anlu Rebellion in the Cameroon (Wipper 1982) testify; women also participated in general tax riots in Tanzania (O'Barr 1975–76). To those unaccustomed to female political participation, women's mobilizations have a disarming, unexpected quality. Thus, women's visible participation in mass-based nationalist movements often proved very effective.

Colonial officials' simultaneous denial and recognition of women's politics reveal the ways in which they imposed a new ideology of gender. T. G. Askwith, commissioner for community development and rehabilitation in colonial Kenya, praised the government-initiated Maendeleo ya Wanawake women's group for "doing a tremendous amount to overcome Mau Mau" that was "not just tea and buns." He could not "resist the idea that if Kikuyu wives had really been in the know . . . there would have been no Mau Mau," yet he stated, "I know this is speculation and that there are many women now in the movement" (Dobson 1954: 457).

Whether official opinion was oblivious or hostile to recognizing women's politics, public–private distinctions operated to transform women's role toward conformity with the gender divisions of early industrial society and thus to serve the needs of capitalist transformation. Women's unpaid production and distribution of food began to underwrite both capitalist and male accumulation, revealing the way in which gender

fits into the schema of international stratification. International assistance programs, by and large, continue these patterns (Staudt 1984a; Rogers 1980).

Initially, this ideological overlay only superficially penetrated African thinking. During the middle colonial years, only those involved in Western education and government programs were exposed to these new conceptions of gender. Both then and now, many women continued to operate somewhat autonomously from government. But eventually governmental structures, distributive patterns, and ideological cues created and molded an ensuing political consciousness that affected women's political actions, especially those integrated into the political mainstream. Besides, the overarching state structure was implanted upon an indigenous ideology that, despite its relative egalitarianism compared to other world regions and legitimation of female participation in production and politics, was male-dominant. As Kitching notes in his analysis of patterns by which husbands ultimately accumulated the surplus from their wives' labor, women are handicapped because they share this ideology (1980:211).

In terms of stratification, surplus is accumulated and monopolized by men and for men, a process reinforced by male-dominant decision-making structures. The more complex the political hierarchy, the more male dominance is found (Whyte 1978:36, ch. 6). The implantation of male-dominated governmental structures under colonialism, their continuation after independence, and the simultaneous depoliticization of women's issues as the separation between public and private spheres became institutionalized all appear to quicken gender stratification in exponential ways. What makes the phenomenon more complex, however, is that women have not been universally disadvantaged. Some women have gained power, prestige, and privilege—and may thereby be termed "elites"—either through independent means or through status derived from their husbands. To the extent that these women dominate women's politics, the seeming integration of female solidarity into mainstream politics serves to disguise class politics.

WOMEN'S CLASS POLITICS

Political stratification is a universal feature of state societies, and women are virtually, though not totally, excluded from the upper strata. A comparative elite theorist concludes, "Women are the most underrepresented group in the political elites of the world" (Putnam 1976:32). Still, some elite women outside positions of authority are politically involved, but in smaller numbers than men.

At the lowest common denominator, all women share basic interests related to reproduction, mothering, and some domestic work, although economic circumstances affect their opportunities and lifestyles. Women's work varies immensely across regions and historical epochs. The work and daily lives of elite women also vary considerably from those of ordinary

women, reducing awareness of, and detracting from, the common interests women share. Certainly, though, the public–private distinction and institutionalization of male interests in laws and state structures have made the existence of women's interests more explicit. Still, household affiliations and class interests cut across concerns that women share and some women have strong economic stakes in the survival of contemporary household and state structures. They protect these stakes through dominant ideologies that serve class interests and through the specific pursuit of narrow, nonredistributive political goals.

In order to support the class interests that maintain the established order, Gramsci suggests that elites foster a dominant ideology in society which is diffused through the media and through educational, religious, and political institutions (Boggs 1976:36). Commercialization, upward mobility, individualism, and competitiveness can serve class interests and reinforce gender stratification, while undermining female solidarity.

The Kenyan media, for example, are permeated with a philosophy of individualism and symbolic affirmations of equality, obscuring systematic discrimination. As newspaper headlines testify, "there's no discrimination" in Kenya. The responsibility and blame for sex disparities are placed squarely in the hands of individual women who, by "working harder" and proving they "can work as hard as men," can "go forward."[4] The media also emphasize women's domesticity; the president of the largest women's organization stated that a "woman's place is in the home" and that a woman "should lay more stress on her domestic role."[5] This distorts the reality of the lives of virtually all rural Kenyan women, who work extensively in agriculture and trading, as well as in domestic pursuits. Similarly in Zambia, the Women's Brigade of the United National Independence Party (UNIP) projects an image of the idealized town mother, castigating "bad town mothers," premarital pregnancy, abortion, mini-skirts and Afro wigs (Schuster 1979:160–65).

Female lifestyle and attitudinal differences are clearly problematic for women acting politically. When elite women are involved in women's politics, one must ask whose interests are being served: those of particular women's economic class, or those of women as a gender class? Are women unconscious pawns, active pursuers of the interests of their household and/or class, or pragmatic activists operating in a public–private political world? In this section, the studies reviewed reveal women's pursuit of narrow goals that serve select class interests and that are compatible with, and therefore perpetuate, public–private distinctions. While organizing in the name of women, women's politics operate like class politics to advance the interests of the already privileged.

Women activists have pursued reform of marriage and divorce laws, as demonstrated in studies of the National Council of Ghanaian Women (Callaway 1976), the Ugandan Council of Women (Little 1973:73), and the Kenyan organization Maendeleo ya Wanawake (Wipper 1971a). While aimed at building an equitable legal foundation, the beneficiaries of such efforts—had they been successful—would be relatively small in number.

The pursuit of equal pay for equal work and of extended maternity leave, the goals of the Sudanese Women's Union (Fluehr-Lobban 1977), would benefit only those women in wage labor, thereby excluding the majority of women, who work in the informal or subsistence economy. Similarly, only the already well-off can afford the fee-based, but government-subsidized, nursery schools promoted by women in Ghana (Klingshirn 1971:227).

Even when organizations widen the scope of their demands, their justifications are sometimes based on conceptions of gender derived from colonialism. The Kenyan Maendeleo group addressed issues ranging from rural women's extensive labor burdens to female deference to men; but their concern was often for symbolic rather than practical issues, such as the extension of the Swahili term of respect for a European woman, *memsahib*, to African women (Wipper 1971a:434–35). That women activists pursue class politics is revealed as much in the issues they do not pursue as in those they do. Unequal distribution patterns in women's most significant economic pursuit, agriculture, are not considered "political," as the following overview drawn from my field research in western Kenya indicates.

THE WESTERN KENYA CASE

Idakho Location, Kakamega District, is a densely settled agricultural area with farm size averaging 2.5 acres. Since the 1930s, many working-age men have left Kakamega to seek wage employment elsewhere, leaving two-fifths of the sample[6] of households as de facto female-headed (Staudt 1978b, 1979). Besides farming, the only income- or wage-earning activities are teaching, working in the civil service, shopkeeping, and beer brewing.

Prior to commercialization and centralized government, there were no resources such as education, employment, and private lands to be captured and controlled by particular groups. Women, then as now, were self-sufficient to some extent, with rights to use land (contingent upon marriage, however) and recognition for their crucial role in reproduction. Nevertheless, community leadership was exclusively male, and women had no right to speak in mixed public groups.

Twentieth-century commercialization and state development have enlarged the available resources, while shrinking women's share of those resources. Wide sex-linked differences in employment and educational opportunities have given men an edge in the acquisition of resources, and land reform, in particular, has institutionalized individual male control over land. While women's access to money, loans, and education has increased, it has not matched that of men. These economic resources and disparities have implications for politics. New criteria have emerged to exert influence—criteria differentially distributed between the sexes such as education, cash, and position.

Classes are beginning to emerge in Idakho Location. Those persons with initial access to education and local positions now constitute an elite

group with a high level of power, privilege, and prestige. Although women have more limited education than men on the whole, those who are highly educated tend to marry men of similar status. These wealthy women participate in an emerging class whose life chances are quite different from those of ordinary households. For example, their land holdings averaged 7 to 9 acres, in contrast to the 2.5 acres for a cross-section of ordinary farm households. Virtually all elite farms were conspicuous income-earning farms, in contrast to two-fifths of the nonelite farms. Elite women both benefit from and actively participate in determining household stratification, leading politically to their identification with households rather than along lines of gender or lineal kinship. Powerful material and ideological interests strenghten that identification (Staudt 1979).

Despite these marked material differences, women at all stratification levels do share common interests. All women participate in agricultural production on their husbands' land, although some women hire laborers and others sell their labor. Virtually all women except the very old and the newly married participate in female solidarity organizations that engage in mutual aid, communal agricultural labor, contract labor for others, and religious activities. Women also share interests related to reproduction, childrearing, and domestic work, including fuel and water collection. Elite women tend to lead women's organizations because of material and personal resources such as education and contacts that are useful in linking women to the political mainstream.

During election campaigns, candidates are accessible to women and eagerly seek their votes. After a previous campaign, the candidate for parliament and his brother helped bring a multipurpose cooperative society to the area, built with assistance from the Danish government. A delegation of women's group leaders went to the candidate and requested diffuse assistance, from "remembering the work women do," and "how they need help," to specific demands to build a women's center. These centers have in the past been associated with government-sponsored women's sewing clubs. The local cooperative society started a sewing club with sewing and knitting machines, but their agricultural pursuits allowed few women the time to take lessons. Also, the expense of material and lack of demand for sewn items limited the extent to which the club provided income for women. Knitted caps were its primary legacy (Staudt 1978b).

Why did the women's interests center on domestic rather than agricultural issues? Great disparities between the sexes in access to agricultural services, such as visits from extension officers, training, and credit, meant that female farm managers always had less access to services than farms with a man present, particularly to such valuable services as credit and training (Staudt 1978a). Moreover, in the multipurpose cooperative societies, women's enrollment was not proportional to their numbers (Staudt 1978b).

Several answers to this question are possible. First, elite women had profoundly different socialization experiences than nonelite women. After

receiving an education that strongly stressed homemaking skills, they continued to participate much more actively than nonelite women in government-sponsored community development projects that are domestically oriented. The underlying ideology of these experiences strengthened their identification with their conjugal families and legitimized their advocacy of domestic activities. Second, elite women's material interests in agriculture were different from those of ordinary women. Elite women farm managers and elite farms with a man present experience near equity in access to agricultural services, with the exception of access to credit (Staudt 1979). Either consciousness about sex inequities is low, or elite women protect their privileged access in this context of scarce resources and zero-sum politics, where gains for one group are seen as losses for another. Elite women may perceive that the pursuit of family interests represents a better investment of their political energies, with greater immediate returns than the pursuit of agricultural interests. In the meantime, both cross-class female solidarity and cross-class male preference in the distribution of services minimize class consciousness and action on the part of those excluded (Staudt 1982).

Although the participation of elite women enhanced the effectiveness of women's politics, the goals of their political action were not redistributive in effect. By not articulating agriculture as a "women's issue," elite women protected privileged access for elite households. Finally, the women's issue—a sewing club—helped to reinforce domesticity and the idea of the private sphere as women's sole realm, thus confirming Bujra's observation (Chapter 7 this volume) that upper class women may redefine the roles of lower class women to suit their own purposes. Yet ordinary women continue their participation in agriculture, to the great benefit of their households and the government.

WOMEN'S GENDER POLITICS

Contemporary women's groups do, on occasion, enter the political fray. But, for reasons related to gender, they meet with limited success. Analysis of Maendeleo ya Wanawake and of women traders in Abidjan, Ivory Coast, reveals how few political and economic goals have been achieved (Wipper 1971b; Lewis 1976). Both elite and nonelite groups experience this difficulty, frequently leading women to remain autonomous from government or from attempts to influence government (Klingshirn 1971). This avoidance strategy may function to compensate for governmental neglect by providing members with mutual aid and self-help, but unlike the experience of indigenous female solidarity organizations in a political context where women's issues were central—even if separate from men's politics— women's group activity in the contemporary context faces the limitations of an ostensibly pluralist setting in which they must compete with other, better-endowed groups. If narrowly based women's class politics do not

thwart redistribution by gender, then the structures women's advocates are up against will do so.

The apolitical stance that many women's organizations take may reflect either a recognition of the depoliticization of their activities or a calculation of the risks they take in entering the political fray and their limited probabilities of success. Ironically, however, women's continuing participation on the periphery of politics and the self-help emphasis of their organizations reinforce their marginality to the political mainstream. Rather than using their resources effectively in the political mainstream, women enter politics on terms set by the male elite, who use women's political energy for their own ends.

Lagos market women have been highly organized and politically active on some occasions. An elaborate traditional organizational network covers over thirty markets and the supreme head is appointed by the *Oba* of Lagos. During the nationalist period competing political parties bid for the support of these large, cohesive, enfranchised groups. Periodically market women protested against blatant corruption and political incompetence, but outside of that, they exerted little pressure on government, even for better market services. "Despite their numbers, organization, and recognized political importance, they remained largely a political resource, which parties attempted to tap, rather than a group or groups active in their own right" (Nelson 1979:309–10; material cited from Pauline Baker 1974). Large-scale survey researchers have discovered enormous gender differences in Nigerian voter turnout and organizational participation (Verba, Nie, and Kim 1978:ch. 12, excluding the north). This description of the contemporary era offers a pointed contrast to the historical situation presented by Johnson in Chapter 13 of this volume.

Outcomes of Female Political Participation

If women—elite or otherwise—opt for participation in the political mainstream, they risk three outcomes: scapegoating, cooptation, and overwhelming odds against achieving gender-based redistribution of resources, if this goal is even articulated. Urban women sometimes become scapegoats because of their allegedly uncontrolled sexuality. Politicians' attacks on pregnant schoolgirls, market women, mini-skirts, and wigs deflect national attention away from substantive economic problems in Zambia (Schuster 1979:165–69), Ghana (Robertson 1983), and Uganda (Obbo 1980:9). An analysis of the Sudanese Women's Union, founded as part of the nationalist movement, portrays women's vulnerability to such charges. Conservative forces after independence labeled members prostitutes, and that, plus the hasty organization of a reactionary group, produced the organization's demise (Fluehr-Lobban 1977). A more recent incident in Nairobi women's politics, where the head of a women's umbrella organization was ousted for "moral laxity," demonstrates female susceptibility to allegations of uncontrolled sexuality even by other women. As an influential weekly news commentator summarized, "The

whole controversy has left observers with the impression that Kenyan women have been unable to manage their own affairs" (*Weekly Review,* 27 February, 1981). National women's organizations, like any similarly ambitious groups, contain potential class, ethnic, and personal conflicts. Whatever the conflict causing the split, female sexuality became the point of public debate.

A second risk that women face in entering the political mainstream is cooptation. Ruling elites can contain women's demands by creating organizations that marginalize women and isolate them from real decision-making power. These women become one of many interest groups relegated to the periphery, with little political leverage. Such associations appear to use women rather than provide a structure that they can use to secure and advance their own interests.

Many women's organizations have been created and/or coopted into ruling parties to strengthen the party's base of support. In order to centralize voluntary associations and subordinate them to the Convention People's Party (CPP), Nkrumah disbanded the Federation of Ghana Women. In its stead, he sponsored the National Council of Ghana Women as a mechanism to neutralize the FGW, thought to be supportive of the opposition. Political parties following the CPP also have had women's party wings, but they are little more than paper organizations during elections (Smock 1977:206). In Zambia, the urban Women's Brigade of the United National Independence Party polices shops and markets to eliminate "profiteering," which badly constrains marginal women traders (Schuster 1979:160–65). The National Union of Malian Women (UNFM), the women's wing of Mali's only party, is designed to tie the women's segment of the population, like the youth and worker segments, to the national government. Women party officials report that the UNFM could not support a women's issue that the party did not support. In the case of one-party states, it is often unclear whether women's wings of the party can apply leverage on government leaders; a shared concern with government survival and an awareness of shared vulnerability may obviate the importance of the question. The ouster of governments, including their women's wings, is not an uncommon occurrence. The fall of Mali's first independent government in 1968 caused the demise of the UNFM's predecessor (McNeil 1979:113–17).

Probably the most thorough study of the women's wing of a political party concerns the National Congress of Sierra Leone Women (Congress), part of the All Peoples Congress (APC). Through regular meetings of the working committee and the executive committee, women's issues are theoretically linked to APC policy formation. Women in the Congress gain wide support for the party both through recruiting members and through serving larger party needs. For example, women challenged soldiers during an attempted coup and created a women's militia unit to protect the prime minister after an assassination attempt. Returns to members are questionable, although they pay both entry fees and monthly dues. Most members are middle- and low-income petty traders who hope to increase

their profits with concessions gained from membership. Yet few receive material benefits from participation. The views of one vegetable seller are apparently typical:

> She feels that she has to appear in favor of the government and join Congress or else they would be thrown out of their one-room apartment and her husband would be thrown out of his job. . . . She finds being a member financially impoverishing. . . . She is a member of Congress because all the people in her yard [compound] are APC supporters. (Steady 1975:25–26; 69)

The Congress' leverage was tested when its leader sought to contest an election under the party symbol. The party forced her to run as an independent, and she lost the election (Steady 1975: postscript).

The above examples also raise questions about whether women's organizations have promoted redistribution of resources and, if so, for whom. In western Kenya, a sublocation-wide women's mobilization with evolving redistributive goals, known as Umoja, illustrates the limits of cooptation as a route into the political mainstream. The location chief and community development assistant (soon to become male subchief) created Umoja both to augment chiefly power through more support from, and control over, the female populace and to acquire labor for implementing land reform in the late colonial era. Women were called upon to tend the euphorbia hedges that demarcated newly consolidated land plots, as well as to disseminate official information that female representatives obtained while attending formerly all-male government announcement meetings, known as *barazas*. It is doubtful that Umoja would have emerged without the chief's legitimation, given female exclusion from formal local political institutions. The use of fines to compel all women to contribute labor or to compensate for their absence gave elite women the option of not participating (Staudt 1980).

Women transformed Umoja to include large-scale agricultural and contract labor on a reciprocal basis and mutual aid, based on cash exchange. Money acquired through Umoja was perceived to be within women's own realm, over which husbands had no authority. The most significant development was a women's court, in which women judged other women. For females to judge their peers in a setting heretofore confining such judgmental power to men was a significant departure from existing authority patterns. Male elders had always questioned parties, assigned fines, and collected small fees; through Umoja, women elders collected such fees, encroaching upon the income of politically significant male elders. Nevertheless, women judges were strict; respondents recall that the fines women judges dispensed against women who were "lazy" or "abusive" to husbands were equal to or harsher than those of male judges.

The distributive process was partially transformed, as women gained in both symbolic and concrete ways from the mobilization. There was an increase in female status associated with appointing female leaders to the same positions as men held, such as subchief and lineage leader, in a

system with no formal female political roles in previous times. Women also gained concrete benefits through group-related agricultural services in which both men and women staff lectured to special women's agricultural *barazas*, provided information and occasionally distributed seeds. Furthermore, top- and mid-level Umoja leaders received financial support to attend short courses at the nearby Bukura Farmer Training Center. Finally, the large-scale agricultural contract labor groups became savings societies, in which money was to be divided equally among members at the year's end.

A number of reasons account for Umoja's collapse, including cessation of the chief's support, failure of women leaders to redistribute savings among members, and distributional patterns that threatened the interests of male elders. First, though the chief had been gradually siphoning off funds throughout Umoja's existence, he was unable to persuade Umoja leaders to deposit all remaining funds with his assistants, who were to have opened a bank account for the group. This disagreement, plus his imminent removal from office at the time of independence, eliminated the chief's support. Second, leaders attempted to build organizational legitimacy and necessary allies through contributions to other organizations and some also received compensation for their time-consuming and occasionally costly participation. Given these expenses, little cash was left to distribute among members, leading to their disaffection. Finally, women elders usurped a substantial proportion of male elders' jurisdiction and income from fees, representing a significant redistribution of community resources and power.

Questions might be raised about how far male authorities will go in redistributing resources, as well as about the degree to which women—often aware of their potential threat to existing resource distribution—will advocate redistribution. The reluctance of women elders to question traditional authority structures based on sex and age suggests that leaders' interest in organizational survival may deter them from seeking more basic restructuring of political or economic power. Though the person in authority might change, the structure went unquestioned; indeed, it was even reinforced.

A final obstacle faced by women when joining the mainstream is the overwhelming odds against transforming the boundaries of political issues in political structures they had no hand in forming. Were women to translate their demands that flow from opposition to institutionalized male control into viable goals and outcomes, the nature and character of contemporary government would resemble none now known. Because of the extreme threat that women would pose, extraordinary measures are taken to dampen their demands.

An analysis of the discrepancy between rhetoric on women's subordination in Tanzania and the actual practice of women's organizations and official programs on behalf of rural women suggests a refusal to confront the issue of male control. The Umoja ya Wanawake ya Tanzania (UWT), the

women's wing of the ruling party, Chama Cha Mapinduzi (CCM), which claims to have more than 180,000 members in over 3,000 branches around the country, is involved primarily in day care and maternal/child health issues and only minimally in economic activities such as cooperatives. Limited government funding exists for women's programs, and women's integration into overall national planning is virtually nil. In a participatory project utilizing Freire-like consciousness-raising techniques, women analyzed their situation as follows:

> Women do not work as hard as the men. They work harder. When we go to the field, he sits under a tree telling me where to cultivate and then complains when the work is not done quickly enough.
>
> Why is it that men leave us to carry all the baggage? I go to the field with a hoe on my shoulder and a child on my back. He carries nothing. Then I return with the hoe, the child, and a huge container of water on my head. Still he carries no part of the load.
>
> The money is spent on drinking, not on us or on the children. We share the work, or do more of it, but he takes all the money telling us it is his—that he earned it. It is a joke. (Stanley 1979, cited in Rogers 1982: 32–33).

In development projects involving income-earning activities, a "gender system in which men control the lives of wives and children but are not economically responsible for them" has neither been called into question nor transformed (S. G. Rogers 1982).

Elsewhere, warnings of the dire consequences of women's equality—the "soaring divorce rate," a "rise in illegitimacy," and the "loss of African customs"—create a hostile climate for women's demands in Kenya and Uganda (Wipper 1971b: 478; Obbo 1980). A major theme in literature on the Algerian Revolution was that the French aimed to "subvert" Algerian culture through women. Women were encouraged to shed the veil and attend school (Fanon 1965). Yet others argue that the colonizer could not "penetrate the realm of male-female relations" and the family became an "Algerian bastion and refuge." The defense of "cultural nationalism" after independence hindered women reformers in its charge that they were betraying the revolution (Boals and Stiehm 1974: 74).

Women beer brewers in Nairobi reportedly rally against such threats to their interests. Some successes are evident, due to women members of Kenya African National Union committees and committees of elders. For example, women have secured a proportion of household units in a relocation project, as well as piped water. Delegations, begging for the president's mercy, forestalled City Council bulldozing of slum units. Nevertheless, women have unequal access to formal jobs and education, and they deny birth control to their daughters, consigning them to a life like their own. While female solidarity is present, it attains only ad hoc, short-term solutions in an environment fraught with comprehensive, long-term problems—an environment in which women are stigmatized, subject to police harassment, and condemned to insecurity and marginal survival (Nelson 1978).

Gender stratification, becoming increasingly rigid, is correspondingly difficult to challenge. Women do not or cannot challenge that stratification without exposure to the risks outlined above. Opting out of seemingly irrelevant political participation into a female culture is a risk-avoidance strategy, yet one that does not alter prevailing stratification patterns. The nature of women's challenge to gender inequality is to gnaw away at it slowly. Ironically, however, in so doing they may secure limited gains at the expense of reinforcing the existing distribution of power and authority.

CONCLUSIONS AND IMPLICATIONS

Both gender and class stratification have profoundly negative consequences for women's politics. The participation of elite women tends to increase, but does not guarantee, the effectiveness of women's politics; indeed, they rarely aim to achieve a redistribution of power and authority between women and men. Nonelite women's politics, which tend more toward redistributing power and authority or stretching the now confined public–private boundaries, are rarely effective. The risks that women of all classes face in joining the male mainstream suggest that gender surpasses class stratification as the key political constraint for women. Furthermore, class divisions among women inhibit a focus on redistribution in their efforts to confront gender stratification, while increasingly institutionalized male preference obscures full political consciousness of class stratification for men. Elite women, increasingly dependent on husbands and the privileges of their household and class, may work politically to advance the interests of their class. Economic interests and a hegemonic gender ideology provide strong incentives for them to act this way. Ironically, though, female solidarity has a cross-class appearance and thus obscures class consciousness.

Yet caution must be exercised in accepting overly deterministic explanations based solely on economic interests. Because of their personal and material resources, it is vital for the ruling elite to contain elite women. The idea of women working politically for women and conceptualizing women as a gender class has radical, redistributive implications.[7] It serves ruling elite interests to bind elite women to their households through economic dependency and domestic-focused gender ideology. If those material and ideological interests did not exist, ties to other women, represented in the precedent of female solidarity organizations, would become more significant politically and would likely produce a more equal distribution of power and resources between women and men. The threat that this poses is averted in the territorial organization of government administration and legislative constituencies. Such organization includes men and women and reinforces the importance of household, kin, and ethnicity, rather than gender.

National government authority disproportionately involves and favors men and simultaneously depoliticizes what was once political—

male–female relations and interests as expressed in female solidarity organizations. Gender stratification and the overwhelmingly male orientation of politics create such severe constraints for women's politics that women may compromise their goals, as in Umoja, resulting in a reinforcement of stratification. The payoff of women's political action has been so limited and the risks in joining the mainstream so great that women typically retreat into an allegedly apolitical stance. While positive in its maintenance of cohesion and solidarity, this withdrawal into self-help may reflect an acceptance and reinforcement of the division of labor and control. Moreover, it may relieve men and the system of their responsibilities in production and reproduction. Indeed, ignoring women may be increasingly "cost-effective" for men and governments.

There are three conditions under which class and gender stratification tend to be challenged. First, regimes with socialist ideologies foster women's participation, emphasize economics as much as domesticity in gender ideology, reduce the importance of class in politics, and even penalize prejudicial attitudes. In Mozambique, women participate in collective production and are compensated directly for that work in what are termed "politically correct" villages. The dominant ideology legitimizes such activity. An analysis of party documents reveals the expulsion of members for expressing derogatory attitudes toward women's emancipation (Isaacman and Stephen 1980: ch. 5). Nevertheless, contradictions still prevail, and the public and private spheres are not joined. No attention is given to alleviating women's work in family food production or to integrating men into that work. In "politically incorrect" villages, men are remunerated for women's work in collective production, which is now women's duty in addition to family food production. African socialist practice is a reminder of the only partial light that Marxism sheds on gender stratification. To the extent that socialist governments can effect economic redistribution, however, the impact of class stratification on women will be alleviated.

Second, a new gender ideology now supplements and potentially undermines the dominant ideology. That new ideology is disseminated through United Nations organizations and conferences and international women's organizations. An offshoot of that ideology has been the creation of "women's machinery" to review, evaluate, and recommend ways to ensure women's equality and to integrate women into all sectors of the economy. In a UN study that analyzes the effectiveness of "national machinery" for women based on questionnaire responses from seventy-nine countries (including some in Africa), women's bureaus, ministries, advisory committees, and party organizations were found to be constrained by limited financing and staffing, social and religious attitudes that legitimize women's subordinate status, and mandates that limit their operations to welfare issues of low priority. Although such machinery has contributed to increased data collection and advocacy, women are "still a marginal consideration in development strategies" (Ooko-Ombaka 1980: 61).

Finally, the gradual growth in female labor force participation brings with it new and aggravated sex discrimination. According to an aggregate data analysis of sixty-one countries, as more women enter the paid work force, discrimination against them increases. During the early'process of participation, women are recruited from the middle classes and treated better than lower-class women. But as the number of women workers increases, they become more economically depressed as a group (Semyonov 1980: 544–45). Combined with female self-sufficiency such as that analyzed by Berger (Chapter 12, this volume) among textile workers in South Africa, a gender-based class consciousness will likely grow. Paradoxically, this adverse material base among women of different classes may create appropriate conditions for women's consciousness and for the renewal of female solidarity organizations.

NOTES

1. Class refers to a set of persons who stand in a similar position with respect to some form of power, privilege, or prestige. Lenski's (1966) more flexible definition of class is utilized here, rather than the more common Marxian definition, in order to incorporate some rural societies where emerging class differentiation is a relatively recent phenomenon and cannot yet be characterized in terms of rigidified relations to the means of production, and in order to incorporate gender, which often becomes invisible in class analysis because capitalists' exploitation of those who sell their labor supersedes exploitation *within* the laboring class or in this case, male exploitation of women. A case in point is Kitching's (1980) Marxist analysis, an excellent weaving of the household political economy into Kenya's integration into the world capitalist economy. But once classes are formed, men's accumulation of female surplus is rendered invisible. Kitching does admit, though, that "bourgeois stratification theory," examining objective and subjective measures of inequality, is useful for drawing political implications (454). For these reasons, stratification and elite–nonelite distinctions are used in this chapter.

The distributive process within households is a fruitful area of micro-level study which complements analysis at the macrolevel. On distributive reversal within households, see Etienne 1980 and Kilby 1969.

2. Gender, referring to the cultural elaboration of differences between men and women, is used in place of sex, referring to biological differences. Gender is a particularly important concept to use because of the "female husband" phenomenon in Africa (see Oboler 1980 and O'Brien 1977).

3. On public–private distinctions in Western political thought, see Elshtain 1981 and Eisenstein 1981. My argument applying this to Africa is made fully in Staudt 1984b.

4. During the author's research in Kenya (see fieldwork analyses below), many articles appeared in national newspapers about women, partly due to the publicity surrounding International Women's Year. For example, see the following issues of the *Daily Nation:* 13 and 23 November 1974, 18 October 1974, and 27 March 1975.

5. The interview was with Jane Kiano, president of Maendeleo ya Wanawake, in *Viva* magazine during 1975, International Women's Year. *Viva* is a slick monthly magazine catering to urbanized, wage-earning, and/or relatively wealthy women, containing such diverse material as recipes, beauty tips, and information about legislation that affects women.

6. This section is drawn from Staudt 1979 and 1978a, where selection methods for the elite sample, forty households, and the cross-sectional sample, 212, are explained.

7. See Eisenstein 1981 for an insightful critique of liberal feminism, along with its radicalizing concept of "women as a sexual class."

Chapter 12

SOURCES OF CLASS CONSCIOUSNESS
South African Women in Recent Labor Struggles

IRIS BERGER

THE RELATIONSHIP BETWEEN household labor, wage labor, and capitalism has received increasing scholarly attention as part of the feminist effort to clarify the nature of women's economic activity. This interest has led to a new awareness of the way in which household labor sustains the system of capitalist production and to a deepened understanding of the complex connections between women's dual spheres of experience as household workers and as wage laborers. Despite the high level of concern with these issues, certain received ideas continue to be accepted with insufficient analysis or examination. One of these is the notion that, because of the split in their lives, women industrial workers do not experience proletarianization as totally or as intensely as men do. Although differing in emphasis according to the time period and the society under consideration, this theory of women's incompete proletarianization attributes the low level of women's participation in workers' struggles to their involvement in reproductive as well as productive activities. Even as full-time wage earners, women continue to assume responsibility for household tasks and, more broadly, for the care and socialization of the next generation of workers. This division of time and concern, the theory goes, leaves them less prone to identify themselves solely as workers and therefore less liable to commit themselves to class-oriented collective action. But their incomplete proletarianization is economic as well as

An earlier version of this paper appeared in the *International Journal of African Historical Studies*; I appreciate their permission to reprint it. I am grateful to the National Endowment for the Humanities and the Social Science Research Council for providing the funding to support this research. Neither, of course, bears any responsibility for my conclusions. I also would like to thank Debbie Gaitskell, Jeanne Penvenne, Karen Sacks, and Julie Wells for their helpful suggestions.

216

psychological; for these arguments also suggest that the option of relying on male incomes for support, if necessary, decreases women's dependence on their own labor power.

Rowbotham takes this position in her discussion of European women workers in the nineteenth century. She suggests, "The particular relationship of the woman to reproduction and consumption within the family mediated her relationship to commodity production," thereby making women "less liable to organize." She elaborates:

> Women continued to work in the home, maintaining the needs of the family, but working for wages became the predominant activity external to family production. The wife's work outside the home was therefore an economic supplement to the family income. Women retained certain features of a precapitalist labour force. They never fully learned the rules of the new economic game (1972: 113).

Recent studies of women workers in contemporary Third World countries have stressed a similar theme. Elson and Pearson, writing on women employed in "world market factories," those that produce solely for export to the centers of capitalist production, found a low level of female participation in trade union activities and a lack of workers' or trade union consciousness. Their explanation, based on the idea of women's "secondary status" in the labor market, is similar to that of Rowbotham (1981: 102–3, citing Cardosa-Khoo and Khoo 1978). A major study of working-class consciousness among Latin American women argues along the same lines that, because of women's family roles and their sexual subordination at home, labor force participation alone may be insufficient to foster class consciousness (Safa 1979: 442–43).[1]

Like the women workers described in these studies, those in South Africa also bear heavy reproductive responsibilities, not only for domestic labor, but also for family support. Female textile workers interviewed in Durban in the mid-1970s were insistent that they assumed the full burden of domestic labor and childrearing. One woman explained, "The woman sees to it that everyone in the family gets food despite that there may be no money available; the man will demand food. This leads the woman to secretly lend [sic] money from others. With a small child the mother has to see to it that he is provided with food and clothing." Typically these women rose at 4:30 A.M. in order to catch a 5:15 bus and returned home between 5:30 and 7 P.M., depending on overtime work and the availability of transport. Cooking, child care, and washing and ironing occupied the evening hours, with heavier household work, sewing, and knitting saved for the weekends. The majority of them relied on family members for child care, although some employed unrelated young girls. Migrant workers usually left their children with relatives in the rural areas (Westmore and Townsend 1975: 27–28, 30).

Despite their heavy family involvement, South African women, like those in many other historical settings, have displayed a degree of work-

ing-class consciousness that is inconsistent with the idea of semi-proletarianization and suggests a number of problems with the concept. First of all, it does not distinguish adequately between the economic and the psychological aspects of women's roles. Secondly, it seems to assume that all women workers are married and have children, failing to take into account the differences in women's ages and family responsibilities. Finally, it ignores aspects of both the work situation and the particular society that may foster or hinder the development of class consciousness and class struggle. In South Africa, although women workers are strongly tied to their families, both emotionally and economically, a number of factors have helped to foster a militant, politically aware female component within the black working class: the heavy economic responsibility most women bear; the large number of women migrants, particularly among Durban textile workers, who live in densely populated and rigidly controlled single-sex hostels; and the strict regulation of black living and working conditions that lends a political dimension to all workers' protest. Furthermore, for working-class women in South Africa, as for farm laborers in Kenya (Presley, Chapter 14 in this volume), female solidarity and class action have been mutually supportive. The ease with which women have come together to voice their demands undoubtedly draws not only on a tradition of union organizing but also on a history of women's solidarity expressed in religious organizations, informal assistance networks, community-based protest movements, the political activities of the African National Congress Women's League, and the campaign against passes for women in the 1950s.

The concept of incomplete proletarianization draws on Marx's definition of free wage labor, which he depicts as "free" in the following double sense: "That as a free individual he can dispose [of] his labour-power as his own commodity and that, on the other hand, he has no other commodity for sale" (Marx 1976: 237). Elson and Pearson, citing this definition to explain women's "secondary status" in the labor market, argue that women are never "free" wage laborers in this classic sense of having no other commodity for sale because they always have the option of obtaining subsistence outside the capitalist labor process in exchange for services "of a sexual or nurturing kind" (1981: 96). In South Africa, however, I would contend that this is not necessarily the case. Since male wages have been kept deliberately at a level sufficient to support only a single wage earner, most working-class women are unable to rely on male "breadwinners" to satisfy their economic needs and those of their families. Furthermore, the inability of all South African blacks to dispose freely of their own labor power may create a stronger basis for solidarity between men and women than exists elsewhere. The limited possibility for economic dependence may, therefore, be an important factor in explaining the proletarianized behavior of South African women.

The implied relationship between economic responsibility and proletarianization gains support from Safa's study of Latin American women. Although most women in her study had a very low degree of working-class

identification, there was a strong element of class consciousness among women who were household heads. She stresses, in particular, the high degree of identification with work roles among these women and the importance of the relationships they formed with their coworkers:

> Women who are heads of households are more prone [than other women] to develop a stronger commitment to their work role because they become the principal breadwinners for their family. They cannot afford to regard their work roles as temporary or secondary as do most of the married women in the shantytown. This lack of commitment to a work role plays a crucial role in the absence of class consciousness among women in the shantytown, since women never identify with their work role nor stay on one job long enough to develop a relationship with their peers. . . . The reason is clear: women must rush home after work to care for children and other household chores, whereas men are free to join their friends, and, as the survey demonstrated, often meet their best friends through work.
>
> Women who are the sole support of their families are more likely to develop class consciousness than women who are still primarily dependent on men to support them (1979: 447–48).

Some of the material from South Africa directly supports the idea of economic independence as a central factor in producing class consciousness among women. From this perspective, family responsibility would foster rather than inhibit women's collective involvement. Yet, even those women who did not have sole responsibility for generating household resources generally identified with their work roles because of a high level of economic obligation to their families, and particularly to their children. "I must work for my children to eat," the words of a Johannesburg garment worker, convey a widespread sentiment.

South African women have a history of participation in working-class struggles that dates back to their involvement in the Industrial and Commercial Workers' Union and the Women Workers' General Union of the 1920s and to the garment and textile organizing of the 1930s.[2] In the early 1930s, thousands of white and colored (the South African term for persons of mixed race) women in these newly expanded industries came out on strike in an effort to stave off wage cuts resulting from the Depression and to gain some control over their wages and working conditions. During the following years the Garment Workers' Union, particularly in the Transvaal, became a strong and stable organization, led by the union's male general secretary, Solly Sachs, but increasingly under the joint leadership of a strong cadre recruited from the ranks of the workers. Notable among these women were Johanna and Hester Cornelius, Anna Scheepers, and Dulcie Hartwell. Bettie du Toit, another activist of the period, gained her initial experiences in the textile industry.

From the late 1930s onward, women leaders of the garment workers, joined by organizers with Communist Party affiliations, succeeded in unionizing large numbers of semiskilled and unskilled workers, among them female sweet and tobacco workers, milliners, and food and canning

workers. The Food and Canning Workers' Union (FCWU) at the Cape, formed and led by Ray Alexander, became a model radical union that combined action on both economic and political issues with campaigns on community-oriented concerns such as workers' housing and living conditions. Through its ranks black and colored leaders like Mary Mafekeng, Liz Abrahams, and Frances Baard rose to responsibile positions not only in the union but also in the Federation of South African Women, the organization that led the massive women's anti-pass demonstrations of the 1950s. This politicization, however, left the FCWU vulnerable during the 1950s and early 1960s, as many of its leaders were banned or banished to remote rural areas.

From World War II on, the garment and textile industries began to change. The latter expanded enormously and came to rely primarily on black male labor. Only from the mid-1960s, when manufacturers began a campaign to introduce a male–female wage differential, did women begin to reenter the textile mills in large numbers. In Transvaal garment factories the gradual replacement of white women by black and colored women was underway by the mid-1940s. Aided by a legal loophole that union officials discovered, black women gained admission to the registered Garment Workers' Union in 1944 and quickly became staunch union members. By the late 1960s, under the leadership of Lucy Mvubelo and Sarah Chitja, two of the first African women to become shop stewards, the primarily female National Union of Clothing Workers (NUCW) had become the largest black union in the country. Unlike the FCWU, which had been progressively weakened by political repression, the NUCW has remained intact by deliberately eschewing politics.

Many of the textile and garment factories that were built in the 1950s were located in rural "homelands"[3] or in adjacent "border areas." In both cases they drew on destitute, proletarianized rural women for whom even the subpoverty datum line wages represented an advance over their meager earning potential in the countryside. In one resettlement township of the Ciskei, for example, residents explained that the two factories employed mostly women because "the wages are so low . . . that only they will work there" (*Inquiry* 1979: 21).[4] Throughout this period, however, the vast majority of black women continued to work either in agriculture or domestic service.[5]

The labor activity of the 1970s followed a relatively quiet period born of severe repression during the previous decade. But, despite the small number of major work stoppages between 1960 and 1970, strike activity did persist, especially among migrant workers in the expanding low-wage textile industry. The resumption of workers' protest during the 1970s occurred within a context of continued low wages and steep price increases, especially in the cost of such essential items as food, clothing, and transportation (Hemson 1978: 19). Furthermore, Africans were legally allowed neither to strike nor to belong to the registered trade unions that alone possessed the right to bargain with their employers. Works committees and liaison committees, designed to voice African grievances, had

little power and were limited to single factories; employers found it easy to victimize outspoken critics.

The period from 1973 to 1980 was marked by a steadily heightened level of industrial protest, although the largest concentrated strikes clustered during the years 1973–74 and 1980–81.[6] In between came the three massive stay-at-homes following the Soweto uprising of 1976, an indication of workers' willingness to withdraw their labor to express political grievances. Increasing acceptance of wildcat strikes and organizational efforts that led to a mushrooming of factory committees and unregistered trade unions were characteristic of struggles during the 1970s. As a result of this intensified labor activity, the government-appointed Wiehahn Commission recommended in 1979 that African trade unions be granted official recognition in order to bring them under the control of the existing system of industrial relations.[7] With the new upsurge of strikes in 1980–1981, mass dismissals, penal sanctions against workers and trade unions, and police intervention in labor disputes became increasingly common. The high level of communication and support between striking workers and their surrounding communities that emerged during this unrest led the author of a major study of class struggle in the 1970s to reflect, "It could only be a matter of time and changing conditions before the weapons developed by the workers in their struggle would be turned to political ends" (du Toit 1981).

Women took full part in this revival of militant protest, as strikes swept through garment, textile, and food processing factories. Organizing efforts even spread to the ranks of domestic workers, normally notoriously difficult to unionize ("Maggie Oewies" 1980: 35–36; Horrell 1977: 312–13; *Star* 25 November 1974).[8] Male trade unionists willingly acknowledged the commitment of their female co-workers. A former official of the Textile Workers Industrial Union, writing on the events of the period, noted the "advanced political consciousness" of African women (Hemson 1978: 32), while during the 1980 textile strike a male shop steward praised the women for having "fought like men" (NLRC 1980: 38).

The typical protests of the period focused primarily on the issues of wages, working conditions, and grievance procedures, particularly the ineffectiveness of management-supported works committees and liaison committees. Differential pay increases were a major issue in the strike of 160 women at Transkei Hillmond Weavers in 1978 (Cooper 1979: 61; Gordon 1978: 260), while the 850 African women engaged in a wildcat strike at the Langeberg canning factory in East London complained of the uncertainty of the amounts of overtime pay to which they were entitled (*Daily Dispatch* 4 October 1978).[9] At Butterworth in the Transkei, pay increases they had never received motivated the January 1980 strike of 1,500 textile workers, whereas the need to meet higher transport costs led the 70 women working for a packaging firm in Johannesburg to demand a raise (*Star* 15 September 1979). In almost all of these cases workers also voiced dissatisfaction over the way in which works committees or liaison committees were handling their grievances. One woman in the Langeberg

canning strike, speaking of the liaison committee, explained, "They are now 'ja baas' [yes boss] instead of putting things right." In the Eveready Electrical Company strike in Port Elizabeth in 1978, which led to an international boycott of the company, the dispute centered on the company's refusal to negotiate with the registered union on behalf of some 200 colored women workers (Gordon 1978: 261; Maré 1979: 22–29). At the Sea Harvest fish factory in Saldanha Bay, a strike of 700 women that began in late December 1979 over unsuccessful wage negotiations was the culmination of a series of conflicts over pay, long working hours (often twelve hours a day), unhealthy working conditions, and the union's right to operate freely in the plant ("Strike" 1980: 26–27).[10] Most strikes were relatively brief and were based on democratic decision-making methods that prevented employers from singling out leaders for victimization.

A strike in Johannesburg in 1974 offers a typical example of an incident in which a minor dispute led rapidly, and seemingly spontaneously, to an expression of more fundamental grievances. The major issues centered on wages, working conditions, and the kinds of controls exercised over the labor force. At the Turnwright Sweet Factory 300 workers, mainly women, walked out during a dispute over working conditions on 21 August 1974. They had arrived at work at the usual hour of 6:30 AM, only to find the factory gates shut since the management had decided to open at 6:50 in the future as a security measure. The women first complained that this late opening left them too little time to change clothes and eat before work began at 7:10. They soon began to shout for wage increases and to complain about their long working hours—7:10 AM to 4:30 PM with only a ten-minute break and twenty-five minutes for lunch—and about the need to clock in and out when they went to the bathroom. Workers also expressed their desire to be represented by the Black Allied Workers' Union (*Rand Daily Mail* 22 August 1974).

These examples verify the fact of women's participation in the labor upheavals of the past decade, but they offer little insight into either the nature or the sources of their collective consciousness. Much of the information necessary to understand their position more fully comes from the two areas of the industrial economy with the highest concentration of women workers: garments and textiles.

During March and April 1973, immediately following the Durban strikes, clothing workers staged a number of stoppages.[11] The first two strikes occurred in a "border" area where the employees were unorganized and received substantially lower wages than their counterparts in the major urban centers. On 26 March, undoubtedly spurred by events in nearby Durban, 1,000 workers at the Veka Clothing Company in Charlestown went on strike for increased wages, leading police to impose a curfew on the nearby township and to prohibit meetings of more than five people. Four days later 700 workers at Trump Clothing, also in Charlestown, struck for higher wages in support of the Veka strike. Although both groups returned to work without promise of an increase (*Sechaba* June 1973: 9; July 1973: 9), these actions represented a significant

political awakening in areas in which clothing manufacturers had hoped to maintain a labor force that was not only cheap, but docile.

The stoppages of garment workers in and around Johannesburg in March and April of 1973 achieved greater success. Fueled by an expected cost-of-living increase, 4,608 black garment workers took part in some twenty-one work stoppages during a three-week period. With quick intervention by the registered Garment Workers' Union and/or the parallel African body, the National Union of Clothing Workers, the employers usually announced concessions and the workers returned to their jobs; only two of the incidents lasted more than five hours (Dekker 1975: 217). In 1980–82 another series of clothing industry strikes on the Witwatersrand culminated in February and March of 1982 in a strike of 1,800 workers in at least twenty factories, all demanding an immediate wage increase of R3.00 ("Wages" 1982: 45).

Garment workers in the largest cities also were involved in other forms of protest that were more anarchistic and more purely political than the 1973 stoppages. During a strike in the early 1970s at a clothing factory in Johannesburg, large numbers of finished garments were slashed, while in another Johannesburg factory an experienced worker took down a fire extinguisher and emptied it onto imported materials worth thousands of rands (IIE 1974: 160). Garment workers also numbered among the most active supporters of the stay-at-homes that followed the Soweto uprisings in 1976. The clothing industry came to a complete halt during the August protest in the Transvaal, despite the fact that trade union leaders appealed to their members not to withdraw their labor. The 300 African shop stewards, mainly women, probably were responsible for organizing the workers (Hemson 1978: 32).[12] Women reportedly led the September stay-at-home in the Cape during which the clothing industry, whose workforce of 50,000 was 90 percent female, lost two days of production (Webster n.d.: 17, 23; Hemson 1978: 31–32; CIS 1977: 40).[13]

By comparison with the textile industry, garment industry work stoppages were extremely brief. Those in border areas were rapidly repressed, while in the Transvaal well-established procedures for handling the disputes were tacitly accepted by employers, the unregistered African union (the National Union of Clothing Workers), and the registered Garment Workers' Union. In the 1973 stoppages, officials of one or both unions intervened immediately. "The existence of an established union such as the NUCW enjoying the confidence of the workers was undoubtedly one reason for the speech in which the disputes were settled" (Dekker 1975: 217). At the same time the activities of the NUCW, in helping members to find work, administering a burial fund, and assisting them in such tasks as applying for unemployment and maternity benefits, have helped to create a sense of collective identity that favors industrial action when necessary. The union structure itself also served an important unifying function in an industry built on large numbers of relatively small factories.

Nonetheless, the suppressed anger, evident in the instances of industrial sabotage and the widespread support for the 1976 stay-at-home,

against the expressed wishes of union officials, is explicable. Extremely low wages continue in the industry,[14] despite the union's nominal acceptance, and the inferior position of the NUCW gives African garment workers less than full representation. In several instances after the 1973 strikes Department of Labor officials deliberately excluded the spokesperson of the NUCW from negotiations. On a structural level, the necessity for the NUCW to negotiate for its members only through the representatives of the GWU has created a dependent relationship between the NUCW and the GWU, the details of which were revealed in a series of allegations and denials published in the *Financial Mail* in 1976 (19 November). The article, drawn from sources within the union, alleged that Anna Scheepers, president of the registered union, dominated the "sister" African body and influenced the decisions of its leaders, vetoing decisions of which she did not approve. It reported, "She calls the executive in and lectures them like grade school children and then tells them to go back and reconsider. Usually they do."

This "mother–daughter" relationship between the two unions has resulted both from the "understandable caution" of the GWU leaders and from the continuing dependence of the NUCW leadership (Dekker 1975: 216–17). Yet the independent action of the shop stewards in 1976 suggests a growing resentment of "maternalism," particularly on the part of younger workers who have entered the industry since the late 1960s. As second- or third-generation urban dwellers, these women are politically sophisticated and skeptical about supporting a moderate trade union (Adam Klein, GWU general secretary, 1973–76, interview, 8 June 1981).

The economic pressures on garment workers, combined with a racially and sexually biased division of labor, have created yet another source of discontent among black women. As urban wages in the industry have risen, capital has tended to expand into rural areas in order to draw on the large reserves of ultra-cheap nonunionized labor. The threat of job loss to urban workers has been continual, while in urban factories the labor process has operated to the detriment of black women. Despite their long history of organization and despite the shortage of white garment workers, they still occupy the least-skilled jobs in disproportionate numbers. In the Transvaal in 1973 European men continued to hold the vast majority of the highest paid supervisory positions. Although a surprisingly high 62 percent of the 120 European women employees earned only R10–20 a week, 98 percent of the colored women and 99 percent of the African women fell into this category. Furthermore, black women (79 percent African and 20 percent colored) held virtually all of the unskilled positions (Thomas 1973).

On one level, then, the activism of the garment workers has drawn on the organizational strength generated by membership in an informally recognized trade union that operates through hundreds of shop stewards and provides a variety of material benefits to its members. Yet the protests of the 1970s came from rank-and-file workers, not from union officials, and the spirit that animated them emerged not as much through the unions as

from opposition to existing union leadership. In the eyes of many women, this leadership has accommodated too readily to an industrial system that has hampered the emergence of strong, independent African unions and that continues to rely on the exploitation of cheap black labor power. Although explicitly women's issues did not figure in the collective action of the garment workers, a high degree of female solidarity was undoubtedly present in an industry with few male employees and a union organized and led by women. Lucy Mvubelo, the general secretary of the NUCW, explained women's reluctance to join with the black male union in the 1950s and 1960s in terms that reflect this sense. When she tried to encourage unity between the two unions, she was met with the response: "Lucy, you want to bring in the men? Men are dominating us enough at home. We don't want to be dominated by men" (Mvubelo, NUCW general secretary, interview 17 June 1983).

The textile industry, concentrated around Durban though scattered throughout the low-paying border areas and "homelands," was among the economic sectors hardest hit during the protests of the 1970s. It operated on a capital-intensive basis that brought together thousands of workers in each mill. Roughly half the textile workers in Durban were migrants, whose housing in company dormitories enhanced the possibility of mass action, as did the heavy concentration of ownership by the Frame Company, a vast industrial empire that in 1973 employed over 22,000 people in factories operating in South Africa, Zimbabwe, Zambia, and Malawi (*Rand Daily Mail* 6 February 1973).[15] Women formed a large part of the work force throughout the decade, but their numbers increased dramatically between 1973 and 1980, under circumstances that undoubtedly contributed to their willingness to protest, particularly in 1973.

Until the mid-1960s, strong pressure from the textile workers' union ensured the unusual policy of paying men and women equal wages. During the mid-1960s, however, the National Textile Manufacturers' Association, under continual pressure from lower-priced imports,[16] began an offensive to force employees to accept a male–female wage differential (Submission made by the National Textile Manufacturers' Association to Dr. F. J. Viljoen, Durban, 8 February 1966). In 1965 and 1966 the unions resisted their effort to grant women only 75 percent of the wages to be paid after a proposed increase, and the NTMA position won only partial and conditional acceptance by an arbitrator: he agreed to lower wages in certain restricted classes of work provided that the categories in question be "suitably diluted" and that the work assigned to women be clearly specified ("Arbitrator's Report and Award," Pretoria, 16 March 1966). By the early 1970s, only 452 of the 3,747 women in the industry were receiving the lower wage fixed at 80 percent of the male wage (Wage Proposals by the National Textile Manufacturers' Association, February 1972). But in 1972 the manufacturers finally won the approval of the industrial tribunal for a uniform policy of paying women a wage 20 percent lower than that of men (IIE 1974: 25).[17] This ruling undoubtedly accounts for the increased number of women textile workers during the 1970s. In a pattern typical for

the industry as a whole, the proportion of women employed in the Frame factories rose from 40 to 70 percent of the total workforce between 1972 and 1980.

In addition to receiving lower pay, black women, in particular, have been employed in the lowest-paid, least-skilled occupations. Although little information is available on the specific sexual division of labor in the industry, which undoubtedly has changed with the recent increase in the number of female employees, most supervisors are male, and women have little chance for advancement. More men than women are employed as weavers, a position that offers both a higher wage and a greater degree of control over one's working conditions than is possible for spinners, the other main category of semiskilled workers.

Despite the large number of women textile workers, the detailed study of the 1973 strikes published by the Institute for Industrial Education (*The Durban Strikes*, 1973), leaves many gaps in its information about women. A list of the percentages of workers in each grade of employment contains no breakdown by sex, and more important, the sample of workers interviewed gives information on Indian women but not on their African counterparts, who formed a far greater proportion of the labor force. This discussion concerns Indian women's fears of African men, thereby conveying the impression that women workers posed a threat to interracial solidarity. The gap in the available information on women workers is partly remedied by a series of interviews conducted with women textile workers in Durban following the strike, but the study, although offering important insights into women's concerns, is marred by its statistical imprecision.

On 19 January, ten days after the strikes began, the first stoppages occurred in the textile industry. The wages throughout the industry were roughly 20 percent lower than those in manufacturing as a whole. At the Frame Cotton Mills in New Germany, male wages apparently had risen by only R1 per week, from R6 to R7, between 1964 and 1972 (not including a R1 attendance bonus). Women at the later date earned R5 with a R1 bonus. But a survey conducted at the Nortex and Seltex mills in July 1972 revealed that some women were earning only R3.50 in basic salary (IIE 1974: 23–24). Textile workers stopped work first in East London, at Consolidated Fine Spinners and Weavers. By 25 and 26 January strikes had spread to the Frame Group, as over 7,000 cotton workers went on strike at the New Germany mill. The other adjacent cotton mills followed in quick succession. In at least one of the textile industry stoppages, it was African women, working for D. Pegler and Company in New Germany, who were first to down their tools (*Natal Mercury*, 30 January 1973). On 29 January the workers at Consolidated Woolwashing and Processing Mills in Pinetown, mainly women rag sorters, came out on strike after the management had ignored a written statement of their grievances presented through a union representative. By that day not a single Frame factory in Natal remained in operation (IIE 1974: 29–31).[18] The strikes in the industry lasted from one to seven days, ending with concessions of R1–2.50 per week from employers.

These settlements did not end the unrest in the textile industry, however. In April 1973, some 300 Indian and African women working as sorters in a woolwashing and processing firm in the Durban suburb of Pinetown were locked out after striking and then refusing an unspecified pay offer (*Sechaba*, April 1973). In July the stoppages spread to women weavers in Umtata, the capital of the Transkei in the eastern Cape (*Sechaba*, July 1973). Again, on 8 August, some 1,000 workers struck at the Frame Group's Wentex Factory in Durban after 600 workers had lost their jobs in the wake of wage demands (IIE 1974: 16). By January 1974, 10,000 Durban textile workers in eleven mills were again on strike, demanding that the government-ordered increases for new workers in the cotton mills also be extended to employees with seniority (*Southern Africa*, 3 March 1974).

The textile strikes are interesting in view of the degree to which the complaints of women workers became submerged in the wake of other grievances. Although as recently as July of 1972 the textile union had included in its demands the removal of wage discrimination against women, this provision rarely was brought up in the negotiations that occurred during the strikes. In the IIE report, the issue of a gender-based wage differential comes out only once, in the description of negotiations at the relatively progressive firm of Smith and Nephew, where the workers demanded a basic wage of R18 "even if it meant that all workers irrespective of sex and skill be paid that amount" (1974: 35). That they settled eventually for a male minimum of R18 and a female minimum of R12 was probably related to the intimidating presence of carloads of plainclothes police at the meeting during which the offer was accepted. More generally, the issue of the recently instituted wage differential may have been ignored because of the nature of the only union operating at the time; it was closed to blacks, had few women members and little power on the shop floor (Halton Cheadle, former secretary of the National Union of Textile Workers, interview 21 June 1983).

In 1980 another massive strike broke out in the Frame factories around Durban. Beginning among weavers in the Frametex plant and lasting for twelve days, the stoppage was triggered by continuing anger at low wages, the manipulation of the bonus system, and the unwillingness of the manager to consult with the liaison committee. Women, who by then comprised 70 percent of the workforce, were involved from the beginning and took an active part in meetings, demonstrations at the bus terminal, and organization at Kranzkloof, the hostel where most of the workers, as migrants, were forced to live. The only grouping of strikers from which they seem to have been excluded was the *impi* or "regiment," which acted as the main strikers' defense force. The following description by the Natal Labour Research Committee, based on interviews with participants, summarizes women's activities succinctly:

Within twenty-four hours of its beginning the women workers at Kranzkloof had organized themselves into two groups, one of which was stationed at the main gate, the other at the opposite end of section D. Here they waited for those women workers who were defying the strike, to return from the facto-

ries. The latter were then prevented from entering the premises, and only later that night (Friday) after the police dispersed the women strikers with tear gas, were they able to steal back into the hostel. Thereafter the women decided to visit each room which was occupied by one or more strike-breakers. This resulted in violent confrontation, with some of the strike-breakers leaving the Hostel for fear of being attacked. Throughout the strike, the women continued to meet regularly in the Hostel corridors, as well as in the grounds near the bus rank where most of the action took place. Their gatherings were coloured by much discussion, militant chanting and singing (1980: 38).

The militancy of women in these protests undoubtedly arose from the same factors that fueled and shaped the resistance of their male co-workers—extraordinarily low wages in a time of rapid inflation, rigidly controlled working conditions, and a lack of adequate procedures for communicating their grievances. The vast scale of production, with several thousand workers in a single factory, the densely packed hostels in which they reside, and the "packed and gregarious" buses on which they ride to and from work have undoubtedly fostered communication and class consciousness among textile workers, male and female alike. The homogeneity of the largely Zulu workforce also figures in discussions of the unrest in Durban in 1973.

Numerous aspects of women's working situations and living condi-tions helped to generate a sense of female solidarity among the strikers. Adding to the frustrations of women's generally disadvantageous position in the labor process, management has relied on male dominance as a means of enforcing industrial discipline. Male supervisors are given the "marginal capacity" to permit small favors such as permission to go to the bathroom or the "privilege" of sitting down during a bout of menstrual cramps in exchange for sexual favors. Women interviewed after the 1973 strike also complained of sexual harassment:

> The women reported that the men workers in their factories have no respect for them. On the factory floor, men ill-treat the women, make fools of them, and become vulgar by "touching the women in embarrassing parts." Others mentioned that the men assault the women that they work with, one noting that if this is reported to the authorities, the latter take the part of the men. (Westmore and Townsend 1975: 26)

Instances of coercive intrusion by capital into workers' personal lives appear to be common in South Africa, especially regarding women's preg-nancy. In one engineering factory it was discovered in 1970 that African women were being forced to take the pill daily under a nurse's supervision. In the Frame factories, prospective female employees who survive a man-datory pregnancy test are then subjected to the continual watchful eye of factory doctors instructed to watch for signs of impending motherhood. Until early 1980 the policy was to terminate the services of pregnant women, but then a change provided for reemployment eight weeks after

confinement. Women workers allege, however, that supervisors retain the arbitrary power to determine whether a woman will be reinstated. Those allowed to return are required to undergo a "retraining" period (which the industry claims to be six weeks and the women claim is actually three months), during which they are excluded from bonuses and overtime work (NLRC 1980: 29–30).

Other arbitrary and sometimes humiliating regulations dominate the lives of women textile workers, both in the factories and at the hostel where a majority of them live. Company policy, for example, forbids them from using any company toilet paper or cotton scraps to supplement the single sanitary napkin they are issued. And, while men are frisked for company property at the end of each day, women must go through a special "searching room," where they are more thoroughly scrutinized. Possession of trade union material found during these searches may provide grounds for dismissal (NLRC 1980: 30).

In Kranzkloof hostel a high degree of paternalism regulates women's daily lives. Whereas men have greater mobility within the area of the hostel, women are largely confined to a fenced-in area that is permanently under guard. The rules are applied more strictly to them than to men, and they are also prohibited from smoking or drinking in their rooms. Control of visitors includes a prohibition on having their babies or young children in the hostel. But the threat of arbitrary expulsion by the superintendent is the aspect of control that has generated the most bitterness. The women complained of facing expulsion for questioning unreasonable demands by the superintendent—such as being selected at random to collect litter in the corridors, a job others are paid to do. Individuals are also arbitrarily victimized, with neither investigation nor recourse to a hearing, for misusing communal facilities. The study of the 1980 strike concluded: "Because women live in constant fear of arbitrary expulsion, they have tended to unite in mutual self-defence against the capricious actions of the authorities. The solidarity and steadfastness of these women were certainly evident during the strike" (NLRC 1980: 39).

In the disorder connected with the strike, women's sexual vulnerability became politicized. Female strikers were the target of youth gangs or *tsotsi*, whose motivation may have been unrelated to the labor dispute, and of police violence. Since the security and regulation system at the hostel broke down, nonresidents, including not only male friends of women residents but also youth gangs, had freer access to women's rooms; numerous incidents of theft and rape were reported. Other women were raped by nonstrikers, who then instructed them to return to work. In one area, women successfully organized themselves to prevent such attacks, but in another part of the hostel they were less successful. Women were often forced to flee the hostel to seek accommodation in the nearby African township of Clermont, frequently in the safest place available—other men's beds. "Once again," according to the 1980 study, "women found themselves having to choose between the lesser of two abuses—rape by, or involuntary submission to male co-workers" (NLRC 1980: 30).

The prevalence of migrant workers among the women is also a significant issue. The hiring of women migrants, who now comprise 90 percent of the female cotton workers in Frame factories around Pinetown, formed an important part of the industry's cost-cutting strategy in the 1970s. Like other migrants, those who supported the 1980 strike risked losing their jobs and accommodation and being forced to return to their "homelands." They were ethnically divided between Zulu, who generally were strikers, and Xhosa from the Transkei, whose less secure employment situation in the Durban area made them more likely not to strike.[19] While violent confrontation between striking and nonstriking women in the hostel did occur, the study of the 1980 strikes seems to imply that the high degree of solidarity generated by fear of expulsion may have mitigated these tensions somewhat among women. Thus, the impact of migrancy is complex. Lacking daily obligation to their families, women migrants had more time to devote to labor activities than did many other women, and the crowded hostels generated both solidarity and personal and ethnic tensions. Yet, the degree of risk women were willing to take may have varied with their sense of job security. Whether such fears affected women and men in different ways remains to be investigated.

Few recent documents from South Africa spell out the ideology supporting the exploitation of female laborers more fully than the report that the National Association of Textile Manufacturers addressed to the industrial arbitrator in 1966 when the organization sought to justify its request for a 25 percent wage differential between men and women (Submission, NTMA 1966). The authors relied on arguments so accepted and stereotyped that they apparently felt little need to substantiate them: women's alleged physical weakness; their lower educational attainments; and their minimal financial needs.

Yet the only recent factual study of women textile workers belies these facile conclusions. Conducted by the National Institute of Personnel Research and published in 1973, this survey found a high degree of financial responsibility among women textile workers—in this case, predominantly settled residents of a border area in the eastern Cape. Shattering the myth of the dependent working woman, it discovered that nearly half (47 percent) were single, 32 percent were formerly married (including widows, divorcees, and women deserted by their husbands), and only 21 percent were married—a very low percentage considering that 64 percent of the women were between twenty-one and thirty-five years old. Although most of these women had no "male breadwinner" on which to rely, they did not lack dependents. According to the report, "Many of these women occupied a key role in the households to which they belonged, for one-quarter of them were household heads and over one half (52 percent) were the main breadwinners of their families." Not only were most of the women self-supporting, but they were, as a group, much better educated than the men employed in the factory. Furthermore, although the women's absenteeism and turnover rates were slightly higher than those of men (another conten-

tion of the textile manufacturers), the report judged both figures to be low, adding that women's high degree of family responsibility as household heads and as main breadwinners "apparently caused them to be stable."[20] Significantly, those who were household heads and those who were married were absent from work more frequently than those women whose mothers were the household heads; the report concluded that lesser domestic responsibilities were associated with a lower rate of absenteeism (Hall 1973).[21]

Whether or not research in other factories bears out this picture of women industrial workers as the main source of family support, there is no doubt about women's heavy economic obligations and the fact that they work primarily to sustain their families. An NIPR-related study of garment workers found that 93 percent of women interviewed in a "homeland" factory and 83 percent of those interviewed in an urban factory stated that they worked for economic reasons, primarily "to support or to assist in supporting" their families. Specific needs cited were basic: food, clothing, education, and transportation. In both cases, the median number of family members was nine (Mkalipe 1979: 46–47). The Westmore and Townsend interviews with women workers in Durban also found a clear consensus that women worked out of economic necessity. Many of those interviewed were the sole source of family income—either as widows, divorcees, single women with or without children, or women living with men who were unemployed or who worked intermittently (1975: 22).[22] Perhaps not atypical were two other cases reported at the time of the 1973 strikes: Annie Msomi, a sixty-year-old textile worker who supported a pensioner husband and five grandchildren on R7.25 a week, R2 of her wage going for her bus trip of 32 km each way; and Kistanah Naidoo, also a textile worker, who provided for herself and three small children with R7.55 a week (*Financial Mail*, 2 February 1973).

Whether the stereotypical working-class wife whose husband earned a steady, dependable wage ever existed in Europe is debatable. She certainly is rare in South Africa, where low wages, high levels of migrant labor, stringent controls on urban migration and residence, and forced resettlement in "homelands" have continuously threatened the stability of family life. Nonetheless, the persistence of strong kin networks, often extending to the provision of child care in the rural areas, and the more limited reproductive demands on female migrants may create some groups of women workers with fewer domestic responsibilities than might be assumed.

In addition to underestimating the variation in women's lives and thereby minimizing the economic demands on women, the idea of semi-proletarianization also explains the behavior of women workers solely by reference to their family situations, without considering other aspects of particular societies that might shape their attitudes as workers. The close connection between class consciousness and nationalist consciousness in South Africa undoubtedly influences women as profoundly as it does

men—a fact expressed in women's overwhelming support for the 1976
stay-at-homes. Throughout the decade, although the stated grievances of
most strikers centered on their position as workers in a capitalist econ-
omy, their struggles also reflected black discontent in a white-dominated
society. One study of the 1973 strikes in Durban concluded that the enor-
mous wage increases the strikers demanded, much higher than those to
which they eventually agreed, "must be interpreted as a statement of
rejection, an affirmation of the desire for a quite different society" (IIE
1974: 101). *Sechaba*, the magazine of the African National Congress, re-
ported on the political overtones of the strikes:

> At one [factory] the workers on strike gathered at the gates of the factory
> singing "Nkosi Sikelele," the African National Congress national anthem. At
> another, . . . demonstrating strikers were lead [*sic*], in a march through the
> streets, by one worker carrying a red flag. In yet another cries of "Amandla!"
> [Power] the A.N.C.'s clenched-first [*sic*] salute were raised at the end of a
> meeting called by the strikers. (5 May 1973: 2)

SUMMARY AND CONCLUSIONS

The experience of black women in recent years, then, suggests a number of
factors that seem to foster class consciousness among women workers in
South Africa. In addition to incredibly low wages and limits on the right
to organize freely, they include a general atmosphere of economic and
political unrest; a high level of coincidence between economic exploita-
tion and racial oppression; communal living situations that simul-
taneously lessen the demands of domestic labor and heighten the sense of
shared experience; gender-based inequality and harassment at work; a
tradition of gender solidarity; and a high degree of economic obligation.
An aspect of the latter factor that remains to be explored more fully for
South Africa is the economic division of responsibility in the family; many
of the other cases in this volume suggest that even where women are not
the main breadwinners, they may assume predominant responsibility for
certain central family expenses.

In an effort to assess the relationship of women's issues to collective
struggles in which women have taken part, Tilly (1981) has proposed the
idea of a continuum that defines women's issues as either incidental to or
intrinsic to particular groups of participants in popular struggles. From
this perspective, the South African women would fall somewhere in the
middle. While women's concerns were not intrinsic to their purpose, as in
explicitly feminist forms of action, neither were they incidental. Although
many women's problems such as unequal wages and sexual harassment
received little or no explicit attention, these issues nonetheless helped to
fuel discontent and, along with other factors, to provide a sense of
women's solidarity that was not incidental to the strikes and stoppages in
question. Moreover, women saw their economic grievances as central to

fulfilling their roles as women. Thus, although some of the issues shaping their consciousness and their struggles might be depicted more explicitly as class issues than as women's issues, it seems clear that their consciousness of themselves as women and as workers were very closely related.

This essay suggests, then, that theories of women's semi-proletarianization are by no means universally applicable and that, under South African conditions, the sense of heavy economic responsibility for their families that most women bear contributes to, rather than negates, their class consciousness and their involvement in class struggles. Women have participated actively and readily in sporadic and relatively short-term forms of protest such as strikes and stay-at-homes, and South Africa boasts a high number of female trade union leaders, among them officials, organizers, and shop stewards.[23] Although church groups and economically oriented cooperative organizations dominate the scarce spare time of most women industrial workers ("Organizing Women?" 1982, citing Barrett 1981), it may be argued that these groups engender a sense of female solidarity that contributes indirectly to the success of workplace organizing. Family, from this perspective, cannot be viewed simply as a force antithetical to class consciousness; not only does it seem to create a sense of purpose that leads women to struggle readily to improve their wages and working conditions, but family members, through their assistance with child care and other reproductive tasks, often provide women with the support networks that enable them to engage in such activity.

Yet this material does leave a number of issues unclear: the extent to which family may interfere with longer, more time-consuming involvement in labor activities (particularly for nonmigrant women); and the more subtle ways in which patriarchal power relationships within the family may constrain women's activities and shape their view of themselves and their work. It is, after all, such attitudes that are responsible for women's consignment to a heavy load of domestic labor. In an excellent and provocative article on Marxist and feminist analysis of South Africa, Bozzoli (1983: 165) has argued that the strong concern with family among black South African women, reflected also in their political struggles, implies an intensely conservative ideology that seeks to preserve and consolidate the traditional patriarchal family and women's position within it. While such an ideology undoubtedly has been prevalent in South African nationalism, it seems necessary to distinguish between ideology, however widely accepted, and the actual role of family relations in people's daily lives. With respect to the relationship between work and home, women industrial workers constantly refer to the necessity to feed, clothe, and educate their children. This is not a longing for an idealized past but the expression of a concrete, present need. How such needs will articulate in the future with class issues and women's issues, both in the workplace and in the household, remains to be determined.

Notes

1. I will use the term "class consciousness" in the way that Safa has defined it: "a cumulative process by which women recognize that they are exploited and oppressed, recognize the source of their exploitation and oppression, and are willing and able to organize and mobilize in their own class interests" (1979: 71).

2. For further historical information on women's involvement in workers' struggles, see Luckhardt and Wall 1980; du Toit 1978; Lapchick and Urdang 1982; Van Vuuren 1979; Carim 1980; Sachs 1975; and Berger forthcoming 1986.

3. The South African government maintains the fiction that black Africans' legal residence is only in the so-called homelands, thus justifying their deprivation of citizenship rights in South Africa. Such reserves contain only 13 percent of the land, but theoretically over 70 percent of the population.

4. As late as 1979, women workers in Babalegi, a "new industrial boom area" in Bophutatswana with over 100 factories, were receiving R6.90 in weekly wages. See "Babalegi" 1979: 32, citing an article by Nadine Hoffman in *Wits Student*, 20 March 1979.

5. The number of black women in industrial work has increased continually in recent years. According to the *Star*, 9 December 1974, the number employed by Johannesburg industries rose by 100 percent between 1965 and 1973, as compared with an increase of 17.5 percent of black men. In the entire country, figures in the surveys of the South African Department of Manpower for 1969 and 1981 give an increase of 133 percent during this period, from 45,216 to 105,168. It should be noted, however, that the latter figures are incomplete because they exclude areas that had become "independent homelands." The number of Asian and colored women in industry increased by 47 percent, from 83,199 to 122,386, between 1969 and 1981.

6. According to South African government figures, from 1959 to 1969 there were about seventy work stoppages per year by Africans; in 1973 the government admitted to 160 in the first three months of the year.

7. The original recommendations have been amended as a result of political pressure to allow the membership of migrant workers and to allow multiracial unions. Additional changes, however, place greater restrictions on the political activities of trade unions and attempt to exercise control over unregistered unions. Whether or not to register was the subject of intense debate within the independent trade union movement during the early 1980s. The *South African Labour Bulletin* has published the opinions of both sides in this discussion.

8. Even after the recent legal changes, government regulations continued to prohibit domestic workers or farm workers from forming recognized trade unions.

9. Male workers did not participate in this strike.

10. This summary is intended to highlight some of the major issues that strikes during the period have addressed rather than to be an exhaustive listing of all such incidents. Two other actions involving women workers that merit mention are the strike at the Fattis and Monis factory in Bellville, South Cape, which was supported by a nationwide consumer boycott, and the strike at the Rainbow Chicken factory in Hammarsdale, Natal, both in 1979. For complete listings of workers' actions, see the yearly issues of *Survey of Race Relations* and the "Labour Action" updates in *Work in Progress.* "A View of the 1973 Strikes," RR. 151/73 (Johannesburg, 1973), published by the South African Institute of Race Relations, details strikes and

stoppages during that year. *Work in Progress* 7 (March 1979): 36–45, covers actions occurring between March 1974 and June 1979.

11. These were not the first signs of discontent in the clothing industry during the 1970s, however. In 1971, 26,000 garment workers in the Transvaal engaged in a "work to rule" protest during a deadlock in wage negotiations, and in June of that year thirty-seven Indian women at the Clairwood Clothing Factory were convicted for participating in an illegal strike (Garment Workers' Union Archives, Bcf 2.1; "A Study of Strikes During the 1970s," *Work in Progress* 5 (November 1978): 111.

12. According to Sarah Chitja, in an interview with Russell Kaplan, shop stewards are elected in the plant in which they work, in the presence of union officials. Each one represents from ten to fifty workers. See "Interview with Sarah Chitja, Deputy General Secretary of the National Union of Clothing Workers," *South African Labour Bulletin* 2 (January–February 1977): 58.

13. Whereas the turnout in industry generally was approximately 50 percent, that in the clothing industry ranged from 10 to 15 percent.

14. See the wage statistics reported regularly in the annual *Survey of Race Relations*. In 1977, for example, the average monthly wages for the clothing industry as a whole were substantially lower than for any other industry in the country, a current phenomenon analyzed in "Wages in the Clothing Industry."

15. It is interesting to compare this degree of concentration with that in the clothing industry. In the latter, comparatively large firms with over one thousand workers employ less than 20 percent of the work force, while in the textile industry less than 10 percent of establishments employ nearly 60 percent of the work force (Hirsch 1979: 14).

16. *Financial Gazette*, 9 February 1973, and *Cape Times*, 14 September 1974, discuss the continuation of these pressures during the 1970s.

17. According to the *Financial Gazette*, 9 February 1983, the South African textile industry had suffered severely during the eighteen-month period preceding the 1973 strikes from a drastic drop in prices worldwide and a 70 percent increase in textile imports, leading the article to characterize the country as "the dumping ground of the world." Between 1960 and 1970, however, Hirsch reports the average wage per employee increased by 140 percent, while profits grew by 365 percent (1979:30).

18. According to the *Financial Mail*, the parent company of Consolidated Wool-washing, among the lowest-paying of the Frame factories, reported an increase of over 70 percent in pretax profits between 1971 and 1972.

19. This was a result both of the greater distance of the Transkei from Durban and of the fact that many companies had ceased to recruit workers from this now "independent" area.

20. The manager of a R10 million cloth and blanket factory at Butterworth in the Transkei reported a women's absentee rate of 3 percent compared with a factory average of 10 percent (*Star* 9 October 1974). Mkalipe's study (1979) of a "homeland" garment factory found that on days when women were absent they were seeking a better-paying job; they left as soon as they found one.

21. The study was based on data collected from 212 workers; 93 were interviewed to obtain more detailed demographic and attitudinal information. Most of the women were settled residents rather than temporary migrants; 63 percent of them had lived for over ten years in the same place.

22. Although half of the women they interviewed lived in the single-sex hostels

and half in the township of Clermont itself, they make no distinction between the two groups in reporting their results.

23. Van Vuuren points out that during the 1970s the general secretaries of nine out of twenty-three African trade unions were women (1979: 96).

Chapter 13

CLASS AND GENDER
A Consideration of Yoruba Women during the Colonial Period

CHERYL JOHNSON

THE HISTORY OF women in Africa during the colonial period has much to contribute to our understanding of the current debates regarding women's marginalization in the political economy and their alienation from the development process on the African continent and elsewhere. Certainly any solution to the problem of women's general lack of political and economic power in Africa is not just a question of the position of women vis-à-vis men in their respective societies, but also a question of the position of the societies in which women find themselves vis-à-vis their former colonizers. Consequently, gender relations alone do not reveal the locus of women's oppression, although both indigenous patriarchy and imposed colonial patriarchal customs and laws figure in women's oppression. The general impoverishment and powerlessness of women, however, will not be resolved by a redistribution of wealth between African women and men. Only an end to the continued exploitative nature of Africa's economic relationships with its former colonizers, begun systematically during the colonial period, can terminate the oppression of all Africans, women and men alike.

The colonial period created economies dependent on the export of cash crops and raw materials. Independent African economies still export these items and often import finished products made from their raw materials, as well as food. The external domination of pricing systems and international currency valuation leaves many African countries with little control or influence over major aspects of their internal economies (Nkrumah 1965; Amin 1973). Continued external economic control is a direct legacy of colonialism which created modes of political and social development that have kept African countries tied to Western capitalist systems of development despite their formal political independence. The maintenance of these exploitative relationships with the former colonies required the colonizers to nurture the development of a class of Africans whose status and wealth depended on neocolonial relationships

237

(Nkrumah 1970). Independence in Nigeria, for instance, was characterized more by a change in personnel than by a change in the economic, political, and social systems of colonialism.

Though gender stratification existed in precolonial society, colonial rule transformed its nature in ways that severely depressed women's status. Especially vulnerable as an exploitable class during the colonial period, most women were even more vulnerable after independence, as a result of the continuing erosion of their economic and political role(s). Any discussion of the position of women in contemporary Nigeria must be informed by the history of women's interaction with the colonial political economy.

This chapter examines the experience of Yoruba women of southwestern Nigeria under colonialism. It will postulate reasons for women's vulnerability during the colonial era, both those located in indigenous culture and those introduced by the colonizers. In addition to a general review of women's experience of colonialism, it will describe in detail the anticolonial activities and leadership of three women's organizations.[1] These case studies will show several things. First, women's precolonial gender solidarity, to a great extent the result of the sexual division of labor, proved to be their most useful tool in battling to protect their interests. Second, women challenged their economic marginalization and the attendant diminution of their political power on the basis of both their common gender and their class position. In fact, the intersection of class and gender in precolonial society often empowered women. Third, colonial patriarchy imposed on indigenous male domination exacerbated the inequalities between women and men and turned the precolonial sexual division of labor into the ghettoization of women in the economy. And fourth, class formation during the colonial period began to erode the solidarity of women and, in combination with the increased nationalism of the 1950s (the decade immediately prior to independence), obscured the true nature of women's precolonial solidarity, i.e., its high degree of class/gender consciousness.

BACKGROUND

The long tradition of urbanization among the Yoruba is important in understanding the precolonial position of women in the political and economic spheres. Because of urbanization and the several wars among Yoruba states in the nineteenth century, men took primary responsibility for farming in the outlying areas. Women traded food and craft goods, and performed services such as hairdressing and cloth making. Even where women did some work on the farms, it was most often they, and not their husbands, who retailed farm produce. Women's importance in crucial sectors of the economy, the distributive and service sectors, imbued them with a group consciousness and solidarity based on mutual interests and needs. Yet, even though women as a group were central to economic life,

the overwhelming majority of individuals operated on a profit base so small that it bordered on subsistence. Hence, the economic survival of individual women depended upon their organization and solidarity. Together they fixed minimum prices, decided on the location and running of markets, created credit unions, and formed cartels of buyers and sellers. Since in addition, women did not ordinarily own or control the distribution of land and were by custom economically independent of their husbands, there was little variation in the material circumstances of the majority of women (see also Chapter 5 in this volume). Thus, the class position of most women was basically the same;[2] their class consciousness, which tended to coincide with their gender consciousness, was high.

The sexual division of labor recognized women (as a group) as a critical component in the political economy. As a result, Yoruba women held certain rights in the public domain: to participate in discussions of public policy; to be represented on governmental decision-making bodies; to own and inherit property; and the freedom to pursue, control, and defend their own economic interests. But these rights did not make women equal partners in society with men. For instance, their representation in governmental bodies was always limited and was not proportional to their percentage of the population.[3] The control (as opposed to the ownership) of land, the basic source of wealth, lay primarily in the hands of men. There were restrictions that prohibited women from assuming certain public offices and positions of authority, and men, by custom, held the balance of power in the familial unit. Though married women inherited from their natal family independently of their husbands, this right also entailed certain economic obligations. But women's prominence in the public economy and their legitimacy as public actors in the political arena were well established, as was their collective mode of protecting their interests and advancing their aims.

Wipper (1972), Hammond and Jablow (1970), the United Nations Human Resources Development Division (1972), and Etienne and Leacock (1980) all discuss the deleterious effects of the dominant male ethos found among British officialdom on the status of women in Africa. It was women's political and economic roles that were most devastated during the colonial period. Colonial administrations refused to recognize that women's organizations and roles were more than social in nature. Subscribing to an ethos that deprecated women's political or economic activity, they were blind to anything that did not fit their preconceived notions of women's place. By refusing women the vote until 1950,[4] not appointing them to any important governmental bodies, and neglecting their education and employment, the British in Nigeria pursued a policy of alienation and exclusion of Yoruba women from the economic and political arenas.

The neglect of women's education reflected both the sexism and class bias of British society. In a discussion of British educational systems in Africa, Curtin concluded: "the whole scheme was to be governed by the

need to provide a docile and uncomplaining working class" (1964: 426). The plan was to develop a very small educated elite in conformity with the pattern in Britain (Baker 1974). Kisekka (1976) criticizes women's education in independent Nigeria as suffering from the "mark of oppression" introduced by colonialism and "uncritically and purposefully perpetuated by Africans themselves" (see also Chapter 6 in this volume).

In 1927 Queens College, Lagos, was founded for the secondary education of girls. The curriculum consisted of needlework, domestic science, and singing. Mathematics and a foreign language were taught only if the parents specifically requested it. The administration publicly stated (National Archives Ibadan [NAI] Com. Col. 824: letter 4 June 1929) that one of the principal reasons for the establishment of Queens College was to educate the daughters of a certain class of parent. Despite the fact that several parents of Queens College students protested in favor of a more academic and vocational curriculum, the principal of the college wrote in 1929:

> The character of girls' education should be of a particular kind. It is almost universally agreed that it should not be a copy of that which is given to boys. It would be in accord with a consensus of opinion . . . if girls' education bore the stamp of that given in the home and good boarding school in Europe, rather than that given in the primary and secondary schools. It is this social environment, containing within itself all the living elements of the past, which is lacking in African communities. It is this which the school ought to supply (NAI, Com. Col. 824).

According to figures reported by O'Connor (1964), as late as 1942 only 1,500 of the 11,500 pupils enrolled in the forty-three recognized secondary schools in British West Africa were girls. As late as 1951 the enrollment in girls' secondary schools in Nigeria totaled 1,599: 125 in the north; 477 in the east; and 997 in the west (NAI, Com. Col. 39, vol. 6). Though the number of girls educated in the north may have reflected the refusal of some parents to have their Muslim daughters educated in Christian schools, in the east and west the availability of female education never kept up with the demand. Even where women obtained a Western education, the primary occupation open to them was teaching—where their salaries were 35 to 50 percent less than the salaries of comparably employed men (O'Connor 1964). The lack of occupational avenues open to women incited them to fight for employment in the civil service, where to their dismay they discovered that British women were still struggling for their own mobility and equal pay (Johnson 1978). But Nigerian women suffered further from racism, lack of educational facilities and/or poor academic preparation, and the small number of positions open to Africans, which they also had to share with men.

Authorities have documented exceptional cases of women who acquired considerable wealth during the colonial period (Little 1965; Leith-Ross 1965; Ekejiuba 1967; and Johnson 1978). When a few women gained access to credit and commodities, they were able to use the new system to

their individual advantage. But for the vast majority of women the growth of cash crops, expansion in the scale of the market economy, and increased volume in the import-export sector grossly devalued both the prestige of, and income from, their traditional occupations in the distributive and service sectors of the economy. Women were placed at a distinct economic disadvantage in relation to British merchants, Lebanese and Syrian commercial agents, and even the relatively small number of African male entrepreneurs. Though women sometimes cultivated cash crops (because of customary Yoruba male farming not nearly as often as men), they rarely earned substantial profits since they did not control access to land. Women lacked the capital and access to credit required to take advantage of expansion in the scale of the market economy. Their continued concentration in "petty trading" also reflected the fact that this was often the most effective way of delivering goods in a situation where storage and preservation facilities were practically nonexistent and a majority of the population lived in areas distant from major centers of distribution (Marshall 1964). Because women often had engaged in trade with European merchants as early as the eighteenth century, O'Connor stated: "One might have expected women to assume greater importance as the volume of foreign commerce increased. However, the history of the period reveals the contrary to be true. The role of women in external trade declined in almost direct proportion as the volume of such trade in West Africa expanded" (1964: 206).

The import-export sector was primarily a European prerogative. By the 1930s, for instance, the colonial government had created the West African Produce Control Board (WAPCB), which established a government monopoly over the export, purchase, and marketing of all West African agricultural products. The WAPCB designated the Association of West African Merchants (a small group of old established European firms whose exclusionary policies were supported by colonial policy on the grounds of "national security") as its buying agent, effectively keeping any new firms from entering the agricultural import-export trade. The WAPCB established quotas and prices for the duration of World War II. By 1949 these merchants of the Association controlled 66 percent of Nigeria's imports and 70 percent of her exports (Coleman 1958: 81).

By attempting to control prices in the markets and to tax women, the colonial government further diminished women's control over their economic activities. Though market women fought back by refusing to accept price controls, protesting female taxation, and hiring lawyers to represent their interests, colonial policies continued to depress their economic status. Slowly, women became locked into low-level economic participation, lacking even the potential mobility that access to land or education might have given them. The market women who enriched themselves, and the "new elite"[5] women who had access to Western education, were atypical of the experience of most women under colonialism.

It was women's importance in the precolonial economy that at least partially accounted for their political participation. As their economic

importance eroded, so too did their political freedoms. A very limited franchise was instituted in 1922, restricted to males resident in Lagos who were over twenty-one and owned real estate worth at least £224 or rented for at least £15 annually. They could vote for three out of ten representatives on the Legislative Council. While a number of associations which protested various policies of the colonial government had developed prior to this time, it was this limited franchise that was primarily responsible for the formation of the first political party in 1923, the Nigerian National Democratic Party (NNDP). The Lagos market women formed a majority of the members of the NNDP and contributed generously to the party. Madam Alimotu Pelewura, *alaga* (head) of Ereko market and later leader of the Lagos Market Women's Association, was an intimate and ally of the founder of the NNDP, Herbert Macaulay. Though women could not yet vote, the opinions of women were freely expressed in NNDP meeetings, especially during periods of Legislative Council elections (Tamuno 1966).

Men founded three other major political parties during the colonial period: the Nigerian Youth Movement (NYM), 1934; the National Council of Nigeria and the Cameroons (NCNC), 1944; and the Action Group (AG), 1950. Women belonged to all of the parties and usually formed all-female party wings. Though they held no major leadership positions, women provided major numerical and financial bases of support. While they often exerted influence in formulating the parties' political platforms, in terms of executive representation and actual decision-making power, documentary evidence and oral testimony concur that women fared better in all-female organizations.

Whether the idea of organizing all-female wings of the parties was derived from the historical political tradition of parallel male and female institutions, or whether it represented a deliberate segregation of the sexes aimed at rendering women powerless and dependent, has been discussed by both Little (1965) and Okonjo (1975). Although both have argued convincingly that the policy was consonant with the traditional pattern and not purposefully discriminatory, the evidence remains that women had little access to executive-level positions in the male-dominated mass parties. This situation probably reflected several factors: the tradition of women operating in all-female organizations, the fact that women did not receive the franchise until 1950, and the encroachment of the Western idea that politics was a male domain.

All of the mass parties campaigned on platforms that called for the enfranchisement of women, however. An NYM pamphlet distributed in 1949 advocated that women in the west and east should have the right to vote. But the pamphlet noted that the status of women in the Muslim north differed from that of women in the south and did not support the franchise for northern women. The NYM's attitude toward northern women probably reflected the influence of another political reality: the need to compromise with the north in order to facilitate a unified struggle for independence. The NYM also called in 1949 for the enfranchisement of the market women, illiterate or not. The party hailed the market women

as central figures in the country's political life and advocated the provision of a special symbol or color to aid them in voting. The Action Group formed formal market wings of the party in each major market in Lagos and Ibadan, and the NCNC along with the NNDP would eventually field women candidates for office and include a few women on its executive committee.

But the masses of women had always organized traditionally as *women*, and this was a pattern they would maintain despite the changed political circumstances. Even the new elite women continued to identify gender as a major organizing focus. One author commented that there appeared to be far more unity among women than among men, despite differences of ethnicity or status (Leith-Ross 1965). Though such thoughts may be a bit idealistic, my evidence does indicate that women identified gender as a common and important bond. It seems reasonable to assert, however, that it was not merely the subjective bond of gender itself, but the objective bond of gender; that their awareness of differential treatment by society helped to draw women together. So women united not only because they were the same kind of people but because they existed in the same kind of circumstances; they were an oppressed class. In keeping with this realization, women utilized and reformulated their traditional market organizations and created new organizational entities that sought to protect their interests and curtail the erosion of their economic and political participation induced by colonialism. I will examine three of these organizations—The Lagos Market Women's Association (LMWA), the Nigerian Women's Party (NWP), and the Abeokuta Women's Union (AWU)—and their activities during the colonial period.

WOMEN'S ANTICOLONIAL ACTIVITY

Though the Lagos market women were a relatively homogeneous population—preponderantly Muslim, illiterate, and operating at a near subsistence economic level—there was no Lagos-wide market organization before the 1920s. The women had organized in an ad hoc manner over particular issues, such as the levying of a water rate tax in 1908 and the exile of the traditional leader Eleko Eshugbayi from 1925 to 1931 (Johnson 1978). But it was from the mid-1920s to about 1950 that the women, organized into the Lagos Market Women's Association (LMWA) under the leadership of Madam Alimotu Pelewura, would mount their most serious campaigns against the policies of the colonial government. Pelewura's leadership, deeply rooted in the indigenous context, was one of the distinguishing features of the association.

A Yoruba born in Lagos, Pelewura followed in her mother's footsteps and had become an important fish trader by 1900. By 1910 she was representing the market women before the traditional rulers of Lagos, and by the 1920s she was elected *alaga* (head of the traders) in Ereko market, the largest and most prosperous meat market in Lagos (NAI, Com. Col. 1185).

A government study in 1932 described Ereko as one of the most efficiently run markets in the city (NAI, Com. Col. 1368). According to this report, the Ereko traders contributed three pence each week to a fund that was used to hire lawyers and literate clerks as needed. The commissioner of the colony criticized the markets' organization, saying that the degree of control the women exercised should be "nipped in the bud" (NAI, CSO 248/24). By 1932 Pelewura was a member of the *Ilu* committee, a component of traditional government that met regularly with the *oba* (king) and chiefs (Cole, 1975: 137); she was a spokeswoman for eighty-four market women's representatives from sixteen markets representing over ten thousand women (Tamuno 1947: 55). Still, Pelewura continued to trade within the labyrinth of the market, maintaining her allegiance to Islam, and remaining illiterate (Johnson 1978).

The taxation of women and the attempt to enforce government pricing in the markets proved to be the greatest areas of contention between the colonial authorities and the LMWA. It was in 1932 that the first rumors circulated that the authorities planned to tax women in Lagos. Pelewura then led a delegation of market women to discuss the issue with the administrator of the colony, C.T. Lawrence (*Daily Times*, 29 January 1932) and reportedly was assured that the government had no intention of taxing women. Within eight years the colonial government enacted an Income Tax Ordinance in order to tax women with annual incomes of £50 or more. The LMWA immediately organized mass protests to challenge the income tax proposals. On 16 December 1940, over a hundred women assembled outside the offices of the commissioner of the colony, who eventually appeared to say that only rich women would be taxed (NAI, Com. Col. 2401). Pelewura responded that once the principle of female taxation was conceded it would eventually extend to all women. With the help of the nationalist NNDP leader Herbert Macaulay, the women formulated a petition against female taxation to which several hundred affixed their thumbprints. The petition detailed the 1932 promises of no taxation of women, as well as stating that such taxation breached "native custom"[6] and was "revolutionary" in its character. The petition also stated that Oba Falolu and the chiefs of Lagos agreed with the women that female taxation was not only contrary to custom but undesirable.

On 18 December protestors held a mass meeting at Glover Memorial Hall, with estimates of the crowd ranging from the government's figure of 1,000 to the *Daily Times* (18 December 1940) figure of 7,000. Both Pelewura and the commissioner of the colony addressed the gathering. Pelewura emphasized the sacrifices that women were already making due to the economic effects of World War II, including paying the taxes of unemployed husbands and other male relatives. According to official accounts, she wound up her talk with a Yoruba version of "votes for women or no taxation without representation." Within a few days the women achieved a limited victory. Governor Bourdillon issued a statement that only women earning over £200 annually (instead of £50) would be taxed and a special

letter to that effect was delivered to Pelewura (*Daily Times*, 18 December 1940).

During the war the British not only conscripted Nigerians to fight in the war but also established quotas of food that the colony was required to supply to feed the soldiers. Acute food shortages throughout Nigeria and male absence from the farms made available food high in price (Olusanya 1964: 241; Oyemakinde 1972: 416). Lagos was especially hard hit as it had a large and concentrated population, a very small percentage of which was engaged in growing food. In response to the high prices, the colonial legislature set price controls for essential foodstuffs in February 1941 (Oyemakinde 1972: 416). In an effort to enforce these controls, the authorities sent government agents to buy food in localities contiguous to Lagos and sell it in designated government centers in the city. The Pullen price control scheme (named after Captain A. P. Pullen, who devised it) struck at the heart of women's economic participation, provoking vigorous opposition by the LMWA. During the first year of the price controls the women farina sellers of Ijebu-Ode (a town a few miles outside of Lagos) stationed themselves on the Sagamu road and removed any farina found aboard vehicles destined for the government centers (NAI, Com. Cl. 2497). In Lagos market women refused to sell at the controlled prices, which were often lower than cost.[7] Several European firms also contravened the price controls.[8] By 1944 the administration estimated that two-thirds of Lagosians were obtaining their food via the black market (Oyemakinde 1972: 422).

In early 1944 Pullen, the deputy controller of foodstuffs, convened a meeting at Oba Falolu's palace between the market women, traditional authorities, and representatives of the colonial government. An estimated 3,000 market women attended, and in the presence of the *oba* and the chiefs they declared their refusal to submit to the controls. Chief Oluwa spoke and informed Pullen that as Pelewura was the head of the market women they must abide by her decision. A few days after this meeting Pelewura went to Pullen's office and threatened to close all of the markets if the controls were not lifted. In desperation Pullen offered to put Pelewura on the government payroll in exchange for her cooperation in enlisting the support of the market women for the price control scheme. In a scathing refusal, Pelewura replied that even if he offered her £100 a month she would not help him to "break and starve the country where she was born" (Macaulay Papers, box 13, file 5). Subsequently, Pullen attempted to blame the aggressive behavior of crowds at the government food-selling centers on "deliberate sabotage by the agents of Madam Pelewura" (NAI, Com. Col. 4037/s.44/c.9).[9] By 1945 the major Lagos newspapers, the *Daily Times* and the *Daily Service*, as well as male nationalist leaders, were supporting the women's call for an end to price controls (Tamuno 1966: 37). In September 1945 the government decontrolled food prices. After a protracted struggle, the women had achieved a victory.

In 1945 the general strike in Nigeria again increased the importance

of the market women in the nationalist ranks. This strike represented a turning point in Nigerian politics, marking the beginning of militant mass movements calling for self-government (Olusanya 1964, 1973; Sklar 1963). The LMWA organized the market women in support of the strike by contributing to the Workers' Relief Fund and keeping the selling price of food low in solidarity with the strikers. On 2 June Pelewura was one of the keynote speakers at a public rally for Michael Imoudu, a strike leader who had just been released from detention (Oyemakinde 1974: 698, 704–5). By supporting the strike, the LMWA demonstrated its ability to recognize its class interests beyond the bounds of gender solidarity.

At about the same time, a new class of women who owed their creation to the Western education and Christian mission activity which attended colonialism began to organize themselves. Lady Oyinkan Abayomi[10] had begun some efforts to organize women on her return from studying in Great Britain with the founding of the British West African Educated Girls' Club (later renamed the Ladies' Progressive Club) in 1927 (Johnson 1978). The organization conducted free literacy classes for market women and hosted teas and other social events to raise money for the erection of a girls' secondary school in Lagos.[11] Abayomi's husband, Dr. (later Sir) Kofoworola Abayomi, was among the founders of the Nigerian Youth Movement (Baker 1974: 117), and she became head of its Ladies' Section. In 1935, in the NYM's literary organ *The Service*, she authored an article entitled "Modern Womanhood" (Macaulay Papers, box 73, file 7). Addressing herself directly to women of her own class, she warned: "The uppishness among the few privileged women who have been educated abroad must be killed. Unless the so-called highly educated make themselves open and approachable they will have no one to lead."

By the early 1940s Abayomi was convinced that women were being "cheated by our men and the government" (interview 12 February 1976). On 10 May 1944, she gathered a dozen prominent women in her home in Lagos to discuss their political situation. This meeting resulted in the formation of the Nigerian Women's Party (NWP). Among the objectives contained in the NWP constitution were to work for the educational, agricultural, and industrial development of Nigeria, to seek by constitutional means the rights of British citizenship for the entire Nigerian populace, and "to work for the amelioration of the condition of the women of Nigeria not merely by sympathy for their aspirations but by recognition of their equal status with men" (private papers of Mrs. Tinuola Dedeke, Lagos). Membership in the party was limited to women of African descent, but patrons could be adults of any nationality at home or abroad who supported the party's objectives. Three committees were set up to deal respectively with health and education, markets and native industry, and political and social issues. Though the party made plans to establish branches, it never appears to have seriously attempted to implement this initiative. The leadership of the NWP was almost solidly drawn from the ranks of Western-educated, Christian middle-class women, most of whom were teachers. The one known exception was Rabiatu Alaso Oke, a wealthy

cloth trader who served for a time as a vice-president (interviews with Mrs. T. Dedeke, 7 April 1976, and Chief Debayo, 14 May 1976).

The response to the formation of the NWP was mixed. The NYM questioned the viability of an all-female political party, especially since women did not yet have the vote, but generally wished the women well (*Daily Service*, 11 May 1944). Herbert Macaulay opposed its formation,[12] and a market woman, Madam Idowu, felt that the party could not speak for the market women (*West African Pilot*, 26 June 1944 and 18 August 1944). Pelewura expressed concern over the ability of Nigerian women to unite, but she also announced her willingness to cooperate with the NWP (*West African Pilot*, 24 July 1944).

Estimates of the numerical strength of the NWP range from 500 to 2,000 (Baker 1974: 235; interview with Dedeke, 2 June 1976), in comparison to a conservatively estimated LMWA membership of 8,000 to 10,000 (Tamuno 1966:37). Still the NWP had influence strong enough to convince the colonial administration to appoint Abayomi as the first woman to serve on the Lagos Town Council shortly after the Party's creation, in response to her criticism that there were no women council members (*West African Pilot*, 24 July 1944).

The major concerns of the NWP were girls' education and literacy classes for adult women, employment of women in the civil service, and protection of women's rights in the political and economic arenas. The party inaugurated literacy classes for market women and called on the government to create more secondary schools for girls and to broaden the curriculum in Queens College to include math and the sciences. Interestingly, it also criticized the lack of scholarships for Muslim girls and the failure of the educational system to observe Muslim holidays (NAI, CSO 43222).

The employment of women in the civil service had been a concern since the 1930s, when Charlotte Obasa (Johnson 1978) and her Lagos Women's League (defunct by the 1940s) fought an ardent battle for the employment of women in government. The NWP also protested the preference of the government for hiring European women, usually the wives of administrative officers, as nurses and secretaries (NAI, CSO 43222). Where African women were hired in those positions, they often received lower salaries than European women (*Daily Service*, 29 July 1946). By 1946 a royal commission in Britain recommended that there be no difference in pay between men and women in subordinate grades of the civil service, but still restricted a number of civil service jobs by sex (NAI, CSO 03571/s.1, s.2). The colonial authorities in Nigeria subsequently adopted the commission's recommendations on the issue of equal pay for women and, in addition, fired a number of European wives from the Nigerian civil service (*Daily Service*, 29 July 1946).

The NWP also protested a number of laws that related more directly to the traditional roles of the market women. The Children and Young Persons Ordinance Act, for instance, forbade any child under fourteen from engaging in street trading and any young girl between fourteen and

sixteen from trading before 6 AM or after 6 PM. As part of the enforcement of the ordinance, police officers met trains entering Lagos and removed young girls who appeared to be between the ages of fourteen and sixteen. The NWP along with the market women vigorously protested this ordinance, and in a letter to the commissioner of the colony, the Women's Party expressed the hope that "this restriction of movement is not a subtle way of introducing the pass system which obtains in South Africa" (*Daily Service*, 21 August 1946). After mass protests following the arrests of several women with young babies on their backs under the ordinance, the government finally rescinded the law. The NWP also protested a government ban on the export of locally woven cloth, enacted during the war on the ostensible grounds that there was a shortage of shipping space. The party cooperated with the market women in their opposition to the Pullen price control scheme and to government efforts to establish the practice of selling by scale weight in the markets.

The Women's Party also actively worked for the enfranchisement of women and the representation of women on political committees and in elective office. In 1950, the first year that women were granted the franchise, four members of the NWP ran for seats on the Lagos Town Council,[13] but none were successful. By this time the balance of power in the Nigerian electorate had shifted from elites to nonelites, and from the Christian to the Muslim community (Baker 1974). In addition, two male-dominated, mass-based parties, the National Council of Nigeria and the Cameroons (NCNC) and the Action Group (AG), had begun to dominate Nigerian politics (Sklar 1963). These parties actively wooed the market women, and many NWP members were also active in the NCNC or the AG. As ethnic rivalries increased in the decade prior to independence, many of the market women and NWP members chose to join the Action Group headed by Obafemi Awolowo and destined to become known, albeit informally, as the party of the western region. The Women's Party lost momentum as nationalist politics heated up, and the women were absorbed into the nationalist parties. But, despite their enthusiastic support for these organizations, they were not rewarded with high office or great influence, although officials did acknowledge the importance of including them. For members of the NWP, gender was no longer a determining factor in their class position, which was now primarily dependent on the status of their husbands and fathers. The working relationship between these women and the market women now rested solely on interests of gender, and sometimes of race and ethnicity, rather than on class. This made it easier for the concerns of the majority of women to be regarded as gender issues and put on the back burner by the mass parties, which were consumed by the struggle for independence and Nigerianization of the economy and the government.

The Women's Party continued until 1956, with most of its activity resting in the hands of a small elite leadership circle that continued to agitate for female education, expanded health care facilities, and a united womanhood in Nigeria. In 1956 an umbrella organization, the National

Council of Women's Societies (NCWS) was formed in Ibadan (Johnson 1978). By 1957 the NCWS had made its way to Lagos, and several members of the NWP Executive Council served as presidents, notably Abayomi and Dedeke. Abayomi also served as the president of the Action Group's Western Regional Women's Conference. The NCWS did not aspire to political power but merely acted as a network of women's societies organized to do social service work. Moreover, by the late 1940s the rise of the Abeokuta Women's Union (AWU) under the leadership of Funmilayo Anikulapo (formerly Ransome) Kuti had begun to eclipse the activities of all the other women's organizations in Nigeria.

Funmilayo Anikulapo Kuti was born and raised in Abeokuta[14] and studied in Britain, where her anticolonial sentiments crystallized. Though christened Frances Funmilayo, she reported that the racism she encountered while studying abroad caused her to drop Frances and use only Funmilayo (interview 13 June 1976). Years later she dropped her husband's European surname, Ransome. Upon returning from abroad in 1922 she accepted the principalship of the Abeokuta Girls' School. In 1925 she wed the Rev. I. O. Ransome-Kuti, an Anglican minister and political activist who was a president of the Nigerian Union of Teachers (NUT), a professional trade union with a multi-ethnic base which gave it a nationalist orientation (Coleman 1958:263–65). He was also active in the NYM and vice-chairman of its Abeokuta branch. Between 1925 and 1931 the couple resided in a town near Abeokuta, Ijebu-Ode, where Mrs. Kuti began literacy classes for market women. Upon her return to Abeokuta she began a nursery school and literacy classes for the market women there. In 1942 she founded the Abeokuta Ladies' Club, which at first mostly undertook charity work. In 1945 the Ladies' Club cooperated with the NUT to provide assistance to market women who had their rice, *gari* (cassava staple food), and chickens confiscated by local government officials, who had been ordered to requisition food for the British war effort (*Daily Service*, 12 November 1945).

Indirect rule in Abeokuta was constituted under the Sole Native Authority (SNA) system, which granted the *alake* (king) powers greatly exceeding those he inherited with his traditional title. The British vested all-encompassing authority in the *alake*, unchecked by the traditional set of balances. Under this form of organization, women lost their traditional avenues of political participation and influence (Awe 1977). As early as 1918 they were subject to taxation; during World War II they were also subject to the Pullen price control scheme. But women in Abeokuta were not organized citywide. The Alake Ademola came to power in 1920 as the first Western-educated *alake* in Abeokuta. Even before the women organized to protest his policies, he had been the target of mass-based protest. In the early 1930s several complaints were filed charging him with appropriating residents' land for lease to European firms and agents (NAI, CSO 23610/s.55, vols. 1, 2). In 1938, 10,000 people thronged the palace to protest his methods of collecting and levying taxes (*Daily Service*, 26 October 1938).

The brunt of the *alake's* policies fell heavily on women, who provided

as much as one-half of district tax revenues (*Daily Service,* 13 June 1947) and were the main distributors of food. In collecting food for the war effort the *alake's* police set up roadblocks at strategic points in and around Abeokuta and seized chickens, yams, gari, and rice. Reportedly the women were told, "Nobody should eat until enough food was collected for the soldiers" (Kuti interview 23 June 1976). Often the women received no compensation for their confiscated produce; when they did it was at a lower rate than that set by the administration. Angry women charged that the *alake* was pocketing illegal profits. The women also charged that they suffered taxation without representation. They had neither representation on the SNA councils nor control over administration of the markets. Besides the income tax they paid, women were also taxed to pay the salaries of the *parakoyis,* or market supervisors, who were appointed by the government. In 1946, building upon the nucleus of the Ladies' Club, the contacts market women made through literacy classes, and the 1945 NUT campaign against the seizure of foodstuffs from women, the Abeokuta Women's Union was formed to redress the women's grievances. The AWU adopted the motto: Unity, Cooperation, Selfless Service, and Democracy. The union's objectives were to unite, defend, and protect women and preserve their social, economic, and political rights. The union specifically expressed the goal of working for Nigerian independence (Kuti personal papers, Abeokuta). One of the greatest strengths of the AWU was the equality that it created between the market women, who were the bulk of the membership, and the educated members. Kuti herself abandoned Western clothing for traditional Yoruba attire and always spoke at public meetings in Yoruba, on one occasion even informing the district commissioner that if he could not understand he should get an interpreter (Kuti personal papers, Abeokuta).

Kuti not only maintained sound links with uneducated women but also initiated international contacts. She traveled throughout Africa and was in touch with the Women's International Democratic Federation. Under their auspices she traveled to China, Bulgaria, the Soviet Union, Poland, East Berlin, Hungary, and Great Britain. Her passport was rescinded more than once for travel to Communist countries, and in the 1950s she was denied a visa to enter the United States on the grounds of her previous travel, though she did later visit the United States (Kuti personal papers, Abeokuta).

In July 1946 the AWU presented a petition to the SNA which demanded that the government not tax the women to pay the salaries of the market supervisors, but rather, since the entire community used market facilities, to take their salaries out of general revenue. They also argued, "Inasmuch as . . . women pay taxes, we too desire to have a say in the management of the country. . . . We request you please to give consideration to our being represented in this council by our own representatives at the next general election" (*Daily Service,* 8 July 1946). Kuti authored numerous letters to Lagos and Abeokuta newspapers and held a number of press conferences in which she outlined the women's grievances and stated

their objectives: (1) the abdication of the *alake*; (2) the abolition of the SNA and its replacement by a more representative form of government which included women; and (3) the abolition of flat rate taxation of women (Kuti personal papers, Abeokuta). The *alake's* response was that any woman who felt her taxes were too high should appeal to him individually as such a matter was "no group business," and he actually increased the tax rate for women (*Daily Service*, 19 October 1946). The AWU next sought to contest the tax levies in court through the test case of a trader, Janet Ashabi, who protested that her tax assessment was excessive. The resident, E. N. Mylius, instead decided to raise Ashabi's taxes (*Daily Service*, 7 November 1946). The women also intensified their efforts by hiring an accountant to audit the SNA accounts and by bringing court cases in which they charged that tax collection was abusive and that women were often beaten and even stripped to assess their age. Early in 1947 such a case against the superintendent of police resulted in his acquittal, though he admitted to beating women (*Daily Service*, 1 March, 20 April 1947). When it became clear that petitions, court cases, and publicity produced no results, the women resolved to adopt more militant tactics including sit-ins, mass demonstrations, and outright refusal to pay taxes. The first demonstration took place on 29 and 30 November 1947. More than 10,000 women maintained an overnight vigil outside the *alake's* palace, during which they sang abusive songs with explicit sexual references (*West African Pilot*, 29 November 1947), a customary means used by West African women to defend themselves by ridiculing men: "O you men, vagina's head will seek vengeance . . . we are not paying tax in Egbaland even if it is one penny . . . Alake is a thief. Council members thieves. Anyone who does not know Kuti will get into trouble. White man you will not get to your country safely. You and *alake* will not die an honourable death."

After the November demonstration the AWU claimed that the Egba General Council promised to suspend taxation while their grievances were investigated (*Daily Service*, 24 January 1948). Instead, harassment began and several women were imprisoned on charges of defaulting on their tax payments. The AWU responded by staging a two-day mass demonstration from 8 to 10 December as large as that of the previous month. Kuti was banned from the palace, but the *alake* stalled for time by promising that he would appoint women to positions within the government (*Daily Service*, 2 January, 20 February, 2 March 1948). The district officer invited the AWU executive to a meeting at the palace from which Kuti was to be excluded, but by an embarrassing mishap an invitation had been addressed to her and the women refused to attend without her. The AWU had by now also garnered the vocal support of the men of the community, and editorials in major African newspapers in the Western region indicated widespread support for the women's demands. The *alake* suspended the taxation of women, agreed to accept women representatives on the central committee of the SNA, and relinquished his position as the sole native authority (*Daily Service*, 1 June 1948). The AWU refused to accept anything less than his abdication as *alake*, however, and continued the demonstrations. Fi-

nally, on 3 January 1949, the *alake* abdicated. Four women, including Kuti, all executives of the AWU, were appointed to an interim council established in place of the SNA, and female taxation was abolished. The membership of the AWU now numbered between 80,000 and 100,000 women (Little 1973:72), and it changed its name to the Nigerian Women's Union, establishing branches in Calabar, Aba, Benin, Lagos, Ibadan, and Enugu (*Daily Service*, 30 December 1949). But, in a pattern similar to that of the LMWA and the NWP, the AWU did not sustain its efforts as an organization of women aiming to garner political power. In the 1950s its members were also integrated into the male-dominated NCNC and the AG. The AWU continued to conduct literacy classes and operate vocational training centers and credit unions for women but lost its specifically political momentum as its members were diffused throughout the nationalist parties.

CONCLUSION

The Lagos Market Women's Association, the Nigerian Women's Party, and the Abeokuta Women's Union had clear political aims in their confrontations with the colonial government. The two mass-based groups, the LMWA and the AWU, perceived colonialism as challenging their traditional roles, which, despite or because of the gender stratification of traditional society, included a high degree of political participation and economic independence. The new elite membership of the AWU was caught in an in-between world in which they had no clearly defined traditional or Western role that imbued them with power or influence. It was the confluence of class and gender in traditional society that created optimum conditions for women's organization and empowered them.

The changed political, economic, and social environment of the colonial period maintained, and even strengthened, the gender stratification of traditional society but it also transformed its character. The development of capitalism and its attendant class formation, as well as the diffusion of Western patriarchal ideas, created a new system of gender stratification characterized by women's economic ghettoization and by their effective alienation from political participation. Class formation among women splintered their ranks and, while it gave a small minority of them access to benefits in the new system, the new character of gender stratification made them dependent on their husbands and fathers for their class status and pigeonholed them into Western notions of women's roles. The majority of women had no access to the new benefits. Perhaps because women misjudged the struggle for independence as a struggle for a change in the system, as well as in the personnel, of government, they were caught up in the nationalist movement and, in the decade just prior to independence, lost sight of themselves as a class. The struggle for independence obscured the incipient development of a class structure in the African population. This was to prove fatal for women's potential economic and political

involvement in postcolonial Nigerian society, which never approached that in precolonial Yoruba society. And of course, an independent Nigeria faced the need to address the role of women in the numerous different societies that now comprised a unified country.

While the legacy of colonialism ensures that women of different classes have gender discrimination in common, women still face the need to deal with the *appearance* of cross-class gender solidarity, which can obscure class consciousness, as Staudt noted earlier in this volume. For it is only by examining the relationship between gender and class, as well as the new character of gender stratification, that the old tool of gender solidarity can be utilized in the best interests of the majority of new women.

Notes

1. This discussion of women's anticolonial activity is based on fieldwork in Lagos, Ibadan, and Abeokuta (all major urban centers in the southwest of Nigeria) in 1975–76.

2. Royal women and women who held high religious office generally had some privileges and wealth that other women lacked. However, their status usually resulted from ascribed rather than achieved position, and they were exceptions to the rule.

3. Such as their representation in the *Ogboni* society in Abeokuta or the *Ilu* committee in Lagos. For further discussion, see Cole 1975.

4. This was twenty-seven years after the first limited franchise was granted to men. Women in northern Nigeria, however, did not receive the franchise until 1977, due to the role of Islam in the north.

5. I use the term "new elite" for women who owed their elite status to institutions introduced by colonialism, primarily Western education and Christianity.

6. Though women were economically independent of their husbands, there had been no direct taxation of women in Lagos (Fadipe 1970). Men were taxed as early as 1927, however (Coleman 1958).

7. For example, northern producers of white beans sold their produce to middlemen at 19s/6d a unit, but the government set the control price at 17s a unit (Oyemakinde 1972: 420).

8. In September 1942 a number of people were charged with selling above the maximum official price. Several market women were imprisoned for a month, whereas an employee of the European firm CFAO was fined £6 for the same offense (NAI, Com. Col. 2686).

9. Market women informants at Jankara market (Lagos, June 1976) were adamant that neither Pelewura nor any of her deputies could control the behavior

of the crowds clamoring for food supplies at the centers. The fact was that lines were long, and moved slowly, and the government frequently ran out of stock.

10. Lady Abayomi was the daughter of Sir Kitoye Ajasa, the first Nigerian to be knighted, and Oyinka Bartholomew Ajasa, the daughter of the first treasurer to the Egba United Government in Abeokuta.

11. In direct response to the club's efforts, Queens College, Lagos, was established.

12. Undoubtedly this was due to the special relationship he enjoyed with the market women, who were solidly organized in support of his Nigerian National Democratic Party. He probably feared the relationship of Abayomi with the Nigerian Youth Movement, a rival party.

13. They were Lady Alakija, Mrs. Ore Jones, Mr. T. Manuwa, and Mrs. Toro-John.

14. She was the daughter of Phyllis Morenke Dese, a dressmaker, and Daniel Olumoyewa Thomas, a farmer and palm oil trader and son of African emigrants from Sierra Leone. Both of her parents were Christians and strong believers in girls' education.

Chapter 14

LABOR UNREST AMONG KIKUYU WOMEN IN COLONIAL KENYA

CORA ANN PRESLEY

A LARGE BODY of literature has focused on the impact of colonialism on African economic systems. Historians and political scientists writing on Kenya have been concerned in particular with new labor relations that were forced on Kenyans after the creation of an imperial British capitalist state; their work examines such questions as land alienation, wage labor systems, and African resistance to being relegated to a position of economic powerlessness (Brett 1973; Clayton and Savage 1974; Furedi 1975; Leys 1924; Lonsdale and Berman 1979; Mungeam 1966; Munro 1975; Sorrenson, 1968; Spencer 1980; Tignor 1976). Throughout this economic historiography, however, there is a persistent gap: the impact of the new colonial relations of labor on women. An examination of the major works reveals that most scholars relegate women to the sidelines in their discussion of wage labor, labor reform, and labor resistance. This essay is intended to help fill that gap.

Political activity and nationalism for the Kikuyu of central Kenya were linked to a number of issues: cultural survival, judicial control, landownership, education, and economic control. Kikuyu women were involved in all of these issues. But the literature on the Kikuyu, through its neglect of female labor activism, falsely conveys the impression that women were uninterested in, and unaffected by, the far-reaching political and economic changes that resulted from British expropriation of Kikuyu land and labor. This essay examines the economic impact of the colonial state for the Kikuyu women of Kiambu District, an area where land was alienated to European settlers and a system of forced labor for women was instituted; partly through an onerous tax system, they were compelled to work for European coffee estate owners. These new conditions resulted in

This essay, based on field research in Kiambu District in Kenya from 1978–1979, was originally presented as a seminar paper at the University of Nairobi in 1978. The research was made possible through a National Fellowships Foreign Area Fellows Grant from the National Fellowships Foundation.

255

a nascent rural working-class consciousness among Kikuyu women. From 1930 until the late 1950s they independently created and directed a significant rural labor movement centered among the thousands of women who worked on coffee estates, mostly in the Kiambu District. Though this labor activism had limited success in achieving its goals, it does demonstrate the historic involvement of women in the economic unrest that was so prominent in African attempts to alter and, ultimately, to dismantle the colonial state in Kenya.

Colonialism had an impact on many aspects of women's economic lives, leading, as elsewhere in Africa, to a considerable loss of political and economic status (Hafkin and Bay 1976: 15). Kikuyu women continued to be involved in the household economy in ways that they had been during the precolonial period; in addition to home and child care, they were active in trading (both local and regional) and played a primary role in food cultivation. With the introduction of new productive relations under British colonialism, the nature of women's economic involvement changed. New trade goods were introduced, and the use of money infiltrated the economy to such an unprecedented extent that the marketplace ceased to be a bartering center and became a place where surplus could be exchanged for cash. In the agricultural sphere, women continued to perform the bulk of the work, particularly those aspects of work that were the most time-consuming and labor-intensive. The introduction of wage labor had widespread effects. Thousands of Kikuyu women became involved in new forms of agricultural labor, and the double burden of indigenous agricultural production and labor for European farmers became part of the economic realities of their lives. Until the latter part of the colonial period, Kikuyu women had little control over their wages and working conditions and few means to seek to redress their grievances. This chapter will explore changes in Kikuyu women's work lives which were introduced with the creation of coffee agribusiness in Kenya and the strategies they developed to adapt to, and protest against, the new system of labor.

BACKGROUND: COFFEE AND COLONIAL LABOR POLICY

Coffee was first introduced in Kenya in the late nineteenth century. By 1902 coffee plants were being grown in the Highlands area on formerly African land (National Atlas of Kenya: 38), and by 1914 coffee had become Kenya's primary export crop, with an estimated value of 68,798 British pounds sterling. Twelve years later 65,140 acres of land in the colony had been converted from indigenous production of food to production of coffee for export on the world market (*East African Standard*, hereafter EAS, 2 January 1926), and by 1938 the amount of land in Kenya reserved for the production of coffee had increased to 94,000 acres (Brett 1973: 175).[1] Coffee had thus proved itself as one of the most important money producers for the settler colony (Sorrenson 1968:156).

The hold that coffee had taken on the imagination and pockets of the

settler community had far-reaching consequences for Kikuyu women. Once the crop was established and began to be cultivated in sufficient quantities, the question of a stable labor supply arose. In the production of other commodities such as maize and beef, the question had been solved partially through the use of squatter labor and, more indirectly, by the extortion of taxes from Africans, forcing them to earn the necessary cash by working for Europeans. Coffee planters, finding this labor pool inadequate for their purposes, sought government aid. The peak requirement period for labor for coffee cultivation occurs between the months of September and December. During this period, which in Kenya coincided with the traditional agricultural planting cycle, settlers demanded a massive number of African laborers. Having to procure nearly 70 percent of the yearly totals of labor they needed for coffee production in those four months (Kenya National Archives, hereafter KNA, Native Affairs Department, hereafter NAD, Annual Report, hereafter AR, 1926: 87), the planters were faced with a definite problem: how to obtain massive amounts of labor for a short period of the year, while maintaining wages at a sufficiently low level to maximize their profits.

The move toward the use of compulsory labor began in 1908, when European settlers put pressure on the government to procure the labor they needed for their estates (Kilson 1955: 128). Such pressure bore fruit in the decade 1910 to 1920, when the Native Land Commission decided that government officials should be used to increase the numbers of Africans available for wage labor through what they termed "encouragement of labour" (Tignor 1976: 164). During World War I, the settler–government coalition found itself in a situation where larger numbers of African workers were needed. This was the result of several factors, the first being the expansion of the infrastructure of the colonial state (roads, railways) and the expansion of cash crop enterprises, particularly in growing coffee, tea, maize, and sisal, which meant that greater demands were placed on the existing pool of labor. The second factor was the war itself. The British conscripted thousands of African males to serve as porters. In 1916 the district commissioner for Kiambu reported that the reserve was so depleted of men that women and children were doing work men had traditionally done (KNA, AR/273, Kiambu District, hereafter KBU, 1915–1916, 9: 1). The Dagoretti Subdistrict report of 1917 noted that recruitment for the carrier corps had affected the life of the Wakikuyu considerably by removing large numbers of young men from their traditional work: "These functions fall to the lot of the women and children more than in the past: one consequence being that the women have less time to keep the shambas clean so that the food supply necessarily suffers to a certain extent" (KNA, AR/275; KBU/10; Dagoretti Subdistrict AR/1916/17:1). In addition to creating a scarcity of men to assist women in the production of food for consumption, military conscription of African males placed the added burden of serving as a pool of wage laborers on Kikuyu women and children. It was during this time that settlers turned to female and child labor for their coffee estates (Orde-Browne 1946: 72).

By 1917 Sir Henry Conway Belfield, governor of Kenya, had endorsed
the policy of inducing Africans to work for Europeans through compulsory
labor (Kilson 1955: 129). The governor's office under the leadership of
General Northey attempted to fill the demand for more African labor by
increased hut and poll taxes. But the amount of labor was still insufficient
to meet the ever increasing settler and government needs. Governor
Northey subsequently issued the Northey Circular, which directed district
commissioners, labor agents, and African chiefs to procure female and
juvenile workers for private and public projects.

By 1920 local government officials were fully involved in the settlers'
labor difficulties and consequently responded enthusiastically to the di-
rective of Labour Circular 1 of 23 October 1919, because it placed them in a
favorable position with the often over-influential local planters. But of-
ficials often failed to see and appreciate African dissatisfaction with their
efforts, since little control was exercised over the recruiters or the treat-
ment of Africans when they were placed as employees in public and
private concerns. A retiring district commissioner (DC) for Kiambu, in his
handing-over report for that period, noted that, as a result of the circular,
women and children had picked a heavy coffee crop (KNA 1918–20
KBU/13: 4). The district commissioner of Kiambu in 1919 summarized his
predecessor's efforts in obtaining labor, observing that women were con-
tent with being used as workers in coffee picking. He did not perceive any
abuse of the system (KNA, AR/278, KBU/13 1919–20: 32).

ABUSE AND REFORM OF LABOR RECRUITMENT

Contrary to the perception of the DC, however, women's discontent and
anger with the scheme was at a high level at that time. Wambui
Wangarama, a resident of Lower Kabete (Kiambu District) and a longtime
political activist, reports that the girls and their parents were deeply
opposed to the practice of "obtaining" them for labor and considered
themselves to be working as slaves:

> We started asking for our freedom when we were young girls during the war
> of 1914. We started putting murram and tarmac along the road and were
> forced to push the leveller. We made the European feel angry. At that time one
> girl was killed on the road; she was beaten in the head and died, they were
> being led by Kiyanjui. Then Harry Thuku was jailed. And our parents said we
> shouldn't work on the roads but at that time we were caught again when
> there was a fight at Nairobi and the fight was because the women asked for
> the men's pants.
> We were brought to a coffee estate here. We were picking coffee and
> cultivating, and after five weeks we were given thirty shillings and no food.
> There was a man who was looking after the women and if he saw that you left
> one part uncultivated he would beat you. A girl called Njeri was beaten and
> her leg was broken. After that we stopped doing the work of picking coffee
> and cultivating as well. When Harry Thuku was sent to Somaliland our

parents refused to let us work. We were doing shaking and scratching [pretended illness] while working on the estates to annoy the Europeans. We did this so that Harry Thuku could be released. (Kenya Women's Texts, hereafter KWT, 1979: interview 30)[2]

Harry Thuku was a Kiambu Kikuyu who received a mission education at the Gospel Mission Station, Kambui, and held several white collar jobs including working for the settler newspaper, *The Leader*. He was instrumental in founding the first African political association in the 1920s, known as the East African Association. When the colonial state required African men to carry a *kipande* (fingerprint registration and work history), doubled the poll taxes, and authorized across-the-board reduction of African wages by a third, the EAA under Thuku's leadership became an important political factor in British–Kikuyu relations. Thuku and the EAA held public meetings to discuss and protest against these policies. Labor abuses against women were among the group's concerns.

One aspect of forced labor that particularly upset women was the high incidence of actual and threatened physical brutality. From 1913 through 1923 physical outrages and intimidation connected with coffee production reached a level only surpassed by the anti-Kikuyu violence under the "emergency" situation during the "Mau Mau" rebellion to the 1950s. Any Kikuyu family in a sufficiently favorable financial position tried to avoid having its women work on the coffee plantations because of the demoralizing effects of the labor and the violence to which the women were often exposed (KWT 1978: interview 15). On 24 October 1916, Kikuyu elders had complained that a male escort was necessary for women who worked on coffee estates. Women laborers were being assaulted by male laborers, particularly on the Mbagthi farm, and while cutting firewood in the forested areas. As a solution, the district commissioner's office suggested that women go to the forests in groups to obtain firewood and that male escorts be provided (KNA, KBU/77, Dagoretti Political Record Book, II, 1913–19: 84–85). The problems of coercion and physical abuse of women, both corporal and sexual, became so acute that missionaries became concerned and began to solicit public support to stop the practice of "encouraging" women to work for Europeans. In a memo written to the *East African Standard* on the question, the East African bishops expressed themselves mildly on the issue, but nevertheless revealed the defects of the system:

> The decision to "encourage" women and children to labour, bearing in mind the meaning that will inevitably be read into the word "encourage," seems to us a dangerous policy. The children below a certain age should be at home or at school. The women work at home; the plantations, the supply of the daily food, the cooking, the care of the children, and the home depend upon the mothers and the wives. To "encourage" as a native headman (with the fear of dismissal behind him) would "encourage" the women and girls to go out from their homes into neighbouring plantations, would be to court disaster, physical and moral. Whatever labour legislation is introduced the women

and children should be left out of it (KNA, Central Province Political Record Book/220, PC/CP.1/1/1/ 1901–26: 269).

Disaster was indeed courted. By 1920 it was common practice for planters to bribe retainers for their efforts to obtain female labor: "Tribal retainers who had escorted women to farms were in many cases being given monthly wages or gratuities and, as it seemed likely that consider-able abuse might arise, the position was represented to His Excellency who has expressed his opinion that the arrangement is undesirable and should be stopped, which has now been done" (KNA, AR/279; KBU/14 1920–21: 44). The district commissioner of Kiambu included in his report a denunciation of this practice of giving "bakshesh." He frankly discussed the attendant ills this system propagated, called the "encouragement" of labor by these retainers extortion, and stated that the district commis-sioner must stringently watch this practice to avert trouble (KNA, AR/279, KBU/14 1920: 28).

By 1922 the inconsistencies and abuses of the system of employing chiefly retainers to induce women to work in the coffee estates were all too obvious. The emerging East African Association made the question of female labor one of the planks in its confrontation with the colonial government at a meeting held at Dagoretti, Kiambu District, in June 1921, along with the issues of *kipande* (pass) laws and the high level of taxes on Africans. In discussing the abuses of the labor system, the young politi-cians maintained that the retainers frequently detained women away from their homes. In one case, they had escorted sixty women to a coffee estate and not allowed them to leave. In another, they had sexually as-saulted and impregnated a number of women. The East African Associa-tion called for reforms that would put an end to these abuses (McGregor-Ross 1968: 225–26).

The women themselves were aware of the activities of the association on their behalf. Even though the EAA followed the precolonial pattern of reserving leadership and membership in political organizations to males, the inclusion of a women's labor issue enhanced the appeal of the EAA to women (not until the 1930s were women included in the membership of a Kikuyu nationalist association). When questioned on the subject of labor abuse, respondents were aware that the efforts of Harry Thuku had helped them to receive more just treatment as wage laborers:

Q: How were you treated as workers on the coffee estates?
A: They treated us badly, we used to go to work from early morning until afternoon, we were beaten and given hard work. They even refused to give us our wages.
Q: Was there anyone to whom you could complain about your treatment?
A: No, you wouldn't complain. If you did, you were punished again (KWT 1978: interview 5).

These women rightly or wrongly attributed the change in the conditions of their employment to Thuku's efforts. One Kikuyu woman who was forced

to work on the coffee estates during this period said, "Harry Thuku is the one who fought for us and stopped us from working like slaves" (KWT 1978: respondent 1). A popular song of the period, frequently sung by the young girls, comments on Thuku's championship of women and his attempt to stop the abuses to which they were subjected:

Philip should be frightened,
Since he is the one who caused
The leader of the women to be deported.
Therefore, women are still in the Coffee-lands.
(Clayton and Savage 1974: 121)[3]

Another contemporary women's song showed women's support of Thuku:

When Harry Thuku left, that is the time I started scratching my buttocks.
When he came back, the scratching stopped.
Let the white man face that,
Because he is the one who forced Harry
Thuku to go to Europe.
(KWT 1979: interview 30)[4]

The malpractice—the beatings, the rapes, the detention of workers away from their homes, the withholding of wages, and the physical coercion to gather workers—were only slowly changed, and even then the effectiveness of the reforms was only partial at best. Pressure in Kenya and London from missionaries, the Colonial Office, and the East African Association to end the forced labor of women and children prompted government action to reform the system; the result was the Native Women's Protection Act (1923). The 1923 act had three provisions which were to govern labor conditions for females and juveniles: estate owners were to provide proper accommodation for single women workers; women who were not living with a husband or father were not to remain on the grounds of the estates after dark; and women were not to work on estates that were farther than three miles from their homes (Clayton and Savage 1974: 119). Officially, the act was successful, so that in 1928 the Native Affairs Department was able to report that conditions under which women and juveniles worked had improved. The report maintained that no abuses of women had occurred since the act was passed in 1923 and that women and juveniles now worked willingly on the coffee estates, usually with the consent of their husbands or parents, although women sometimes made the decision themselves (KNA, NAD, AR/1928: 100).

The district reports for Kiambu show that the colonial government kept careful records of the number and nature of violations of its own laws; to each report is appended an account of criminal acts and the punishment given to Africans. However, the colonial administrators were either unable or unwilling to record abuses perpetrated against the African population either in the name of the government or as a result of

Africans' involvement with the coffee estates. For this reason it is difficult to estimate the number of cases in which Kikuyu women were mistreated or abused as a result of colonial labor laws. We can, however, obtain some idea of the effect such work had on their lives. An examination and comparison of the reports for Kiambu District and the labor reports of the Native Affairs Department illuminate this question.

WOMEN'S EMPLOYMENT ON COFFEE ESTATES AND THE BEGINNING OF PROTEST

The number of women employed as seasonal laborers on coffee estates was quite large. The Kiambu district officer for the year 1923 estimated that farms in the district employed a monthly average of 3,089 women. The figures of 2,947 juvenile laborers and 11,615 men appear for that year (KNA, AR/1923, KBU/16: 19), which represented nearly half of the total number of African women working in wage labor in the colony and nearly a third of the children who worked on European-owned agricultural and pastoral concerns. In 1925 the total number of African workers on European farms was 78,427. In that and the next year the numbers of women involved were similar, but the number of children rose to 14,000 (KNA, AR/1925: 64; NAD/1926: 79). Most of the female and juvenile labor lived in the reserves and returned home at night, so that squatting was not the predominant labor relation for women and children. Though women and children were still needed for subsistence agriculture and the cycle of coffee picking coincided with the peak period of the traditional agricultural cycle, the planters and labor recruiters made no concessions to their difficulties. They were considered casual labor, recruited to produce the largest agricultural export of the colony. The numbers of women workers employed by the coffee estates steadily grew as more acreage was appropriated and put under cultivation and as the export market expanded; by 1956, 27,000 women were employed on the coffee estates in Kiambu (KNA, NAD, AR/1956: 40).

Despite the increasing demands for female and juvenile labor, the remuneration for this work did not increase at a comparable rate. International coffee prices rose twice during the colonial period, between 1905 and 1910 and from 1945 to 1962. Planters made successful efforts to lower wages during the periods of price contraction, particularly during the depression of the 1930s, when African wages were reduced in every district in Kenya by 30 to 50 percent (Van Zwanenberg 1975: 53). But rarely did the employers increase wages during the periods of expansion. A comparison of African wages for the colony (see Appendix 14.1) reveals that coffee laborers were among the four lowest-paid categories of workers and that, except for child labor, women's wages were at the very bottom of the scale. In 1925 women workers received 10s to 12s per month with a food allotment. Coffee pickers received 15d per each four gallons of coffee berries picked and a food allotment (KNA, NAD, AR/1925: 71). The food allotment

consisted of 1.5 to 2 pounds of maize meal per day (KNA, NAD, AR/1926: 64).[5]

The bulk of the labor required for harvesting on coffee estates occurs in the period from October to March. Appendices 14.2–4 show the distribution of labor on a biannual basis; they also show the percentages of women, men, and children employed on the estates and the division of labor according to the age of the coffee trees and the type of care the plants required. Most of the female and juvenile labor was required for mature coffee trees, that is, for harvesting the berries. During the harvest period female and juvenile pickers totaled 64 percent of the workforce. In the slack period, April through September, women and children comprised only 40 percent of the workforce for the fruit-bearing trees (see Appendix 14.2). Women and children were never used for clearing and planting, but they made up 40 percent of the workforce used throughout the year for maintenance, especially weeding (see Appendix 14.3). Workers estimated that the average picker could gather five "debbes" of coffee berries per day (a "debbe" was equivalent to thirty pounds of berries, Bunyasi 1973: 19). They also stressed that coffee picking was very painful. At the end of each day a picker's arms smarted with scratches from the stiff branches of the tree and beginners found that their fingers were swollen and stiff. They were expected to meet daily production quotas.

In the period from 1913 to 1923 women's labor protest and that of the EAA focused on the coercion of women workers. The Kiambu District archives contain evidence showing that estate owners experienced difficulty in obtaining women to pick coffee in a number of years: 1924–25, 1934–35, 1937, 1941, and 1947. The first available data on the problem comes from a complaint lodged with the district commissioner's office on 31 May 1912; a man called Wahotho had prevented his wives from going to work for a Mr. Lushington, who had employed an African named Kinwangika to recruit women to work for him. Lushington had told Kinwangika that he was "of the government" and that the district commissioner had told him that Kinwangika should do his recruiting. When Kinwangika ordered the women to work, Wahotho refused on the grounds that his wives were helping to build his homestead (KNA, KBU/Political Record Book, KBU/114 1911–27:8).

This early example of male intervention against recruiting women to work for Europeans is atypical. The dominant pattern that emerged over the next decades of women's labor unrest was rather one of independent female protest; women organized labor stoppages on their own and attempted to change their conditions of work. As coffee agribusiness expanded and gross exploitation of women and juvenile laborers was reformed, the focus of women's labor protest shifted to questions of the amount of wages and the food allotment, which was considered a part of their wages. These complaints were a continuing irritant for the settlers and the district commissioners, who tended to categorize all labor protest as politically subversive. The beginning of collective action among women

workers dates to the post-1925 period, when women who worked on the coffee estates began to organize work stoppages.

There were earlier instances of women protesting en masse against British exploitation, however. At first, Kikuyu women used their traditional means of criticizing male authority, transforming a traditional ritual curse against Kikuyu men into a criticism of European officials and estate owners. This was most dramatically illustrated in the Nairobi "riot" of 1922 connected with the arrest of Harry Thuku. Mary Muthoni Nyanjiru was the first to mobilize a crowd of 2,000 Africans, who were attempting to obtain Thuku's release from jail. As recounted in *The Myth of Mau Mau*: "Mary Muthoni Nyuanjiru leapt to her feet, pulled her dress right over her shoulders and shouted to the men: "You take my dress, and give me your trousers. You men are cowards. What are you waiting for? Our leader is there. Let's get him" (Rosberg 1966: 51–52). While this bold and derisive act might appear on the surface as a defiance of traditional patterns of female behavior, it was, on the contrary, a recognized means of expressing female dissent used only in the most extreme circumstances, similar to those used by West African women (Johnson, Chapter 13 this volume). By lifting her skirt, a woman demonstrated that she held the offender in contempt and no longer recognized his authority.

Nyuanjiru acted as an individual spurring a mixed group on to collective protest. But she followed a precolonial precedent of collective action by women only, that also became the pattern of women's subsequent labor activism. Kikuyu women workers did more than recognize the commonality of their work conditions from 1925 through 1960; they planned numerous demonstrations to improve their wages and working conditions, and they did so without the formal aid of male-dominated political associations and trade unions.

LABOR "SHORTAGES" AND THE INCREASE IN PROTEST

European planters held definite views on the relationship between wages and labor shortages, most of which did not include raising wages to attract workers. Major F. LeBreton, in a letter to the *East African Standard*, stated that the problem was not one "of finding work for the unemployed, but finding native labourers to do the work on offer." He might well have added to his statement, *at the price we are willing to pay*. He offered three solutions to the problem of increasing the labor supply: finding new sources; increasing attractions to available labor; and increasing the efficiency of available labor. Increasing wages was in his estimation an impractical solution, since "the margin of profit is not large, and the limit of increased wages if not accompanied by increased efficiency is soon reached." He concluded by suggesting that increased amenities such as the distribution of medicine to sick workers could be used as an inducement to attract and keep an industrious labor force (*EAS* 10 December

1937). Less typical was the view of another planter, who insisted that the African labor force could indeed be attracted by increased wages, as he himself had no problems since he gave a square deal: "good housing, plenty of food and decent wages"; he reported that the laborers were disinclined to go to work on the coffee estates because they would only be paid from 6s to 9s per month—which meant they would have to work two months to pay *kodi* (taxes). When he asked workers if they would work on the coffee estates for 12s per month, the reply was an immediate yes. He concluded, generously for the times, that there were "lazy natives certainly but piecework cures this. . . . The native if treated decently is not a bad fellow" (*EAS* 13 December 1937).

However they perceived the problem, the majority of the planters had serious problems recruiting labor. African men were reluctant to work on the coffee estates either as permanent or seasonal workers because of the low wages, forcing planters to rely increasingly on female and child labor to harvest their crops. A coffee conference held in 1937 urged the government to conduct an inquiry into the shortage of labor. African women had applied pressure for an increase in their wages during that picking season (*EAS* 30 November 1937) and, according to a newspaper report, the shortage had reached such proportions that the ripe crop could not be picked, meaning that laborers had to be diverted from other maintenance-oriented activities on the estates (*EAS* 1 December 1937). Ten years later the planters still complained of a labor shortage when they had "a few bad moments" in their efforts to find pickers (*EAS* 12 December 1947). The problem of recruiting and keeping labor had not abated despite resolutions by coffee boards and government inquiries.

If planters expressed continual concern at the difficulty of finding labor, workers expressed equally continual dissatisfaction with their wages. Wages paid for coffee picking remained constant at 10c(1s = 75 cents) per "debbe" for much of the colonial period. Officially, the rate was 15c to 1s/20c plus food allowances (KNA, AR/1960: 15). Respondents insisted, however, that they received no more than 10c per "debbe" with one pound of maize meal per day. They voiced their grievances through temporary work stoppages and strikes. It is not possible with the current data to determine the number of stoppages that actually took place on the coffee estates or to ascertain how many of these strikes and stoppages occurred in Kiambu District. But, according to colonial government sources, of 232 work stoppages in 1960, 122 of them occurred in the agricultural sector, mainly on the coffee estates in Central Province (KNA, AR/1960: 15).

Most of these stoppages were abortive attempts to force up wage rates. Work stoppages were fairly common (see Appendix 14.5) and grew more popular as time went on. Many years showed increases in the number of work stoppages and the number of workers involved, with the exception of 1951 to 1956, a time of guerrilla struggle against colonial rule called the "Mau Mau" emergency, which involved severe governmental repression. During this period, restrictive measures to control the movements of the

Kikuyu, the general suspicion of activists, and strict penalties for anyone suspected of insurrectionist intentions probably led to the sharp drop in labor action.

The first reference to stoppages involving coffee pickers occurred during the 1930s. In 1934, pickers in the Ruiru area staged a boycott to express dissatisfaction with their wages. The government intervened, and the workers were obliged to accept the current wage rate. Although the stoppage was brief and unsuccessful, a headman was convicted for "illegally inducing coffee pickers to leave work" (KNA, AR/306, KBU/26 1934: 16). In another form of collective action, the district commissioner of Kiambu reported a reluctance on the part of pickers to work on the estates in 1937, confirming the fears of the coffee estate owners that both female and male coffee pickers were not working as willingly as they had before. He noticed that workers were going to those farms that offered better wages, forcing other settlers to raise the rates they paid. This indirect means of shaping their wages produced a "squeeze on but not [a] shortage of labour. All coffee was picked but the settlers were uneasy about the 'crisis'" (KNA, AR/309, KBU/28 1937: 18).

Wage increases were also the primary motive in the major strikes of the period. In 1947, when African trade unionism was in its first effective stages in Kenya, Chege Kibachia, a trade unionist from Mombasa, reportedly came to the Uplands Bacon Factory to organize a strike there. The outbreak of a coffee strike only one week after his departure led the district commissioner to attribute the strike to his activities:

> Later in the same month of September a strike of coffee pickers was organized in the area between the Chania and Ndaruga—ostensibly it was organized by the women only and roads were picketted. Although not proven, there is every indication that this strike was organized by Local Native Councillor Solomon Memia and Lawson Mobgua who started the Kibathi agitation. Direct action stopped this strike and the pickers were mostly back at work happily within a week (KNA, AR/320, KBU/38 1947: 2).

WOMEN AND THE ORGANIZATION OF WORK STOPPAGES AND STRIKES

Little information regarding women's actions is found in official records, but oral sources offer varied accounts of who organized them. Respondents in Kitambaya, near Ruiru town, claimed that there were no special organizers of the strike. Women who wanted to start a boycott or a stoppage would "just talk" with one another in their homes about the low wages. Women who wanted to convince others to join a concerted action waited outside the gates of the various estates and spoke to other women workers about striking (KWT 1979: interview 26). Some women did claim an influence from the trade union movement, however:

Q: Why did you decide to strike?
A: We wanted higher salaries.
Q: How much were you receiving?
A: We got 7 shillings a month.
Q: Who organized you?
A: The political party did not organize us. There was a man who helped us to organize but I don't remember his name. The strike started in Nairobi with the railway workers, when they did so people in the petrol station also started. Then the ones who worked on the coffee estates said to the headman that they would strike too and the European said that if the headman started the strike he would be taken away. The people said if the headman was taken away we would not work on the estates for eighty days.
Q: How long did the strike last?
A: Two days, we got 25s after that.

<div align="right">(KWT 1979: interview 40)[6]</div>

Despite the evidence of recurring strikes and stoppages, Kikuyu women in Kiambu District did not present a united front to estate owners and government officials over the issues of wages and conditions of work. As the colonial relationship solidified and British control over the economic and political life of the Kikuyu became more complete, women found it increasingly necessary to earn wages for economic reasons. After the incidence of physical and sexual abuse declined, work on the coffee estates became more attractive. Because they became dependent on wages to pay taxes and school fees for their children, many women refused to participate in a strike or to be absent from work for a long period of time, thus decreasing the level of female solidarity that was achievable in labor actions. Furthermore, many devout Christian converts opposed labor activism, believing, according to one respondent, that it was religiously wrong to resist the Europeans (KWT 1978: interview 5). Such women sometimes were reluctant to join their fellow workers in a stoppage or a strike. The following two testimonies indicate the two poles of thought and action among the women workers:

When the strike started I worked on the Kuwhite estate. We were paid thirteen shillings a month and given thirty pounds of maize flour [per month]. Then the Europeans decided to increase the wages by one shilling and to stop giving flour. We objected to this and demanded that the wages should be more. We asked that we should be given fifty cents per "debbe" instead of ten cents per "debbe." Each woman had to pick three "debbes" per day. We women voluntarily worked on the estates but the chiefs would force women to work to make up the numbers that way. Also the chiefs were bribed by the whites to force women to work. Children starting from the ages of ten and twelve were forced to work on the estates. The women who went on strike were punished by having their wages cut by one day. There was no physical punishment because of the strike. The estates that I know to have been involved in the strike were Kuwhite, Muhia (now called Ndinota), Kamrefu,

Kiora and Kaface. Three villages would work on one estate. I don't know how many women were involved but we were very many. (KWT 12 December 1978: interview 7)

The preceding statement about a strike in 1953 came from a woman who spent thirty years as a political activist. Whether local "Mau Mau" women organized other women to participate in strikes and stoppages is not clear, however. A large number of women in Kiambu District were involved in the resistance movement and many respondents who claimed to have participated in the rebellion had also been involved in labor activism (Presley 1984). A contrasting view comes from the next statement provided by a staunch Christian woman. Though she had participated in the strike, she and her daughter were forced to do so by activist women who threatened to kill them if they refused to join the strikers:

Q: Did you go to work on the coffee estates?
A: I worked on the estates in 1951.
Q: Did you know anything about a strike?
A: Yes. The women struck because they refused to raise the wages. We were forced to go back to work.
Q: Which estates were involved?
A: Several estates were involved. Muhia was one of them.
Q: How many women were involved?
A: Many more than 100.
Q: Did you take part in the strike?
A: Yes.
Q: How did the women decide to strike?
A: I don't know. I wasn't at the meeting. I was on the church side, so I did not go to the meeting.
Q: How did they convince others to strike?
A: They communicated by word of mouth and the word would go out to refuse to go to work.
Q: Did you get any results? Did you receive better wages?
A: No.
Q: What were your wages at that time?
A: I was paid 45 shillings a month.

(KWT 1978: interview 5)[7]

Why did women continue to work on the coffee estates, when information from newspapers, government sources, and individual women shows that incidents of brutality against women continued to occur and that the rate of pay continued to be low in comparison with the wages of other African laborers? However little it brought, they needed the money. Colonialism forced Kikuyu women to enter a cash economy and the means of access to cash were limited. They were compelled to work for Europeans if they wanted to obtain cash with which to pay taxes, to purchase commodities that could not be produced in the traditional economy, and later on to pay school fees for their children. Women in Kiambu District had few alternatives to coffee picking. Most women in wage labor in the colony

were employed in the agricultural sector on coffee estates, although a limited amount of employment was available harvesting maize and picking pyrethrum (KNA, NAD, AR/1928:100; KNA, NAD, AR/1937: 205–6; KNA, NAD, AR/1938: 113; Stichter 1975–76: 59).

Did women want wage labor to gain autonomy from male or older relatives? It is important to examine whether they retained control over their earnings or whether the money was controlled by family members with authority over them. In 1937 a government report noted that paying taxes to the government had ceased to be "a family affair in which all members assisted and the result was very apparent in the large number of exemptions which had to be granted, especially in the case of widows and old women. In the past the whole family helped to pay the taxes and when this stopped the head of the family frequently found it difficult or impossible to find the money" (KNA, NAD, AR/1937: 3). One woman supplied evidence suggesting that as a young girl before she married she did not have full control over her earnings. When she collected her wages, she and her sisters gave the money to their mother, who used it to buy necessities such as cloth for the girls' dresses (KWT 14 April 1979: interview 7). The sparse data do not demonstrate a pattern of male control over wages earned by women and juveniles. It would seem rather that parents controlled the wages of children and unmarried women and that married women had full control over their earnings. If future research confirms this pattern, then wage labor may have given women more economic freedom and increased their options. If women did not have direct and full control over their wages, then they were not operating under one of the most basic rationales for selling their energy. In any case, the demands on their wages, their low level, and the limited employment available gave them less choice than men in the colonial economy.

CONCLUSION

Women's involvement in wage labor on the coffee estates began early in the colonial period as a marriage of convenience between local planters and colonial officers. Gradually, however, the brutal methods used to recruit and retain female labor evoked an outcry from missionaries and early African nationalist politicians. Vocal protest led to reform of recruitment methods and better treatment of women workers. But the reforms fell short of recommending wage increases, and during the 1930s women themselves began to voice dissatisfaction with their situation. Provoked by withholding or lowering of wages and food allotments during the Depression, women workers developed an attitude of defiance and rebellion that colonial officials considered to be truculence. This attitude manifested itself in recurring labor stoppages aimed at increasing wages from the 1930s to the 1960s. Two contrasting statements illustrate the change from women's passive suffering and waiting for male activists to initiate reforms to direct action initiated *by* women to achieve the goal of improving

labor and wage conditions, from "Harry Thuku is the one who stopped us from working like slaves," to "We objected to this and demanded that the wages should be more."

The shift in emphasis of these two statements indicates a dramatic change in women's attitudes toward themselves and in the range of activities they considered suitable for them *as women*. This change occurred in an era of increased African political activism in Kenya generally as well as in Kiambu District. Women were not absent from the increased activity and militancy. Such attitudinal changes were the beginning of political organization and new forms of solidarity among women, who refused to be excluded from political life and continually confined to cultivating and child care. That this solidarity did not transcend class lines and was marred by divisions even among rural laborers, helped by the advent of Christianity, does not impair its significance. Although men's greater access to wage labor and higher cash incomes may have decreased the importance of women's share in family maintenance, woman's contribution to taxes and school fees was nonetheless essential. As wage laborers, these coffee plantation workers were among the relatively small number of rural African women to have formal jobs, but as daily laborers who continued and even increased their work on family land they never became part of a rural proletariat. In doing both they confirm Bujra's assertion (Chapter 7 this volume) that incorporation into the world capitalist economy increased rather than decreased African women's economic participation. And, by organizing on class lines, these Kikuyu women acquired a political voice that became an effective part of labor protest in colonial Kenya.

Notes

1. The enactment of the Crowns Land Ordinance of 1902 resulted in a huge expropriation of African lands by European settlers in the Kenya Protectorate: 220,000 acres by 1904 (Kilson 1955: 112); by 1912 60,000 acres had been alienated from the Kikuyu of Kiambu District.

2. The respondent is in error in stating that Harry Thuku was sent to Somaliland. Thuku was actually sent to Vanga, Kwale District.

3. Philip Karanga was the head of the Kikuyu Association, an organization of British-appointed chiefs. The Kikuyu Association had antagonistic relations with the East African Association and was responsible for securing evidence against Harry Thuku, leading to his arrest and deportation and the banning of the East African Association in 1922.

4. A traditional Kikuyu method of female criticism of male authority involved women of a particular village or ridge lining up in front of a male who had offended

the women of the area, turning their backs toward the offending male, and lifting their skirts. The scratching of the buttocks referred to in this song was an adaptation of this practice and used by Kikuyu women to express criticism of colonial officials and their agents.

5. Women laborers received no wage increases for long periods of time, though some African male laborers did receive small increases. For example, in 1926 public works department workers received an increase of 2s and in 1928 squatters received an increase of wages that placed minimum wages between 6s and 12s per month.

6. The strike mentioned in this account must have taken place in 1950 as that is the year of the railway strike.

7. There is some confusion about the wages the respondent claims she received at that time. According to D. J. Penwill, the district commissioner of Kiambu, the standard wage rate in 1956 for permanently employed chiefly male coffee workers was 20s to 25s with a food allowance. See also Clayton and Savage (1974: 325) for wage rates in the 1950s.

KIKUYU WOMEN'S TEXTS

The following interviews, referred to by number in the text, were conducted by the author in Kiambu District, Kenya, during the years 1978–1979:

Interview 1: Anonymous respondent, 1 October 1978.
Interview 5: Tabitha Wambui, 3 October 1978.
Interview 7: Virginia Gachika, 16 November 1978, 12 December 1978, 14 April 1979.
Interview 15: Cecelia Wanga, 12 December 1978.
Interview 26: Wagara Wainana, 29 April 1979.
Interview 30: Wambui Wangarama, 29 April 1979.
Interview 40: Christine Wangui, 10 May 1979.

APPENDIX 14.1

African Wage Rates in Kenya, 1925–1928

Class	Rate	Method of Payment
Coffee pickers	15–20c	Per 4 gallons with food
Farm hands (squatters)	6–12s	Per 30 days with food
Dock hands (Kisumu)	18s	Per 30 days with food
Dock hands (Mombasa)	1s/38c–2s	Per diem without food
Fuel cutters	14–16s	Per 30 days with food
General laborers (out districts)	16–18s	Per 30 days with food
General laborers (towns)	18–20s	Per 30 days with food
Railway construction	16–20s	Per 30 days with food
Juveniles, generally	6–8s	Per 30 days with food
Women	10–12s	Per 30 days with food
Railway maintenance	16–18s	Per 30 days with food
Plantation hands (sisal)	16–18s	Per 30 days with food
Farm hands (general)	12–14s	Per 30 days with food
Public works department	16s	Per 30 days with food

Source: Compiled from labor data of the Kenya National Archives, Native Affairs Department 1925:71; 1926:89; 1928:110.

APPENDIX 14.2

Plantation Workers Distribution by Season and by Sex, 1926

(Three-Year-Old Coffee Plants)

Period	Units	Total Workers	Men	Women and Children	Percentage of Women and Children
April through September	48	22,110	13,270	8,849	40
October through March	80	36,850	13,266	23,584	64

Source: KNA. NAD. AR 1926: 87.
Note: Coffee trees do not produce berries for harvest until they are three years old.

APPENDIX 14.3

Plantation Workers Distribution by Season and by Sex, 1926

(Coffee Plants One to Three Years Old)

Period	Units	Total Workers	Men	Women and Children	Percentage of Women and Children
April through September	25	5,722*	3,422	2,280	40
October through March	25	5,722*	3,422	2,280	40

Source: KNA. NAD. AR 1926: 87.
Note: Coffee trees do not produce berries for harvest until they are three years old.
*The figure should be 5,702; the error stems from transcription in the source.

APPENDIX 14.4
Work Required of Coffee Laborers, 1926

Category	Per Diem Requirement
Coffee picking (light crop)	6 gal.
Coffee picking (heavy crop)	16 gal.
Coffee pruning (heavy crop)	20–50 trees
Coffee weeding and cultivation	500–1,000 sq. yd.

Source: KNA. NAD. AR 1926: 87.

APPENDIX 14.5
Work Stoppages, 1948–1960

Year	Work Stoppages	Workers Involved	Work Days Lost
1948	87	17,287	10,885
1949	81	10,148	24,945
1950	n.d.	n.d.	n.d.
1951	57	6,610	9,671
1952	84	5,957	5,721
1953	39	3,221	2,674
1954	33	1,518	2,026
1955	35	17,852	81,870
1956	38	5,170	28,238
1957	77	21,954	25,391
1958	96	21,395	59,096
1959	67	42,214	431,973
1960	232	72,545	747,860

Source: Kenya National Archives, Annual Colonial Reports 1960: 15.
N.d. indicates no data available.

BIBLIOGRAPHY

Abernethy, David. 1969. *The Political Dilemma of Popular Education: An African Case.* Stanford: Stanford University Press.

Acker, Joan. 1973. "Women and Social Stratification: A Case of Intellectual Sexism." *American Journal of Sociology* 78(4):936–45.

———. 1980. "Women and Stratification: A Review of Recent Literature." *Contemporary Sociology* 9:25–39.

Addo, N. O. 1974. "Some Employment and Labour Conditions on Ghana's Cocoa Farms." In *The Economics of Cocoa Production and Marketing: Proceedings of Cocoa Economics Research Conference, Legon, April, 1973*, ed. R. A. Kotey, C. Okali, and B. E. Rourke. Legon: University of Ghana Institute of Statistical, Social and Economic Research (ISSER).

Adejuwon, Oladipo. 1971. "Agricultural Colonization in Twentieth-Century Western Nigeria." *Journal of Tropical Geography* 33:1–8.

Afonja, Simi. 1981a. "Changing Modes of Production and the Sexual Division of Labour Among the Yoruba." *Signs* 7(2):299–313.

———. 1981b. "Current Explanations of Sex-Inequality: A Reconsideration." *Nigerian Journal of Economics and Social Studies* 21(2).

———. 1983. "Women, Power and Authority in Traditional Yoruba Society." In *Visibility and Power: Essays on Women in Society and Development*, ed. Leela Dube, Eleanor Leacock, and Shirley Ardener. Delhi: Oxford University Press.

Aidoo, Agnes Akosua. 1981. "Asante Queen Mothers in Government and Politics in the Nineteenth Century," pp. 65–77. In *The Black Women Cross-Culturally*, ed. Filomina Chioma Steady. Cambridge, Mass.: Schenckman.

Ake, C. 1978. *Revolutionary Pressures in Africa.* London: Zed Press.

Alpers, E. A. 1984. "State, Merchant Capital, and Gender Relations in Southern Mozambique to the End of the Nineteenth Century." *African Economic History* 13:23–55.

Amin, Samir. 1964. "The Class Struggle in Africa." *Revolution* 1(9):23–47.

———. 1973. *Neo-Colonialism in West Africa.* Harmondsworth: Penguin.

Amin, S. 1976. *Unequal Development.* England: Harvester Press.

"Arbitrator's Report and Award," 1966. Pretoria.

Arizpe, Lourdes. 1977. "Women in the Informal Sector: The Case of Mexico City." *Signs* 3(1):25–37.

———, and Josefina Aranda. 1981. "The Comparative Advantages of Women's Disadvantages: Women Workers in the Strawberry Export Agribusiness in Mexico." *Signs* 7(2) 453–73.

Arrighi, G., and J. Saul. 1973. *Essays on the Political Economy of Africa.* New York: Monthly Review Press.

274

Atanda, J. A. 1969. "The Bakopi in the Kingdom of Buganda 1900–1912. *The Uganda Journal* 33, 2: 151–62.

Ault, Jim. 1976. "Traditionalizing 'Modern' Marriage: A Neglected Aspect of Social Struggle on the Zambian Copperbelt." Mimeo.

Awe, Bolanle. 1977. "The Iyalode in the Traditional Yoruba Political System," pp. 140–60. In *Sexual Stratification: A Cross-Cultural View*, ed. A. Schlegel. New Haven: Yale University Press.

"Babalegi: Exploiters Paradise." 1979. *Work in Progress* 8 (May).

Baker, P. 1974. *Urbanization and Political Change: The Politics of Lagos*. Berkeley: University of California Press.

Barrett, Jane. 1981. "Knitmore: A Study in the Relationship Between Sex and Class." B.A. honors dissertation, University of the Witwatersrand.

Barrett, Michèle. 1980. *Women's Oppression Today: Problems in Marxist Feminist Analysis*. London: Verso.

Barthel, D. 1975. "The Rise of a Female Professional Elite: The Case of Senegal." *African Studies Review* 18(3):1–17.

Battle, V. M., and C. H. Lyons, eds. 1970. *Essays in the History of African Education*. New York: Columbia Teachers College Press.

Beneria, L. 1981. "Conceptualizing the Labour Force: The Underestimation of Women's Economic Activities," pp. 10–28. In *African Women in the Development Process*, ed. N. Nelson. London: Cass.

Berger, Elena. 1974. *Labour, Race and Colonial Rule*. Oxford: Oxford University Press.

Berger, Iris. 1976. "Rebels or Status-Seekers? Women as Spirit Mediums in East Africa," pp. 157–181. In *Women in Africa*, ed. N. Hafkin and E. Bay. Stanford University Press.

———. 1983. "Sources of Class Consciousness: South African Women in Recent Labor Struggles." *International Journal of African Historical Studies* 16(1):49–66.

———. Forthcoming 1986. "Solidarity Fragmented: Garment Workers of the Transvaal, 1930–1960." In *Class, Ideology and Politics in Twentieth Century South Africa*, ed. Shula Marks and Stanley Trapido. London: Longman.

Bernard, G. 1972. "Conjugalité et rôle de la femme à Kinshasa." *Canadian Journal of African Studies* 6(2):261–74.

Bernstein, H. 1975. *For Their Triumphs and for Their Tears: Women in Apartheid South Africa*. London: International Defence and Aid Fund.

Bernstein, Henry. 1977. "Notes on Capital and Peasantry." *Review of African Political Economy* 10:60–73.

Berry, Sara. 1974. *Cocoa, Custom and Socio-Economic Change in Rural Western Nigeria*. Oxford: Clarendon Press.

Beveridge, A., and A. Oberschall. 1979. *African Businessmen and Development in Zambia*. Princeton: Princeton University Press.

Biraimah, Karen C. 1982. "The Impact of Western Schools on Girls' Expectations: A Togolese Case," pp. 188–200. In *Women's Education in the Third World: Comparative Perspectives*, ed. G. Kelly and C. Elliott. Albany: SUNY Press.

Blumberg, Rae. 1978. *Stratification: Socioeconomic and Sexual Inequality*. Dubuque, Ia.: William C. Brown.

Boals, Kay, and Judith Stiehm. 1974. "The Women of Liberated Algeria." *Center Magazine* 7(3):74–76.

Boggs, Carl. 1976. *Gramsci's Marxism*. London: Pluto Press.

Boserup, Ester. 1970. *Woman's Role in Economic Development*. London: Allen and Unwin.

Bottomore, T. B. 1966. *Classes in Modern Society*. New York: Pantheon Books.

Bowman, M. J., and C. A. Anderson. 1982. "The Participation of Women in Education in the Third World," pp. 11–30. In *Women's Education in the Third World: Comparative Perspectives*, ed. G. Kelly and C. Elliott. Albany: SUNY Press.

Bozzoli, Belinda. 1983. "Marxism, Feminism and South African Studies." *Journal of South African Studies* 9(2):139–71.

Brain, James. 1976. "Less than Second Class: Women in Rural Settlement Schemes in Tanzania," pp. 265–82. In *Women in Africa: Studies in Social and Economic Change*, ed. Nancy Hafkin and Edna Bay. Stanford: Stanford University Press.

Brett, E. A. 1973. *Colonialism and Underdevelopment in East Africa*. London: Heinemann.

Brooks, George. 1976. "The *Signares* of Saint-Louis and Gorée: Women Entrepreneurs in Eighteenth-Century Senegal," pp. 19–44. In *Women in Africa*, ed. N. Hafkin and E. Bay. Stanford: Stanford University Press.

———. 1984. "A *Nhara* of the Guinea-Bissau Region: Mae Aurelia Correia," pp. 295–319. In *Women and Slavery in Africa*, ed. C. Robertson and M. Klein. Madison: University of Wisconsin Press.

Bryceson, D. 1980. "The Proletarianization of Women in Tanzania." *Review of African Political Economy* 17:4–27.

Bryceson, Deborah Fahy, and Marjorie Mbilinyi. 1978. "The Changing Role of Tanzanian Women in Production: From Peasants to Proletarians." Paper presented at the Sussex University Conference on Women and Subordination, September.

Bujra, Janet M. 1973. "Pumwani: The Politics of Property." Unpublished report. Social Science Research Council for Great Britain.

———. 1975. "Women Entrepreneurs of Early Nairobi." *Canadian Journal of African Studies* 9(2):213–34.

———. 1977. "Sexual Politics in Atu." *Cahiers d'études africaines* 65(17)1:13–39.

———. 1978a. "Female Solidarity and the Sexual Division of Labour," pp. 13–45. In *Women United, Women Divided*, ed. P. Caplan and J. Bujra. London: Tavistock.

———. 1978b. "Proletarianization and the 'Informal Economy': A Case Study from Nairobi." *African Urban Studies* 47:47–66.

———. 1982a. "Prostitution, Class and the State," pp. 145–61. In *Crime, Justice and Underdevelopment*, ed. C. Sumner. London: Heinemann.

———. 1982b. "Women 'Entrepreneurs' of Early Nairobi." In *Crime, Justice and Underdevelopment*, ed. C. Sumner. London: Heinemann.

Bukh, Jette. 1979. *Village Women in Ghana*. Uppsala: Scandinavian Institute of African Studies.

Bunyasi, J. S. Makokha. 1973. "Labour in the Kenya Coffee Industry: An Economic Analysis." Master's thesis, University of Nairobi.

Burton, John. 1981. "Ethnicity on the Hoof: On the Economics of Nuer Identity." *Ethnology* 20:157–62.

Buvinic, Mayra, and Nadia Youssef. 1978. *Women Headed Households: The Ignored Factor in Development*. Monograph prepared for the Office of Women in Development, USAID.

Cabral, Amilcar. 1969. *Revolution in Guinea*. London: Stage One.

Callaghy, Thomas. 1983. "External Actors and the Relative Autonomy of the Politi-
cal Aristocracy in Zaire." *Journal of Commonwealth and Comparative Politics* 21,
3:61–83.

Callaway, Barbara. 1976. "Women in Ghana," pp. 189–201. In *Women in the World: A
Comparative Study*, ed. Lynne Iglitzin and Ruth Ross. Santa Barbara, Calif.:
Clio Press.

Callaway, Helen. 1975. "Indigenous Education in Yoruba Society," pp. 26–38. In
Conflict and Harmony in Education in Tropical Africa, ed. G. N. Brown and M.
Hiskett. London: Allen and Unwin.

Caplan, P. 1978. "Women's Organizations in Madras City, India," pp. 99–128. In
Women, United, Women Divided, ed. P. Caplan and J. Bujra. London: Tavistock.

Carby, H. 1982. "White Woman Listen! Black Feminism and the Boundaries of
Sisterhood," pp. 212–35. In *The Empire Strikes Back*. Birmingham: CCCS.

Carchedi, G. 1975. "On the Economic Identification of the New Middle Class."
Economy and Society 4(1):1–85.

Cardosa-Khoo, Jane, and Kay Jinn Khoo. 1978. "Work and Consciousness: The Case
of Electronics 'Runaways' in Malaysia." Paper presented at the Conference on
the Continuing Subordination of Women in the Development Process, Institute
of Development Studies, University of Sussex.

Carim, Shirene Cadet. 1980. "The Role of Women in the Trade Union Movement."
UN Centre Against Apartheid, Notes and Documents.

Carnoy, Martin. 1974. *Education as Cultural Imperialism*. New York: Longman.

Carter, Jeanette, and Joyce Mends-Cole. 1982. *Liberian Women: Their Role in Food
Production and Their Educational and Legal Status*. Washington, D.C.: USAID.

Chafetz, Janet S. 1984. *Sex and Advantage: A Comparative Macro-Structural Theory of
Sex Stratification*. Totowa, N.J.: Rowman and Allenheld.

Chanock, Martin. 1982. "Making Customary Law: Men, Women and Courts in
Colonial Northern Rhodesia." In *African Women and the Law: Historical Per-
spectives*, ed. M. J. Hay and M. Wright. Boston: Boston University Papers on
Africa Vol. 7, pp. 53–67.

Chauncey, George. 1981. "The Locus of Reproduction: Women's Labour in the Zam-
bian Copperbelt, 1927–1953," *Journal of Southern African Studies* 7, 2 (April):
135–64.

Christaller, Johann G. 1933. *Dictionary of the Asante and Fante Language*. Basel:
Basel Evangelical Missionary Society.

Ciancanelli, Penelope. 1980. "Exchange, Reproduction and Sex Subordination
Among the Kikuyu of East Africa." *Review of Radical Political Economy*
12(2):25–36.

Clark, Carolyn M. 1980. "Land and Food, Women and Power, in Nineteenth Century
Kikuyu." *Africa* 50(4):357–69.

Clark, L. M. G. and L. Lange, ed. 1979. *The Sexism of Social and Political Theory*.
Toronto: University of Toronto Press.

Clayton, A., and C. Savage. 1974. *Government and Labour in Kenya, 1895–1963*.
London: Cass.

Cliffe, Lionel. 1976. "Rural Political Economy of Africa," pp. 112–30. In *The Political
Economy of Contemporary Africa*, ed. P.C.W. Gutkind and I. Wallerstein. Beverly
Hills, Calif.: Sage.

———. 1982. "Class Formation as an 'Articulation' Process: East African Cases,"
pp. 262–78. In *Introduction to the Sociology of Developing Societies*, ed. H. Alavi
and I. Shanin. London: Macmillan.

Cohen, Robin. 1976. "From Peasants to Workers in Africa," pp. 155–60. In *The Political Economy of Contemporary Africa*, ed. P. C. W. Gutkind and I. Wallerstein. Beverly Hills, Calif.: Sage.

Cohen, Ronald. 1970. "Social Stratification in Bornu," pp. 225–67. In *Social Stratification in Africa*, ed. A. Tuden and L. Plotnicov. New York: Free Press.

Coker, C. B. A. 1966. *Family Property Among the Yorubas*. London: Sweet and Maxwell.

Cole, P. 1975. *Modern and Traditional Elites in the Politics of Lagos*. Cambridge: Cambridge University Press.

Coleman, J. S. 1958. *Nigeria: Background to Nationalism*. Berkeley; University of California Press.

Collier, Jane F., and Michelle Z. Rosaldo. 1981. "Politics and Gender in Simple Societies," pp. 275–329. In *Sexual Meanings: The Cultural Construction of Gender and Sexuality*, ed. S. B. Ortner and H. Whitehead. Cambridge: Cambridge University Press.

Comhaire-Sylvain, Suzanne. 1968. *Femmes de Kinshasa: hier et aujourd'hui*. Paris: Mouton.

Conant, Francis P. 1974. Comment. In "Economic Development and Economic Change: The Case of East African Cattle," by H. K. Schneider. *Current Anthropology* 15: 259–76.

Conti, Anna. 1979. "Capitalist Organization of Production Through Non-Capitalist Relations: Women's Role in a Pilot Resettlement in Upper Volta." *Review of African Political Economy* 15–16:75–92.

Cooper, Carole. 1979. "Details of Strikes During 1978." *South African Labour Bulletin* 5(1): 57–66.

Counter Information Service. 1977. *Black South Africa Explodes*. London: CIS.

Critique of Anthropology. 1977. 3, Nos. 9–10. Special issue on women.

Crummey, Donald. 1982. "Women, Property, and Litigation Among the Bagemder Amhara, 1750s to 1850s," pp. 19–32. In *African Women and the Law: Historical Perspectives*, ed. M. J. Hay and M. Wright. Boston University Papers on Africa. Vol. 7. Boston: Boston University.

Curtin, Philip. 1964. *The Image of Africa*. Madison: University of Wisconsin Press.

Cutrufelli, Maria R. 1983. *Women of Africa: Roots of Oppression*. Trans. Nicolas Romano. London: Zed Press.

Daily Service (Lagos). 1944–48.

Daily Times (Lagos). 1932–44.

Dalla Costa, M., and S. James. 1972. *The Power of Women and the Subversion of Community*. Bristol: Falling Wall Press.

Deblé, I. 1980. *The School Education of Girls*. UNESCO.

Deere, C. D. 1976. "Rural Women's Subsistence Production in the Capitalist Periphery." *Review of Radical Political Economy* 8(1): 9–17.

———. 1977. "Changing Social Relations of Production and Peruvian Peasant Women's Work." *Latin American Perspectives* (12–13): 48–69.

———, and M. Léon de Leal. 1981. "Peasant Production, Proletarianization and the Sexual Division of Labor in the Andes." *Signs* 7(2): 338–60.

Dekker, L. Douwes, et al. 1975. "Case Studies in African Labour Action in South Africa and Namibia," pp. 206–38. In *The Development of an African Working Class: Studies in Class Formation and Action*, ed. R. Sandbrook and R. Cohen. Toronto: University of Toronto Press.

Delphy, Christine. 1977. *The Main Enemy.* London: Women's Research and Resources Centre.

Dennis, C. 1984. "Capitalist Development and Women's Work: A Nigerian Case Study." *Review of African Political Economy* (27–28): 109–19.

Dey, Jennie. 1981. "Gambian Women: Unequal Partners in Rice Development Projects?" pp. 109–22. In *African Women in the Development Process*, ed. Nici Nelson. London: Cass.

Dinan, C. 1977. "Pragmatists or Feminists? The Professional Single Woman in Accra, Ghana." *Cahiers d'études africaines* 65(17)1: 155–76.

Dobson, Barbara. 1954. "Women's Place in East Africa." *Corona* 6(12): 454–57.

Douglas, Mary. 1963. *The Lele of Kasai.* London: Oxford University Press.

Dumont, René. 1969. *False Start in Africa.* New York: Praeger.

du Toit, Bettie. 1978. *Ukubamba Amadolo: Workers' Struggles in the South African Textile Industry.* London: Onyx Press.

du Toit, D. 1981. *Capital and Labour in South Africa: Class Struggle in the 1970s.* London: Routledge and Kegan Paul.

East Africa Standard. 1925–50.

Edholm, F., O. Harris and K. Young. 1977. "Conceptualising Women," *Critique of Anthropology* 3, Nos. 9–10: 101–30.

Eisenstein, Zillah R. 1981. *The Radical Future of Liberal Feminism.* New York: Longman.

Eisenstein, Zillah, ed. 1978. *Capitalist Patriarchy and the Case for Socialist Feminism.* New York: Monthly Review Press.

Ekejiuba, E. 1967. "Omu Okwei: Merchant Queen of Ossomari." *Journal of the Historical Society of Nigeria* 3: 633–46.

Eliou, M. 1973. "Scolarisation et promotion féminine en Afrique francophone." *International Review of Education* 19(1): 30–46.

Elshtain, Jean. 1981. *Public Man, Private Woman.* Princeton: Princeton University Press.

Elson, Diane, and Ruth Pearson. 1981. " 'Nimble Fingers Make Cheap Workers': An Analysis of Women's Employment in Third World Manufacturing." *Feminist Review* 7: 87–107.

Engels, Friedrich. 1972 (1884). *The Origin of the Family, Private Property and the State.* Ed. E. Leacock. New York: International.

Epstein, A. L. 1953. "The Role of the African Courts in Urban Communities of the Northern Rhodesian Copperbelt," *Human Problems in British Central Africa* 13: 1–18.

———. 1954. "Juridical Techniques and the Judicial Process: A Study in African Customary Laws." Rhodes-Livingstone Papers no. 23. Manchester: Manchester University Press.

———. 1981. *Urbanization and Kinship: The Domestic Domain on the Copperbelt of Zambia 1950–1956.* London: Academic Press.

———. n.d. Papers.

Etienne, Mona. 1980. "Women and Men, Cloth and Colonization: The Transformation of Production-Distribution Relations Among the Baule (Ivory Coast)," pp. 214–38. In *Women and Colonization*, ed. Mona Etienne and Eleanor Leacock. New York: Praeger.

———, and E. Leacock, eds. 1980. *Women and Colonization: Anthropological Perspectives.* New York: Praeger.

Evans-Pritchard, E. E. 1951. *Kinship and Marriage Among the Nuer.* Oxford: Clarendon Press.

Fadipe, N. 1970. *The Sociology of the Yoruba.* Ibadan: Ibadan University Press.

Fafunwa, A. B., and J. U. Aisiku, eds. 1982. *Education in Africa: A Comparative Study.* London: Allen and Unwin.

Fallers, Lloyd A. 1973. *Inequality: Social Stratification Reconsidered.* Chicago: University of Chicago Press.

Fanon, Frantz. 1963. *The Wretched of the Earth.* New York: Grove Press.

Fapohunda, Eleanor. 1978. "Characteristics of Women Workers in Lagos: Data for Reconsideration by Labour Market Theorists." *Labour and Society* 3(2): 158–71.

Farrell, J. P. 1982. "Educational Expansion and the Drive for Social Equality," pp. 39–53. In *Comparative Education,* ed. P. Altbach et al. New York: Macmillan.

Feldman, R. 1981. *Employment Problems of Rural Women in Kenya.* Addis Ababa: ILO.

First, R. 1983. *Black Gold: The Mozambican Miner, Proletarian and Peasant.* New York: St. Martin's Press.

Fluehr-Lobban, Carolyn. 1977. "Agitation for Change in the Sudan," pp. 127–43. In *Sexual Stratification,* ed. A. Schlegel. New York: Columbia University Press.

Fortmann, Louise. 1982. "Women's Work in a Communal Setting: The Tanzanian Policy of Ujamaa," pp. 191–206. In *Women and Work in Africa,* ed. Edna Bay. Boulder, Colo.: Westview Press.

Foster, P.C. 1965. *Education and Social Change in Ghana.* Chicago: University of Chicago Press.

Foster-Carter, Aidan. 1978. "The Modes of Production Controversy." *New Left Review* 107: 47–77.

Fox, B., ed. 1980. *Hidden in the Household.* Toronto: Women's Educational Press.

Freeman, B. 1978. "Female Education in Patriarchal Power Systems," pp. 207–42. In *Education and Colonialism,* ed. P. Altbach and G. Kelly. New York: Longman.

Freud, Sigmund. 1965. "Femininity." In *New Introductory Lectures in Psychoanalysis,* ed. J. Strachey. New York: Norton.

Friedl, Ernestine. 1975. *Women and Men: An Anthropologist's View.* New York: Holt, Rinehart and Winston.

Froebel, F., J. Heinrichs, and O. Kreye. 1980. *The New International Division of Labour.* Cambridge: Cambridge University Press.

Furedi, F. 1975. "The Kikuyu Squatters in the Rift Valley, 1919–1929," pp. 177–94. In *Hadith 5: Economic and Social History of East Africa,* ed. B. A. Ogot. Nairobi: East African Publishing House.

Gaitskell, D., et al. 1984. "Class, Race and Gender: Domestic Workers in South Africa." *Review of African Political Economy* (27–28): 86–108.

Galletti, R., K.D.S. Baldwin, and I. O. Dina. 1956. *Nigerian Cocoa Farmers.* London: Oxford University Press.

Gardinier, D.E. 1974. "Schooling in the States of Equatorial Africa." *Canadian Journal of African Studies* 8(3): 517–38.

Gertzel, Cherry, Maura Goldschmidt, and Donald Rothchild, eds. 1969. *Government and Politics in Kenya: A Nation Building Text.* Nairobi: East African Publishing House.

Gessain, Monique. 1971. "Les classes d'âge chez les Vassari d'Etyolo (Sénégal Oriental)," pp. 157–84. In *Classes et associations d'âge en Afrique de l'ouest,* ed. Denise Paulme. Paris: Librairie Plon.

Ghai, Y.P., and J.P.W.B. McAuslan. 1970. *Public Law and Political Change in Kenya.* Nairobi: Oxford University Press.

Ghana. 1959. *Ghana Law Reports.* Accra: General Legal Council.

———. 1968. *Statistical Yearbook, 1967–68.* Accra: Government Printer.

Ghana. Sunyani Archives. Labour Department Records.

Gilpin, C., and S. Grabe. 1975. "Nigeria: Programs for Small Industry Entrepreneurs and Journeymen," pp. 644–68. In *Education for Rural Development,* ed. M. Ahmed and P. Coombs. New York: Praeger.

Goldschmidt, Walter. 1976. *The Culture and Behavior of the Sebei.* Berkeley: University of California Press.

Goody, Jack. 1971. "Class and Marriage in Africa and Eurasia." *American Journal of Sociology* 76(4): 585–603.

———. 1973. "Bridewealth and Dowry in Africa and Eurasia." In *Bridewealth and Dowry,* ed. J. Goody and S. J. Tambiah. Cambridge: Cambridge University Press.

———, and S. J. Tambiah. 1973. *Bridewealth and Dowry.* Cambridge: Cambridge University Press.

Gordon, Loraine, et al., comps. 1978. *A Survey of Race Relations, 1977.* Johannesburg: South African Institute of Race Relations.

Gould, David J. 1978. "From Development Administration to Underdevelopment Administration: A Study of Zairian Administration in the Light of Current Crisis." *Les Cahiers du CEDAF* (Brussels) (6).

Gould, Terri F. 1978. "Value Conflict and Development: The Struggle of the Professional Zairian Woman." *Journal of Modern African Studies* 16(1): 133–39.

Grabe, S. 1975. "Upper Volta: A Rural Alternative to Primary Schools," pp. 335–62. In *Education for Rural Development,* ed. M. Ahmed and P. Coombs. New York: Praeger.

Gran, Guy, ed. 1979. *Zaire: The Political Economy of Underdevelopment.* New York: Praeger.

Grandmaison, Colette Le Cour. 1969. "Activités économiques des femmes dakaroises." *Africa* 39:138–52.

Great Britain. 1935. *Report of the commission to inquire into the disturbance on the Copperbelt, Northern Rhodesia, 1935* (Chairman Alison Russell), Cmd. 5009, London. *(The Russell Report).* Evidence listed as: evidence to the Russell Commission.

———. 1938. *Report on the commission appointed to enquire into the financial and economic position of Northern Rhodesia.* (Chairman, Sir Alan Pim), Colonial No. 145, London. *(The Pim Report).*

Gregory, J., and V. Piché. 1982. Excerpt from *The Causes of Modern Migration in Africa* (1978), pp. 27–29. In *Sociology of 'Developing Societies': Subsaharan Africa,* ed. C. Allen and G. Williams. London: Macmillan.

Grier, Beverly. 1981. "Underdevelopment, Modes of Production, and the State in Colonial Ghana." *African Studies Review* 24(1):21–48.

Gunnarson, C. 1978. *The Gold Coast Cocoa Industry: 1900–1939: Production, Prices and Structural Change.* Lund: Economic History Association.

Gutkind, Peter C. W., and Peter Waterman, eds. 1977. *African Social Studies: A Radical Reader.* New York: Monthly Review Press.

———, and Immanuel Wallerstein. 1976. *The Political Economy of Contemporary Africa.* Beverly Hills, Calif.: Sage.

Guyer, Jane I. 1981. "Household and Community in African Studies." *African Studies Review* 24(213):87–137.

Haag, D. 1982. *The Right to Education: What Kind of Management?* UNESCO.

Hafkin, Nancy, and Edna G. Bay, eds. 1976. *Women in Africa: Studies in Social and Economic Change.* Stanford: Stanford University Press.

Hagaman, Barbara. 1977. "Beer and Matriliny: The Power of Women in Lobir, Ghana." Ph.D. dissertation, Northeastern University.

Hall, S. K. 1973. "An Exploratory Investigation Into the Labour Stability and Attitudes of Bantu Women in a Textile Factory." National Institute for Personnel Research, Johannesburg.

Hammond, D., and J. Jablow. *The Africa that Never Was.* New York: Twayne.

Hansen, Karen T. 1983. "Gender Ideology and Work Prospects: The Beer and Sex Link in Urban Zambia." Mimeo.

Harbison, F., and C. A. Meyers. 1964. *Education, Manpower and Economic Growth: Strategies of Human Resource Development.* New York: McGraw-Hill.

Harries-Jones, Peter. 1964. "Marital Disputes and the Process of Conciliation in a Copperbelt Town," *Rhodes-Livingstone Journal* 35: 30–72.

Hartmann, Heidi. 1979. "The Unhappy Marriage of Marxism and Feminism: Towards a More Progressive Union." *Capital and Class* 8:1–33.

Hay, M. J. 1976. "Luo Women and Economic Change During the Colonial Period," pp. 87–110. In *Women in Africa*, ed. N. Hafkin and E. Bay. Stanford: Stanford University Press.

———, and Sharon Stichter, eds. 1984. *African Women South of the Sahara.* N.Y.: Longman.

Heisler, Helmuth. 1974. *Urbanization and the Government of Migration: The Interrelations of Urban and Rural Life in Zambia.* London: C. Hurst and Company.

Hemson, David. 1978. "Trade Unionism and the Struggle for Liberation in South Africa." *Capital and Class* 6:1–41.

Herskovits, M. J. 1926. "The Cattle Complex in East Africa." *American Anthropologist* 28:230–72, 361–88, 494–528, 633–44.

Heyman, R. D., R. F. Lawson, and R. M. Stamp. 1972. *Studies in Educational Change*, pt. 2, "African Initiatives for Control and Reform of Education." Toronto: Holt, Rinehart and Winston.

Hill, M. E. 1956. *Planters' Progress: The Story of Coffee in Kenya.* Nairobi: Coffee Board of Kenya.

Hill, Polly. 1958. "Women Cocoa Farmers." *Economic Bulletin of Ghana* 2(6):70–76.

———. 1959. "The Cocoa Farmers of Asafo and Maase (Akim Abuakwa) with Special Reference to the Position of Women." Cocoa Research Series no. 17. Ghana University College Economics Research Division.

———. 1963. *Migrant Cocoa Farmers of Southern Ghana.* Cambridge: Cambridge University Press.

Hindess, B., and P. O. Hirst. 1977. *Mode of Production and Social Formation.* London: Macmillan.

Hirsch, Allan. 1979. "An Introduction to Textile Worker Organisation in Natal." *South African Labour Bulletin* 4(8):3–42.

Hobley, C. W. 1938 (1922). *Bantu Beliefs and Magic.* London: Cass.

Hobsbawm, E. J. 1972. "Karl Marx's Contribution to Historiography," pp. 265–83. In *Ideology in Social Science: Readings in Critical Social Theory*, ed. Robin Blackburn. Glasgow: Fontana/Collins.

Hoffer, Carol. 1972. "Mende and Sherbro Women in High Office." *Canadian Journal of African Studies* 6(2):151–64.

Holding, E. Mary. 1942. "Women's Institutions and the African Church." *International Review of Missions* 31:290–300.

Horrell, Muriel, et al., comps. 1977. *A Survey of Race Relations, 1976.* Johannesburg: South African Institute of Race Relations.

Hoselitz, B. F. 1960. *Sociological Factors in Economic Development.* Chicago: Free Press.

Hunter, J., M. Borus, and A. Mannan. 1974. *Economics and Non-Formal Education.* Michigan State University Program of Studies in Non-Formal Education, Team Report.

Huntington, Suellen. 1975. "Issues in Woman's Role in Economic Development: Critique and Alternatives." *Journal of Marriage and the Family* 37(4):1001–12.

Imoagene, O. 1976. *Social Mobility in an Emergent Society.* Canberra: Australian University Press.

Institute for Industrial Education. 1974. *The Durban Strikes 1973.* Durban: Institute for Industrial Education/Ravan Press.

International Labour Office. 1981. *Year Book of Labour Statistics.* Geneva: ILO.

Isaacman, A. 1982. "A Luta Continua: Creating a New Society in Mozambique." in *Sociology of 'Developing Societies': Subsaharan Africa,* ed. C. Allen and G. Williams. London: Macmillan.

Isaacman, Barbara, and June Stephen. 1980. *Mozambique: Women, the Law and Agrarian Reform.* Addis Ababa: UN/ECA.

Jackson, Sam. 1978. "Hausa Women on Strike." *Review of African Political Economy* 13:21–36.

Jaggar, Alison. 1977. "Political Philosophies of Women's Liberation," pp. 5–21. In *Feminism and Philosophy,* ed. M. Vetterling-Braggin, F. A. Elliston, and J. English. Totowa, N.J.: Littlefield, Adams.

———, and Paula S. Rothenberg. 1984. *Feminist Frameworks: Alternative Theoretical Accounts of the Relations Between Women and Men.* New York: McGraw-Hill.

Johnson, Cheryl. 1978. "Nigerian Women and British Colonialism: The Yoruba Example with Selected Biographies." Ph.D. dissertation, Northwestern University.

———. 1981. "Madam Alimotu Pelewura and the Lagos Market Women." *Tarikh* 7(1):1–10.

Jones, M. T. 1982. "Educating Girls in Tunisia: Issues Generated by the Drive for Universal Enrolment," pp. 31–50. In *Women's Education in the Third World: Comparative Perspectives,* ed. G. Kelly and C. Elliot. Albany: SUNY Press.

Jorgensen, Jan Jelmert. 1981. *Uganda: A Modern History.* New York: St. Martin's Press.

Katz, Stephen. 1980. *Marxism, Africa and Social Class: A Critique of Relevant Theories.* Occasional Monograph no. 14. Montreal: Centre for Developing-Area Studies, McGill University.

Kenya. 1965. *African Socialism and Its Application to Planning in Kenya.* Sessional Paper no. 10. Nairobi: Government Printer.

———. 1970. *National Atlas of Kenya.* Nairobi: Survey of Kenya.

Kenya. Baringo District. 1913–60. *Baringo District Annual Reports.* Nairobi: National Archives of Kenya.

Kenya National Archives. 1901–26. Central Province Political Record Book. PRB/220.

———. Dagoretti Subdistrict. 1913–19. Political Record Book. Vol. 2. Annual Report. KBU/77.

————. Dagoretti Subdistrict. 1916–19. Political Record Book. Annual Report.

————. 1918–20. Handing Over Report. KBU/13.

————. 1912–60. Kiambu District. Annual Reports.

————. 1912–60. Kiambu District. Political Record Book. KBU/114.

————. 1925–60. Native Affairs Department. Annual Reports.

Kenyatta, Jomo. 1938. *Facing Mount Kenya*. New York: Vintage Books.

Kershaw, Greet. 1973. "The Kikuyu of Central Kenya," pp. 47–59. In *Cultural Source Materials for Population Planning in East Africa*, vol. 3, *Beliefs and Practices*, ed. Angela Molnos. Nairobi: East African Publishing House.

Kertzer, David I., and Oker B. B. Madison. 1981. "Women's Age-Set Systems in Africa: The Latuka of Southern Sudan," pp. 109–30. In *Dimensions: Aging, Culture and Health*, ed. Christine L. Fry. New York: Praeger.

Kettel, Bonnie. 1980. "Time Is Money: The Social Consequences of Economic Change in Seretunin, Kenya." Ph.D. dissertation, Urbana: University of Illinois.

Kieran, J. A. 1969. "The Origins of Commercial Arabica Coffee Production in East Africa." *African Historical Studies* 2(1):51–67.

Kiernan, V. G. 1974. *Marxism and Imperialism*. New York: St. Martin's Press.

Kikuyu Women's Texts. 1978–79.

Kilby, P. 1979. *Industrialization in an Open Economy: Nigeria, 1945–66*. London: Cambridge University Press.

Kilson, M. 1955. "Land and the Kikuyu: A Study of the Relationship Between Land and Kikuyu Political Movements." *Journal of Negro History* 40(2):103–53.

Kimble, J., and E. Unterhalter. 1982. "We Opened the Road for You, You Must Go Forward: ANC Women's Struggles 1912–1982." *Feminist Review* 12:11–36.

Kisekka, M. K. 1976. "Polygyny and the Status of African Women." Paper presented at the University of Ibadan Conference on Women and Development, April 26–30.

Kitching, Gavin. 1980. *Class and Economic Change in Kenya: The Making of an African Petite Bourgeoisie 1905–1970*. New Haven: Yale University Press.

Klima, G. 1970. *The Barabaig: East African Cattle Herders*. New York: Holt, Rinehart and Winston.

Klingshirn, Agnes. 1971. "The Changing Position of Women in Ghana." Doctoral dissertation, Marburg/Lahn.

Kossoudji, Sherrie, and Eva Mueller. 1983. "The Economic and Demographic Status of Female Headed Households in Rural Botswanna." *Economic Development and Cultural Change* 31(4):831–59.

Kuhn, Annette. 1978. "Structures of Patriarchy and the Family," pp. 44–67. In *Feminism and Materialism: Women and Modes of Production*, ed. Annette Kuhn and Ann Marie Wolpe. London: Routledge and Kegan Paul.

————, and AnnMarie Wolpe, eds. 1978. *Feminism and Materialism: Women and Modes of Production*. London: Routledge and Kegan Paul.

LaFontaine, Jean S. 1974. "The Free Women of Kinshasa," pp. 89–113. In *Choice and Change: Essays in Honor of Lucy Mair*, ed. J. Davis. New York: Humanities Press.

Lambert, H. E. 1956. *Kikuyu Social and Political Institutions*. London: Oxford University Press.

Lamphere, Louise. 1977. "Review Essay: Anthropology." *Signs* 2(3):612–27.

Lapchick, Richard, and Stephanie Urdang. 1982. *Oppression and Resistance: The Struggle of Women in Southern Africa*. Westport, Conn.: Greenwood Press.

Leacock, Eleanor. 1972. "Introduction" to F. Engels, *The Origin of the Family, Private Property and the State*, ed. E. Leacock. New York: New World Press.

———. 1978. "Women's Status in Egalitarian Society: Implications for Social Evolution." *Current Anthropology* 19(2):147–75.

———. 1981. *Myths of Male Dominance*. New York: Monthly Review Press.

Leakey, L.S.B. 1977. *The Southern Kikuyu Before 1903*. Vols. 1–3. London: Academic Press.

Lebeuf, Annie M. D. 1963. "The Role of Women in the Political Organization of African Societies," pp. 93–120. In *Women of Tropical Africa*, ed. Denise Paulme. Berkeley: University of California Press.

Leis, Nancy. 1974. "Women in Groups: Ijaw Women's Associations." In *Woman, Culture and Society*, ed. Michelle Rosaldo and Louise Lamphere. Stanford: Stanford University Press.

Leith-Ross, S. 1939. *African Women*. London: Faber and Faber.

———. 1965. "Rise of a New Elite Amongst the Women of Nigeria," pp. 221–29. In *Africa: Social Problems of Change and Conflict*, ed. P. Van den Berghe.

Lenin, V. I. 1964. *The Development of Capitalism in Russia*. Vol. 3. Moscow: Progress Publishers.

Lenski, Gerhard. 1966. *Power and Privilege*. New York: McGraw-Hill.

Lévi-Strauss, Claude. 1969. *The Elementary Structures of Kinship*. Boston: Beacon Press.

Lewis, Barbara. 1976. "The Limitations of Group Activity Among Entrepreneurs: The Market Women of Abidjan, Ivory Coast," pp. 135–56. In *Women in Africa: Studies in Social and Economic Change*, ed. Nancy Hafkin and Edna Bay. Stanford: Stanford University Press.

———. 1977. "Economic Activity and Marriage Among Ivoirian Urban Women," pp. 161–91. In *Sexual Stratification: A Cross-Cultural View*, ed. A. Schlegel. New York: Columbia University Press.

Leys, Colin. 1975. *Underdevelopment in Kenya: The Political Economy of Neo-Colonialism*. London: Heinemann.

———. 1978. "Capital Accumulation, Class Formation and Dependency: The Significance of the Kenya Case." In *The Socialist Register*, ed. R. Miliband and J. Saville. London: Merlin Press.

Leys, N. 1924. *Kenya*. London: Hogarth Press.

Little, K. 1965. "The Position of Women," pp. 118–37. In *West African Urbanization*. Cambridge: Cambridge University Press.

———. 1973. *African Women in Towns*. Cambridge: Cambridge University Press.

Llewelyn-Davies, Melissa. 1979. "Two Contexts of Solidarity Among Pastoral Maasai Women," pp. 206–37. In *Women United, Women Divided*, ed. P. Caplan and J. M. Bujra. Bloomington: Indiana University Press.

———. 1981. "Women, Warriors and Patriarchs," pp. 330–58. In *Sexual Meanings*, ed. S. Ortner and H. Whitehead. Cambridge: Cambridge University Press.

Lloyd, P. C. 1962. *Yoruba Land Law*. London: Oxford University Press.

———. 1974. *Power and Independence: Urban Africans' Perception of Social Inequality*. London: Routledge and Kegan Paul.

———. 1966. *The New Elites of Tropical Africa*. London: Oxford University Press.

Lonsdale, J., and Bruce Berman. 1979. "Coping with the Contradictions: The Development of the Colonial State in Kenya, 1895–1914." *Journal of African History* (20):487–505.

Ly, F. 1975. "Mali: Educational Options in a Poor Country," pp. 217–48. In *Education for Rural Development*, ed. M. Ahmed and P. Coombs. New York: Praeger.

Mabogunje, A. 1968. *Urbanization in Nigeria.* London: University of London Press.

Macauley, Herbert. Collected Personal Papers. University of Ibadan Library.

MacGaffey, Janet. 1983. "How to Survive and Get Rich Amidst Devastation: The Second Economy in Zaire." *African Affairs* 82(328):351–66.

MacGaffey, Wyatt. 1982. "The Policy of National Integration in Zaire." *Journal of Modern African Studies* 20(1):87–105.

Mackintosh, M. 1979. "Domestic Labour and the Household," pp. 173-91. In *Fit Work for Women,* ed. S. Burman. London: Croom Helm.

Mafeje, Archie. 1973. "Agrarian Revolution and the Land Question in Buganda," in *Dualism and Rural Development.* Copenhagen: Institute for Development and Research.

"Maggie Oewies Talks About the Domestic Workers Association." 1980. *South African Labour Bulletin* 6(1):35–36.

Malira, Kubuya Namulemba. 1974. "Regard sur la situation sociale de la citoyenne luchoise d'avant 1950." *Likondoli* (Lubumbashi) 2(1):63–71.

Mamdani, Mahmood. 1976. *Politics and Class Formation in Uganda.* New York: Monthly Review Press.

Mandala, Elias. 1984. "Capitalism, Kinship, and Gender in the Lower Tchiri (Shire) Valley of Malawi, 1860–1960: An Alternative Theoretical Framework," *African Economic History* 13:137–69.

Maré, Gerhard. 1979. "Eveready to Exploit." *Work in Progress* 7:22–29.

Marshall, G. 1964. "Women, Trade and the Yoruba Family." Ph.D. dissertation, Columbia University. Also published as Sudarkasa, Niara, 1973. *Where Women Work: A Study of Yoruba Women in the Marketplace and in the Home.* Ann Arbor: University of Michigan Press.

Marx, Karl. 1930. *Capital.* Vol. 1. London: J. M. Dent.

———. 1976. *Capital.* Vol. 1. Harmondsworth: Penguin.

Masemann, V. 1974. "The 'Hidden Curriculum' of a West African Girls' Boarding School." *Canadian Journal of African Studies* 8(3):479–93.

Mbilinyi, M. 1969. *The Education of Girls in Tanzania.* Dar-es-Salaam: University College Institute of Education.

———. 1982. "The Political Practices of Peasant Women in Tanzania." Paper presented at the Twelfth World Congress of the International Political Science Association, Rio de Janeiro.

McNeil, Leslie. 1979. "Women of Mali: A Study in Sexual Stratification." B.A. thesis, Harvard University.

McSweeney, B. G., and M. Freeman. 1982. "Lack of Time as an Obstacle to Women's Education: The Case of Upper Volta," pp. 88–103. In *Women's Education in the Third World: Comparative Perspectives,* ed. G. Kelly and C. Elliott. Albany: SUNY Press.

McWilliam, H.O.A., and M. A. Kwamena-Poh. 1975. *The Development of Education in Ghana.* London: Longman Group.

Meillassoux, Claude. 1964. *Anthropologie économique des gouro de Côte d'Ivoire.* Paris: Mouton.

———. 1972. "From Reproduction to Production: A Marxist Approach to Economic Anthropology." *Economy and Society* 1(1):93–105.

———. 1981. *Maidens, Meal and Money: Capitalism and the Domestic Economy.* Cambridge: Cambridge University Press.

Merry, Sally. 1982. "The Articulation of Legal Spheres," pp. 68–89. In *African Women*

and the Law: Historical Perspectives, ed. M. J. Hay and M. Wright. Boston: Boston University Papers on Africa Vol. 7.

Middleton, John, and Greet Kershaw. 1965. *The Central Tribes of the North-Eastern Bantu*. London: International African Institute.

Mies, Maria. 1982. *The Lace Makers of Narsapur*. London: Zed Press.

Millett, Kate. 1971. *Sexual Politics*. London: Hart-Davis.

Mitchell, J. Clyde. 1954. "African Urbanization in Ndola and Luanshya." Rhodes-Livingstone Communication no. 6, Lusaka.

———. 1957. "Aspects of African Marriage on the Copperbelt of Northern Rhodesia." *Human Problems in British Central Africa* 22:1–30.

Mkalipe, Pauline Clara Masodi. 1979. "A Sociological Study of Black Women in the Clothing Industry." M.A. thesis, University of South Africa.

Molyneux, Maxine. 1977. "Androcentrism in Marxist Anthropology." *Critique of Anthropology* 3(9–10):55–81.

Monsted, M. 1976. "The Changing Division of Labour Within Rural Families in Kenya." Centre for Development Research, Nairobi.

Moore, R.J.B. 1940. *Man's Act and God's in Africa*. London.

Mueller, M. 1977. "Women and Men, Power and Powerlessness in Lesotho," pp. 154–66. In *Women and National Development*, ed. Wellesley Editorial Committee. Chicago: University of Chicago Press.

Mullings, Leith. 1976. "Women and Economic Change in Africa," pp. 239–64. In *Women in Africa: Studies in Social and Economic Change*, ed. N. J. Hafkin and E. G. Bay. Stanford: Stanford University Press.

Mungeam, G. H. 1966. *British Rule in Kenya, 1895–1912*. London: Clarendon Press.

Munro, J. F. 1975. *Colonial Rule and the Kamba*. Oxford: Clarendon Press.

Muntemba, Maud Shimwaayi. 1982. "Women and Agricultural Change in the Railway Region of Zambia: Dispossession and Counterstrategies, 1930–1979," pp. 83–104. In *Women and Work in Africa*, ed. Edna Bay. Boulder, Colo.: Westview Press.

Muriuki, Godfrey. 1974. *A History of the Kikuyu, 1500–1900*. Nairobi: Oxford University Press.

Murray, C. 1982. Excerpt from "Migrant Labour and Changing Family Structure in the Rural Periphery of Southern Africa," pp. 30–34. In *Sociology of Developing Societies*, ed. C. Allen and G. Williams. London: Macmillan.

Murray-Brown, J. 1972. *Kenyatta*. London: Allen and Unwin.

Nash, June, and Helen Safa. 1980. *Sex and Class in Latin America: Women's Perspectives on Politics, Economics and the Third World*. New York: Bergin.

National Textile Manufacturers' Association. 1966. Submission to Dr. F. J. Viljoen, Durban.

———. 1972. Wage Proposals.

Natal Labour Research Committee. 1980. "Control Over a Workforce: The Frame Case." *South African Labour Bulletin* 6(5):17–48.

Nelson, Joan. 1979. *Access to Power: Politics and the Urban Poor in Developing Countries*. Princeton: Princeton University Press.

Nelson, Nici. 1978. "Women Must Help Each Other," pp. 77–98. In *Women United, Women Divided*, ed. P. Caplan and J. Bujra. Bloomington: Indiana University Press.

Newton, J., M. Ryan, and J. R. Walkowitz, eds. 1982. *Sex and Class in Women's History*. London: Routledge and Kegan Paul.

Ngugi wa Thiong'o. 1981. *Detained: A Writer's Prison Diary.* London: Heinemann.

Nigerian National Archives, Ibadan (NAI). Commissioner of Colony Series (Com. Col.).

Nigerian National Archives, Ibadan (NAI). Colonial Secretary's Office Series (CSO).

Nkrumah, K. 1965. *Neo-Colonialism: The Last Stage of Imperialism.* New York: International.

———. 1970. *Class Struggle in Africa.* London: Panaf Books.

Northern Rhodesia. 1931. *Annual Report Upon Native Affairs.*

———. 1938. *Annual Report Upon Native Affairs.*

———. 1941. *Report of the Commission Appointed to Inquire Into the Disturbances in the Copperbelt of Northern Rhodesia (The Forster Report)*, chairman Sir John Forster, Lusaka. Evidence listed as: Evidence to the Forster Commission.

———. 1943. *A Report on Some Aspects of African Living Conditions on the Copperbelt of Northern Rhodesia (The Saffery Report)*, chairman A. Lynn Saffery, Lusaka.

———. 1946. Northern Rhodesian African Representatives Council, 1st Session (November).

———. 1951. *Annual Report of the Department of Labour.*

———. 1956. *Annual Report of the Department of Labour.*

———. 1961. *Annual Report of the Department of Labour.*

Nzinunu, Mampuya. 1978. "Les Femmes commerçantes de Kisangani et leur association AFCO." Mémoire de license sur gestion des entreprises, UNAZA, Kisangani.

Oakley, A. 1974. *The Sociology of Housework.* London: Martin Robertson.

O'Barr, Jean. 1975–76. "Pare Women: A Case of Political Involvement." *Rural Africana* 29:121–34.

Obbo, Christine. 1980. *African Women: Their Struggle for Economic Independence.* London: Zed Press.

Oboler, Regina. 1977. "The Economic Rights of Nandi Women." Working Paper no. 328. Institute of Development Studies, Nairobi.

———. 1980. "Is the Female Husband a Man? Woman/Woman Marriage Among the Nandi of Kenya." *Ethnology* 19(1):69–88.

———. 1984. *Women, Power and Economic Change: The Nandi of Kenya.* Stanford: Stanford University Press.

O'Brien, Denise. 1977. "Female Husbands in Southern Bantu Societies," pp. 109–26. In *Sexual Stratification: A Cross-Cultural View*, ed. A Schlegel. New York: Columbia University Press.

O'Connor, Sister G. A. 1964. "The Status and Roles of West African Women: A Study in Cultural Change." Ph.D. dissertation, New York University.

Ogunmodede, E. 1983. "Nigeria's Expulsions Reconsidered." *New African* 187 (April).

Okali, C. 1973a. "Family Labour on Cocoa Farms." Family Research Papers no. 4. University of Ghana Institute of African Studies.

———. 1973b. "Some Cocoa Families in Brong-Ahafo." Family Research Papers no. 2. University of Ghana Institute of African Studies.

———. 1975. "Dominase, A Mobile Cocoa Farming Community." Technical Publication Series no. 35. University of Ghana Institute of Statistical, Social and Economic Research.

———, K. Gyeke, and S. Mabey. 1974. "Report on the Socioeconomic Characteristics of the Ashanti Cocoa Rehabilitation Project Area." Legon: University of Ghana ISSER.

——, and S. Mabey. 1975. "Women in Agriculture in Southern Ghana." Paper presented at the Conference on Manpower Planning, Development and Utilisation in West Africa, Legon, Ghana, March.

Okeyo, Achola Pala. 1980. "Daughters of the Lakes and Rivers: Colonization and the Land Rights of Luo Women," pp. 186–213. In *Women and Colonization: Anthropological Perspectives*, ed. M. Etienne and E. Leacock. New York: Praeger.

Okonjo, Kemene. 1975. "Political Systems with Bisexual Functional Roles: The Case of Women's Participation in Politics in Nigeria." Paper presented at the annual meeting of the African Studies Association, October 29–November 1.

——. 1976. "The Dual Sex Political System in Operation: Igbo Women and Community Politics in Midwestern Nigeria," pp. 45–58. In *Women in Africa: Studies in Social and Economic Change*, ed. Nancy Hafkin and Edna Bay. Stanford: Stanford University Press.

Olusanya, G. O. 1964. "The Impact of the Second World War on Nigeria's Political Evolution." Ph.D. dissertation, University of Toronto.

——. 1973. *The Second World War and Politics in Nigeria*. London: Evans.

Ooko-Ombaka, Oki. 1980. "An Assessment of National Machinery for Women." *Assignment Children* 49/50:45–61.

Oppong, Christine. 1974. *Marriage Among a Matrilineal Elite*. London: Cambridge University Press.

Orde-Browne, Granville St. John. 1946. *Labor Conditions in East Africa*. Colonial Report no. 193. London: Her Majesty's Stationery Office.

"Organising Women?" 1982. *Work in Progress* 11:14–22.

Ortner, Sherry B., and Harriet Whitehead, eds. 1981. *Sexual Meanings: The Cultural Construction of Gender and Sexuality*. Cambridge: Cambridge University Press.

"Out-of-School Education for Women in African Countries." 1973. *Convergence* 6:7–18.

Oyemakinde, W. 1972. "The Pullen Marketing Scheme: A Trial in Food Price Control in Nigeria, 1941–47." *Journal of the Historical Society of Nigeria* 6:413–24.

Oyono, F. 1970. *Houseboy*. London: Heinemann.

Pala, Achola (see also Okeyo). "African Women in Rural Development: Research Trends and Priorities." No. 12. Washington, D.C.: Overseas Liaison Committee, American Council on Education.

Papanek, H. 1979. "Family Status Production: The 'Work' and 'Non-Work' of Women." *Signs* 4(4): 775–81.

Parkin, Frank. 1971. *Class Inequality and Political Order*. London: MacGibbon and Kee.

p'Bitek, Okot. 1973. *African Cultural Revolution*. Nairobi: Macmillan Books.

Pine, F. 1982. "Family Structure and the Division of Labour: Female Roles in Urban Ghana," pp. 387–405. In *Introduction to the Sociology of 'Developing Societies,'* ed. H. Alavi and T. Shanin. New York: Macmillan.

Plotnicov, Leonard. 1970. "The Modern African Elite of Jos, Nigeria," pp. 269–302. In *Social Stratification in Africa*, ed. Arthur Tuden and Leonard Plotnicov.

Poewe, Karla. 1981. *Matrilineal Ideology, Male–Female Dynamics in Luapula, Zambia*. London: Academic Press.

Pons, Valdo G. 1969. *Stanleyville: An African Community Under Belgian Administration*. London: Oxford University Press.

Powdermaker, Hortense. 1962. *Copper Town: Changing Africa*. New York: Harper & Row.

Presley, C. A. Forthcoming 1984. "Kikuyu Women in the Mau Mau Rebellion." In *'Resistance not Acquiescence': Studies in African, Afro-American and Caribbean History,* ed. Gary Okihiro. Amherst: University of Massachusetts Press.

Putnam, Robert. 1976. *The Comparative Study of Political Elites.* Englewood Cliffs, N.J.: Prentice-Hall.

Ram, R. 1982. "Sex Differences in the Labor Market Outcomes of Education," pp. 203–27. In *Women's Education in the Third World: Comparative Perspectives,* ed. G. Kelly and C. Elliott. Albany: SUNY Press.

Reiter, Rayna R., ed. 1975. *Toward an Anthropology of Women.* New York: Monthly Review Press.

Rapport annuel administration du territoire de la région du haut Zaire. 1977.

Remy, D. 1975. "Underdevelopment and the Experience of Women: A Nigerian Case Study," pp. 358–71. In *Toward an Anthropology of Women,* ed. R. Reiter. New York: Monthly Review Press.

Reynolds, Edward. 1974. *Trade and Economic Change on the Gold Coast, 1807–1874.* London: Longman.

Rigby, Peter. 1976. "Ritual Values and Social Stratification in Kampala, Uganda," In *A Century of Change in East Africa,* ed. W. Arens. Paris: Mouton.

Robertson, Claire. 1976. "Ga Women and Socioeconomic Change in Accra, Ghana," pp. 111–33. In *Women in Africa: Studies in Social and Economic Change,* ed. Nancy Hafkin and Edna Bay. Stanford: Stanford University Press.

———. 1977. "The Nature and Effects of Differential Access to Education in Ga Society." *Africa* 47(2):208–19.

———. 1983. "The Death of Makola and Other Tragedies: Male Strategies Against a Female-Dominated System." *Canadian Journal of African Studies* 17(3):469–95.

———. 1984a. "Formal or Informal Education: Women's Education in Accra, Ghana." *Comparative Education Review* 28(4):639–58.

———. 1984b. *Sharing the Same Bowl: A Socioeconomic History of Women and Class in Accra, Ghana.* Bloomington: Indiana University Press.

———, and Martin Klein, eds. 1984. *Women and Slavery in Africa.* Madison: University of Wisconsin Press.

Rogers, Barbara. 1980. *The Domestication of Women.* London: Tavistock.

Rogers, Susan G. 1982. "Efforts Toward Women's Development in Tanzania: Gender Rhetoric vs. Gender Realities." *Women and Politics* 2(4):23–41. See also 1983, pp. 23–42. In *Women in Developing Countries: A Policy Focus,* ed. Kathleen Staudt and Jane Jaquette. New York: Haworth Press.

Rogers, Susan. 1983. "Woman's Place: A Critical Review of Anthropological Theory." *Comparative Studies in Society and History* 20(1):123–62.

Rosaldo, Michelle. 1980. "The Use and Abuse of Anthropology—Reflections on Feminism and Cross-Cultural Understanding." *SIGNS* 5(3):389–417.

Rosaldo, Michelle, and Louise Lamphere, eds. 1974. *Woman, Culture and Society.* Stanford: Stanford University Press.

Rosberg, Carl, and John Nottingham. 1966. *The Myth of Mau Mau.* New York: Praeger.

Roscoe, John. 1911. *The Baganda.* New York: Barnes and Noble.

Ross, McGregor W. 1927. *Kenya from Within.* London: Allen and Unwin.

Rousseau, Ida Faye. 1975. "Identity Crisis? Some Observations on Education and the Changing Roles of Women in Sierra Leone and Zaire," *Women Cross-Culturally: Change and Challenge.* ed. Ruby Rohrlich-Leavitt. Paris: Mouton, pp. 41–52.

Routledge, W. Scoresby, and Routledge, Katherine. 1910. *With a Prehistoric People: The Akikuyu of British East Africa*. London: Cass.

Rowbotham, Sheila. 1972. *Women, Resistance and Revolution: A History of the Modern World*. New York: Pantheon.

Rubin, Gayle. 1975. "The Traffic in Women: Notes on the 'Political Economy' of Sex," pp. 157–210. In *Toward an Anthropology of Women*, ed. R. R. Reiter. New York: Monthly Review Press.

Sachs, E. S. 1957. *Rebels' Daughters*. London: Macgibbon and Kee.

Sacks, Karen. 1974. "Engels Revisited: Women, the Organization of Production and Private Property," pp. 207–22. In *Woman, Culture and Society*, ed. Michelle Rosaldo and Louise Lamphere. Stanford: Stanford University Press.

———. 1979. *Sisters and Wives: The Past and Future of Sexual Inequality*. Westport, Conn.: Greenwood. 1982. Also Urbana: University of Illinois Press.

Safa, Helen. 1979. "Class Consciousness Among Working Class Women in Latin America: A Case Study in Puerto Rico," pp. 441–59. In *Peasants and Proletarians*, ed. Robin Cohen, Peter Gutkind, and Phyllis Brazier. New York: Monthly Review Press.

———. 1981. "Runaway Shops and Female Employment: The Search for Cheap Labor." *Signs* 7(2):418–33.

Saffioti, Heleith. 1978. *Women in Class Society*. New York: Monthly Review Press.

Safilios-Rothschild, C. 1979. "Access of Rural Girls to Primary Education in the Third World." USAID Women in Development Office Report.

Sanday, Peggy. 1974. "Female Status in the Public Domain," pp. 189–206. In *Woman, Culture and Society*, ed. Michelle Rosaldo and Louise Lamphere. Stanford: Stanford University Press.

Sandbrook, R., and R. Cohen. 1975. *The Development of an African Working Class*. London: Longman.

Sanderson, L. 1975. "Girls' Education in the Northern Sudan (1898–1956)," pp. 229–46. In *Conflict and Harmony in Education in Tropical Africa*, ed. G. N. Brown and M. Hiskett. London: Allen and Unwin.

Sargent, Lydia, ed. 1981. *Women and Revolution: A Discussion of the Unhappy Marriage of Marxism and Feminism*. Boston: South End Press.

Saunders, Margaret. 1979. "Women's Divorce Strategies in Mirria County, Niger Republic: Cases from the Tribunal de Premier Instance." Paper presented at the African Studies Association meeting, November.

Schatzberg, Michael G. 1980. *Politics and Class in Zaire: Bureaucracy, Business and Beer in Lisale*. New York: Africana.

Schildkrout, Enid. 1982. "Dependence and Autonomy: The Economic Activities of Secluded Hausa Women in Kano, Nigeria," pp. 55–81. In *Women and Work in Africa*, ed. E. Bay. Boulder, Colo.: Westview Press.

Schlegel, Alice, ed. 1977. *Sexual Stratification: A Cross-Cultural View*. New York: Columbia University Press.

Schneider, Harold K. 1979. *Livestock and Equality in East Africa: The Economic Basis for Social Structure*. Bloomington: Indiana University Press.

Schuster, Ilsa. 1979. *New Women of Lusaka*. Palo Alto, Calif.: Mayfield.

Schuster, I. 1981. "Perspectives in Development: The Problem of Nurses and Nursing in Zambia," pp. 77–97. In *African Women in The Development Process*, ed. N. Nelson. London: Cass.

Schwartz, Alf. 1972. "Illusion d'une émancipation et alienation réelle de l'ouvrière zairoise." *Canadian Journal of African Studies* 6(2):183–212.

Seibel, Jans D., and Andreas Massing. 1974. *Traditional Organizations and Economic Development in Liberia.* New York: Praeger.

Semyonov, Moshe. 1980. "The Social Context of Women's Labor Force Participation: A Comparative Analysis." *American Journal of Sociology* 86(3):534–50.

Shivji, Issa G. 1976. *Class Struggles in Tanzania.* New York: Monthly Review Press.

Simmons, Emmy. 1976. "Economic Research on Women in Rural Development in Northern Nigeria." No. 10. Washington, D.C.: Overseas Liaison Committee, American Council on Education.

Sklar, R. 1963. *Nigerian Political Parties.* Princeton: Princeton University Press.

Smith, Mary. 1965. *Baba of Karo.* London: Faber and Faber.

Smock, Audrey C. 1977. "Ghana: From Autonomy to Subordination," pp. 173–216. In *Women's Roles and Status in Eight Countries,* ed. Janet Giele and Audrey Smock. New York: Wiley.

———. 1982. "Sex Differences in Educational Opportunities and Labor Force Participation in Six Countries," pp. 235–52. In *Comparative Education,* ed. P. Altbach, et al. New York: Macmillan.

Solzbacher, R. M. 1968. "Urban Stratification as a Socio-Cultural System." Paper presented at the Sociology of Development Workshop. 1968. Kampala: Makerere University, Department of Sociology Working Paper 80.

Sorrenson, M. P. K. 1967. *Land Reform in the Kikuyu Country: A Study in Government Policy.* Nairobi: Oxford University Press.

———. 1968. *Origins of European Settlement in Africa.* Nairobi: Oxford University Press.

Spearpoint, Frank. 1937. "The African Native and the Rhodesia Copper Mines." *Journal of the Royal Africa Society* 36(144) (supp. 3):1–59.

Spencer, I. 1980. "Settler Dominance, Agricultural Production and the Second World War in Kenya." *Journal of African History* 21:497–514.

Stamp, Patricia. 1975–76. "Perceptions of Change and Economic Strategy Among Kikuyu Women of Mitero, Kenya." *Rural Africana* 29:19–44.

———. 1982. "Kenya: The Echoing Footsteps." *Current History* 81(March):115–18, 130, 137–38.

Stanworth, Michelle. 1984. "Women and Class Analysis." *Sociology* 18(2):159–70.

Staudt, Kathleen A. 1978a. "Administrative Resources, Political Patrons, and Redressing Sex Inequities: A Case from Western Kenya." *Journal of Developing Areas* 12(4):399–414.

———. 1978b. "Agricultural Productivity Gaps: A Case Study of Male Preference in Government Policy Implementation." *Development and Change* 9(3):439–57.

———. 1979. "Class and Sex in the Politics of Women Farmers." *Journal of Politics* 41(1):492–512.

———. 1980. "The Umoja Federation: Women's Co-optation Into a Local Power Structure." *Western Political Quarterly* 33(2):278–90.

———. 1981. "Women Farmers and Inequities in Agricultural Services," pp. 207–24. In *Women and Work in Africa,* ed. E. Bay. Boulder, Colo.: Westview Press.

———. 1982. "Sex, Ethnic and Class Consciousness in Western Kenya." *Comparative Politics* 14(1):149–58.

———. 1984a. *Women, Foreign Assistance and Advocacy Administration.* New York: Praeger.

———. 1984b. "Women's Politics in African States: Creating Conditions for Capitalist Transformation." Women in International Development Working Paper Series, no. 54. Michigan State University, East Lansing.

Steady, Filomina Chioma. 1975. *Female Power in African Politics: The National Congress of Sierra Leone Women*. Pasadena: Munger Africana Library, California Institute of Technology.

Stichter, Sharon. 1975–76. "Women in the Labor Force in Kenya, 1895–1964." *Rural Africana* 29:45–67.

Strathern, Marilyn. 1981. "Self-Interest and the Social Good: Some Implications of Hagen Gender Imagery," pp. 166–71. In *Sexual Meanings: The Cultural Construction of Gender and Sexuality*, ed. S. B. Ortner and H. Whitehead. Cambridge: Cambridge University Press.

"Strike at Sea Harvest." 1980. *Work in Progress* 11:26–27.

Strobel, Margaret, 1979. *Muslim Women in Mombasa*. New Haven: Yale University Press.

———. 1982. "African Women." *Signs* 8(1):109–31.

Sudarkasa, Niara. 1973. *Where Women Work: A Study of Yoruba Women in the Marketplace and in the Home*. Anthropological Papers, no. 53. Ann Arbor: Museum of Anthropology, University of Michigan.

Sutton, J. E. G. 1968. "The Settlement of East Africa," pp. 69–99. In *Zamani: A Survey of East African History*. ed. B. A. Ogot and J. A. Kieran. Nairobi: East African Publishing House.

Svalastoga, Kaare. 1965. *Social Differentiation*. New York: David McKay.

Swainson, Nicola. 1977. "The Rise of a National Bourgeoisie in Kenya." *Review of African Political Economy* 8:39–55.

Szereszewski. R. 1965. *Structural Changes in the Economy of Ghana: 1891–1911*. London: Weidenfeld and Nicolson.

Tadesse, Zen. 1979. "The Impact of Land Reform on Women: The Case of Ethiopia," pp. 18–21. In *Women, Land and Food Production*, ISIS Bulletin no. 11.

Tamuno, T. 1966. *Nigeria and Elective Representation*. London: Heinemann.

Tardits, C. 1963. "Réfléxions sur le problème de la scolarisation des filles au Dahomey." *Cahiers d'études africaines* 3(2):226–81.

Taylor, John G. 1979. *From Modernization to Modes of Production: A Critique of the Sociologies of Development and Underdevelopment*. London: Macmillan.

Taylor, J. V., and D. Lehmann. 1961. *Christians of the Copperbelt*. London: S.C.M. Press.

Terray, Emmanuel. 1972. *Marxism and "Primitive" Societies*. New York: Monthly Review Press.

Thomas, J. H. 1973. "The Wage Structure in the Clothing Industry." South African Institute of Personnel Management and South African Institute of Race Relations, Johannesburg.

Thurow, Lester, 1977. "Education and Economic Inequality," pp. 325–35. In *Power and Ideology in Education*, ed. J. Karabel and A. Halsey. New York: Oxford University Press.

Tignor, R. L. 1976. *The Colonial Transformation of Kenya*. Princeton: Princeton University Press.

Tilly, Louise A. 1981a. "Paths of Proletarianization: Organization of Production, Sexual Division of Labour and Women's Collective Action." *Signs* 7(2):400–417.

———. 1981b. "Women's Collective Action and Feminism in France, 1870–1914," pp. 207–31. In *Class Conflict and Collective Action*, ed. Louise A. Tilly and Charles Tilly. Beverly Hills, Calif.: Sage.

Trevor, J. 1975. "Western Education and Muslim Fulani/Hausa Women in Sokoto,

Northern Nigeria," pp. 247–70. In *Conflict and Harmony in Education in Tropical Africa*, ed. G. N. Brown and M. Hiskett. London: Allen and Unwin.

Tuden, Arthur, and Leonard Plotnicov, eds. 1970. *Essays in Comparative Social Stratification.* Pittsburgh: University of Pittsburgh Press.

Tyree, Andrea, Moshe Semyonov, and Robert Hodge. 1979. "Gaps and Glissandos: Inequality, Economic Development, and Social Mobility in 24 Countries." *American Sociological Review* 44:410–24.

UNESCO. 1950–80. *Statistical Yearbooks.*

UNESCO. Division of Statistics on Education. 1980. *Comparative Analysis of Male and Female Enrolment and Literacy.*

United Missions in the Copperbelt (UMCB). 1936–48. *Annual Reports.*

Urdang, S. 1979. *Fighting Two Colonialisms: Women in Guinea-Bissau.* New York: Monthly Review Press.

Van Allen, Judith. 1972. "Sitting on a Man: Colonialism and the Lost Political Institutions of Igbo Women." *Canadian Journal of African Studies* 6(2):165–82.

Van Allen, J. 1976. " 'Aba Riots' or Igbo 'Women's War'? Ideology, Stratification, and the Invisibility of Women," pp. 58–86. In *Women in Africa*, ed. N. J. Hafkin and E. G. Bay. Stanford: Stanford University Press.

Van der Vaeren-Aguessy, D. 1966. "Les Femmes commerçantes au detail sur les marchés dakarois," pp. 244–55. In *The New Elites of Tropical Africa*, ed. P. C. Lloyd. London: Oxford University Press.

Van Onselen, C. 1976. *Chibaro.* London: Pluto Press.

Van Vuuren, Nancy. 1979. *Women Against Apartheid.* Palo Alto, Calif.: R&E Research Associates.

Van Zwanenberg, R. 1975. *Colonial Capitalism and Labor in Kenya, 1919–1939.* Nairobi: East African Literature Bureau.

Vellenga, Dorothy D. 1975. "Changing Sex Roles and Social Tensions in Ghana: The Law of Measure and Mediator of Family Conflict." Ph.D. dissertation, Columbia University.

———. 1977. "Attempts to Change the Marriage Laws in Ghana and the Ivory Coast," pp. 125–50. In *Ghana and the Ivory Coast: Perspectives on Modernization,* ed. P. Foster and A. Zolberg. Chicago: University of Chicago Press.

———. 1982. "Who Is a Wife: Legal Expressions of Heterosexual Conflict in Ghana," pp. 144–55. In *Female and Male in West Africa*, ed. C. Oppong. London: Allen and Unwin.

Venema, L. B. 1978. *The Wolof of Saloum: Social Structure and Rural Development in Senegal.* Wageningen: Center for Agricultural Publishing and Documentation.

Verba, Sidney, Norman Nie, and Jae-on Kim. 1978. *Participation and Political Equality: A Seven-Nation Comparison.* Cambridge: Cambridge University Press.

Verhaegen, Benoit, 1978. "Impérialisme technologique et bourgeoisie nationale au Zaire," pp. 347–79. In *Connaissance du tiers monde*, ed. C. Coquery-Vidrovitch. Paris: Union Générale d'Editions.

———. 1979. "Les Mouvements de libération en Afrique: le cas du Zaire en 1978." *Genève-Afrique* 17(1):173–81.

———. 1981. "Le Centre extra-coutumière de Stanleyville (1940–1945)." *Les Cahiers du CEDAF* (Brussels), no. 8.

Vincent, Joan. 1971. *African Elite: The Big Man of a Small Town.* New York: Columbia University Press.

———. 1982. *Teso in Transformation: The Political Economy of Peasant and Class in Eastern Africa.* Berkeley: University of California Press.

Vogel, Lise. 1983. *Marxism and the Oppression of Women: Toward a Unitary Theory.* New Brunswick, N.J.: Rutgers University Press.

Wachtel, Eleanor. 1976. "A Farm of One's Own: The Rural Orientation of Women's Group Enterprises in Nakuru, Kenya." *Rural Africana* 29:69–80.

———, and Andy Wachtel. 1977. "Women's Co-operative Enterprise in Nakuru." Discussion Paper no. 250. Institute for Development Studies, University of Nairobi.

"Wages in the Clothing Industry." 1982. *Work in Progress* 23:46–49.

Ward-Price, H. L. 1933. *Land Tenure in the Yoruba Provinces.* Lagos.

Webb, M. 1982. "The Labour Market," pp. 114–74. In *Sex Differences in Britain,* ed. I. Reid and E. Wormald. London: Grant McIntyre.

Weber, Max. 1947. *The Theory of Social and Economic Organization,* ed. T. Parsons. London: Hodge.

Weis, Lois. 1980. "Women and Education in Ghana: Some Problems of Assessing Change." *International Journal of Women's Studies* 3(5):431–53.

West, J. 1978. "Women, Sex and Class," pp. 220–53. In *Feminism and Materialism,* ed. A. Kuhn and A. Wolpe. London: Routledge and Kegan Paul.

West African Pilot (Lagos). 1944–46.

Westmore, Jean, and Pat Townsend. 1975. "The African Women Workers in the Textile Industry in Durban." *South African Labour Bulletin* 2(4):18–32.

White, Luise. 1983. "A Colonial State and an African Petty Bourgeoisie: Prostitution, Property and Class Struggle in Nairobi 1936–1940," pp. 167–94. In *Struggle for the City,* ed. F. Cooper. Beverly Hills, Calif.: Sage.

Whyte, Martin King. 1978. *The Status of Women in Preindustrial Societies.* Princeton: Princeton University Press.

Wilks, Ivor. 1975. *Asante in the Nineteenth Century: The Structure and Evolution of a Political Order.* Cambridge: Cambridge University Press.

Williams, G. 1980. *State and Society in Nigeria.* Nigeria: Afrografika.

———. N.d. "Inequalities in Rural Western Nigeria." Occasional Paper no. 16. University of East Anglia School of Development Studies.

Willis, Roy. 1981. *A State in the Making.* Bloomington: Indiana University Press.

Wilson, Godfrey. 1942. *An Essay on the Economics of Detribalization in Northern Rhodesia.* Rhodes-Livingstone Paper no. 6. Manchester: Manchester University Press.

Wipper, Audrey. 1971a. "Equal Rights for Women in Kenya?" *Journal of Modern African Studies* 9(3):429–42.

———. 1971b. "The Politics of Sex." *African Studies Review* 14(3):463–82.

———. 1972. "Editorial." *Canadian Journal of African Studies* 6:144.

———. 1975. "The Maendeleo ya Wanawake Organisation: The Cooptation of Leadership." *African Studies Review* 18(3):99–120.

———. 1982. "Riot and Rebellion Among African Women: Three Examples of Women's Political Clout," pp. 50–72. In *Perspectives on Power: Women in Africa, Asia and Latin America,* ed. Jean O'Barr. Durham: Duke University Center for International Studies.

Wolff, R. D. 1974. *The Economics of Colonialism.* New Haven: Yale University Press.

World Bank. 1975. *Kenya: Into the Second Decade,* ed. John Burrows. Baltimore: Johns Hopkins University Press.

———. 1979. *World Development Report.* Washington, D.C.: World Bank.

———. 1980. *Zaire: Current Economic Situation and Constraints.* Washington, D.C.: World Bank.

———. 1981. *Accelerated Development in Sub-Saharan Africa.* Washington, D.C.: World Bank.

Wrigley, C. C. 1965. "Kenya: The Patterns of Economic Life, 1902–1945," pp. 209–65. In *History of East Africa,* ed. V. Harlow, E. M. Chilver, and A. Smith. Vol. 2. Oxford: Oxford University Press.

Xydias, Nelly. 1956. "Labor: Conditions, Aptitude, Training," pp. 275–367. In *Social Implications of Industrialisation and Urbanisation in Africa South of the Sahara.* UNESCO.

Yates, B. 1981. "Colonialism, Education and Work: Sex Differentiation in Colonial Zaire," pp. 127–52. In *Women and Work in Africa,* ed. E. Bay. Boulder, Colo.: Westview Press.

———. 1982. "Church, State and Education in Belgian Africa: Implications for Contemporary Third World Women," pp. 127–51. In *Women's Education in the Third World: Comparative Perspectives,* ed. G. Kelly and C. Elliot. Albany: SUNY Press.

Yeld, E. R. 1961. "Educational Problems Among Women and Girls in Sokoto Province of Northern Nigeria." *Sociologus* 11:160–74.

Young, Crawford. 1965. *Politics in the Congo.* Princeton: Princeton University Press.

Young, Kate. 1978. "Modes of Production and the Sexual Division of Labour: A Case Study from Oaxaca, Mexico." In *Feminism and Materialism: Women and Modes of Production,* ed. Annette Kuhn and Ann Marie Wolpe. London: Routledge and Kegan Paul.

Zambia. 1966. *Report of the Commission of Inquiry into the Mining Industry (The Brown Report),* chairman Roland Brown. Lusaka: 1966.

Zimbabwe Women's Bureau. N.d. (ca. 1980). *Black Women in Zimbabwe.*

INDEX

Abayomi, Oyinkan, 246–47, 249, 254 n.10
Abayomi, Kofoworola, 246
Abeokuta, Nigeria, 12, 82–83, 85, 89, 91 n.7, 249–51
Abeokuta Ladies' Club, 249–50
Abeokuta Women's Union (AWU), 249–52
Abernethy, David, 111–12
Absentee rate: in textile industry, 230–31, 235 n.20
Abusa system, 66–71, 73, 75
Accra, Ghana, 109, 110, 126
Acker, Joan, 3
Action Group (AG), 242–43, 248–49, 252
Ademola, 249–52
Adultery, 50, 144, 152, 154
African Mineworkers' Union (AMWU), 147, 148
African National Congress, 232
African National Congress Women's League, 218
African Social Studies: A Radical Reader, 8
Age-grade organizations, 27, 30, 34, 44 n.13, 55–57; among Kikuyu, 35, 36–37; among Tugen, 47, 54
Age set, 44 n.13, 55–57, 61 n.4
Agnatic descent. *See* Patriliny
Agricultural contract labor groups, 209–10
Agricultural education, 109, 200
Agricultural labor, 98, 108–109, 124–25, 127–29, 131; and access to resources, 92; on Idakho Location, 204–206; performed by women, 5–6, 27, 86, 190, 256; trade unions for, 234 n.8; and women's status, 199–200; in Yoruba society, 86, 238
Agriculture, 5–6, 119, 205–206, 257, 262. *See also* Subsistence agriculture
Akan, 63–65
Alake (king): in Abeokuta, 249–52
Algeria, 211; education in, 96, 101, *tables* 94–95, 97, 101; wage labor force, *table* 123

All Peoples Congress (APC), 208–209
Amin, Idi, 185, 192
Androcentrism: in social sciences, 28, 32
Anglo-American (AA) mining company, 142, 143, 151, 156–57 n.1
Angola: education in, 93, 96, *tables* 94–95, 97
Anthropology, 7, 198
Apartheid, 127, 140 n.9
Asante (Ashante; Ashanti), 63, 77, n.8, 201
Aseda (rum agreement), 68
Ashabi, Janet, 251
Asia, 33–34, 122
Askwith, T. G., 201
Association des Femmes Commerçantes (AFCO), 175–76
Association of West African Merchants, 241
Athamaki, 36, 37, 39
Atu, Kenya, 174
Autonomy, 165, 198–99, 269
Awe, Nigeria, 83
Ayahs (nursemaids), 130

Bakshesh, 260
Banks, 168, 171, 179
Barabaig, 49, 56–57, 180
Baringo District, Kenya, 47, 57, 59
Barrett, Michèle, 140 n.6
Barmaids, 192
Bawejjere, 191
Beer brewing, 125, 144, 145, 150, 158 n.35, 204
Beer halls, 145–46
Belfield, Sir Henry Conway, 258
Belgium: and education, 106–107, *tables* 105, 106
Benin (Dahomey): education in, 93, 96, 100, 102, 110, tables 94–95, 97, 101
Bernstein, Henry, 40–41, 138
Berry, Sarah, 84, 89
Bilateral (cognatic) descent, 81–83
Birth control, 211, 228
Black Allied Workers' Union, 222

ABOUT THE CONTRIBUTORS

Patricia Stamp is Associate Professor of Social Science at York University in Toronto and teaches African studies and women's studies. She earned her doctorate at London University in 1981 and has published on municipal politics, Kikuyu women's organizations, administrative training institutes, and more recently on Kenyan politics and ideology, with a focus on the connection between class formation and other dimensions of social organization: gender, ethnicity, and government institutions.

Bonnie Kettel is a migrant anthropologist who has taught at the Universities of Northern Colorado, Saskatchewan, Toronto, and York. In addition to her work with the Tugen, she has carried out ethnographic research among the Kwakiutl of British Columbia and in the Tuscan region of Italy. She is presently Assistant Professor of Anthropology at York University in Toronto.

Dorothy Dee Vellenga taught secondary school and also did extensive research in Ghana. She received her Ph.D. in sociology from Columbia University in 1975 and published numerous articles concerning the situation of rural women in Ghana. She was Professor of Sociology at Muskingum College in Ohio for some years. She died on October 3, 1984, after a valiantly fought and lengthy illness.

Simi Afonja is a Senior Lecturer in the Department of Sociology and Anthropology, Faculty of Social Sciences, University of Ife, Ile-Ife, Nigeria, and has done extensive research on Yoruba women. She is presently part of a national team involved in research on women's work in Nigeria.

Claire Robertson is Assistant Professor of History and Women's Studies at Ohio State University. She received her Ph.D. in African history from the University of Wisconsin–Madison. She has published a number of articles, including several on African women's education, and is author of *Sharing the Same Bowl: A Socioeconomic History of Women and Class in Accra, Ghana*, and coeditor with Martin Klein of *Women and Slavery in Africa*.

Janet M. Bujra studied sociology and anthropology at London University. She has carried out research in Kenya, Tanzania, and Gambia and taught at the American University in Cairo and at the University of Dar es Salaam. She is coeditor with Pat Caplan of *Women United, Women Divided* and has written widely on questions of class, gender, and development. She is a Lecturer in Sociology at the University College of Wales, Aberystwyth.

Jane L. Parpart is currently Assistant Professor of History at Dalhousie University and author of *Labor and Capital on the African Copperbelt*. She has published a number of articles on labor and women in Africa.

Janet MacGaffey is an anthropologist specializing in economics and urban studies who has done research in Zaire and taught anthropology for several years. She is currently working with the Institute for the Study of Human Issues doing research on the underground economy in Philadelphia, Pennsylvania.

Christine Obbo is a Ugandan urban anthropologist who graduated from Makerere University College, Uganda, and the University of Wisconsin–Madison. She has conducted research in rural as well as low-income urban areas and has published on a variety of subjects related to social change and women. Currently she is studying a midwestern suburb and elite women in East Africa to determine the communication patterns in both research situations. She teaches at Wheaton College in Massachusetts.

Kathleen Staudt is an Associate Professor of Political Science at the University of Texas at El Paso. She received her Ph.D. in political science, with a minor in African studies, at the University of Wisconsin–Madison. She has published numerous articles on women farmers and women's politics and authored *Women, Foreign Assistance, and Advocacy Administration* (N.Y.: Praeger, 1984).

Iris Berger is Assistant Professor of History and African and Afro-American Studies at the State University of New York at Albany, where she has just completed a three-year term as Director of Women's Studies. She has written widely on African women and is the author of *Religion and Resistance: East African Kingdoms in the Precolonial Period*. She is currently working on a social history of women industrial workers and trade unionists in South Africa.

Cheryl Johnson has a Ph.D. in African History and is Acting Director of the Program of African Studies at Northwestern University in Evanston, Illinois. She has published numerous articles on Nigerian women.

Cora Ann Presley is Associate Professor of History at Loyola University, New Orleans, Louisiana. She did her graduate work at Stanford University.